WOMEN IN ITALIAN
RENAISSANCE ART

FOR STUART

SONIA

AND FOR

MY MOTHER

WOMEN
IN ITALIAN
RENAISSANCE
ART

GENDER
REPRESENTATION
IDENTITY

❀

Paola Tinagli

MANCHESTER
UNIVERSITY PRESS
Manchester and New York

distributed exclusively in the USA by St. Martin's Press

Published by Manchester University Press
Oxford Road, Manchester M13 9NR, UK
and Room 400, 175 Fifth Avenue, New York, NY 10010, USA

Distributed exclusively in the USA by
St. Martin's Press, Inc., 175 Fifth Avenue, New York, NY 10010, USA

British Library Cataloguing-in-Publication Data
A catalogue record is available from the British Library

Library of Congress Cataloging-in-Publication Data
Tinagli, Paola.
 Women in Italian Renaissance art : gender, representation, identity / Paola
Tinagli.
 p. cm.
 ISBN 0–7190–4053–1. — ISBN 0–7190–4054–X (pbk.)
 1. Women in art. 2. Gender identity in art. 3. Feminine beauty (Aesthetics)
4. Painting, Italian. 5. Painting, Renaissance—Italy. 6. Painters—Italy—Psychology.
ND/1460.W65T56 1997
757′.4′094509024—dc20 96–27485

ISBN 0 7190 4053 1 *hardback*
ISBN 0 7190 4054 X *paperback*

First published 1997
01 00 99 98 97 10 9 8 7 6 5 4 3 2 1

Printed in Great Britain
by Redwood Books, Trowbridge

CONTENTS

LIST OF ILLUSTRATIONS

Measurements are expressed in centimetres

FOREWORD

This book deals with some of the different ways in which women have been represented in Italian Renaissance painting. It attempts to place these images of women within the cultural context of the artists who painted them and of the patrons who commissioned them. It also tries to make accessible to the modern viewer some of the meanings which were the common currency of the period, and to uncover some of the problems with which artists grappled. A careful selection has been made from the vast range of representations of women produced from the early fifteenth century to the second half of the sixteenth, and these are examined in order to demonstrate the immensely complex and varied landscape of the past.

The images are grouped according to their 'function' – the ways in which they were used, and the reasons why they were commissioned. Considering function helps us to shift the emphasis from the present to the past, and to highlight the differences between a modern viewer's perception, assumptions and expectations, and those belonging to the culture in which these paintings were produced. Function leads us also to examine the material context of the paintings – the location – that is, where and how they were actually displayed. The book also explores the intentions of the patrons, the artistic problems investigated by the artists, and the ways in which works of art were discussed in writing. Changes in pictorial representation, and the material transformations in function and manner of display from the first half of the fifteenth century to the second half of the sixteenth, are examined. Finally, traditional and new interpretations given by art historians, scholarly controversies about the meaning of the works, a guide to recent scholarship and the results of recent research, are outlined in the footnotes. An annotated bibliography provides an additional tool for other study. I hope that the material presented here will encourage readers to undertake further investigations and research in this area at a variety of levels.

ACKNOWLEDGEMENTS

I am very grateful to Edinburgh College of Art for the research and travel grants made available to me to complete this book, and to my colleagues in the Department of Humanities for their patience and sense of humour. Margaret Daly Davis was very generous with her time and encouragement, and very helpful in obtaining photographs. I would also like to thank the following people: Catherine King, Michael Bury, Judy Rowson, Jane Bridgeman, Tricia Allerston, Mary Rogers, Con Gillen, Colin Bailey, Hans Speitel, Mandy Begbie, Desmond Ryan.

A special thanks to my editor, Katharine Reeve, for her enthusiasm, encouragement and suggestions. The following institutions have helpfully provided photographs: Ministero per i Beni Culturali e Ambientali, Rome; Archivio Pinacoteca Nazionale, Bologna; Soprintendenze per i Beni Artistici e Storici, Florence, Milan and Mantova; Accademia Carrara di Belle Arti, Bergamo; Biblioteca Apostolica Vaticana; Reunion des Musées Nationaux, Paris; Photographie Giraudon, Paris; Courtauld Institute Galleries, London; National Gallery, London; The Warburg Institute, London; Royal Collection Enterprises; National Galleries of Scotland; Prince Czartorysky Foundation; Staedel Kunstinstitut, Frankfurt; Kunsthistorisches Museum, Vienna; Museo del Prado, Madrid; Colección Thyssen-Bornemitzsa, Madrid; The Metropolitan Museum of Art, New York; National Gallery of Art, Washington, DC; Memphis Brooks Museum of Art; The Isabella Stewart Gardner Museum, Boston.

I owe much to my daughter, Sonia, for her practical help and for her support. To my husband, *grazie dal profondo del cuore*.

INTRODUCTION

Man may be the expression of the perfect proportions of the universe, as Leonardo's famous image of the Vitruvian man implies, but to the average tourist visiting the Uffizi or the Louvre it is images of women which embody the ideals of beauty and harmony of the Italian Renaissance. Women are the subject matter of paintings, so well known that they are in fact part of the visual baggage even of people who have never entered a museum or an art gallery. Who is not familiar with the grace and ethereal beauty of Botticelli's *Primavera* and of his naked Venus? Who cannot recognise the smile of Leonardo's *Mona Lisa*? Who has not seen in reproduction the maternal sweetness of a Raphael Madonna, or the opulent Venetian sensuality of Titian's *Venus of Urbino*? From the public's point of view, the terms 'Renaissance' and 'Woman' seem to be synonymous.

The familiarity of the images and the painters' mastery of technique may lead the viewer to believe that these paintings are like mirrors which reflect the reality of the past. It is easy to be 'tricked' into believing that, when we look at a painting produced during this period, we are looking at 'the real world'. Leon Battista Alberti, humanist, writer, painter and architect, wrote in the mid-1430s in his treatise *On Painting* that 'the painter is concerned solely with representing what can be seen'.[1] Alberti expresses the notion that knowledge is derived from sensory perception, and that painting is based on the observation of objects made visible by light. Masaccio was described as 'imitator of nature' (*imitatore di natura*), while Leonardo urged painters to explore 'the causes of nature's phenomena regulated by nature's laws'.[2] From the beginning of the fifteenth century to the first decades of the sixteenth, artists studied the appearance of the natural world, inspired also by stories about two famous painters of antiquity, Zeuxis and Parrhasios, and about their prodigious skills in the imitation of nature. According to Pliny the Elder, Zeuxis had painted some grapes which looked so 'real', that birds tried to peck at them. Parrhasios then asked Zeuxis to look at his painting, which was veiled by a curtain: when Zeuxis tried to move the curtain aside, he realised that it was in fact painted.[3]

'Nature', however, had to be filtered through the ideal: concepts of beauty, harmony and divine proportions were seen as the manifestation of the perfection of an idea and of the infinite goodness of God. The painters of Greece and Rome had knowledge of these 'secrets' which Renaissance artists were trying to rediscover. The search for the ideal is evident throughout this period, and

is manifested in the study for the proportions to be used in the representation of the human body, in the design of buildings, in the plans for ideal cities. Idealisation and selection of what is best in nature were necessary for the painter in order to eliminate the imperfections of reality. Alberti advised the painter: 'always take from nature that which you wish to paint, and always choose the most beautiful'. He used an example from antiquity as a warning: the painter should not follow Demetrius '. . . an antique painter, [who] failed to obtain the ultimate praise because he was much more careful to make things similar to the natural than to the lovely'.[4] Both Cicero and Pliny the Elder told another story about Zeuxis, which became famous during the Renaissance, and which Alberti reported in his treatise:

> In order to make a painting which the citizens placed in the temple of Lucina near Croton, Zeuxis, the most excellent and most skilled painter of all, did not rely rashly on his own skills as every painter does today. He thought that he would not be able to find so much beauty as he was looking for in a single body, since it was not given to a single one by nature. He chose, therefore, the five most beautiful young girls from the youth of that land in order to draw from them whatever beauty is praised in a woman. He was a wise painter.[5]

About eighty years later, in 1514, Raphael would make references to the same story in a letter to Baldassarre Castiglione. Discussing his fresco representing the nymph *Galatea*, which he had painted for Agostino Chigi in his *villa suburbana* in Rome, Raphael wrote:

> As for the Galatea, I should consider myself a great master if only half of the many compliments your Lordship wrote to me are deserved. However, I recognize in your words the love you bear me, and would say that in order to paint one beautiful woman I'd have to see several beautiful women, always on the condition that I had your Lordship at my side in making the choice. But since there is a shortage both of good judges and of beautiful women, I make use of a certain idea which comes into my mind. Whether it carries any excellence of art I do not know, but I work hard to achieve it.[6]

Perfection, then, could be achieved through the 'idea' present in the artist's mind, even if there were no beautiful women available, nor anybody able to judge their beauty!

The images of women discussed in this book are not direct representations of 'reality', nor of 'what the painter saw'. They are the embodiment of a set of ideals and values, both aesthetic and social, shared by the artists and by the patrons who commissioned the paintings. The culture in which they were made was very different from ours: we need to learn their language in order to understand what they are saying.

Artistic genres

Painted furniture

The first images of women in this book appear in the domestic environment of the fifteenth-century house. In this period furniture was decorated with painted stories, usually representing subject matter derived from Greek, Roman or fourteenth-century literature, or from the Old Testament. In these narratives women often figure as heroines and protagonists. In our museums we now see these panels in conditions which are totally different from their original context. The series of panels made to decorate and insulate the walls of Renaissance rooms have been separated, and the painted beds and chests dismembered, so that these panels are now shown as easel paintings. Until recently, these works have attracted the attention of scholars but not of the general public, probably because many of them are not linked to the prestigious names of well-known artists. Yet they are extremely important objects, both for the history of art, and for our understanding of fifteenth-century culture. These panels can tell us much about the material conditions in which a section of fifteenth-century society lived – from the moderately wealthy shopkeepers to the families of the cultural and political elite of cities like Florence and Siena. They also reveal a taste for elaborate decoration and for the growing use of luxury objects in the home. Quite early in the fifteenth century a number of stock subjects was developed, from which painters and patrons could draw. These stories can help us to understand the aspirations of that society, ideals and attitudes towards the place of the family, and the roles which men and women were supposed to fulfil within marriage. They show how men and women were presented with ideal models of behaviour which conformed to specific rules. Feminine ideals, however, did not exist in isolation. They were the counterpart of male ideals in a society which demanded strict codes of behaviour from both men and women.

These narratives, like all visual story-telling, required complex manipulation of pictorial language and artistic skill. They tell, after all, of dramatic events which convey emotion and meaning through figures. Leon Battista Alberti explained in his book *On Painting* that the *istoria*, or narrative, is the 'greatest work of the painter'. This is because the artist has to be able to convey so much through the human figure, expressing through it the emotion required by the story, and using it consistently within its role in the narrative. The individual figures have to be meaningfully grouped together, reacting with gesture to one another. Meaning and emotion are also conveyed by the setting of the story. A wide range of such artistic problems was explored during the century, and can be studied through an examination of furniture panels, from the

anatomy of the human body to the representation of three-dimensional space through the use of perspective, from the development of secular narratives to the study of the antique. These paintings, therefore, are not just examples of a 'minor' form of art. As Giorgio Vasari wrote in the middle of the sixteenth century, even well-known artists used to produce in their workshops painted furniture decorated with *istorie*: Botticelli was one of them. Through the function and context of these objects, through the subject matter, and through the way in which the stories are told, the modern viewer can find a way towards an understanding of the position of women in a culture so distant from ours.

Portraiture

After looking at the ideal roles of women as heroines in fifteenth-century secular narrative paintings, we then examine another version of the ideal woman, this time through portraits which represent 'real' women – women who actually existed, and about whom we may have some historical information. These images of women, however, still appear to the viewer through the screen of the ideals of the society in which they were produced: ideals of beauty, of behaviour, of display. In them we still see not an individual, but a cypher, and we have to be aware of the conventions which guided these modes of representation followed throughout the fifteenth century by, among others, Pisanello, Filippo Lippi, Piero della Francesca and Ghirlandaio.

We have already seen how, during the fifteenth century, painters developed skills which helped to convey a sense of emotion and of inner life, so that the viewer could experience an apparent communication with the image. This interaction with the spectator was at the core of artistic problems related to the perception and representation of reality – of the physical appearance of the natural world – which were explored in Italy, and expecially in Florence. During the second half of the fifteenth century, all these problems became linked to the function of the portrait, as shown by the works produced by Leonardo da Vinci during the last decades of the century and at the beginning of the next. The profile portrait, which in the representation of women had continued for decades more or less unaltered, was abandoned in favour of poses which allowed for eye-contact between sitter and viewer.

The size of portraits, the ways in which they were displayed, and the reasons for commissioning them, changed and diversified during the sixteenth century, as Italian society shifted towards one in which the more formal and etiquette-conscious behaviour of the courts dominated. From the small-scale female profile busts of the fifteenth century, to the imposing portraiture of the sixteenth produced by painters such as Raphael, Titian and Bronzino, display of wealth through detailed representation of jewellery and clothes was always

a crucial sign of status. A display of finery was not an empty gesture of vanity, but a significant means through which women made their position visible to the eyes of society.

Beauty, and especially the beauty of women, was a subject of great interest in the milieu of the educated elite, and it became fashionable not only to read and write poems about beautiful women, but also to commission and collect paintings representing imaginary beauties. The erotic charge of these images, which play with the representational conventions of portraiture, leads us to explore questions related to the perception and to the function of these paintings of beautiful women.

The nude

The representation of the nude figure, male and female, was central to all Renaissance art, and ample visual and written evidence testifies to this concern. Any study of images of the female nude opens up a number of problems, which yet again centre on questions of intention and function, representation and perception. 'The nude', however, was not only a supreme test for artists: there is much contemporary evidence showing that these images of the naked body were openly recognised to arouse sexual feelings, in women as well as in men. The thoughts and feelings we find expressed in conventional descriptive set-pieces, in more casual and spontaneous observations about the paintings, as well as in the treatises and pronouncements of churchmen on the dangers inherent in the representation of the naked human body, are interestingly complex. To understand them we must forget the dichotomy which exists in the English language between 'naked' and 'nude', so brilliantly explained by Kenneth Clark in his book *The Nude*. Clark distinguishes between a body 'deprived of clothes', therefore 'naked' and tinged by 'the embarassment which most of us feel in that condition', and a term, 'nude', which has 'no uncomfortable overtone', which indicates 'a balanced, prosperous and confident body: the body re-formed' by art. The use of these two terms tells us much more about Anglo-Saxon attitudes to art and to the body than about Italian Renaissance viewpoints. This distinction does not exist in the Italian language, and both 'nude' and 'naked' are translated, today as during the Renaissance, by the same term, *nudo*. By forgetting about the differences between the two English terms, it will be easier to understand how the representations of male and female naked figures painted in Italy during this period could embody a complex range of impulses and thoughts, at times contradictory, such as lust, platonic ideals of goodness and perfection, memories of the antique past, erotic pleasure, and delight in the sensuous appreciation of the surfaces and colours of the paintings. These pictures were perceived as 'art', but they did not occupy

a rarefied sphere of the mind, separated from the life of emotions and of physical responses. These images are erotic, but they had a very different position, in the culture of the sixteenth century, from the modern throwaway images of seduction, such as advertisements and soft-porn photographs, to which John Berger compared them in his *Ways of Seeing* of 1972. According to Berger, common conventions of representation which encourage voyeurism link these images produced in different centuries by different cultures.[7] In spite of what Berger wrote, in this case the medium *is* the message, and there is no better reply to his argument than Ludovico Dolce's letter to Alessandro Contarini published in 1559, which describes, through rhetorical conventions, one of Titian's famous female nudes. Dolce claims that at the core of the 'seriousness of intent' of the representation of the nude lies the authority of antique art, and the viewer's awareness of the skill of the artists in manipulating form and surface qualities. Dolce stresses that all the knowledge and all the artistic skills the painter possesses are used, and this is a constant aspect of Renaissance art, to produce images which can move the viewer. In the case of representations of the nude, they will often knowingly move the viewers to lust.

Religious images

A discussion of the representation of women in Renaissance painting cannot ignore the importance that religion had in the lives of people from all strata of society. Religion was so tightly enmeshed with all aspects of life, that it is often impossible to separate it from the secular. Images of the Virgin Mary and of female saints can help us to gain an insight into the way in which women, and men too, experienced religion. Yet again we find that emotion is a key element in the relationship between the faithful and the saints, a relationship mediated through the use of images which were used in order to help to concentrate the mind on devotion and prayers. In a perceptive essay on the role of images of the Virgin Mary, Julia Kristeva examines the way in which the presence of the feminine operates in a culture at the level of psychological needs. Kristeva asks 'what is it about the representation of the Maternal in general, and about the Christian or virginal representation in particular, that enables it not only to calm the social anxiety and supply what the male lacks, but also to satisfy a woman, in such a way that the community of the sexes is established beyond, and in spite of, their flagrant incompatibility and permanent state of war?'[8] Kristeva's analysis of the needs fulfilled by the Virgin Mary and her representations could be extended, under certain aspects, to the role which the protection and consoling powers provided by female saints had in the interior lives of both men and women. For women, female saints offered examples of womanly virtues and religious dedication which were difficult to equal. At

the same time, the Church opened up to women important possibilities of self-realisation which were absent in other areas of social life.

Methodology: 'representation', 'reality' and interpretation

The post-modern debate on history and historical interpretation has made us familiar with the notion that the past is not an immutable foreign country, waiting for the historian to discover all its sources, and to decipher all its meanings in an objective search towards an unchanging truth. We have become aware that each historian brings to his/her search a baggage of choices, of differences in perception and experience, which belong to gender, age, nationality, class, race and religion. In the same way, as Roland Barthes has pointed out, each viewer re-formulates anew the meaning of a text (or a work of art). In our perception of the work of art we can, and we should, distinguish the difference between our modern position and the historical significance of the image.

To be able to make sense of the art of the past, we first need to be aware of the ways in which artists interpreted their vision of the world, defined as 'schemata' by E. H. Gombrich, and used as a means of representing the world, available at a particular time within a particular culture. We also have to take account of what Gombrich called the 'beholder's share' – the part played in the perception and understanding of images by the contemporary (in this case, fifteenth- and sixteenth-century) viewer, and by the modern viewer. Renaissance artists and their public shared a common world view, a way of relating to knowledge. They also shared a number of assumptions about images and image-making. They had absorbed those social and artistic conventions which guided visual representation in their culture, so that the meaning (or meanings) of a work could be transmitted and elaborated. Michael Baxandall defines 'the skills one happens to possess, the categories, the model patterns and the habits of inference and analogy' as the 'cognitive style' of a period. Images, he writes, are decoded and made meaningful by 'the period eye'. The modern viewer has to become familiar with the 'cognitive styles' of the past, and has to become aware of 'the period eye' of the Renaissance viewer.[9]

If the organisation and interpretation of sources are, for the historian, beset with problems, for the art historian the task is made even more complex by the relationship between the work of art and the society in which it was created. How do society and representations relate to each other? The theory that art 'reflects' society has long since lost all credibility, and to use works of art as straightforward and unproblematic illustrations of the attitudes and

customs of a culture is to misrepresent a more complex history.[10] Francis Haskell warns that visual art 'does have a language of its own which can be understood only by those who seek to fathom its varying purposes, conventions, styles and techniques', and advocates a collaboration of the historian and art historian, both being aware of the differences and peculiarities of their disciplines.[11] Michael Podro, following Wittgenstein's conception of language, suggests that 'art may be seen both to emerge out of the context of our other activities, and to be irreducible to them and to transform them'.[12]

'The viewer', whether contemporary to the images presented in this book, or modern, is an abstraction. In reality, there is no typical viewer. There is, however, a type of contemporary viewer who, through different kinds of writing, has left evidence of his way of seeing. By necessity, the historian is forced to listen to his voice and to interpret it above all others. This viewer is the educated, often wealthy man – the patron, his agent, the *letterato* (man of letters) – and, at times, the artist himself. We have little evidence of women as viewers, apart from some very matter-of-fact observations which we find in their letters, mostly about the buying and commissioning of paintings.

As we cannot listen to the voice of women talking about paintings, we can study the way in which they have been represented. Why, however, should we isolate these 'representations of women'? Are there any advantages in treating women as a separate category, as a subject matter to be examined apart from others? Looking only at pictures representing women may help us to highlight specific aspects of the historical and social context in which these pictures were made. It can lead us to reflect on the role played by gender in the making and in the perception of images. It may encourage the historian to look for evidence which speaks with the voices of men *and* of women, and to be sensitive to any differences between them. When concentrating on portraits representing only women, for example, it becomes impossible to discuss portraiture without taking into account questions which touch on the notion of female beauty and on those modes of behaviour pertaining specifically to women. In other words, we will be led to examine the ideals which these images of women presented to male and female viewers. We will become aware that 'representation' is inevitably gender-specific, and that an 'ungendered history' distorts our perception of the past by assuming that the past has a single viewpoint and a single voice. At times, however, problems arise when theory is applied ruthlessly and insensitively to historical evidence. In some cases, standards and anachronistic preoccupations which belong to our own culture are imposed on the culture and society of the past. Using a particular theoretical viewpoint simply as a means to highlight the fact that in the patriarchal society of Renaissance Italy women did not possess the same juridical rights as men, or berating with

8

indignation the notions that different standards were applied to judge the cap-
abilities and virtues of women, does not help us to understand the culture of
the fifteenth and sixteenth centuries. It is ahistorical to apply modern concepts
of individualism and achievement to this period, and to conclude that women's
lives, within the structure of the family, remained by necessity unfulfilled.
Concepts of equality and of 'equal opportunities', needless to say, are not
really relevant or helpful for a study of Renaissance history.[13]

Women and art during the Renaissance

Representations of women: historiography

During the last two decades, probably in response to the work carried out by
historians of sexuality in France and in Britain, the representation of women
as subject matter in nineteenth-century art has attracted the attention of a large
number of art historians, resulting in exhibitions and books directed also to
the general public. By contrast, the effort of Renaissance art historians has,
on the whole, been confined to articles published in scholarly journals and to
collections of essays destined for the specialist reader. No curator, for example,
has been tempted to organise a thematic exhibition centred on the representa-
tion of the Renaissance woman using an approach similar to the 1989 ex-
hibition 'Degas – Images of Women' at the Tate Gallery, Liverpool and at the
Burrell Collection, Glasgow.[14]

Since the early 1970s, an attempt has been made by a number of art his-
torians to challenge the *status quo* of art historical scholarship, and to consider
the possibility of changing the perspective from which to reassess the representa-
tion of women in Renaissance art. The spotlight of the 'new art history' has
focused on the iconography of biblical and mythological female characters.
Using psychoanalytical theory, semiotics, and the concepts of the male and
female gaze, art historians have reinterpreted the function and meanings of
narratives, such as the stories of Judith and Holofernes, of Samson and Delilah,
Susannah and the Elders, Esther and Ahasuerus, Orpheus and Euridice, of
Jupiter's seduction of Danae. The Old Testament heroine Judith, for example,
has been seen as a construction of the patriarchal system, even if she appears
in art as an invincible castrating virago.[15] Delilah has also been interpreted as
the embodiment of man's fear of feminine power.[16] The significance of reli-
gious iconography has been explored in the context of customs and modes of
behaviour pertaining to women's lives – such as the motif of the *Virgo lactans*
in Tuscan painting, or the creation of hagiographic typologies in the representa-
tion of female saints.[17]

The most interesting and successful work on women as subject matter in

Italian Renaissance painting has been produced by those scholars who have firmly anchored their thorough analysis to the discourse of Renaissance treatises and debates about women. The discussions on beauty, from the writings of Petrarch to the treatises by writers such as Firenzuola in the sixteenth century, for example, are the context for the work carried out by Mary Rogers and by Elizabeth Cropper on women's portraits and on paintings representing beautiful women with no specific identity. Sharon Fermor looks at the importance given, in contemporary writing, to the concept of 'grace'. Using dance manuals as additional source material, she relates the graceful movements advocated by writers as being appropriate to women of a certain status to the poses of the female figures in the works by Botticelli and Ghirlandaio.[18]

Portraits of women have been analysed by Patricia Simons not as demonstrations of the 'Renaissance glorification of the individual', but with the awareness that 'women's claims to civic recognition, familial regard, entrepreneurial success, and intellectual worth, although not impossible, were more limited than they were for men'. Simons takes issue with Burckhardt's 'patriarchal, bourgeois, nineteenth-century vision' which she sees as still colouring the history of the Renaissance, and advocates a historical approach guided by the 'apparatus of critical theory available in a post-modern or, rather, post-structuralist age'.[19]

Representations of women through the medium of print – woodcut, etching or engraving – predicate a different relationship between object and viewer. These printed images have recently been the subject of studies by scholars, such as Sara F. Matthews Grieco. Prints could be bought directly from printers' shops, or from stationers' shops, from booksellers, and – in the case of the very cheap prints at the lower end of the market – from itinerant sellers. Prints of different quality and price were produced, so that they could be purchased by different kinds of clients. More expensive prints designed by famous masters would satisfy a sophisticated and wealthy public, while cheap ones would be bought by those members of society who could never afford a painting. These images could be produced in relatively large numbers, and were easy to transport, these factors ensuring their wide distribution. All of these are reasons why the study of prints representing women is a particularly interesting area. In some cases they are a product of 'popular culture' which may allow us an insight into a different level of discourse. The subjects represented were secular as well as religious, from mythological subject matter to erotica and pornography; and from allegorical representations to images of saints and of the Virgin Mary. Patricularly interesting are the broadsheets outlining the desired behaviour expected from women, which allow us to see, as Matthews Grieco has perceptively pointed out, the gulf between reality and ideals.[20]

The role of women as patrons has only recently begun to attract the attention of scholars, and much work is still needed in this area to obtain a satisfactory picture of this important aspect of women's history. The limitations which circumscribed women's patronage during the fourteenth and fifteenth centuries have been examined by Catherine King. Women, excluded from the political and economic life of the society in which they lived, usually commissioned religious works not only for private use, but also for public functions and locations, such as altarpieces and furnishings for funerary chapels. These commissions, King writes, 'were properly pious and usually intended to benefit their family or community – and therefore fittingly "feminine"'. She identifies three groups of women who, because of their relative financial independence, could dispose of their money through art patronage and could enter into contractual agreements with artists. These were widows of merchants, bankers and minor rulers, daughters of wealthy families who lived in monasteries as nuns, and wives of powerful rulers.[21] Among this last group is the Marchioness of Mantua, Isabella d'Este, wife of Francesco Gonzaga. Without any doubt, she must be considered the most important woman patron in fifteenth-century Italy, for the range and scope of her commissions and for the amount of information we have about her taste and her dealings with artists.[22] New research has highlighted the role of women as patrons of architecture: Carolyn Valone has found evidence of fifty female patrons of buildings in Rome in the second half of the sixteenth century.[23]

Women artists in the Renaissance: sixteenth-century viewpoints

In the fifteenth and sixteenth centuries, a woman artist was a rare phenomenon indeed. Any discussion of the paintings or of the sculptures produced by a woman could not be separated from the sense of wonder at the special talent she possessed, which singled her out from the rest of women. Two literary works which would have been known to educated men, Pliny's *Historia Naturalis* and Boccaccio's *De Claris Mulieribus*, guided writers about the expression of conventional terms of praise towards those few women who practised as artists. Pliny listed six famous women painters from Greece and Rome. Boccaccio, in his gallery of illustrious examples of female virtue and admirable behaviour written in the last decades of the fourteenth century, used Pliny as his source, and mentioned three female artists from antiquity: Thamyris, Irene and Marcia.

In the second edition of his monumental work, the *Lives of the Artists*, which was published in Florence in 1568, the painter, architect and historian, Giorgio Vasari, introduced some biographical material about a small number of women artists. Like Boccaccio, he praises them as a marvel of nature, and,

11

remarking that women have succeeded in all the areas where talents and skill are required (*in tutte quelle virtù ed in tutti quelli esercizi*), he reminds the reader that women in antiquity excelled in war, in poetry, in philosophy. Vasari then lists his female contemporaries who 'have acquired the highest fame' as writers and poets, and quotes the poet Ludovico Ariosto, agreeing with him that women have reached excellence in all the arts they have cared to practise.[24]

Vasari's words have been dismissed as a patronising rhetorical device which precludes any serious discussion of these artists and of their work. It is true, however, that for a woman to succeed as a painter or an engraver, or rarest of all, a sculptor, the circumstances in which she trained and then practised as an artist had to be exceptional indeed. The expressions of surprise from sixteenth-century writers like Vasari must have been in part the result of a sense of wonder sincerely experienced. Not only were women's intellectual capacities believed to be inferior to men's, and therefore little suited to overcome the difficulties of painting, but also the possibility of obtaining an adequate training without being able to follow the usual apprenticeship in a workshop presented considerable problems.[25] Most of these women had learned their craft from their fathers. In the *Life of Paolo Uccello*, Vasari mentions that the painter had a daughter, Antonia, a Carmelite nun, 'who could draw'. She died in 1491, and is identified as 'painter' (*pittoressa*) in the Death Register in Florence.[26] In Mantua, Vasari had seen the engravings of Diana Scultore, the daughter of an engraver and sculptor called Giovambattista, and wrote that her works were 'very beautiful, and I marvelled at them'. In Ravenna, in the house of a painter called Luca Longhi, Vasari had met his young daughter Barbara, who 'draws very well, and she has begun to colour some things with good grace and manner'. Barbara Longhi was praised by Maurizio Manfredi in a lecture given in Bologna in 1575: 'You should know that in Ravenna lives today a girl of eighteen years of age, daughter of the Excellent painter Messer Luca Longhi. She is so wonderful in this art that her own father begins to be astonished by her, especially in her portraits as she barely glances at a person that she can portray better than anybody else with the sitter posing in front.'[27]

Together with his praise expressed within the conventional sixteenth-century notion of woman, Vasari also makes perceptive and precise remarks which show his keen and discriminating observation, and which make his accounts of the works of these women, however brief, very interesting reading. These remarks give us an insight into the difficulties and problems women artists had to face in their training and in their career. Describing the work of another nun, suor Plautilla Nelli, who was the abbess of the monastery of St Catherine of Siena in Florence and who was still alive at the time, Vasari notes that she did not have much experience in painting men. He felt that her heads of women

were more skilfully carried out, because, he says, she has had occasion to see and study many more women than men. He judges that her copies from the works by other artists were more successful than her own original compositions because of her lack of sufficient training. He adds that her works show that she could have done wonderful things, 'as men are able to do', if she had been able to study and dedicate more time to drawing. In spite of these drawbacks, she must have been quite successful: Vasari notes that her paintings could be found in monasteries, in churches, and in innumerable private houses. Among suor Plautilla's works, Vasari mentions a 'much praised' *Adoration of the Magi* and a *Last Supper*, which were in her own monastery. A large altarpiece with the Virgin and Child accompanied by St Thomas, St Augustine, Mary Magdalene, St Catherine of Siena, St Agnes, St Catherine of Alexandria and St Lucy, could be seen in the monastery of S. Lucia in Pistoia. In the cathedral of Florence, Santa Maria del Fiore, there was another of her works, a predella illustrating episodes from the life of one of the patron saints of Florence, St Zenobi. Among her private commissions were two Annunciations, which were in possession of two Florentine ladies.[28]

Some women, Vasari writes, have not hesitated to grapple with 'the roughness of marble and the harshness of iron' with their soft white hands. In his famous book of drawings, he had collected some examples by the only contemporary woman sculptor, Properzia de' Rossi from Bologna, who also worked as an engraver. He even dedicates a separate *Life* to her, accompanied by a portrait. As is often the case in his *Lives* of male artists, Vasari embellishes his information with anecdotes, curious details about her life and personality in order to create an interesting narrative. Properzia de' Rossi was considered by the citizens of Bologna as a '*grandissimo miracolo della natura*'. Vasari writes that she was very beautiful – an important physical trait for a sixteenth-century artist, male or female. She could play and sing better than any other woman in Bologna, and she was envied by both men and women because of her knowledge and skill. For the sculpted decoration of the portals of the cathedral of Bologna, S. Petronio, Properzia de' Rossi made a marble relief illustrating the story of Joseph, escaping from the seductive embrace of the wife of Potiphar. Vasari adds that in this story she 'gave vent . . . to her passion' for a young man who, apparently, was not interested in her. Vasari adds that she was paid very little for her relief because of the machinations of an envious painter, Amico Aspertini.[29]

While the works of these women artists are only briefly mentioned, Vasari gives a more detailed account of the achievements of Sofonisba Anguissola (?1535–1625).[30] Germaine Greer takes Vasari to task for not treating the work of the Anguissola sisters seriously, and for not 'assessing their contribution to

art'.[31] In fact, he certainly does take them seriously, as can be seen from the attention he pays to the paintings and to the Anguissola sisters' careers, even if, as he writes, he had seen only a few works by them. His descriptions of Sofonisba's paintings contributed to their fame throughout Italy and to the successful career of the artist. Sofonisba Anguissola was the most accomplished and well known amongst a group of sisters – Elena, Lucia, Minerva, Europa and Anna Maria – all painters, who belonged to a noble family in Cremona. Sofonisba's sister Lucia, who died one year before Vasari visited the Anguissola household in 1566, was also an accomplished portrait painter, as was another sister, Europa, in spite of her young age: at the time she probably was not yet twenty. Even the fifth sister, Anna Maria, who was still a child, showed great promise. Vasari writes that the house of Amilcare Anguissola 'seemed to me the house of painting, or in fact, of all talents'.

With the constant help and encouragement from her father, Sofonisba trained with the Cremonese painter Bernardino Campi. Her career was remarkable: she was well known in Italy and abroad, and she received advice and encouragement from Michelangelo. By the time Vasari visited Cremona, where he went with the specific intention to see her paintings, Sofonisba had already left her native city. In 1559 she had been called to the Spanish court in Madrid as a lady-in-waiting to the young wife of Philip II, Isabella de Valois. There she painted a number of portraits of the Queen and of other members of the court. Vasari was enthusiastic about Sofonisba's paintings, which he described in a letter to his friend, the *letterato* Vincenzo Borghini, as 'wonderful'. In his *Lives*, Vasari mentions two group portraits by Sofonisba which he saw in her father's house. The first represents three of the Anguissola sisters sitting around a table, covered by an oriental carpet; two are playing chess, while the third one, together with an old woman of their household, looks on (Poznan, Museum Narodowe). In the other portrait, Sofonisba's father is shown sitting between her sister Minerva ('of rare accomplishments as a painter and as a writer') and her brother Asdrubale, against the background of a distant fantastic landscape moulded on Northern European examples (Nivaa, Nivaagaards Malerisamling). In the house of the archdeacon of Piacenza Vasari saw the archdeacon's portrait and Sofonisba's own self-portrait, and he comments that 'both figures only lack speech'. Vasari praises the portraits with the terms he uses in relation to the works of great artists, saying that the figures 'seem to breathe, and look alive'.

Even Pope Pius IV wanted one of Sofonisba's works, a portrait of the Queen of Spain, which the artist sent with a letter, duly transcribed by Vasari together with the Pope's reply.[32] Vasari had in his own collection one of her drawings, representing a little girl laughing at a crying boy who has been

bitten by a crayfish, which originally had been sent to Duke Cosimo de Medici by Michelangelo's friend, Tommaso Cavalieri, together with a drawing by Michelangelo. Sofonisba's drawing, wrote Cavalieri to the Duke, 'is not simply beautiful, but also exhibits considerable invention'. This is a great praise indeed, as 'inventione' according to sixteenth-century theory was a distinctive intellectual quality related to the content of a work of art. Averardo Serristori, the Florentine ambassador to the papal court, agreed with this praise when he wrote in a letter to Duke Cosimo de Medici that Sofonisba's drawing was 'something quite rare'.[33] Various contemporary writers also concurred in this assessment of Sofonisba's work: in his *Ragionamento Quinto* of 1564, an imaginary dialogue between the Greek sculptor Phidias and Leonardo da Vinci, Giovan Paolo Lomazzo writes that all princes in Europe were astonished by Sofonisba's portraits. Alessandro Lamo comments, in his 1584 treatise *Discorso Intorno alla Scoltura e Pittura*, that Sofonisba is remarkable for her talent in painting as she is for the nobility of her spirit. The Anguissola sisters, he continues, are beautiful in mind and in body, and are adorned by ladylike qualities.[34]

Women artists in the Renaissance: recent historiography

In 1976, Ann Sutherland Harris and Linda Nochlin, with their catalogue for the exhibition *Women Artists 1500–1950*, brought to the attention of the public a large number of works by women artists. In a series of introductory essays, the catalogue provided much important information on the social and literary context of contemporary writing about women artists, and on the conditions in which these women lived, trained and worked. Short but comprehensive biographies for each of the artists selected for the exhibition complete the work.[35]

In *The Obstacle Race. The Fortunes of Women Painters and their Work* (1979), Germaine Greer set out to raise a number of questions about the contribution of women to the visual arts, including those concerning the conditions in which these women lived and worked, and the 'disappearance' of their works through the centuries. Useful as this book was in bringing together so much material, its polemical position painted a one-sided picture for the reader, who was invited to see the lives of these artists as beset by a series of obstacles (training, family, love, and so on) which targeted women as their principal victims. These are stories of unfulfilled aspirations, broken hopes, untold miseries which are peculiar to women because, Greer wrote, to women belongs that 'carefully cultured self-destructiveness'. The tales of these thwarted lives take precedence in Greer's book over analysis of the actual works.

While much work has been done in the last twenty years to rediscover and assess the works by nineteenth-century women artists, and to present afresh information about their lives and careers, the considerable problems surrounding

research on sixteenth-century women artists have held back our knowledge of their achievements. These problems have not been helped by polemical and partisan positions taken by some writers, often intent upon demonstrating above everything else that women artists were not treated seriously by their contemporaries, and that their works have been, through the centuries, deliberately ignored. Other writers seem to be reluctant to abandon a romantic view of the artist driven by self-expression, in their desire to use biographical information which may highlight, in the works by women artists, a sense of 'otherness', a 'difference', an essentially 'feminine' way of painting.

What is really needed, instead, is some fundamental research. In many cases, when studying the careers of women artists, basic problems of attribution and of identification of the paintings, supported also by more archival research, need to be solved in order to have a better understanding of their work, or to establish a *corpus* of work for those artists who are, for the moment, mere names. A large group of paintings by Sofonisba Anguissola and her sisters, first shown in her native Cremona in 1994, and then the following year at the Kunsthistorisches Museum in Vienna and at the National Museum of Women in the Arts in Washington, has brought this artist to the attention of the general public and to renewed scrutiny from scholars. It has also helped to answer some questions about the style and attribution of a number of portraits executed at the Spanish Court, and to assess Sofonisba Anguissola's place in the development of genre painting in Northern Italy in the late sixteenth century. The exhibition has also revealed the high quality of Lucia Anguissola's work.[36]

During 1994, the Museo Civico Archeologico in Bologna housed an exhibition dedicated to the most famous among the women painters from Bologna, Lavinia Fontana (1552–1614). Trained by her father, the painter Prospero Fontana, Lavinia produced works for private and public commissions: portraits, altarpieces, images of famous women, such as Cleopatra and Judith, and a painting representing a naked Minerva, executed in 1613 for Cardinal Scipione Borghese. The exhibition placed Lavinia Fontana within the context of late sixteenth-century painting in Bologna, and also explored the crucial factor of the particularly strong interest in women artists in that city. It also looked at the relationship between father and daughter by comparing paintings of similar subjects by Prospero Fontana and by Lavinia.[37]

Notes

1 Leon Battista Alberti, *On Painting*, trans. J. R. Spencer, Yale University Press, New Haven and London, 1st ed. 1956, repr. 1966, p. 43.

2 Michael Baxandall explains the concept of 'imitation of nature' through a discussion of Cristoforo Landino's and of Leonardo's texts in *Painting and Experience in Fifteenth Century Italy. A Primer in the Social History of Pictorial Style*, Oxford University Press, Oxford, 1st ed. 1972, 2nd ed. 1988, pp. 119–21.

3 For the Zeuxis and Parrhasios stories and their meaning, see E. H. Gombrich, *Art and Illusion. A Study in the Psychology of Pictorial Representation*, Phaidon Press, London, first published 1960, 5th ed. 1977, pp. 172 ff.

4 Alberti, *On Painting*, pp. 94 and 92.

5 Alberti, *On Painting*, p. 93.

6 Raphael's letter is cited by E. H. Gombrich in 'Ideal and Type in Italian Renaissance Painting', *Gombrich on the Renaissance. Vol. 4: New Light on Old Masters*, Phaidon Press, London, first published 1986, 2nd ed. 1993, pp. 89–124, esp. pp. 89–90. It is also analysed at length in P. Barocchi, *Scritti d'Arte del Cinquecento*, vol. 2, Riccardo Ricciardi Editore, Milan and Naples, 1973, pp. 1529–31, and in E. Camesasca (ed.), *Raffaello. Gli Scritti. Lettere, Firme, Sonetti, Saggi Tecnici e Teorici*, Rizzoli, Milan, 1994, pp. 154–67.

7 Kenneth Clark, *The Nude. A Study of Ideal Art*, first published John Murray, London, 1956, repr. by Pelican Books, Harmondsworth, 1960; John Berger, *Ways of Seeing*, Penguin Books, Harmondsworth, 1972. For a discussion of Clark's and Berger's definitions of the terms 'naked' and 'nude' and an assessment of the ideologies which structure their positions, see L. Nead, *The Female Nude. Art, Obscenity and Sexuality*, Routledge, London and New York, 1992, pp. 12 ff. Discussing what she sees as one of the fundamental problems in the representation of the nude – the relationship between the power of the painter/medium and the passivity of the female/surface, Nead looks at the ways in which the actual act of painting has been seen as sexualised: 'the female nude within patriarchy thus signifies that the woman/surface has come under the government of the male style' (p. 57). She adds that 'the sexualised metaphorization of the female nude within art criticism has systematically reinforced patriarchy' (p. 59). While the critic envisaged by Nead indefatigably and relentlessly pursues 'politically vigilant forms of interpretation' (p. 59), it is to be hoped that the historian, sensitive and respectful towards the different cultures of the past, will be able to understand and interpret attitudes without condemning them.

8 Julia Kristeva, 'Stabat Mater', in S. Rubin Suleiman (ed.), *The Female Body in Western Culture. Contemporary Perspectives*, Harvard University Press, Cambridge, Mass., and London, 1986, pp. 99–118, esp. p. 101.

9 The concepts of schemata of representation and of the 'beholder's share' are explored by E. H. Gombrich in his *Art and Illusion. A Study in the Psychology of Pictorial Representation*, Phaidon Press, London, 1977, first published 1960. M. Baxandall discusses the visual and cognitive skills of the Renaissance viewer ('the period eye') in *Painting and Experience in Fifteenth Century Italy. A Primer in the Social History of Pictorial Style*, Oxford University Press, Oxford, first published 1972, 2nd ed. 1988.

10 On the relationships between society and culture, see R. Chartier, 'Intellectual History and the History of "Mentalités". A Dual Re-evaluation', in his *Cultural History: Between Practices and Representations*, Polity/Blackwell, Oxford, 1988, pp. 19–52.

11 F. Haskell, *History and its Images. Art and the Interpretation of the Past*, Yale University Press, New Haven and London, 1993. The book deals with 'how, when and why historians have tried to recapture the past, or at least a sense of the past, by adopting the infinitely seductive course of looking at the image that the past has left of itself'. On the disciplines of history and art history, Haskell wisely cautions : 'Fruitful cooperation between the historian and the art historian can be based only on a full recognition of the necessary differences between their approaches, not, as it is often implied, on the pretence that these approaches are basically the same' (pp. 9–10). On this problem, see especially the Introduction and Chapter 8, 'The Arts as an Index of Society'. On the problems concerning the use of visual artifacts as historical sources, see also the review by M. Bury, *History*, 79, 258, February 1994, pp. 89–90.

12 M. Podro, *The Critical Historians of Art*, Yale University Press, New Haven and London, 1982, p. 216. Chapter 10, 'The Tradition Reviewed', is particularly relevant to the question of interpretation.

13 In their introduction to *Feminism and Art History. Questioning the Litany*, Harper & Row, New York, 1982, Norma Broude and Mary D. Garrard write: 'Feminism has raised other, more fundamental questions for art history as a humanistic discipline, questions that are now affecting its functioning at all levels and that may ultimately lead to its redefinition. In its broadest terms, we would define the impact of feminism on art history as an adjustment of historical perspective' (p. 1). By the same authors, see the Introduction to *The Expanding Discourse. Feminism and Art History*, Harper Collins, New York, 1992, pp. 1–25. See also L. Nead, 'Feminism, Art History and Cultural Politics', in A. L. Rees and F. Borzello (eds), *The New Art History*, Camden Press, London, 1986, pp. 120–4. Griselda Pollock ('Feminist Interventions in the Histories of Art: An Introduction', in *Vision and Differences: Femininity, Feminism and the Histories of Art*, Routledge, London and New York, 1988) summarises the development of feminist art history and charts its evolution through the instruments of Marxism, semiotics, Foucault's 'discourse analysis' and psychoanalytical theory. These have provided, respectively, a way of considering art as a 'social practice', an instrument for the analysis of texts, a means to examine art history itself as a 'discursive formation', and an insight into the construction of sexuality. Pollock writes that the importance of feminist art history lies in its fundamental critique of the discipline: 'Art history itself is to be understood as a series of representational practices which actively produce definitions of sexual difference and contribute to the present configuration of sexual politics and power relations. Art history is not just indifferent to women; it is a masculinist discourse, party to the social construction of sexual differences' (p. 11). Pollock feels that the feminist art historian should be engaged in a 'feminist rewriting of the history of art in terms which firmly locate gender relations as a determining factor in cultural production and in signification' (p. 12). She ends her analysis with the assertion that feminist art history (or 'a feminist intervention in the histories of art') is an aspect of the women's movement. Pollock writes that 'this is no "new art history" aiming to make improvements, bring it up to date, season the old with current intellectual fashions or theory soup. The feminist problematic in this particular field of the social is shaped by the terrain – visual representations and their practices – on which we struggle' (p. 17). For an assessment of Pollock's conceptual framework, see E. Fernie, *Art History and its Methods. A Critical Anthology*, Phaidon, London, 1995, pp. 296–9.

14 One of the early examples of 'feminist art history' which explored the representation of women as subject matter was Linda Nochlin's essay 'Eroticism and Female Imagery in Nineteenth-Century Art', in T. B. Hess and L. Nochlin (eds), *Woman as Sex Object, Studies in Erotic Art, 1730–1970*, Newsweek, New York, 1972. For further bibliography, see W. Chadwick, *Women, Art and Society*, Thames and Hudson, London, 1990.

15 E. Ciletti, 'Patriarchal Ideology in the Renaissance Iconography of Judith', in M. Migiel and J. Schiesari (eds), *Refiguring Women. Perspectives on Gender and the Italian Renaissance*, Cornell University Press, Ithaca and London, 1991, pp. 35–70. M. Jacobus gives a psychoanalytical reading of Judith in her 'Judith, Holofernes and the Phallic Woman', in *Reading Woman*, Columbia University Press, New York, 1986, pp. 110–36.

16 M. Millner Kahr, 'Delilah', *The Art Bulletin*, 54, September 1972, pp. 282–99, repr. in Broude and Garrard, *Feminism and Art History*, pp. 119–45. This is an analysis of a number of representations of the Samson and Delilah story from the thirteenth to the seventeenth century.

17 M. R. Miles, 'The Virgin's One Bare Breast: Nudity, Gender and Religious Meaning in Tuscan Early Renaissance Culture', in Rubin Sulemain, *The Female Body in Western Culture*, pp. 193–208, repr. in Broude and Garrard, *The Expanding Discourse*, pp. 27–37. Miles writes that the exposed breast of the Virgin would have been associated, in the mind of the contemporary viewer, with actual women nursing their babies.

18 M. Rogers, 'Sonnets on Female Portraits from Renaissance North Italy', *Word and Image*, 2, 4, October–December 1986, pp. 291–305; 'The Decorum of Women's Beauty: Trissino, Firenzuola, Luigini and the Representation of Women in 16th Century Painting', *Renaissance*

Studies, 2, 1, 1988, pp. 47–89; and, by the same author, 'Decorum in Ludovico Dolce and Titian's *Poesie*', in F. Ames-Lewis and A. Bednarek (eds), *Decorum in Renaissance Narrative Art*, Birkbeck College, University of London, 1992, pp. 111–20.

19 P. Simons, 'Portraiture, Portrayal and Idealization: Ambiguous Individualism in Representations of Renaissance Women', in A. Brown (ed.), *Language and Images in Renaissance Italy*, Clarendon Press, Oxford, 1995, pp. 263–311. See the useful bibliographical indications on pp. 262–3, notes 1, 2 and 3, for different positions in historical methodology. For an assessment of Burckhardt's *Civilization of the Renaissance in Italy*, see, in the same volume, the 'Introduction' by Alison Brown, esp. pp. 7–10.

20 Matthews Grieco's work on representations of women in prints began with studies of images produced in France and Belgium as well as Italy: see, for example, 'Mito e immagine della donna nelle incisioni del Cinquecento francese: il discorso morale sulla sessualita', in B. Vetere and P. Renzi (eds), *Profili di donne. Mito, Immagine, Realtà fra Medioevo e Età Contemporanea*, Congedo, Lecce, 1986, pp. 197–222, and *Mythes et iconographie de la femme dans l'estampe du XVIe siècle européen. Images d'un univers mental*, Flammarion, Paris, 1986.

21 C. King, 'Medieval and Renaissance Matrons, Italian-style', in *Zeitschrift für Kunstgeschichte*, 1992, 55, 3, pp. 372–93. See also her forthcoming work *Patronage and Gender in the Italian Renaissance: Upper Class Wives and Widows: c. 1300–1550* (provisional title). An anthology of essays with the provisional title *Women as Viewers and Users of Art and Architecture in Italy, c. 1300–1600*, edited by King, is in course of preparation. It will examine not only the role of women as patrons and the scope of female patronage, but also the way in which these women may have used, and looked at, the works they commissioned. This anthology will include essays on the patronage of religious organisations, the court, upper-class wives and widows, and the 'living saints'.

22 On the patronage of Isabella d'Este, see J. Fletcher, 'Isabella d'Este, Patron and Collector', in D. Chambers and J. Martineau (eds), *Splendours of the Gonzaga*, exhibition catalogue, Amilcare Pizzi, Milan, 1981, pp. 51–63.

23 Carolyn Valone examines the background to women's architectural patronage and the motivations of some of these women in 'Roman Matrons as Patrons: Various Views of the Cloister Wall', in C. A. Monson (ed.), *The Crannied Wall. Women, Religion and the Arts in Early Modern Europe*, The University of Michigan Press, Ann Arbor, 1992, pp. 49–72.

24 Vasari's praise for women artists is at the beginning of the *Life of Madonna Properzia de' Rossi*, in G. Vasari, *Le Opere*, ed. G. Milanesi, 9 vols, Sansoni, Florence, 1906, repr. 1981 (henceforth Vasari – Milanesi), V, pp. 73–4, while the Ariosto quotation is on p. 81.

25 For a brief but very informative account of the cultural climate which saw the emergence of women artists in fifteenth- and sixteenth-century Italy, see A. Sutherland Harris and L. Nochlin, *Women Artists 1550–1950*, Alfred Knopf, New York, 1976, pp. 20–5 and 26–32. See also W. Chadwick, *Women, Art and Society*, pp. 59–86.

26 For the daughter of Paolo Uccello, see Vasari – Milanesi II, p. 217.

27 The engraver Diana Scultore is mentioned in Vasari – Milanesi VI, p. 490, while the scarce information on Barbara Longhi is in VII, p. 421. On this artist, see a brief article on her Madonna and Child paintings, by L. De Gerolami Cheney, 'Barbara Longhi of Ravenna', *Woman's Art Journal*, 9, 11, Spring–Summer 1988, pp. 16–20. Vasari does not mention the Bolognese painter Caterina Vigri (1413–63), a nun in the convent of the Poor Clares, who was canonised in 1707. There are no works which can be attributed to her with certainty. On Caterina Vigri, see entries in V. Fortunati (ed.), *Lavinia Fontana 1552–1614*, exhibition catalogue, Electa, Milan, 1994, pp. 178–9. See also G. Alberigo, 'Caterina da Bologna dall'agiografia alla storia religiosa', *Atti e memorie delle Deputazioni di Storia patria per le province della Romagna*, XV–XVI, 1963–1964 / 1964–1965, pp. 5–23.

28 On suor Plautilla Nelli, see Vasari – Milanesi V, pp. 79–80.
Vasari also mentions the painter Lucrezia Quistelli, a pupil of Alessandro Allori and the wife of Count Clemente Pietra. Her paintings and portraits, he adds, are 'worth everybody's praise'. For Lucrezia Quistelli, see Vasari – Milanesi V, p. 80.

29 On Properzia de' Rossi, see V. Fortunati Pietrantonio, 'Per una storia della presenza femminile nella vita artistica del Cinquecento bolognese: Properzia de' Rossi "schultrice"', *Il Carrobbio*, VIII, 1981, pp. 168–77, and F. H. Jacobs, 'The Construction of a Life: Madonna Properzia de' Rossi "Schultrice" Bolognese', *Word and Image*, 9, 1993, pp. 122–32. Jacobs discusses Vasari's 'myth and fiction' constructed around the life of this artist. The relief by Properzia de' Rossi, *Joseph and the Wife of Potiphar* (Bologna, Museo di San Petronio) is discussed in the exhibition catalogue *Lavinia Fontana, 1552–1614*, pp. 179–80. See also the entries on a jewel decorated with peach stones carved with figures of saints, and on one, attributed to her in the exhibition, with a carved cherry stone, pp. 180–1. These miniature carvings brought her much praise from Vasari. Mary Rogers has noted the importance that artists' beauty had during the sixteenth century in 'The Artist as Beauty' (unpublished paper delivered at the 22nd Annual Conference of the Association of Art Historians, Newcastle, 12–14 April 1996.)

30 Sofonisba Anguissola is discussed in Vasari – Milanesi V, pp. 80–1, and, together with her sisters, in VI, pp. 498–502.

31 Germaine Greer's comment on Vasari's treatment of Sofonisba Anguissola's work is in *The Obstacle Race. The Fortunes of Women Painters and their Work*, Secker & Warburg, London, 1979, p. 69. Whitney Chadwick also misunderstands Vasari's comments when she writes that 'Vasari and other male writers responded to Anguissola and her sisters as prodigies of nature rather than artists'. See her *Women, Art and Society*, Thames and Hudson, London, 1990, pp. 70–7. Fredrika H. Jacobs gives a more accurate and penetrating account of Vasari's treatment of Sofonisba Anguissola, placing it in the context of sixteenth-century theories on art and creativity ('Women's Capacity to Create: the Unusual Case of Sofonisba Anguissola', *Renaissance Quarterly*, 47, 1, Spring 1994, pp. 74–101). Jacobs points out that the kind of praise Vasari reserves for Sofonisba's portraits is in fact exceptional (pp. 78 and 91 ff.).

32 Vasari quotes in full the letter from Pius IV as evidence of Sofonisba's talent: '*Pius Papa IIII. Dilecta in Christo filia.* Dearest daughter, we have received the portrait of the most serene queen of Spain, which you have sent to us. This was very agreeable to us, both because of the person it represents, whom we love very dearly because of her religious feelings and for the other beautiful qualities of her soul, and because it has been painted with such diligence by your own hand. We thank you for it, and we assure you that we shall keep it amongst our dearest possessions. We praise this talent of yours, which, even if it is so wonderful, is only the smallest among your many talents. And we send you again our blessing and wishes that Our Lord should keep you. *Dat. Romae, die XV octobris 1561*' (Vasari – Milanesi VI, p. 500).

33 The letters from Tommaso Cavalieri and Averardo Serristori to Duke Cosimo are cited by I. S. Perlingieri, *Sofonisba Anguissola. The First Great Woman Artist of the Renaissance*, Rizzoli, New York, 1992, p. 72. On Tommaso Cavalieri's use of the term '*inventione*', see F. H. Jacobs, 'Women's Capacity to Create', pp. 95 ff.

34 For the comments made by Lomazzo and Lamo, see *Sofonisba Anguissola e le sue sorelle*, exhibition catalogue, Leonardo Arte, Milan, 1994, pp. 404 and 405.

35 Sutherland Harris and Nochlin, *Women Artists 1550–1950*. The catalogue also provides very useful bibliographies for each artist. This is the most thorough among a number of books covering similar ground and structured in a similar way, which, however, abandon the standard of scholarship of Harris and Nochlin to follow a polemical line.

36 On this exhibition, see the review by A. Bayer, *Burlington Magazine*, 137, March 1995, pp. 201–2. The excellent catalogue of the exhibition, *Sofonisba Anguissola e le sue sorelle*, is an example of scholarly dedication and precision.

37 See the catalogue for this exhibition, *Lavinia Fontana 1552–1614*. Particularly important is an essay by Angela Ghirardi on the typology of the self-portrait by women artists during the late sixteenth century, 'Lavinia Fontana allo specchio. Pittrici e autoritratto nel secondo Cinquecento', pp. 37–51, which examines two self-portraits by Lavinia Fontana (one, signed and dated 1577, now in the Accademia Nazionale di San Luca in Rome; the other, signed and dated 1579, in the Corridoio Vasariano in the Uffizi, in Florence), and compares them with the self-portraits by Sofonisba Anguissola.

WOMEN, MEN AND SOCIETY: PAINTED MARRIAGE FURNITURE[1]

❦

In fifteenth-century Florence the lives and behaviour of men and women belonging to the mercantile middle and upper classes were bound by a series of obligations. In a society where the men were expected to take part in the administration of the state, and where the actions and choices of individuals and of families had direct effect upon public life, the boundaries between public and private spheres were not clearly defined. In Florence, as in all other Renaissance cities in Italy, family and group loyalties had precedence over strictly individual interests. Marriage was not a private act between two individuals, and was seen as the very basis of civic morality and of the existence and growth of the family. The stability of the political and economic system and of the social order depended on it. The expectations of society and the ideals to which the newly-married couple should aspire were reinforced by the largely instructional narrative paintings which decorated the furniture of their bedroom. The choice of subjects was guided by the belief that images could be used as *exempla*, that is, as exortations and moral admonitions for an ideal behaviour.[2]

Marriage and society

This view of the role of marriage within society was put forward by all fifteenth-century writers on this subject. Two of the most famous treatises on marriage and the family written in this period, Francesco Barbaro's *De Re Uxoria* (1415), and Leon Battista Alberti's *Della Famiglia* (1430s–1440s), state that the first and foremost duty of a man is marrying and increasing his family.

Numerous sons mean prosperity for the family and for the state; the family provides security and offers fertile ground for the growth of virtues, and therefore for the development of a noble and moral character. In Matteo Palmieri's *Della Vita Civile* (*c.* 1436), marriage and the family are seen as the very building blocks of the city, which is held together by bonds of alliances and the system of relatives (*parentadi*). Marriage was expected: it was required by society and encouraged by laws, and the celibacy of one of its members was considered a catastrophe for a family.

This fundamental rite of passage in the lives of men and women was marked by an important private act: the commissioning of marriage furniture. The most important elements were the marriage bed, chests (*cassoni*), day-beds (*lettucci*), and painted panels set above the wainscoting of a room (*spalliere* and *cornici*). Giorgio Vasari conveys the impression that, even from his mid-sixteenth-century point of view, this fifteenth-century furniture was remarkable for its richness and variety:

> in those times it was customary to have, in town houses, large wooden *cassoni* in the shape of sarcophagi, or with lids of other different shapes; and besides the stories which were painted on the front or on the sides, there were also the coats of arms of the families on the corners and in other places. And the stories painted on the front were usually taken from Ovid and from other poets, or stories told by Greek and Latin historians, as well as hunting scenes, jousts, love stories, and other similar themes, according to taste. The inside then was lined with cloth or silk, according to the wealth and power of those who commissioned them, to protect the clothes and other precious things kept there. And not only *cassoni* were painted like this, but also *lettucci, spalliere* and the *cornici* around the rooms, and other similar decorations which were customary at that time, so that an infinite number can still be seen everywhere in the city. And this fashion lasted for so many years, that even the greatest painters worked on these commissions, without being ashamed, as many would today, to paint and gild this kind of objects.[3]

The *cassoni* (called *forzieri* in Florence), were expensive and lavishly decorated chests, originally paid for by the bride's father, but after the middle of the century they were financed by the groom or by his father (Figure 1). The other pieces of furniture for the new couple were also almost always commissioned by the groom or his family as part of the refurbishing of a suite of rooms in the groom's family house.[4] The painted narratives (*istorie*) had not only decorative functions, but also celebratory and exhortatory aims. Charged as these objects were with public and private symbolic meanings, the stories illustrated in the painted panels were not only a display of current learning and taste, but also followed the well-known Renaissance conception of history and history painting as *exemplum virtutis*. The stories were chosen not only for their

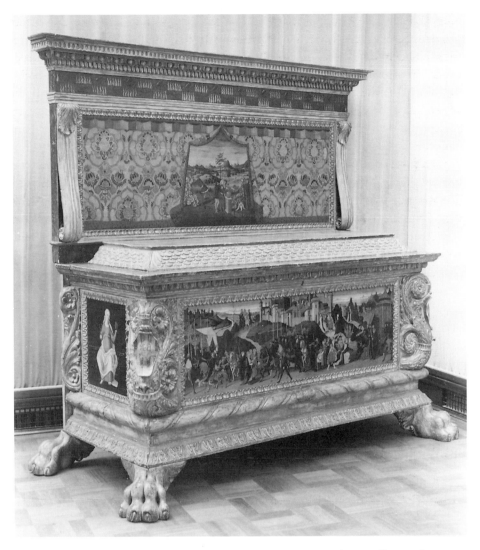

1 Zanobi di Domenico, Jacopo del Sellaio and Biagio d'Antonio, The Morelli – Nerli *cassone*

decorative effects, but also because they might be auspicious to the union, or because they would act as examples of moral qualities desired from both partners.[5]

What were the ideal modes of behaviour which were presented to Florentine men and women? Obedience was the main requirement of the ideal fifteenth-century woman, first towards her parents, then towards her husband. Young women were considered by society to be pliable and inherently weak, hence they needed constant moral guidance. In Book II of *De Re Uxoria*, written

23

in 1415 after a visit to the household of the two sons of Giovanni di Bicci, Lorenzo and Cosimo de Medici, Francesco Barbaro dedicates the first chapter to the 'faculty of obedience'. Barbaro, a friend of the humanists Leonardo Bruni, Niccolò Niccoli and Ambrogio Traversari, writes: '. . . obedience . . . is her master and companion, because nothing more important, nothing greater can be demanded of a wife than this'. After obedience, the greatest quality of a woman is *virtù*: the feminine virtue *par excellence* is virtuous sexual behaviour. In Francesco da Barberino's *Reggimento e Costumi di Donna*, written in the first quarter of the fourteenth century, but still very popular during the fifteenth, the personifications of *Innocenza*, *Verginitade* and *Castità* introduce the sections of the book dedicated respectively to girls, brides and married women. St Bernardino da Siena preached in Santa Croce that 'the honest woman is a crown for her husband' (*la donna onesta è corona del suo marito*), adding that a woman's betrayal of her husband is more serious than a husband's betrayal of his wife, because 'she has no other virtue to lose' (*ella non à altra virtù che perdere*). Leon Battista Alberti in *Della Famiglia* writes that a wife should be good, chaste and fruitful, and that 'one should never cease praying God that he may keep one's wife faithful, tranquil and loving', adding that, next to total celibacy, the worse fate for a family is a dishonoured woman. In Book III of *Della Famiglia* one of the participants to the dialogue, Giannozzo, tells that at the beginning of their marriage he had requested three things from his young wife: that she should never want another man to share her bed; that she should take care of the household, presiding over it with modesty, serenity, tranquillity and peace; and that she should see that nothing went wrong in the house.[6]

Vespasiano da Bisticci includes the life of one woman in his collection of biographies *Vite di Uomini Illustri del Secolo XV*, that of Alessandra de' Bardi, 'very chaste and very honest' (*castissima e onestissima*). She should be an example for all the women of Florence, and mothers should remember her when instructing their daughters. Virtue, he writes, is a more valuable dowry than money.[7] Alessandra was beautiful and graceful, modest and reserved. She charmed the ambassadors of Emperor Sigismund when she danced for them at a banquet in 1432. Vespasiano notes that, before she was married, she did not waste her time being idle and looking out of her window. Her good upbringing and her innate virtues served her in good stead after her husband, Lorenzo di Palla Strozzi, was exiled from Florence, and she had shown her courage by shouldering the responsibility of running the household and taking care of her family's affairs. Alessandra's virtues as a married woman were not limited to the private sphere of her life, because the political life of the city entered within the walls of the house. In Alberti's *Della Famiglia* it is certainly significant that

the longest discussion on the duties of a wife should be included not in Book II, dedicated to marriage, but in Book III, which deals with the economic organisation of the household. Women's virtues, all these writers agree, contribute to the stability and the good organisation of the city.

The ideal fifteenth-century man was first of all a married man. Marriage completed a lengthy process of socialisation which turned him, in his early thirties, from an unruly *giovane* without responsibilities into an 'adult man' (*uomo fatto*).[8] Matteo Palmieri sees adolescents (and he includes in this category young men up to the age of twenty-eight) as being naturally inclined towards evil, and exorts fathers to take great care of their moral education, because 'this is the age when [the adolescent] thinks he has already gained knowledge, and has freedom to choose, and wants to live as he likes'.[9] Young men, especially those belonging to the mercantile elite, were believed to be emotionally unstable, driven by passions, unchecked by reason or piety, and dominated by an uncontrollable sexual drive. Their lack of social responsibility would often lead them to antisocial actions, like seducing married women, behaving violently, creating unrest in the city, or squandering their patrimony. Contemporary writers, like Alberti, concerned by their destructive influence, discussed at length those civil vices which threatened social order, like anger, irascibility, volatility, hate and discord, greed, cupidity, desire and lust: 'He disagrees with others; he creates disorders in the halls of princes; and he corrupts all things with quarrels and divisions. From this arise plots and conspiracies, murders, destructions, poisonings and those black plagues, which are wont to undermine all public and private establishments.' Sexual passion was considered to be among the most brutish of these vices; a man in the grip of lust 'does not care for fame, for honour, or for any tie however sacred, if he may but fulfill his vile appetite'. He is 'thoroughly contemptible, lower than any weak and insignificant beast, vile and despicable'. 'Enamoured men . . . act not under the guidance of reason, but always in the spirit of madness.' To follow lust means to abandon reason, and to show 'the greatest foolishness' (*somma stoltizia*).[10] The fear of prostitution and especially of the sin of sodomy surfaces as the greatest preoccupation in fifteenth-century sermons concerning the behaviour of young men.

The antidote to all this disruption was marriage, since responsibilities towards a wife and children were believed to have a sobering effect. 'There is madness, here is reason; there shame, here praise; there vice, here honesty; there cruelty, here loyalty', writes Alberti, comparing the lives of young men before and after marriage. There was, however, a strong resistance against the bliss of married life, and Alberti vividly presents a situation which he saw as extremely serious:

25

Young men . . . very often do not cherish the good of the family. Marriage, per-
haps, seems to them to take away their present liberty and freedom of life . . . or
perhaps, also, young men find it hard enough to manage one life, and see as an
excessive and undesirable burden the task of supporting a wife and children . . . For
this reason they see the conjugal bed as a troublesome thing, and they avoid the
legitimate and honourable path to increasing the family . . . We must persuade
our young men to take wives, with reasons, blandishments, prizes, and with every
argument, effort and skill.[11]

Only in his thirties, after marriage, as a full member of society, having
painfully and slowy acquired those valued qualities of reason, moderation,
gravity, caution and control over his passion, a man would be ready to take
on his role as an active participant in the political and economic life of the city.
The process of socialisation, entailing the curbing of passions and the exercise
of restraint, was not easy or painless. The task of moulding boys and young
men into restrained and responsible adults was long and arduous.[12] It began
during childhood, and incessant teaching by examples was recommended by
all the writers on the family. Giovanni Dominici, in his *Regola del Governo
di Cura Familiare* (*Rule for the Management of Family Care*) written for the
widow Bartolomea degli Obizzi in 1403, reminds parents that their sons are
members of the Republic and must be brought up 'in order to be useful to
it' (*a utilità di quella*). They have to grow up as just men 'with the balanced
scales [of Justice] in [their] hand' (*colla diritta bilancia in mano*) because
the Republic must not be torn apart by sectarian interests.[13] *Exempla* are
the fundamental instrument of education, and Giovanni Dominici advises that
images of holy figures should be held 'as mirrors' from childhood onwards.[14]
Alberti writes:

It is good to encourage young men to the pursuit of excellence. One should,
in every discussion, praise good men to them . . . the ancients . . . used to rehearse
in song the praises of their greatest men . . . What a prudent and useful custom!
What a good example! Fathers should not fail, in every discussion they have in the
presence of children, to extol the virtues of other men. They should also clearly
condemn the wickedness of such as are wicked.[15]

At the end of this process, after the troublesome years of adolescence, a man
should possess '*virtù civile*', defined by Matteo Palmieri as *Prudentia, Giustitia,
Fortezza* and *Modestia*.[16]

Marriage rituals and painted furniture panels

Images could be used to convey an important message, an *exemplum*, not just
for the education of children and adolescents, but also during the rest of one's

26

life. An image, a story, could remind the newly-wed couple of the ideal social behaviour to which good citizens should aspire. At the beginning of their life together, the couple would be surrounded, in their bedroom, by painted furniture commissioned especially for them, and decorated with suitably inspiring subjects. During the fifteenth century, the bedroom of a wealthy Florentine was the heart of the household: it was not only a private place for sleeping, but also a room where one could receive relatives and friends, read and study. It was for the bedroom that the most expensive items of furniture were commissioned, as well as decorative *spalliere* and devotional paintings.[17]

In the complex marriage rituals of the early fifteenth century, the *cassoni*, carried by porters, were an element of the procession which took the bride from her father's house to her husband's – or more often, to her husband's father's. Through this procession, the marriage was made public to the eyes of the whole community. The bridal procession was also a display of the wealth and power of the two families, and one of the *cassoni*'s original functions had been to hide the luxuries of the trousseau from the eyes of the crowd, in accordance to sumptuary laws which tried to curb public displays of riches. The expensive and lavishly decorated chests, glowing with gold leaf, with their painted narratives in which a multitude of elegant and stylised figures in ornate contemporary costumes acted out stories against backgrounds full of details, provided a reminder of the richness of the objects hidden within. The importance of their decorative qualities cannot be overemphasised. During the first half of the fifteenth century, the narratives often followed the International Gothic Style, even after this had become less fashionable in other types of commissions, while the subject matter of the stories reflected the humanistic learning of the educated Florentine elite.

Once placed in the bedroom of the newly married couple, the *cassoni* were not only repositories of clothes: when opened, many of them reveal, inside the lid, representations of reclining male and female ideal figures (Figure 2). These were almost always nude, and were painted there to convey an allegory of love, or with apotropaic functions: it was believed that the contemplation of physical beauty would help the conception of beautiful children. The number of subjects decorating the exterior of the *cassoni*, as well as the other pieces of furniture in the bedroom of the married couple, like the marriage bed, *lettucci* and *spalliere*, became quickly established by convention. By the first half of the fifteenth century, these subjects had become part of the common knowledge of every moderately educated person in Florence, and the meaning of these stories was not hidden behind abstruse complexities. Petrarch's *Trionfi*, especially the Triumph of Love and the Triumph of Chastity, understood as allegories of the progress of the soul, provided apt subjects for the glorification

27

2 A nude, inside of *cassone* lid

of the theme of marriage, and of love and virtue within marriage, while also offering suitable displays of pageantry. Some scenes were chosen for their decorative effect: jousts and historical or recent battles were good subjects for a display of the chivalric paraphernalia which became increasingly fashionable during the century. Often the subjects were allusions to the importance of marriage, with the celebratory and decorative functions of the panels emphasised by the choice of scenes representing wedding processions and feasts. These gave the possibility of displaying fanciful costumes and ornaments, as in the large panel, perhaps a *spalliera*, commissioned for the wedding of Boccaccio Adimari and Lisa Ricasoli in 1420 (Florence, Accademia) and attributed to Giovanni di ser Giovanni, called 'lo Scheggia', who was Masaccio's brother. The *cassone* panel by the same artist, illustrating a popular *novella*, the dramatic love story of Lionora de Bardi and Filippo Buondelmonti (Grassina, Collezione Alberto Bruschi), also shows a custom related to the wedding rituals: on the left of the narrative, a *cassone* is being carried by a servant through the streets towards the house of the new couple.

In the first half of the century the two different aspects of love, lust and honesty, that is, chastity (*lascivia* and *onestade*), were celebrated by panels loosely based on some of Boccaccio's popular poetic works, like the *Teseide*, the *Caccia di Diana* and the *Ninfale Fiesolano*, with marriage being presented as the rightful and just conclusion of the conflict between Diana and Venus, between virginity and passion. Ancient mythology, through Ovid's *Metamorphoses* and Boccaccio's *Genealogia Deorum*, provided themes like the stories of Narcissus, of Diana and Actaeon, Bacchus and Ariadne, Love and Psyche, Jason and the Argonauts. The *Odyssey* and the *Aeneid*, the latter seen as a work

28

of history rather than of literature, were also favourite sources. Panels decorated with stories from these two works show battles, fantastic episodes like the story of Polyphemus and that of the Sirens, and love stories, among which the Judgement of Paris and the Abduction of Helen, or the Wedding of Thetis and Peleus, the Banquet of Dido and Aeneas, and the Wedding of Aeneas and Lavinia, with scenes of celebrations and feasts always being given pride of place.

Morality and ideals: ancient history and the Old Testament

In the second half of the century, stories with a didactic theme recur more frequently, pointing to examples of virtuous conduct for both husband and wife. The contemplation of examples, images and stories illustrating the lives of good men and women to be used as 'mirrors', and the comparison of their behaviour to one's own, were exercises familiar from childhood. In the room of a married couple, it was the role of the stories painted on the furniture to reflect towards both husband and wife, as a mirror, their respective ideals. In accordance with the role of history and of painted *istorie* as presenting a mirror for contemplation, these stories do not illustrate an actual reality. The behaviour exemplified was prescriptive, rather than descriptive, or at times an admonition against what was considered dangerous for society and therefore to be avoided. These stories are an expression of society's belief in a myth, an ethos, an ideal. Their examples relied for their effectiveness on transparent allusions obvious to all. At a time when the authority of ancient history was believed to lie in the teaching of moral lessons, and when the members of the Florentine elite saw themselves as the heirs to the power, the virtues, and the civilisation of the ancient Romans, it was fashionable to commission *cassoni*, *spalliere* and furniture decorated with subjects which derived directly from historians such as Livy and Plutarch, or which were filtered through the works of fourteenth-century writers, like Petrarch's *De Viris Illustribus* and Boccaccio's *De Casibus Virorum Illustrium*. These works, and the more recent writings by humanists active in the political arena, like Coluccio Salutati and Leonardo Bruni, helped to spread the knowledge of the lives and actions of the ancient heroes. These characters were appropriated by Quattrocento (fifteenth-century) Florentines as part of their legitimate heritage, 'moralised' as examples to follow and as 'mirrors' to reflect their civic ideal. The protagonists of these stories were seen as *exempla virtutis*, indispensible in shaping the unruly *giovani* and the malleable young women into moral citizens, and the lessons they taught were well known to all the educated Florentines. There was no need for explanations to understand that Caesar was a symbol of pardon, Trajan of love

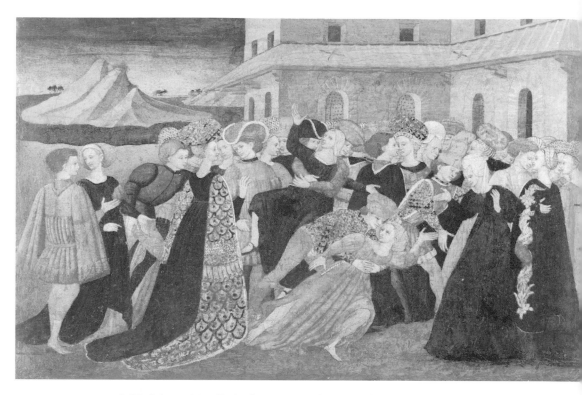

3 Workshop of Apollonio di Giovanni, *The Rape of the Sabines*, fragment

and justice, Alexander and Scipio of generosity and sexual restraint. The story of the Battle of Issus, with Alexander the Great showing clemency to the female relatives of the defeated Persian king Darius, was seen as an example of male virtues and restraint in relation to the moral behaviour to be adopted towards women, and so was another favourite representation of similar virtues, the Continence of Scipio. Alexander was also seen as an example of that most necessary civic virtue, reconciliation, having brought together under his rule the West and the East. Heroes from Roman Republican history, like Horatius Cocles and Mutius Scaevola, pointed the way to virtues suited to the defence of the republic, and were particularly significant to Republican Florence. Some of these characters provided examples of bad behaviour, or faults to be avoided and wickedness to be condemned. Darius and Xerxes, for instance, were shown defeated in war because of their overreaching pride.

Even episodes of history which to our modern eyes lack moral content were chosen as *exempla*: the Rape of the Sabines, for instance, beside referring to the Florentines' Roman ancestors, was a topic deemed suitable for celebrating the reconciliation between enemies, the beneficial effects of marriage on both

30

individuals and society, and the beginning of a new lineage. This story was represented with the customary emphasis on decoration and spectacle, with the Sabines richly attired in contemporary clothes and head-dresses, and the Romans as young fashion-conscious Florentines, attending a series of games in a circus (Figure 3). The abduction itself was often presented as a chivalric contest. This story was also seen as an example of womanly submissiveness, a virtue considered necessary for the stability of society. Together with these figures from classical antiquity, characters from the Old Testament were also seen as belonging to ancient history, and therefore as suitable *exempla* of moral behaviour. David, Solomon and Joseph personified virtues such as magnanimity, wisdom, devotion to one's family, generosity, forgiveness and continence. David's victory over Goliath was interpreted as an act of civic courage.

Heroines of antiquity and of the Old Testament

Heroines of antiquity were used as the ideal models for women's behaviour, and in his *De Re Uxoria* Francesco Barbaro constantly presents to women examples from ancient Greece and Rome to stress his moral lesson. Together with works by Greek philosophers and Latin historians, Boccaccio's *De Claris Mulieribus*, a book written with the intention of presenting examples of vices and virtues, was a rich source of material.[18] The Vestal Virgin Tuccia, accused of fornication but able to prove her virtue, was a famous *exemplum* of chastity. Dido was described by Petrarch and by Boccaccio as an *exemplum* of faithfulness, since she committed suicide rather than marry King Massitanus, and Francesco Barbaro in his *De Re Uxoria* asks: 'who can fail to admire, with the greatest of pleasure, the chastity of Dido?'[19] The intrepid heroines Cloclia and Camilla presented *exempla* of civic courage and public defiance in the face of the enemy: Cloelia led the escape of a group of Roman maidens imprisoned by the Etruscan king Lars Porsena, and Camilla fought at the head of an army of Volscians against Aeneas.

The Dominican preacher Girolamo Savonarola disapproved of the fashion for painted marriage furniture, complaining that 'heathen stories' from Greek and Roman mythology were perverting young women's minds, and that beds decorated with naked men and women would lead young people to dishonest acts. Well-known Old Testament heroines, however, appear frequently in bedroom furniture decoration. Both Esther and Judith, with their courage and their initiative, were instrumental in saving their people and were therefore seen as *exempla* of civic behaviour. The contrast between the reward of the virtuous Esther and the humiliation of the proud Queen Vashti, together with

the representation of banquet scenes set at the court of Ahasuerus, made this story particularly suitable for the decoration of *cassoni*. Susannah's defence of her virtue and reputation against the two lascivious elders, together with her integrity, seems to define exactly the behaviour of the ideal fifteenth-century married woman. Her moral courage is rewarded by the justice she finally receives from David.[20] The Queen of Sheba's desire to meet Solomon, celebrated for his wisdom, can be seen as a reference to a woman's tribute to her husband's virtue, while her meeting with Solomon is a direct visual reference to wedding ceremonies and to the pomp surrounding them.[21] Chastity, courage, and desire for justice are the recurring themes of these stories, which show no clear boundaries between private and public virtues.

Boccaccio's heroines and wifely behaviour

Boccaccio's *Decameron* was the source for a number of painted *exempla* of good wifely behaviour, especially of the virtues of *honestade* and *obbedientia*, with his two heroines, Adalieta, from the tale of Saladin and Torello, and Ginevra of Genoa. One of the most well-known stories in the whole book was the *novella* of Griselda, which is the last in the *Decameron*.[22] Petrarch, who read it together with some friends, had been moved to tears by it. In his Latin translation the *novella* had become popular all over Europe. It was circulated in hundreds of manuscript versions and, in the second half of the fifteenth century, in a large number of printed editions. This story provided the subject matter for three *spalliere* panels painted *c.* 1500 by an artist close to Signorelli and Pinturicchio (Figures 4, 5 and 6). Griselda is a peasant girl, chosen by Gualtieri, the Marquess of Saluzzo, as his wife, on condition that she will give him unconditional obedience, whatever he does or says. In the first panel, on the left, Gualtieri is seen hunting in the countryside, and he is shown the way to Griselda's house, while on the right, he meets Griselda, in rags, near her father's house. In the centre, against the background of a triumphal arch, Gualtieri marries Griselda, now beautifully dressed. She is cruelly and unjustly tested by her husband, who even simulates the murder of their two children: in the second panel of the series, on the left, their baby is taken away by a servant. In the centre, under a loggia, Gualtieri pretends to have received permission from the Pope to dissolve their marriage, because, he says, his ancestors have all been lords and hers humble workers, and he wants a wife from his own background. So, after thirteen years of marriage, Griselda is stripped of her beautiful clothes and, on the right of the panel, she is sent back to her father's house, with just a shift to cover her. After this public rejection of his

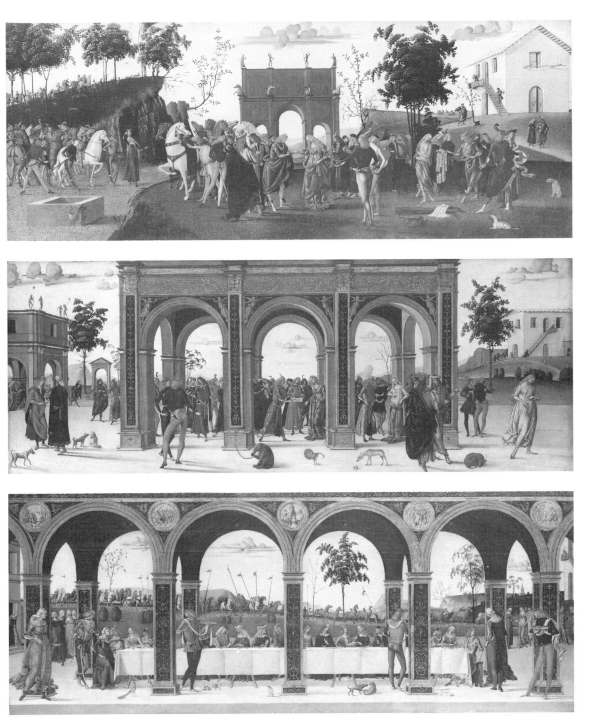

4, 5, 6 Master of the Story of Griselda, *The Story of Griselda*, Part I, Part II, Part III, *c.* 1500

wife, Gualtieri asks for the ultimate demonstration of obedience: Griselda is called back to act as a servant to his new bride. In the third and last panel, the continuous narrative device shows us the conclusion of the story under a *loggia*: on the left, Griselda, dressed in grey, sweeps the floor in preparation for the arrival of the new bride. On the right, she welcomes the bride, not recognising that in fact she is her long-lost daughter. Gualtieri is now satisfied: his wife's obedience has been put to the test and, needless to say, her goodness has conquered even his heart. She is finally reinstated at her rightful place as Gualtieri's wife, and she is reunited with both her children. The banquet brings together all the protagonists of the story.

Griselda never wavers in her obedience, loyalty and love for her husband. She is seen as an *exemplum* of superhuman patience and obedience, and the message of the story seems at first to be directed only towards women. The story, with its ritualised dressing and undressing of Griselda, has been understood as an illustration of Florentine nuptial customs. It has also been interpreted as a reference to the custom that young widows had to leave behind all their clothes, jewels and all the gifts received for the wedding before returning to their fathers' house.[23] The *novella* is so extreme that it is easy to see it just as a demonstration of misogyny, and to modern eyes the character of Griselda in her total submissiveness is unpleasantly masochistic. Boccaccio cast his tale in the language and mode of a fairy story, with tests to be undertaken and ritual actions to be observed. Griselda is a mystical figure, modelled on the representation of saints in medieval hagiography, with the account of her tribulation presented as one of the stories of Christian martyrs. Her humility and her acceptance can be understood only in a religious context: she is a female version of Job, a new St Elizabeth of Hungary, presented as a woman above all women. Petrarch wrote of Griselda that her virtues 'surpassed her age and sex'. Her closest 'sister' is St Uliva, whose life is also the subject of at least one *cassone* panel. Concentrating solely on her as an *exemplum* of obedience, however, distorts the story: Griselda, a noble character in spite of her low birth, is contrasted with her aristocratic husband, the brutish Gualtieri. Boccaccio ends his *novella* with a barbed comment: '. . . divine souls are sometimes rained down from Heaven into poor houses, while in royal palaces are born those who are better fitted to herd swine than to rule over men. It would perhaps not have been such a bad thing if he had chosen one of those women who, if she had been driven out of her home in a shift, would have let another man so shake her fur that a new dress would have come from it'. In this story we are presented with two examples of behaviour: one is to be revered as suitable to a saint, the other is to be avoided. In the introduction to the story, Boccaccio warns the reader against Gualtieri: 'I shall tell you about a marquess, but not

of his munificence. It will be about his silly brutality, although good came out of it in the end. I do not advise anyone to imitate him, for it was a great pity that good did come to him.' And in the story there is another indication of Gualtieri's bad character, together with an exhortation for men to get married: 'He was wifeless and childless, spent his time hunting and hawking, and never thought about marrying or having children ... This displeased his subjects, who several times begged him to take a wife, so that he might not die without an heir and leave them without a ruler.'

Women and the domestic environment

It is important to remember that so many of these moralizing narratives decorating marriage furniture deal with events which have men as well as women as the protagonists of the action. Painted panels for nuptial furniture have been interpreted by some art historians as being addressed specifically to an audience of women, to be understood within a feminine frame of reference and seen through feminine experiences, shared among the women who lived in the domestic spaces assigned to them.[24] What evidence is there to support such a reading? As far as a supposedly 'feminine space' within the fifteenth-century wealthy Florentine house is concerned, the evidence about the use of rooms is contradictory and fragmentary. Alberti, in Book V of his *De Re Aedificatoria*, advocates separate bedrooms for husband and wife of high rank, but in Book IX he mentions that the room where the marriage bed is placed should be common to both spouses. In *Della Famiglia* only one common bedroom is mentioned.[25] Archival research has shown that in Florentine fifteenth-century inventories the couple's bedroom is identified with the name of the husband, and the only rooms specifically identified with women's names are those used by widows. The bedroom was not used only for sleeping, nor was it exclusively private: as the richest room in the house and the room with the largest number of furniture and paintings, it was also used to receive guests.[26] About the way in which paintings were 'seen', experienced and discussed in the fifteenth century we know very little, apart from the literary conventions which guided learned writings about art. We are aware of the well-documented moral readings of some paintings as *exempla*, and of the emotional relationship to religious images. We know nothing at all about how the particular genre of furniture panels was discussed from the point of view of meaning.[27] Furthermore, there is no evidence to support the notion that these objects and the painted stories which decorated them were destined specifically and solely for female spectators. Needless to say, no fifteenth-century woman, in her letters,

has left us any evidence which could help the modern historian to construct a 'feminine gaze' for this period. Attempts to interpret these paintings according to a theory developed in order to analyse modern media are ahistorical and anachronistic. Such attempts may help to deconstruct (or rather, construct) meanings for the modern reader, but the historical usefulness of this method is questionable. Even the stories which have female characters as protagonists deal in fact with the predicament of both sexes, and seem therefore to be addressed to both husband and wife. For the families of the Florentine mercantile elite, women's virtuous behaviour was not a separate concern which regarded a supposedly private and separate sphere of life: together with men's *virtù civili*, it was at the root of social life. In the ideal picture of a well-ordered society, both men and women contributed to the stability and to the good organisation of the city.[28]

Botticelli and painted *spalliere*

An illustration of the duties of both men and women in society is provided by two series of *spalliere*, both painted in the workshop of Botticelli during the last quarter of the fifteenth century. Antonio Pucci commissioned, on the occasion of the marriage of his son Giannozzo to Lucrezia Bini in 1483, four *spalliere* panels, decorated with another well-known *novella* from Boccaccio's *Decameron*, the *storia* of Nastagio degli Onesti (Figures 7, 8, 9 and 10). The Pucci were 'clients' of the Medici family, and the marriage between Giannozzo and Lucrezia had been mediated by Lorenzo the Magnificent himself.[29] At the beginning of the story, Nastagio degli Onesti behaves like a typical foolish *giovane* in the grip of sexual passion: he is hopelessly in love with a wealthy young woman of Ravenna, the daughter of Ambrogio Traversari. Having been refused by her and feeling hurt and rejected, he acts irrationally and irresponsibly, squandering his patrimony. Following his friends' advice, he decides to leave Ravenna: 'after much preparation, as if he were getting ready to travel to France, or to Spain, or to another far-away place', he only goes as far as the pinewoods of Classe, 'perhaps three miles away from Ravenna'.[30] There he sets up camp, and spends his time lunching and dining with his many friends. His beloved, who refuses love and marriage, is guided by selfishness and pride, her beauty and her nobility making her 'harsh and hard and wild' (*cruda e dura e selvatica*).[31] One day, while walking dejectedly in the pinewoods, thinking about his beloved, Nastagio witnesses a horrifying spectacle: he sees a naked woman chased by a knight on a horse and by his hounds. The hounds finally pounce on her and bring her down. When Nastagio tries to help the woman,

he is stopped by the knight, who jumps off his horse and kills her, cuts her open with a knife, and throws her innards to the dogs. The knight then tells the petrified Nastagio his story. His name was Guido degli Anastagi. Once he had been in love with this woman, who had rejected him. Unable to stand the pain of his unrequited love, he had killed himself, to the great joy of the woman, who had felt pride in her power. After her death, they had been condemned together to this eternal punishment: the chase and the murder are to be repeated over and over again, in the same place, at the same time. And in fact, to Nastagio's utter amazement, the woman, apparently unharmed, gets up again, and the chase starts anew. In the first two panels, through the device of continuous narrative, the viewer follows Nastagio in the pinewood of Classe, and witnesses the chase and the killing of the woman. The third panel of the series shows a banquet, set up by Nastagio in the pinewood. He has invited Ambrogio Traversari and his beautiful daughter, their relatives and friends, on the day when the recurring chase and the 'murder' will take place, so that the cruel spectacle should frighten his beloved into changing her mind. The scene of pursuit and death is punctually re-enacted right in front of the dinner tables, and the guests are visibly shocked by the event. On the right-hand side of the third panel the nurse of the Traversari daughter communicates to Nastagio that her mistress has finally changed her mind, and she is ready to accept his love. She is now convinced that she should no longer refuse love, and she offers to Nastagio a night of passion. By this stage Nastagio has become a mature, responsible man: Boccaccio tells us, in his *novella*, that 'he wanted his pleasure with her honour, and this meant marrying her' (*con onore di lei voleva il suo piacere e questo era sposandola per moglie*).[32] What this series of *spalliere* illustrates is not so much the cruel ordeal of one woman and the submission of another, but rather the vision of an organised social community which is opposed to chaos, even at the expense of the individual. In the first three panels, the horror of the naked woman attacked by the hounds and cut open by the knight is central to the composition. The images of the vivid portrayal of the slaughter are exceptional in fifteenth-century Florentine painting. It would, however, be wrong to isolate the female predicament in this call to order, and to see these panels as an *exemplum* directed only to women. The lesson is addressed to both male and female: neither should live in an unmarried state, locked in a selfish, private world. This is a story dealing with the attainment of wisdom for both protagonists. They change from being young and irresponsible to being mature and finding fulfilment in the acceptance of their respective social roles, whatever the personal sacrifices. Nastagio leaves behind his youthful ways and stops wasting his money; the daughter of Ambrogio Traversari has to forget her pride and take him as her husband. In this ideal

37

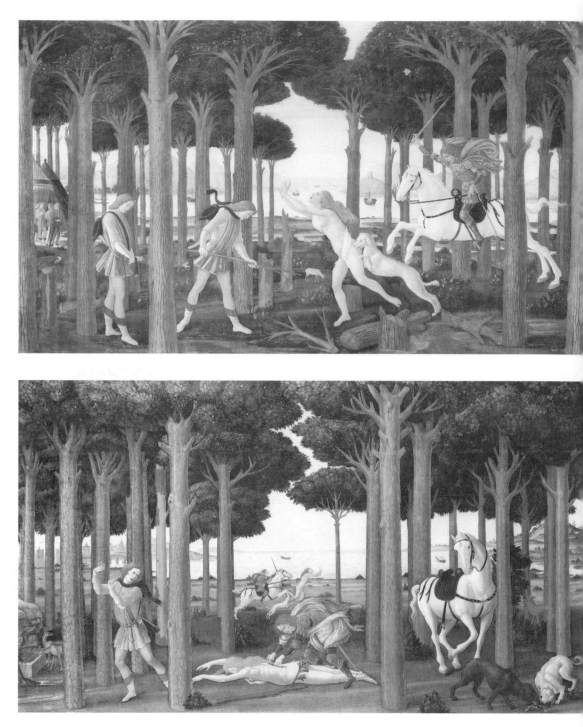

7, 8 Workshop of Botticelli, *The Story of Nastagio degli Onesti*, Part I and Part II, *c.* 1483

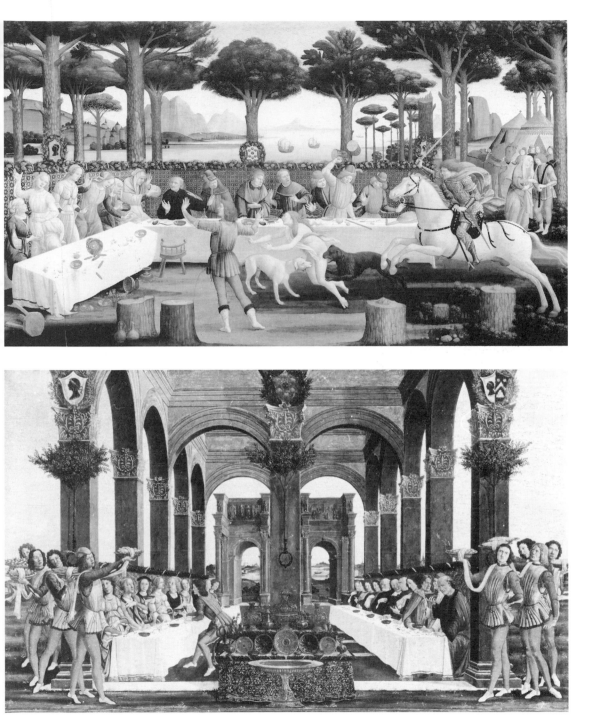

9, 10 Workshop of Botticelli, *The Story of Nastagio degli Onesti*, Part III Part IV, *c.* 1483

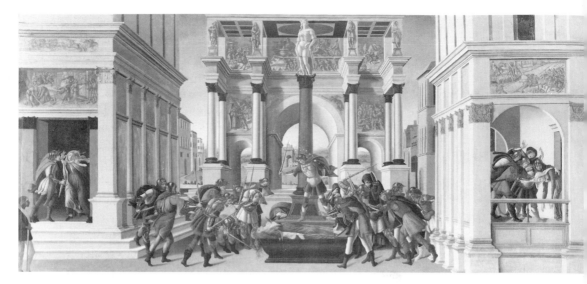

11 Workshop of Botticelli, *The Story of Lucretia*, c. 1496–1504

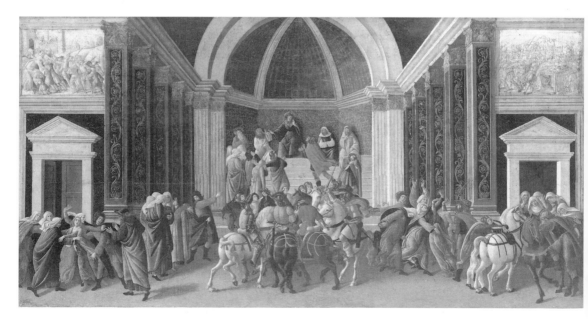

12 Workshop of Botticelli, *The Story of Virginia*, c. 1496–1504

society happiness will be there for both. In the fourth panel of the series, the wedding feast of Nastagio and his beloved takes place under a *loggia*. After three scenes centred on cruelty and disorder, the painted image at last leads the viewer to a place of happiness and order: under the coats of arms of the Pucci, the Bini and the Medici, the ritual of the wedding banquet, through the symmetry of the composition, its perspectival organisation and the placing of the figures within it, can be seen as a symbol of the perfect society where men and women eventually occupy their appointed places.

Two further *spalliere* panels, also produced in the workshop of Botticelli, illustrate the stories of two of the most famous Roman heroines, Lucretia and Virginia (Figures 11 and 12). Both were well-known *exempla* of chastity (*pudicitia*) and had been celebrated as such by Livy and Valerius Maximus. Lucretia's story was also included in Boccaccio's *De Claris Mulieribus*. The dating of these *spalliere* is uncertain, and there is no informaton about the commission. It has been suggested that these panels were part of a series, perhaps painted for the marriage of Giovanni Vespucci and Namicina di Benedetto Nerli in 1500.[33] The story of Lucretia's sacrifice of her own life in order to safeguard the honour of her husband's name after she had been raped is shown using the device of continuous narrative. The public aspects of the event are emphasised as the actions take place in an exterior setting. On the left, the rapist, Tarquin, threatens Lucretia on her doorstep; on the right, Lucretia collapses in the arms of her husband and her father, while in the centre of the panel the body of the dead Lucretia, the knife still in her chest, is the focus for the Romans' plans of revenge against the Tarquins. Right at the centre of the composition, Brutus incites the inhabitants of Collatia to rebel against the Tarquins, a rebellion which will give birth to the Roman Republic.

The *istoria* which decorates the second panel of the pair shows the death of Virginia at the hand of her own father, Virginius, in order to preserve her virtue and the good name of her family from the dishonour brought about by the lust of Appius Claudius. Reading the narrative from left to right, we see first of all Marcus Claudius who, agreeing to the plot organised by Appius, declares Virginia to be his slave. To give an appearence of legality to the planned abduction, Marcus suggests that Virginia should appeal to Appius's tribunal, which will decide her fate. In the centre of the panel, Appius orders Virginia to remain in his custody. In this way, she will be powerless in his hands. In the meantime, Virginius has been warned of Appius's plot. There is only one possible solution: on the right of the panel, Virginius kills his daughter and then escapes. The viewer's attention is brought back to the centre of the composition, where we witness the revolt of the citizens and soldiers against the tyrant Appius.

Both these stories are acted out against *all'antica* architectural settings, in

the presence of groups of people who participate and react with great emotional and dramatic intensity. The tragedies of the two heroines are presented as events having great public resonance; they are caused by the unrestrained sexual desires of public figures who, acting irresponsibly and abusing their power, have betrayed the trust with which they had been invested. The consequences of the lust of public figures determine the whole destiny of the city, and are given great prominence. In the Lucretia story the message is stressed by fictive reliefs illustrating subjects which deal with heroism and defiance against the enemy, and by the statue of David, a well-known Florentine symbol of rebellion against tyrants, placed high on a column, in the middle of the composition.[34] The defence of female chastity and of public safety are intertwined, and the honour of the women is at one with the honour of the city.[35]

The stories which recur in the decoration of furnishings commissioned on the occasion of weddings illustrate how the two spheres of private and public behaviour in the lives of both men and women were perceived as being closely connected. Selflessness, the crucial role of the family, the well-being of society, are all intertwined. The fundamental importance of chastity goes hand-in-hand with public demonstrations of restraint, of justice, and with the glorification of civic sentiments. Women's behaviour cannot be separated from men's: any offence by men to women's virtue, or any transgression by women, brings about disorder through civil disruption and political upheaval. These stories are convenient vehicles for contemporary private and public moral values. But it is not only the content of these stories, the 'moral' lesson, which points to a public platform for a virtuous life. In these marriage paintings of the last decades of the fifteenth century, the artists stage all the actions in the middle of crowds of participants and spectators, within a framework of symmetrical architectural settings structured in such a way to stress the utopian character of this ideally ordered society.

Notes

1 An abbreviated version of this chapter was read at the conference 'Culture, Society and Women in Renaissance Italy', 21–23 April 1994, Royal Holloway, University of London, and will appear in forthcoming proceedings, edited by L. Panizza.

2 The question of marriage in Renaissance Florence is discussed by D. Herlihy and C. Klapisch-Zuber in *Tuscans and Their Families. A Study of the Florentine Catasto of 1427*, Yale University Press, New Haven, 1978, pp. 202–31. See also C. Klapisch-Zuber, *Women, Family and Ritual in Renaissance Italy*, University of Chicago Press, Chicago, 1985. On the significance of the family, of its extended grouping (*consorteria*,) and of the system of relatives (*parentadi*), see F. W. Kent, 'Individuals and Families as Patrons of Culture in Quattrocento Florence', in A. Brown (ed.), *Language and Images of Renaissance Italy*, Clarendon Press, Oxford, 1995, pp. 171–92, esp. pp. 177–8.

3 Vasari – Milanesi II, pp. 148–9.

4 The most extensive study of *cassoni* and *spalliere* panels and of their subject matter is still P. Schubring, *Cassoni. Truhen und Truhenbilder der italienischen Frührenaissance: ein Beitrag zur Profanmalerei in Quattrocento*, K. W. Hiersemann, Leipzig, 2nd ed. in 2 vols, 1923. A general, beautifully illustrated, introduction to *cassone* panels is J. Pope-Hennessy and K. Christiansen, *Secular Painting in 15th-Century Tuscany. Birth Trays, Cassone Panels and Portraits*, Metropolitan Museum of Art, New York, 1980, repr. from *Metropolitan Museum of Art Bulletin*, Summer 1980. The social and historical context is provided by R. A. Goldthwaite, *The Building of Renaissance Florence. An Economic and Social History*, Johns Hopkins University Press, Baltimore, 1980, repr. 1990. E. Callmann gives an excellent and detailed account of commissions and functions of the *cassoni*, and of the styles and subject matter of the panels, in *Apollonio di Giovanni*, Clarendon Press, Oxford, 1974. In 'Apollonio di Giovanni and Painting for the Early Renaissance Room', *Antichità Viva*, 27, 3–4, 1988, pp. 5–18, Callmann discusses the changes which took place from the early to the late fifteenth century, and the vast range of objects commissioned for the complete decoration of the bedroom of newly-weds.

5 E. H. Gombrich writes that the *cassone* was not only a repository for clothes, but 'a carrier of happy auguries, if not of lucky charms' ('Apollonio di Giovanni. A Florentine Cassone Workshop Seen Through the Eyes of a Humanist Poet', in *Norm and Form. Studies in the Art of the Renaissance*, Phaidon, London, 2nd ed., 1971, pp. 11–28, esp. p. 21. On the functions of *cassoni* and *spalliere*, and on the meaning of the subject matter of the painted panels, see E. Callmann, 'The Growing Threat to Marital Bliss as Seen in Fifteenth-century Florentine Paintings', *Studies in Iconography*, 5, 1979, pp. 73–92. A detailed discussion of *spalliere*, including problems concerning subject matter and meaning, is A. B. Barriault, 'Florentine Paintings for Spalliere', unpublished doctoral dissertation, University of Virginia, 1985.

6 Francesco Barbaro, *De Re Uxoria*, trans. B. G. Kohl, in *The Earthly Republic. Italian Humanists on Government and Society*, eds B. G. Kohl and R. G. Witt, Manchester University Press, Manchester, 1978, pp. 179–228, esp. p. 193; Francesco Da Barberino, *Reggimento e Costumi di Donna*, ed. G. E. Santore, Loescher-Chiantore, Turin, 1957; S. Bernardino da Siena, *Le Prediche Volgari*, ed. C. Cannarozzi, 2 vols, Pistoia, 1934, repr. 3 vols, Florence, 1940, I, pp. 414 and 413; Leon Battista Alberti, *Opere Volgari*, ed. C. Grayson, 3 vols, Laterza, Bari, 1960, I, p. 116. For Alberti's requirements for a good bride, see pp. 110 ff.

7 Vespasiano da Bisticci, *Vite di Uomini Illustri del sec. XV*, ed. P. d'Ancona and E. Aeschlimann, Hoepli, Milan, 1951, pp. 539–69, esp. p. 569.

8 The profile of the young man and his vices is analysed by D. Herlihy in 'Some Psychological Roots of Violence in the Tuscan Cities', in L. Martines (ed.), *Violence and Civic Disorder in Italian Cities, 1200–1500*, University of California, Berkeley and Los Angeles, 1972, pp. 129–54. On the question of young men and morality, see also G. Ruggiero, 'Marriage, Love, Sex and Renaissance Civic Morality', in J. G. Turner (ed.), *Sexuality and Gender in Early Modern Europe. Institutions, Texts, Images*, Cambridge University Press, Cambridge, 1993, pp. 10–30.

9 Matteo Palmieri, *Libro della Vita Civile*, Giunti, Florence, 1529, p. 22.

10 Alberti, *Opere*, I, p. 94.

11 *Ibid.*, p. 96.

12 In their introduction to *The Expanding Discourse*, Norma Broude and Mary Garrard write that while the education of women through exemplary images was based on 'regulation and control', men were guided by 'inspiration and caution' (p. 8). Contemporary sources on the moulding of boys and young men into responsible moral citizens do not lead me to similar conclusions, since they all stress the difficulty of this process.

13 Giovanni Dominici, *Regola del Governo di Cura Familiare*, ed. D. Salvi, Garinei, Florence, 1860, pp. 177–8.

14 *Ibid.*, pp. 131–2.

15 Alberti, *Opere*, I, p. 67.

16 Palmieri, *Libro della Vita Civile*, p. 39.

17 R. A. Goldthwaite traces the changes in the function of the bedroom and in the character of the furnishings in 'L'interno del Palazzo e il Consumo dei Beni', in D. Lamberini (ed.), *Palazzo Strozzi. Metà Millennio 1489–1989*. Atti del Convegno di Studi, Firenze, 3–6 Luglio 1989, Istituto della Enciclopedia Italiana, Rome, 1991, pp. 159–66. He points out that during the first half of the fifteenth century the bedroom was richly decorated, while the other rooms were left almost empty. With the increase in the commissioning of furniture and of works of art, the functions of the various rooms became more and more specific. The organisation of domestic life changed accordingly. Goldthwaite explains these changes not as the result of an increased availability of money, nor as the consequence of a more 'middle-class' mentality. He sees the consumption of objects as a 'creative force in the construction of a cultural identity' (p. 165). Culture becomes a justification for the possession of objects. J. K. Lydecker, in 'The Domestic Setting of the Arts in Renaissance Florence', unpublished doctoral dissertation, Johns Hopkins University, 1987, differentiates between the terms *camera* (bedroom) and *sala* (hall), their furnishings and their use (pp. 26 ff.). The *camera* was a more personal space, the focus of private life and the most important room in the house. The *sala* contained trestle tables and benches. Lydecker provides a series of case studies, showing changing patterns of acquisition of furniture, *spalliere*, devotional paintings and portraits from the fifteenth to the sixteenth century.

18 For an analysis of Boccaccio's text, see C. Jordan, 'Boccaccio's Infamous Women: Gender and Civic Virtues in the *De Mulieribus Claris*', in C. Levin and J. Watson (eds), *Ambiguous Realities: Women in the Middle Ages and Renaissance*, Wayne University Press, Detroit, 1987, pp. 27–47.

19 On the figure of Dido, see C. Jordan, *Renaissance Feminism. Literary Texts and Political Modes*, Cornell University Press, Ithaca and London, 1990, pp. 37–8.

20 In her analysis of the Susannah story, both as it appears in *cassone* panels and as told in Quattrocento theatrical representations, C. L. Baskins proposes that the *exemplum* not only refers to the heroine's virtue, but to her silencing as a legal being – with a direct reference to the legal position of Florentine women who could not take a case to court on their own, but had to act through a legal guardian. Baskins writes that it is not Susannah's own voice to be heard in her defence, but that of Daniel. (' "La festa di Susanna": Virtue on Trial in Renaissance Sacred Drama', *Art History*, 14, 3, September 1991, pp. 329–44.) It is doubtful whether such precise references to specific customs were in fact intended, and these *exempla* should rather be seen as directed towards an ideal behaviour in the context of civic values. In the Lionora de Bardi story, for example, Lionora's eloquence in front of the Podestà succeeds in rescuing Filippo Bondelmonti from a sentence of death: the story should not be seen as advocating for women an ideal of a 'female lawyer', bold and learned enough to speak in a public court, but rather as a celebration of the role of marriage in bringing together two warring families, and of the importance of the just judge. On the *Lionora de Bardi* story, see J. Rawson, 'Marrying for Love: Society in the Quattrocento *Novella*', in *Culture, Society and Women*, forthcoming. Concerning the question whether these images should be seen as directed towards a generalised ideal, see the position taken by D. Owen Hughes in 'Representing the Family: Portraits and Purposes in Early Modern Italy', in R. I. Rotberg and T. K. Rabb (eds), *Art and History. Images and their Meaning*, Cambridge University Press, Cambridge, Mass., 1986, pp. 7–38. Discussing *cassone* panels, she writes: 'They exemplify ways in which pictures are both created and viewed not as a reflection of social and personal reality but rather as idealised or admonitory representations of what is desired or what is feared' (p. 11).

21 For the story of the Queen of Sheba, and for a discussion of the panels which illustrate it, see Callmann, *Apollonio di Giovanni*, pp. 42–3.

22 Giovanni Boccaccio, *Decameron*, ed. V. Branca, Accademia della Crusca, Florence, 1976, Giornata X, Novella 10, pp. 702–21.

23 For interpretations of the story of Griselda, see V. Tatrai, 'Il Maestro della Storia di Griselda e una famiglia senese di mecenati dimenticata', *Acta Historiae Artium*, 25, 1979, pp. 27–60, and A. Colasanti, 'Due novelle nuziali del Boccaccio nella pittura del '400', *Emporium*, XIX,

1904, pp. 200–15. C. Klapisch-Zuber discusses the figure of the widow returning to her father's house without possessions in 'The Griselda Complex: Dowry and Marriage Gifts in the Quattrocento', in her *Women, Family and Ritual in Renaissance Italy*, University of Chicago Press, Chicago and London, 1985, pp. 213–46.

24 R. M. San Juan, in 'Mythology, Women and Renaissance Private Life: The Myth of Eurydice in Italian Furniture Painting', *Art History*, 15, 2, June 1992, pp. 127–45, isolates both the character of Eurydice and the duties of woman from their contexts, concentrating on feminine virtues and contrasting an ideal of male heroic action to passive female selflessness. She presupposes a 'shared experience' of women in front of these paintings, facilitated by the 'private domestic spaces' in which women lived (p. 127), and the possibility for these mythological paintings for women to be 'a focus for discussion and a way of articulating, however indirectly, a shared experience' (p. 142). She writes (p. 141) that factors related to the function of the painted furniture panels 'suggest a less conventionalised and hence less predictable viewing experience' than that provided by the conventional, highly formalised ekphrastic descriptions of paintings.

25 L. B. Alberti, *On the Art of Building in Ten Books*, trans. J. Rykwert, N. Leach and R. Tavernor, MIT Press, Cambridge, Mass., 1988, pp. 121, 149 and 299. In *Della Famiglia* the household arrangements are discussed in Book III.

26 See also Lydecker, 'The Domestic Setting', pp. 39 and 33 and 'Il Patriziato Fiorentino', pp. 217–18. On the works of art commissioned by and for women in a different social and political context, that of the Northern and Central Italian courts, see the essay by E. Welch, 'In My Lady's Chamber: Places for Women in the Palaces of Fifteenth-century Italy' (provisional title), in C. King (ed.), *Women as Viewers and Users of Art and Architecture in Italy c. 1300–c. 1600*, forthcoming.

27 The 'period eye' is discussed by M. Baxandall, *Painting and Experience in Fifteenth Century Italy. A Primer in the Social History of Pictorial Style*, Oxford University Press, Oxford, 1st ed. 1972, 2nd ed. 1988, who also examines fifteenth-century writings on painting, and contemporary stylistic terms of reference.

28 In her important and thought-provoking essay 'La famiglia patrizia fiorentina nel secolo XV', in *Palazzo Strozzi*, pp. 126–37, Strocchia (pp. 127 ff.) stresses that the borderlines between public and private life in fifteenth-century Florence were very fluid, and the links between politics, *parentela* and patronage very complex. S. Chojnacki comments on the historical debate on the relationship between the private and public spheres in his essay 'Comment: Blurring Genders', *Renaissance Quarterly*, 40, 1987, pp. 743–51, esp. 748–9. See also his useful discussion on the application of the concept of 'patriarchy' (pp. 745–8). On the interrelationship between public and private spheres in the lives of fifteenth-century Florentine women, see also the observations made by P. Salvadori in her introduction to Lucrezia Tornabuoni, *Lettere*, Istituto Nazionale di Studi sul Rinascimento, Studi e Testi, XXXII, Olschki, Florence, 1993, esp. pp. 38–9. Salvadori points out that while the cases of Lucrezia Tornabuoni or of Alessandra Macinghi Strozzi are certainly exceptional, fifteenth-century women, denied an access to official political life, exercised their direct and indirect influence on society through the life of the family. Their activities took them outside the limits of their home.

29 The panels are described by Vasari in his *Vita di Sandro Botticelli* (Vasari – Milanesi III, p. 313). They are discussed by R. Lightbown in *Sandro Botticelli*, 2 vols, Elek, London, 1978, I, pp. 69–70, and II, pp. 47–51. The functions of these *spalliere* panels and their subject matter are analysed in the context of fourteenth-century literature and of fifteenth-century social and moral expectations by C. Olsen, in 'Gross expenditure: Botticelli's *Nastagio degli Onesti* panels', *Art History*, 15, 2, June 1992, pp. 146–70. Olsen interprets the themes of the panels as 'gastronomical, financial and amatory over-indulgence'. She points out that 'excessive extravagance receives punishment or reward based not . . . on an economy of morals in the tale but instead on the marital economy of nuptial exchange of which the panels, as a wedding gift, formed a tangible part'.

30 Giovanni Boccaccio, *Decameron*, Giornata V, Novella 8, pp. 379–84, esp. p. 380.

31 *Ibid.*, p. 379.

32 *Ibid.*, p. 383.

33 For a discussion of the panels, and references to previous studies, see Lightbown, *Sandro Botticelli*, I, pp. 141–5, and II, pp. 101–6. Lightbown dates the panels from *c.* 1496 to 1504. The Virginia and Lucretia panels have been linked to Vasari's vague description of the decoration of a room in the house of Giovanni di Guidantonio Vespucci (Vasari – Milanesi III, p. 312).

34 The subjects of the simulated reliefs in the Lucretia panels are (a) Mucius Scaevola, at the door of Porsena's tent, stabs the King's secretary, believing his is the king; (b) Mucius Scaevola holds his right arm over the flames; (c) Marcus Curtius, on his horse, leaps into the flames in the Forum; (d) spoils of a Roman triumph; (e) Achilles drags the body of Hector round the walls of Troy; (f) the story of Judith; (g) Horatius Cocles at the bridge.

35 Lightbown's interpretation of the Lucretia and Virginia panels is more directly political than personal: he sees direct references to the expulsion of the Medici from Florence in 1494. He therefore disagrees with the attempt to pinpoint Guidantonio Vespucci as the patron, since both Guidantonio and his son Giovanni were close allies of the Medici (R. Lightbown, *Sandro Botticelli*, I, p. 144). Further analysis of the iconography of the story of Lucretia, and discussion of political and private virtues is in G. Walton, 'The Lucretia Panel in the Gardner Museum', in *Essays in Honor of Walter Friedlaender*, ed. Marsyas Institute of Fine Arts, New York University, New York, 1965, pp. 177–86. I. Donaldson, *The Rapes of Lucretia. A Myth and its Transformation*, Clarendon Press, Oxford, 1982, writes that Lucretia's capacity for action is circumscribed by the fact that she is a woman: she can only kill herself, while Brutus is the real agent of the story. Donaldson contrasts the passive Lucretia with the active Judith, one of the few heroines, he writes, who has full control over her actions. Finally, C. L. Baskins, 'Corporeal Authority in the Speaking Picture: The Representation of Lucretia in Tuscan Domestic Painting', in R. Trexler (ed.), *Gender Rhetorics. Postures of Dominance and Submission in History*, Medieval and Renaissance Texts and Studies, Binghamton, New York, 1994, pp. 187–200, explores the literary sources for the story of Lucretia and analyses rather speculatively the meaning of the iconography in panels by the Master of Marradi, Filippino Lippi, Jacopo del Sellaio and Botticelli. She criticises those art historical interpretations which, though valuable, 'proceed within the terms of patriarchal representation; they neglect the construction of meaning and propose an unproblematic referentiality or closure' (p. 198). As 'Renaissance woman is associated with body, image, spectacle, rather than oratory or rhetoric', Baskins sees these pictures as revealing 'the strategic aims of the rhetorical process whereby women's speech is translated into inarticulate "body language"' (p. 188).

PROFILE PORTRAITS IN THE QUATTROCENTO: VIRTUE AND STATUS

❧

A portrait is the representation of a specific likeness, but it is also a constructed image of the self which, through a summary of artistic ideas and experiments about the possibilities of art, helps to create or to redefine social and cultural ideals, and at the same time responds to them. It contains a series of signs which require interpretation.

The portraits of women painted in Italy during the fifteenth century may strike the modern viewer as distant and alien. No eye contact is possible, as almost all of these small female portraits are in profile and therefore there is no illusion of communication through an 'exchange of glances' with the sitter. In the display culture of Renaissance Italy, these portraits signified wealth and the importance of lineage.

Identity and portraiture

A portrait may seem seductively easy to define as the representation of an individual.[1] This definition, however, may lead us to presuppose that the concept of 'individual' is unproblematic, placed outside history, immutable, applicable to all cultures at all times. The changes in portraiture will then be seen simply as changes in style, or responses to changes in function. In the mid-nineteenth century Jacob Burckhardt saw the Renaissance as a time when, in contrast with the Middle Ages, a consciousness of the subjective was developed and, emancipating himself from groups – family, people, corporation, party – man was transformed into an individual: he became an independent personality aware of his own dignity – the 'universal man'. It is perhaps true that, in the contemporary accounts of the protagonists of the history of the Italian Renaissance, we

find characteristics such as self-consciousness, competitiveness and individualism, but modern historians have noted how, during this period, identity still develops within social groups, of which the family is perhaps the most influential. Identity is not just a private matter, but a public one, and this was particularly true during the Renaissance. What we see in a portrait is the public face of an identity, moulded by the ideals of the society to which it belongs. The presentation of this public face was so steeped in the awareness of antiquity, that the first half of the Quattrocento is dominated by two types of portraits derived from this tradition: the profile portrait and the portrait bust. Fifteenth-century collections of Roman and, increasingly, contemporary medals would have been veritable galleries of profile portraits. Indeed, the awareness of the use of portraits in antiquity and the cult of the ancestors was at one with the commemorative function of portraiture. This is outlined by Leon Battista Alberti at the beginning of Book II of *On Painting*: 'Painting contains a divine force which not only makes men present, as friendship is said to do, but moreover makes the dead seem almost alive. Even after many centuries they are recognized with great pleasure and with great admiration for the painter . . . the face of a man who is already dead certainly lives a long life through painting.'[2]

Profile portraits: ideals, lineage and display

The male profile portraits of the fifteenth century painted in Northern Italy and in Florence have been seen as visual parallels to the ideals of different political systems. To the nobility of birth of the members of aristocratic dynasties, whether recent or already well established, is contrasted the nobility of soul and the achievement of virtue of the mercantile elite of the Florentine Republic. At the courts of Ferrara, Rimini, Milan and Urbino profile portraits such as Pisanello's *Leonello d'Este*, c. 1441 (Bergamo, Accademia Carrara), or Piero della Francesca's *Sigismondo Malatesta*, c. 1450 (Paris, Louvre), celebrate the power, the elegance and the wealth of the lord. In Florence the reliance on a formula based on a limited amount of characterisation, on the sobriety of clothing, and on the repetition of motifs such as the *cappuccio* worn by the sitters, seems to dominate the male profile portraits of the first decades of the fifteenth century. Leon Battista Alberti, writing his treatise *On Painting* in the mid-1430s, repeatedly mentioned the portraits he had seen in Florence when he had visited the city with the retinue of Pope Eugenius IV in 1431. He remarked how a figure portrayed from life (*ritratto dalla natura*) succeeds in attracting the attention of the viewer who recognises the features of a 'well known and worthy man'. Anything drawn from nature, Alberti writes, possesses a great force. But what may seem a recipe for an unproblematic 'naturalism'

is immediately qualified: 'for this reason, always take from nature that which you wish to paint, and always choose the most beautiful'. Selection, then, and idealisation, are the means through which the fifteenth-century painter can use the study of nature in the making of a portrait – a figure which is truly noble. The characteristics of these profile portraits have been interpreted as the embodiment of the desire to create the representation of an ideal republican citizen as an individual controlled by reason and guided by moderation. In fifteenth-century Florence the representation of identity was centred around the necessity of documenting and celebrating the ethos of the republican oligarchy through the cult of the family, of the ancestors, and through a demonstration of sobriety and restraint. The stress on the peculiarities of facial features and hairstyles, the details and ornaments of the clothing in the portraits of Northern Italian noblemen present a telling contrast with these Florentine examples.[3]

Women and portraiture

Women, however, had other ideals to follow and a different role to play in society, and it is essential to take this into account when we examine their profile portraits.[4] As we have seen already, the importance of women in society was centred around the family and around their roles as wives and mothers. They were the instruments through which two lineages came together in crucial alliances. The profile portraits from the Northern Italian courts celebrate women who were exceptional because of their aristocratic birth, but whose contribution to society was seen principally in the forging of family connections through marriages, and in the preservation of the family name through the birth of male heirs. In this they were similar to the daughters and wives of the members of the non-aristocratic Florentine oligarchy. The portraits of women in the fifteenth-century courts and in Florence are 'dynastic' portraits, and it is family lineage which is stressed. The majority of these portraits were commissioned posthumously to commemorate the sitter and to remind the viewers – her descendants, relatives and their friends – of her place within the family. Again, as in the case of the male portraits, what is presented to the viewer is an ideal, or rather, an identity shaped by an ideal. It is not so much an individual but a cypher which still possesses her own recognisable facial characteristics, fashioned to convey a specific role. The profile portraits of this period, both male and female, are not studies of the self: the values they convey are social, not personal. For the female portraits, this remains true for almost the whole of the century. The women represented in these portraits, virtuous, beautiful and decorative, continue to turn their profiles to the viewer even when, in male portraits of the second half of the fifteenth century, this

49

pose was abandoned for a different set of conventions which began to explore the relationship between the viewer and the perception of a painted 'self'. The persistence of the profile tradition in female portraits seem to indicate a desire for continuity of ideals, for the stability of those values which these icons of femininity represented and transmitted from generation to generation.

The traits of the ideal female beauty fashionable during the fifteenth century seem to have been developed for the purpose of being represented in a profile portrait: the painters exploit the decorative quality of the long, sinuous line which runs uninterrupted from the domed forehead revealed by the hair scraped tightly back, to the base of the neck. They stress the richness of head jewels, the complexities of the head-dresses and of the twisted and plaited strands of hair, placed well away from the face to expose and emphasise the profile. In spite of the typology of fashionable beauty such as high round forehead and plucked eyebrows, and of the limited use of light and shade to define the structure of cheek and jaw and the solidity of the head, these portraits still succeed in characterising the sitter. This is done through the attention paid to individual peculiarities. While the profile pose does not allow eye contact with the viewer, a certain amount of expression and individuality is conveyed by differences in the shape of the eye and its placing in the eye socket, by the tilt of the head and by the placing of the neck in relation to the shoulder. Different ways of arranging the hair and the use of veils and head-dresses also contribute to provide variety to the silhouette and characterisation to the profile. Within the confines of the conventions and of the pose, variations are also achieved by using slightly different viewpoints for the different parts of the face, even within the same portrait, and by changing the relationship between the upper torso and the picture plane.

It is principally through the elegance of the sitter, her clothes, ornaments and jewellery that these portraits convey their meaning to the viewer. Heraldic devices, often embroidered or woven into the clothes, show the lineage to which the woman belongs – either her own family or her husband's – and the richness of clothes and the jewels speak of her social standing and wealth. Sumptuary laws controlling not only women's clothing, but also men's, as well as pomp and display at funerals and weddings, appear in the legislation of Italian towns from the thirteenth century. During the fifteenth century, these laws seem to be motivated in some instances by economic and social reasons, in others by moral concerns. Lavish expenditure on clothes could threaten the accumulation of wealth and divert the use of money, which could be more usefully invested, towards superfluous 'conspicuous consumption'. The desire to resist this trend seems to be at the root of those laws forbidding large amounts of cloth being used for extravagantly long trains and large sleeves,

as well as costly fabrics, precious embroideries, ornaments such as pearls and precious stones, gold and silver, and expensive furs. It was also felt that the great expense involved in women's clothes would discourage men from marrying. Sumptuary laws not only tried to curb the expenditure on clothes, but highlighted the differences between social ranks by codifying what types of clothes and ornaments could be worn in public, and by allowing the members of the wealthiest families to use more expensive fabrics and jewels. Long lists of exemptions, in fact, favoured the higher ranks of society. The representation in a portrait of certain types of cloth, like damask or cloth of gold, and of precious embroidery and gems, was therefore charged with meaning. Renaissance culture was a 'display culture', where authority, respect, and moral and political influence were gained through the visibility of those signs which spoke of nobility and *magnificenza*, and therefore of virtue.[5] Through their patronage of works of art, their participation in public events such as processions and celebrations, the manner of dress, the manner of speaking and of walking, the members of the political and cultural elite demonstrated to themselves and to others their wealth and their dignity.

Women's clothes and jewels were one of the means through which the family's wealth was made public, and fifteenth-century texts on the family insist on the importance of women's display of finery. This was also one of the few ways available to women to show their status, especially on formal public occasions, since, with the exception of the wives of rulers who took the role of regents when their husbands were absent, they could not take an active part in the political life of the city. Their luxurious clothes spoke of their dignity and pride, and the representation of these clothes in formal portraiture fixes and codifies the signs of their rank.[6] Women often acted against what they saw as the extreme harshness of sumptuary laws: in 1450 Venetian women petitioned the Pope so that they could be exempted from the decree of the Patriarch of Venice and could be allowed to wear jewellery 'for the honour of their families and their own beauty'. In Bologna in 1453 Nicolosa Sanuti wrote an oration against the laws imposed by Cardinal Bessarion. The rules, she stated, were too restrictive, and did not allow women to display the differences in rank: 'ornaments and apparel . . . are our insignia of worth'.[7] Jewels and precious gowns, which were often part of their dowry or were wedding presents from the groom's family, were a visual demonstration of the respect accorded to women. The Florentine Alessandra Macinghi Strozzi, writing to her son Filippo in July 1465, tells him to prepare the jewels for his future bride: 'As she is beautiful, and [the bride] of Filippo Strozzi, she needs beautiful jewels and as you have honour in other things, we must not be lacking in this [matter].'[8]

One of the earliest surviving Italian portraits representing a woman is a

profile by Pisanello (Figure 13). It shows a lady with her hair pulled back from a fashionably high, round forehead, and tied with simple white *bande*. She wears no jewellery, but the sleeve of her *gamurra* (gown) is embroidered with a vase richly decorated with pearls. The device of the vase containing olive branches, with chains attached to the handles, appears also on the reverse of a medal with the profile portrait of Lionello d'Este, the Marquis of Ferrara. This heraldic device has led to the suggestion that the the sitter could be Leonello's wife, Margherita Gonzaga, who died in 1439, four years after their marriage. The juniper (*ginepro*) sprig decorating the bodice, however, seems to indicate that the woman represented here is Lionello's sister, Ginevra. Ginevra d'Este, born in 1419, married Sigismondo Malatesta, lord of Rimini, in 1434, and died six years later. The portrait, painted probably in the 1430s, follows the conventions already outlined, with minimal use of shading to give volume to the head, and with attention given to the peculiarities of her profile, sihouetted against a background of bushes studded with flowers and butterflies. The flowers have been identified as carnations and roses, usually associated with love and marriage, and columbines, a symbol for both the passion of love and the passion of Christ.

In the *Portrait of a Woman with a Man at a Casement* attributed to Filippo Lippi, the profiles of husband and wife are combined within the architectural space of an interior (Figure 14).[9] The painting predates those double profile medals cast later in the century to commemorate husband and wife. It is exceptional because it represents a couple and an interior setting, also for the detailed rendering of the landscape seen through the window in the background, and for its size, which is larger than usual for a portrait of this period. The man's profile, surmounted by a simple red *berretta alla capitanesca*, appears through a window on the left and barely intrudes into the space of the painting, which is dominated by a richly attired woman. Her three-quarter figure is dressed in a red fur-lined overdress (*giornea*) over a dark gown (*cioppa*) with embroidered sleeves. She wears a head-dress which is exceptionally elaborate for a portrait of this period, called *sella alla fiamminga* or *alla francese*, with an embroidered cap edged with pearls and a damask *cappuccio*, also embroidered and decorated with pearls. The head-dress emphasises the high, domed forehead which was seen as a mark of elegance and female beauty during this period. There is a string of pearls around her neck, a brooch (*fermaglio*) on her shoulder and another brooch (*brocchetta da testa*) on her head-dress. Her hands, clasped in front and held below the waist, are decorated with rings. On the cuff of her *giornea*, embroidered in gold and pearls, is a single word, *LEALTA* (loyalty), a declaration of her wifely duty and virtue. This portrait is not an examination of character, nor it is an exploration of the relationship between the two personages represented: rather, it is a commemoration of a

woman, and the importance of lineage is indicated by the presence of an embroidered coat of arms placed on the window-sill under the man's gesturing hand. The coat of arms – *or*, three bends sable – has been linked to the Scolari family, and the couple tentatively identified as Lorenzo di Ranieri Scolari and Angiola di Bernardo Sapiti. They married in 1436, and it was only in 1444 that their first child, Ranieri, was born. It is not known when or for what occasion this portrait was commissioned. While its style has suggested a dating from the mid-1430s to the mid-1440s, portraits to commemorate an engagement or a wedding were most unusual in Florence during the fifteenth century, and there is no evidence at all for portraits commissioned on the occasion of the birth of a child.

The conventions used in these profile portraits also continued to appear after the middle of the century. The *Portrait of a Lady in Yellow* attributed to Alessio Baldovinetti has been stylistically dated from the early 1450s to the mid-1460s (Figure 15). The profile head, with its distinctive nose and the lively loose locks of hair, is rigidly placed against a uniformly blue background. The portrait displays an heraldic device embroidered on the sleeve of the yellow-gold gown (*camora*): three palm leaves and two feathers bound together with a ribbon. Yet again the sleeve has pride of place in the portrait: sleeves were considered as precious objects in their own right and were often valued separately from the gown. They were usually detachable, made with particularly rich fabrics, and often decorated with expensive embroideries. In this portrait, the heraldic device again proclaims the woman's lineage and her place in her husband's family: the three palm leaves tied with two feathers are probably the coat of arms of the family of Angelo Galli, a diplomat and a poet from Urbino. If this is the coat of arms of the Galli family, then the sitter could be Francesca degli Stati, Angelo Galli's second wife. Francesca, also known as Contessa delle Palme, uncovered in 1445 a plot against Count Federico da Montefeltro, the ruler of Urbino, and was then celebrated at the Urbino court for her courage. Unfortunately there is no evidence as to the circumstances of the commission.

Wifely virtues and power: Battista Sforza

All these examples rely on coats of arms or emblems to identify the sitter's role within a family and to give her status. Other means were used to denote status in the profile portrait of Battista Sforza, the Countess of Urbino (Figure 16). It was painted by Piero della Francesca probably during the mid-1470s and it employs the power of words and of allegory to celebrate Battista's qualities and her virtuous behaviour. This panel was painted as a pair with the profile portrait of her husband, the Count of Urbino Federico da Montefeltro, and there is evidence that the two panels were originally hinged together to form a diptych.

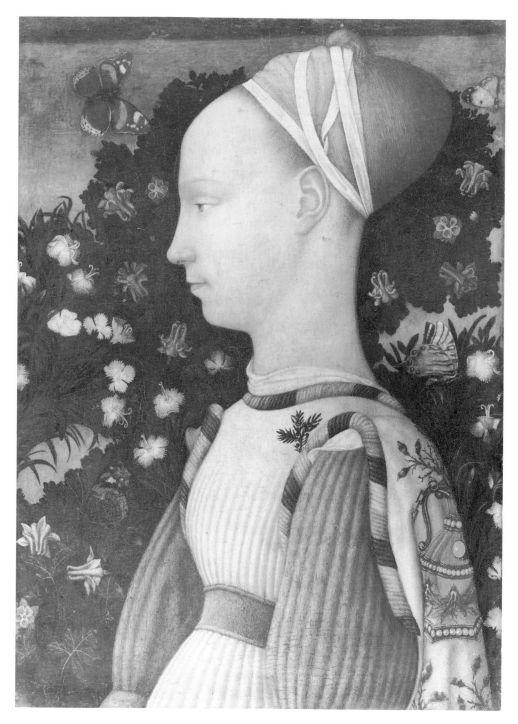

13 Pisanello, *Portrait of an Este Princess*, 1430s

54

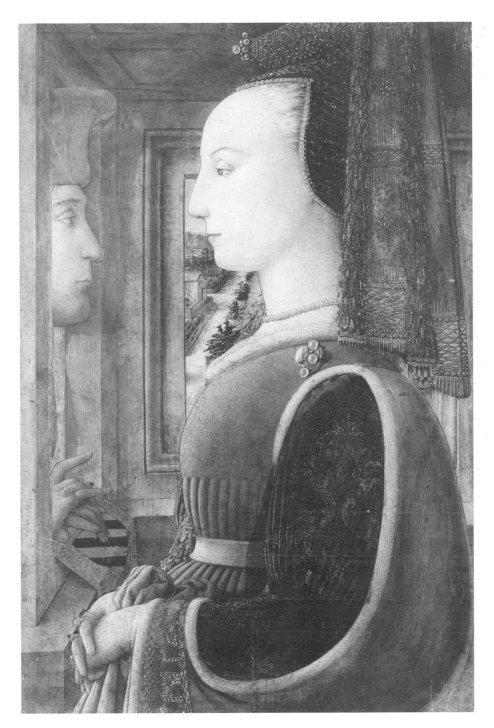

14 Attributed to Filippo Lippi, *Portrait of a Woman with a Man at a Casement*, c. 1435–45

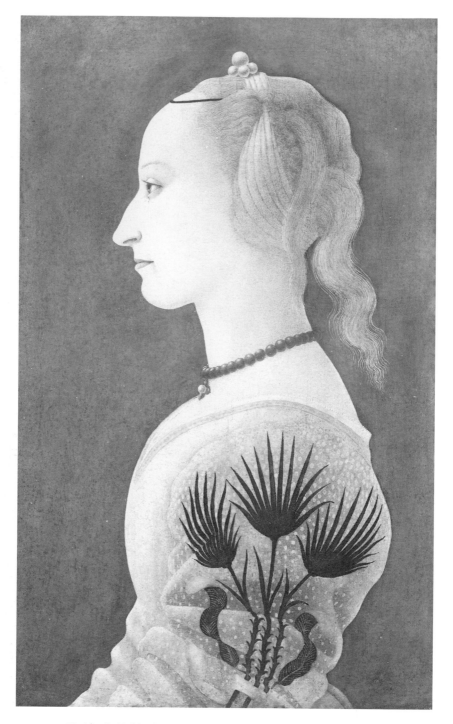

15 Alessio Baldovinetti, *Portrait of a Lady in Yellow*, c. 1445–55

56

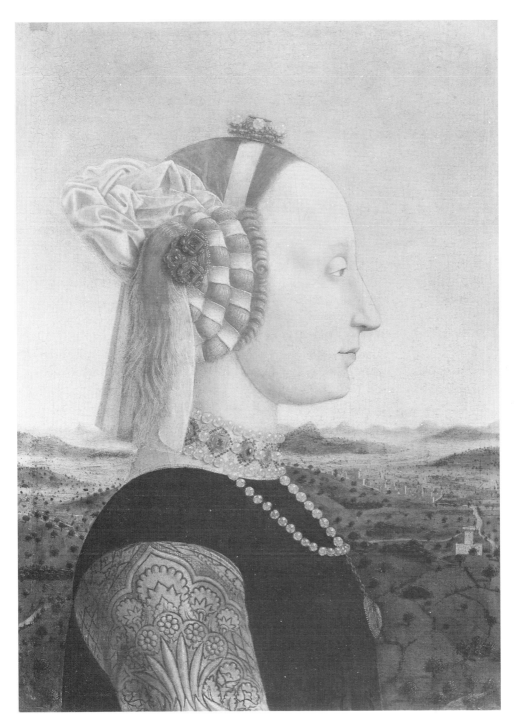

16 Piero della Francesca, *Portrait of Battista Sforza, Countess of Urbino*, mid-1470s

Both profiles are set against extensive landscape backgrounds, a feature introduced in Italy by the portraits of the Flemish painter Hans Memlinc. Battista Sforza married Federico da Montefeltro in 1460, when she was thirteen years old. She died in July 1472 at the age of twenty-five, a few months after the birth of her son, Guidobaldo, the heir to the title and the first boy after six daughters. As a sign of honour and respect, Battista's image is placed on the dexter side, the viewer's left. She was celebrated in life as a pious woman, who acted wisely as a regent in Federico's name during his absences from Urbino.[10]

The aerial perspective of the landscape, and the changing tones of the sky provide an environment of space and light for the profile of the Countess. Her upper torso is dressed in a dark blue *camora* with a gold brocade sleeve and is framed by the darker tones of the landscape, while her head is silhouetted against the light sky. Battista's face is as luminous as the sky itself, the light skin tones a sign of beauty and rank. It is painted with a minimum amount of shading, and yet it conveys a perfectly understood sense of structure. The idealised treatment of the face contrasts with the detailed representation of the hair and of the jewels. Her blond hair is pulled back from the forehead, then coiled and woven with white *bende* at the side of the head, covering the ears. A white cloth, worn at the back of the head and bunched in a series of irregular folds, creates volume and patterns of light and shade which contrast with the smoothness of the face. The different texture of tightly curled or loosely waved hair, the lustre of pearls, the sheen of precious stones, the glitter of gold, the precision of details in the representation of the *brocchette da testa* and of the *bocchetta* around Battista's neck, invite the viewer's perception to concentrate on these visual manifestations of the Countess's high rank.

The reverse of both panels are painted with the *Trionfi* of the Count and Countess, a subject suitable to the celebration of the virtues of a couple, which appears also in the decoration of marriage *cassoni* (Figure 17). Triumphal chariots, placed on rocky ledges set high against panoramic landscape backgrounds, represent, under the form of allegory, the virtues of this aristocratic couple. Battista Sforza sits on her chariot, pulled by two unicorns, the mythical animals which, according to the legend, allow themselves to be captured only by a chaste woman. She is shown dressed in red and gold reading a small book, probably devotional, and accompanied by the allegorical representations of virtues. Charity and Faith sit at the front of the chariot, with Hope hidden behind them, while Chastity and Modesty (*Pudicitia*) stand behind the Countess. While Federico is represented crowned by Fortune, wearing an armour and accompanied by virtues appropriate to a soldier and a ruler – Justice, Prudence, Fortitude and Temperance – Battista is celebrated as the exemplary wife. She is glorified by those virtues which were the necessary requirements

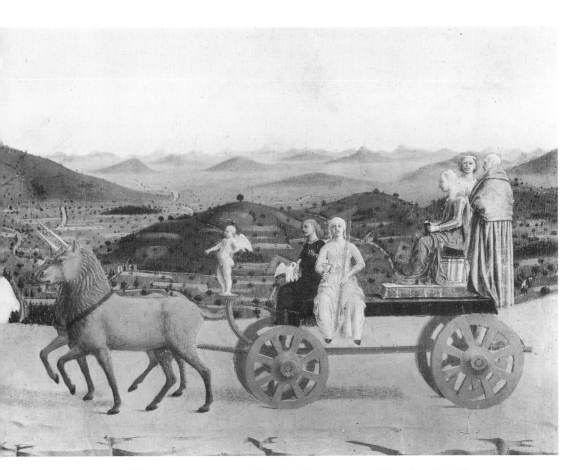

17 Piero della Francesca, *Portrait of Battista Sforza*, reverse, *Triumph*, mid-1470s

of an ideal Renaissance woman, and which are mentioned in all the panegyrics written in her honour, before and after her death. The inscription which accompanies the triumphal scene refers to her in the past tense, indicating that this celebratory portrait must have been painted after her death. These words point to her role as wife of a famous leader and to her modest and restrained behaviour: 'She that kept her modesty in favourable circumstances, flies on the mouths of all men, adorned with the praise of her great husband's exploits.'

The Urbino diptych was clearly the model for another double portrait, attributed to Ercole Roberti, representing Giovanni Bentivoglio and his wife, Ginevra Sforza (Washington, National Gallery of Art, Samuel H. Kress Collection). Giovanni Bentivoglio was lord of Bologna from 1462 to 1508, and his wife Ginevra was the sister of the Countess of Urbino. The couple are shown facing each other, their profiles silhouetted against dark curtains which are

59

drawn back to reveal a view of Bologna. In another pair of portraits attributed to Bonifacio Bembo, which have been dated *c.* 1460 and which therefore precede the Urbino diptych, the painter has placed the profiles of Francesco Sforza, Duke of Milan from 1450 to 1466, and of his wife Bianca Maria Visconti against plain blue backgrounds, which emphasise the physical peculiarities and characteristics of the sitters (New York, Metropolitan Museum). Both sitters are shown sumptuously dressed. Bianca Maria, the illegitimate daughter of the last Visconti, Filippo Maria, married Francesco in 1432. Her unmistakeable profile appears again, together with other male and female members of the Sforza dynasty, in a series of frescoed lunettes, now in the Pinacoteca del Castello Sforzesco, Milan, which used to decorate one of the ground floor rooms of the palace belonging to Giacomotto della Tela in Milan.

All these portraits were conceived for the semi-private setting of an aristocratic palace, or of a wealthy merchant's town house. Whether hanging on a wall and openly displayed, or, as was more usual, covered by a shutter or by a veil, or kept in a chest and protected by a case or a bag to be brought out for special occasions, these relatively small portraits were painted to be seen only by a selected group of viewers – members of the family, their friends, their guests.

Female donor portraits in religious paintings

Portraits of women also appear in another context, where the display is staged for a different type of function and addresses a wider public. Donor portraits flanking religious images speak of public demonstrations of piety and religious feeling, of the preoccupation with the salvation of the soul and with eternal life, of the desire to offer sacred images for the glorification of God. The donor portrait takes the place of the sitter in an act of continuous devotion. In the altarpieces commissioned by members of the Northern Italian courts, the donors often appear in all the magnificence of their sumptuous clothes and jewels. Examples of this type of portraiture are the images of Bernarda di Bresse and Giovanna and Bianca Paleologo in a fresco in the chapel dedicated to St Margaret at the Santuario in Crea (*c.* 1480), the unknown donor in the altarpiece by Macrino d'Alba (Turin, Museo Civico d'Arte Antica), and the representation of Violante Bentivoglio, wife of Pandolfo Malatesta, in the altarpiece dedicated to St Vincenzo Ferrer (Rimini, Museo Civico) painted *c.* 1493–97 by the workshop of Domenico Ghirlandaio. All these images underline the wealth and elegance of these aristocratic patrons. The painters have given great attention to fabrics and to the fashionable details of the gowns, of the head-dresses and jewels. The best example of this type of donor portrait is the *Pala Sforzesca*, perhaps the most important amongst the Sforza commissions (Figure 18). This

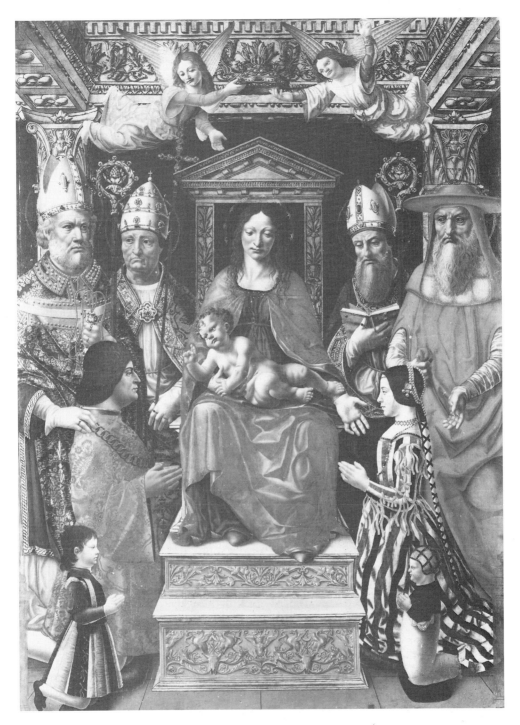

18 Master of the Pala Sforzesca, *Pala Sforzesca*, *c.* 1495

altarpiece, painted with clear dynastic intentions for the church of St Ambrogio in Nemo in Milan *c.* 1495, was a crucial piece of political propaganda for Ludovico who, having acted as the regent of Milan since 1479, had taken the title of Duke of Milan in October 1494, after the death of the legitimate ruler, Ludovico's nephew Gian Galeazzo Sforza. In fact, contemporary historians suspected that Gian Galeazzo had been poisoned by his own uncle. In this strictly symmetrical *sacra conversazione* Ludovico is shown kneeling in profile, with the protective hand of St Ambrose, the patron saint of Milan, on his shoulder. Together with St Ambrose, the other Doctors of the Church, St Augustine, St Gregory and St Jerome, stand beside the throne of the Virgin. At the centre of the composition, the Virgin, holding the Child, stretches her hand towards Ludovico's wife, Beatrice d'Este, who kneels, also in profile, facing her husband. The two sons of the new Duke and Duchess are also shown in profile with their parents. Massimiliano, born in January 1493, is next to his father, and Francesco, born in February 1495 and therefore just a few months old, kneels in his swaddling clothes next to Beatrice. The altarpiece, shimmering with the gold of the architectural details, the brocade and gems of the vestments of the saints and of the garments of the donors, is a good example of the luxurious taste of the Sforza court, the most splendid in late Quattrocento Italy. Beatrice's yellow-gold satin *camora* with blue and black velvet *liste* (stripes), the bows and the fluttering ribbons which tie her sleeves, the jewels around her neck, the brooch and the large pearls decorating her head-dress, and her hair tied back in a long plait (*coazzone*) according to the fashion of the Milanese court, speak of the Sforza's concern for the importance the role of clothes and jewellery in the display of power and elegance. Beatrice d'Este, described by her contemporaries as 'the inventor of new fashions' (*novarum vestiarum inventrix*) and as a 'woman of the greatest luxury' (*donna di grandissima pompa*), rivalled and surpassed her sister Isabella at the court of Mantua in the number and splendour of her clothes. The letters between the two sisters provide first-hand evidence of the importance of clothes at court; the detailed discussions of their gowns, of the embroideries made for them, of the artisans involved in designing and executing these precious objects, and their descriptions of the clothes worn by visitors at their courts, show both the regard they had for these important signs of status, and the pleasure these two women experienced in their patronage of this art form.

Even at court, however, luxury was sometimes considered inappropriate. In the altarpiece dedicated to the Beata Osanna Andreasi by Francesco Bonsignori, completed in 1519, the donor portrait of Isabella d'Este, the Marchioness of Mantua, is shown kneeling in strict profile, dressed in the sombre and restrained garb of a widow, in a black mantle and white head cloth, echoing

the habit of the Dominican nuns who kneel on the opposite side (Figure 19). This image, believed to have been painted for the convent of S. Vincenzo in Mantua, was one of the Gonzaga commissions in honour of the Beata Osanna, a Dominican tertiary close to the milieu of the Gonzaga court, and demonstrates Isabella's particular devotion to her. In this altarpiece dedicated to the saintly life of the Beata Osanna and to her visions Isabella, dressed according to her state as a widow, scorns the display of wordly finery.

In republican Florence, an overt showing of luxury was not deemed to be appropriate for these kneeling profile figures of donors, and almost all women donors appear in the conventional attitudes suggesting prayer and humility. Their heads are covered with a white cloth, and they wear the restrained, dark, but still expensive garments suitable to their mature age. These conventions rule the representations of Florentine female donors throughout the fifteenth century – from the image of the wife of the Standard-bearer of Justice, Lorenzo Lenzi, who, wrapped in a dark mantle, witnesses with her husband the vision of the crucified Christ in Masaccio's *Trinity* in Santa Maria Novella (*c.* 1425), close to their family tomb, to Nanna Capponi, presented to the Virgin Mary by St Catherine of Alexandria in the altarpiece commissioned by her husband Tanai de' Nerli from Filippino Lippi for their family chapel in Santo Spirito (*c.* 1494).

In their family chapel in Santa Trinita, decorated with frescoes by Ghirlandaio and completed by the end of 1485, the Florentine banker Francesco Sassetti and his wife Nera Corsi are represented according to the donor portrait conventions, in profile, kneeling, hands joined in prayer, against a simulated marble background (Figure 20).[11] Their images flank the altarpiece which represents the *Adoration of the Shepherds*, and join the kneeling Virgin in the worship of Christ. Their portraits form a triptych with the central image, thus indicating, in their funerary chapel, their hope for the salvation of their souls through their presence at the birth of Christ. But the individual does not exist in isolation: the decoration of the chapel embodies their prayers for the salvation of the whole family. The identity of the Sassetti is affirmed through the repeated use of their *impresa*, a sling with stones, which appears in their coat of arms and disguised in a number of small reliefs on and around their sarcophagi. Francesco and Nera's lineage is displayed for posterity by the portraits of all their ten sons and daughters, who are painted as witnesses to some of the episodes from the life of Francesco Sassetti's patron saint, St Francis of Assisi. Above Nera Corsi's kneeling donor portrait, her five daughters are shown in a group of bystanders present at the *Miracle of the Roman Notary's Son* (Figure 21). The miracle is represented as taking place in the square in front of the church of Santa Trinita and of the Sassetti palace, an

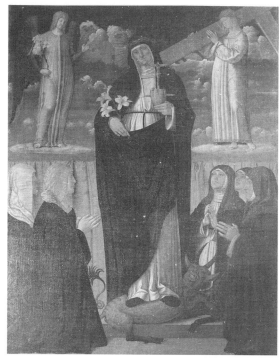

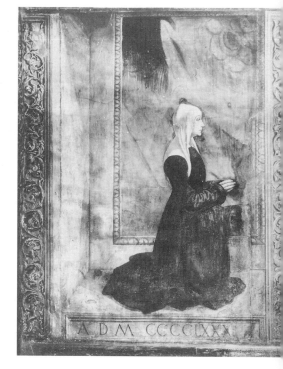

19 Francesco Bonsignori, *Altarpiece of the Blessed Osanna Andreasi, c. 1519*

20 Domenico Ghirlandaio, *Portrait of Nera Corsi, c. 1485*

urban context suitable to the Sassetti women. Francesco, with four of his five sons and with his patron and employer Lorenzo the Magnificent, appears in the story of the *Confirmation of the Rule*, set against the background of Piazza della Signoria, the political centre of Florence.

Civic portraiture: the Tornabuoni family

Alberti mentions in *On Painting* the early fifteenth-century custom of introducing portraits of well-known and worthy citizens in religious narratives. This tradition continues in the family patronage of public religious commissions of the late fifteenth century. It also gives scope for female portraits to be included in a very important genre, that of collective civic portraiture. Perhaps the best example of a religious commission which stresses the significance of public display in such a context, while at the same time illustrating the difference of men's and women's ideal roles and behaviour in late fifteenth-century Florentine society, is provided by another series of frescoes by Ghirlandaio and his workshop. The decoration of the apse (*cappella maggiore*) of the Dominican church

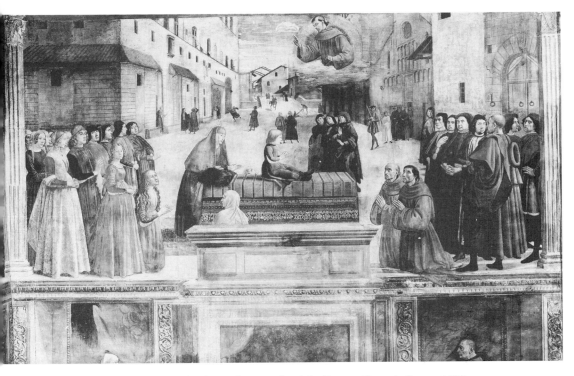

21 Domenico Ghirlandaio, *The Miracle of the Roman Notary's Son, c.* 1485

of Santa Maria Novella in Florence, commissioned by Giovanni Tornabuoni in 1485, was carried out between 1486 and 1490.[12] This was the largest fresco commission in Florence in the last decades of the fifteenth century, for one of the most important churches of the city. Giovanni Tornabuoni was one of the wealthiest and most influential men in Florence, tied to the Medici by links forged by marriage, business and political interests. His sister Lucrezia was the wife of Piero de Medici and the mother of Lorenzo the Magnificent. In the same year as his sister's marriage, 1444, Giovanni had first entered the Medici bank. In 1465 he became director and partner of the Medici bank in Rome, and eventually treasurer and financial adviser to Pope Sixtus IV. On the end wall of their chapel in Santa Maria Novella, Giovanni appears with his wife Francesca Pitti. Both are simply dressed and are shown kneeling in prayer: Giovanni in three-quarter pose, hands crossed over his chest, his head bare, in a pale red robe. Francesca, who had died in childbirth in Rome in 1477 and had been buried in Santa Maria sopra Minerva, is shown in profile, hands joined, her clothing almost identical to Nera Corsi's – a black gown without ornaments, with the veil worn by married women covering her head.[13]

Two fresco cycles decorate the side walls of the apse. They illustrate the lives of the Virgin Mary on the left, and of Giovanni's patron saint and patron saint of Florence, St John the Baptist, on the right. The portraits of the members of the Tornabuoni family and of relatives, friends, allies and clients of the Medici and the Tornabuoni are included as spectators to the holy stories. The frescoes proclaim the Christian and civic virtues of the patron, and, as the contract states, they were commissioned by Giovanni 'as an act of piety and love of God, to the exaltation of his house and family and the enhancement of the said church and chapel'. On the lower register of the right wall, in the fresco illustrating the *Annunciation to Zachariah*, twenty-one male portraits are grouped around the miraculous event, in front of an *all'antica* architectural setting (Figure 22). Giovanni Tornabuoni stands in the most important place, at the right of the angel, with his brother Leonardo and members of the other families belonging to his own *consorteria*, the Tornaquinci. An inscription on the arch at the right proclaims that in the year 1490 the city of Florence, made beautiful by works of art and architecture, enjoyed wealth, health and peace. Cristoforo Landino, Agnolo Poliziano and Marsilio Ficino, the intellectual protagonists of Medicean Florence, are included among the portraits as the living proofs of Florence's cultural glory and superiority. The men responsible for this idealised view of the city stand, some in profile, some in three-quarter, with their faces turning towards each other or towards the viewer, as witnesses to a scene which gives assurance to the miraculous continuation of the power of their family. They gesture gravely to each other, and are represented by the painter according to the rules of *decorum* appropriate to their rank. Their faces are fully characterised. They wear a *cappuccio* or a *berretta* on their heads, and are wrapped in plain but expensive *cremisi*, *vermiglio* and *pavonazzo* robes and heavy cloaks which are like the uniforms of their public offices and therefore signal their place in Florentine society. Giovanni Tornabuoni, who had been elected Standard-bearer of Justice for the *quartiere* (district) of St Maria Novella in 1482, is dressed entirely in red. On the opposite wall, in the first narrative of the Life of the Virgin, Giovanni's son Lorenzo stands as a witness to Joachim being cast out of the Temple.

In the story adjoining the *Annunciation to Zachariah*, the *Visitation*, it is appropriately a female member of the Tornabuoni family who has been chosen to witness the meeting between the Virgin Mary and St Elizabeth, the moment when the two holy women rejoice about each other's pregnancy (Figure 23).[14] On the right, a young woman, represented in strict profile, advances, accompanied by two other women, one young, one old, whose heads are turned slightly towards the viewer. She has been identified as Giovanna degli Albizzi, the wife of Giovanni Tornabuoni's only son, Lorenzo. The three women, grave

and formal, stand against the background of a cityscape, their arms folded, their hands clasped at the waist, Giovanna holding a handkerchief. Her gold brocade *giornea* is woven with heraldic devices – the Tornabuoni diamond together with doves and sunbursts. An 'L' for Lorenzo is embroidered on her shoulder. Her small head, with her blond hair tied in a knot at the back and left loose in curls on her cheeks, is supported by a long columnar neck (Figure 24). Her stiff garments fall heavily to the ground as she walks, looking decorously in front of her, in the measured manner appropriate to her gender and status. Her image is at the same time the representation of an individual and of an ideal of beauty and *decorum*. It establishes her as an icon of female perfection. Lorenzo the Magnificent described this ideal when writing about another famous young woman in Florence, Simonetta Cattaneo Vespucci, in his *Commento ... Sopra Alcuni dei Suoi Sonetti.* The image of beauty he conjures with his words belongs to a convention which is derived from Dante's description of Beatrice in the *Vita Nuova*, rather than to an individual, and could be easily applied also to Giovanna degli Albizzi:

> Her beauty was wonderful ... she was of an attractive and ideal height; the tone of her skin, white but not pale, fresh but not glowing; her demeanour was grave but not proud, sweet and pleasing, without frivolity or fear. Her eyes were lively and her gaze restrained, without trace of pride or meanness; her body was so well proportioned, that among other women she appeared dignified ... in walking and in dancing ... and in all her movements she was elegant and attractive; her hands were the most beautiful that Nature could create. She dressed in those fashions which suited a noble and gentle lady ...[15]

Giovanna degli Albizzi had married Lorenzo Tornabuoni in 1486 when she was not yet eighteen years old – a marriage arranged through the mediation of Lorenzo's cousin, Lorenzo the Magnificent. The marriage had been a sumptuous occasion, marking the union of two among the most important and oldest Florentine families which in the first half of the century had been political enemies. A cortège of one hundred well-born girls and fifteen young men had accompanied Giovanna to the cathedral of Florence, Santa Maria del Fiore, where the wedding ring was given to her in the presence of the Spanish ambassador to the Pope. The festivities included banquets and dances organised on wooden platforms, specially built for the occasion next to the Tornabuoni and the Albizzi palaces. In October 1487, Giovanna had given birth to Giovanni Tornabuoni's first grandson, who had been also called Giovanni. By the time Ghirlandaio painted her portrait in the *Visitation*, she was already dead. She died one year after the birth of her son, during a new pregnancy, and was buried in S. Maria Novella.

Giovanna's posthumous portrait in this cycle confirms to posterity the

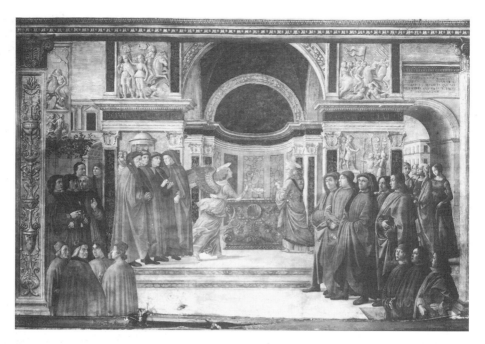

22 Domenico Ghirlandaio, *Annunciation to Zachariah*, 1486–90

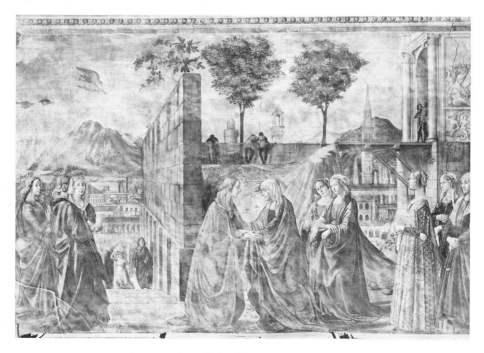

23 Domenico Ghirlandaio, *Visitation*, 1486–90

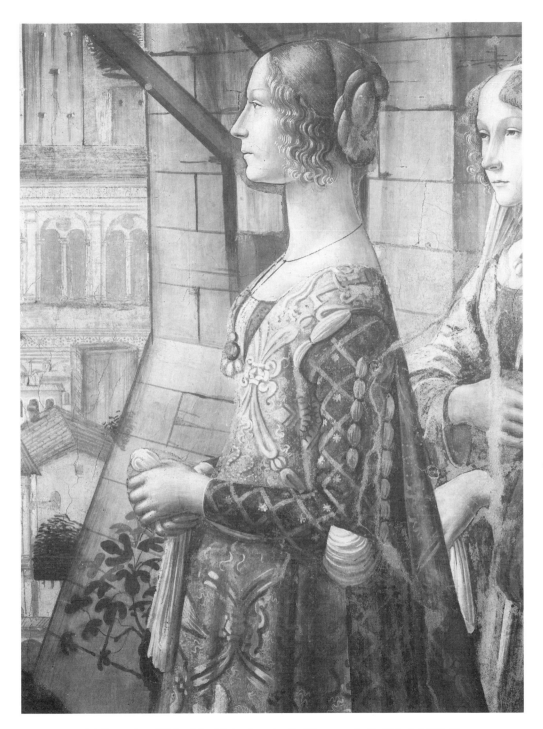

24 Domenico Ghirlandaio, *Visitation*, detail: *Giovanna degli Albizzi*, 1486–90

importance of her place amongst the Tornabuoni, as she was the means through which the family name was transmitted to a new generation. The hieratic character of her image is stressed, through the repetition of pose and garments, by another portrait painted in the story facing the *Visitation* fresco. On the lower register of the opposite wall, as a witness to the *Birth of the Virgin Mary* which takes place in a contemporary Florentine bedroom, another young Tornabuoni woman, Lodovica, the only daughter of the patron, stands in front of a group of companions (Figure 25). Her pose is almost identical to Giovanna degli Albizzi's and she wears a *giornea* of the same fabric and colour, decorated with the same heraldic motifs. In 1490 Lodovica was only fourteen, and she appears to the viewer as the ideal virginal young girl, modest and beautiful. A younger version of her characteristic profile can be seen in a medal, almost certainly cast in 1486. On the reverse of the medal, a unicorn, symbol of virginity, kneels in front of a dove perched on a tree – and a dove on a branch

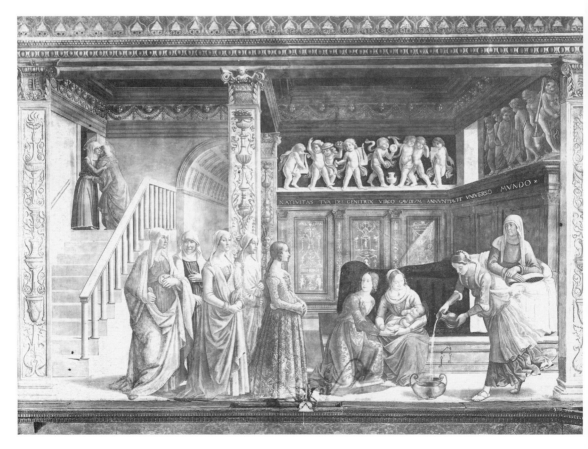

25 Domenico Ghirlandaio, *Birth of the Virgin*, 1486–90

is one of the motifs woven into her gold brocade gown.[16] In 1491 Ludovica married Alessandro di Francesco Nasi, whose portrait is painted next to that of her brother Lorenzo in the Joachim story.

A third, unidentified, young woman stands almost at the centre of another story, the *Birth of St John the Baptist*, on the second register of the right wall (Figure 26). This time her portrait is not in the usual profile pose: she turns her head and her gaze towards the viewer, holding a handkerchief in her clasped hands, and wearing a pink *giornea* decorated with small gold motifs over a creamy *cioppa* embroidered with flowers and pomegranates. An ink study for the clothing of this figure in the British Museum shows the importance given to the accurate rendering of the details of her *giornea*, with its side openings cut into decorative leaf shapes and the sleeves of the *cioppa* slashed to show the thin fabric of the *camicia*. Behind this richly dressed young woman is a portrait of an older woman, plainly dressed, which has been identified as

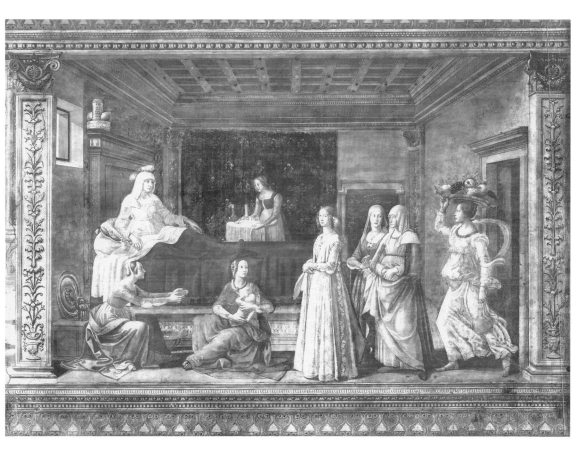

26 Domenico Ghirlandaio, *Birth of St John the Baptist*, 1486–90

the patron's sister, Lucrezia Tornabuoni.[17] According to fifteenth-century manuals on behaviour and manners, clothing had to be appropriate not only to social rank and income, but also to age. Lucrezia Tornabuoni, who belonged by marriage to the most powerful Florentine family, the Medici, plays here only a supporting role, with her simple gown almost completely hidden by a cloak and a white cloth which covers her head.[18]

The three young women, two shown in profile, one in three-quarter pose, attract the attention of the viewer because of their beauty and the richness of their gowns. They occupy a privileged place in the three stories in which they appear and which, appropriately, deal with pregnancy and birth. The way they have been represented, with their identical stance, the heavy garments which completely hide their bodies, their facial features idealised according to a similar type of beauty, and the absence of any gesture, contrasts with the simpler clothing, the more varied physical characteristics, ages and countenances of their companions. But there is an even more marked contrast, in these frescoes, between the representations of those women who stand as spectators, and which are recognisable as portraits, and the idealised figures who take part in the sacred narratives. The latter show the use of a variety of gestures and facial expressions to communicate emotion and meaning appropriate to their role in the narrative. In the *Birth of the Virgin Mary* the woman who sits holding the baby smiles expressively while another, pouring water from a pitcher, steps forward with her clothes fluttering behind her, revealing her ankles. In the *Birth of St John the Baptist* an attendant rushes through a door on the right, holding a tray of fruit over her head. Her light clothes reveal her figure, while a wisp of hair and a veil indicate the speed of her movement. The difference could not be more obvious: the slow and measured step of the 'real' women, and the absence of any gesture show the formality of an ideal mode of behaviour and a consciousness of social status, which is reinforced by the movements and the appearance of the fictitious characters. The images of the three young women are singled out by their place in the composition, by their appearance and behaviour. Beauty, demeanour and the wealth of their clothes mark them as belonging to a privileged group.[19]

These civic portraits speak of the different ideal roles for men and women. *Gravitas* and *decorum* are indispensable to both, but the similarities end there. The male portraits identify for the viewer the protagonists of the political organisation of the city, presented as the makers of social order and prosperity. The Florentine male elite proclaims the power which derives from family lineage and alliances, and their individualised features placed above the austere uniformity of their garments speak of an ideal world of civic virtue. The women, brides or brides-to-be, essential to their relatives' plans for the continuation of

lineage, dressed in their opulent, expensive clothes, their necks decorated with jewels, their virtues signified by their measured step and by their folded hands, operate in a world concerned with marriage and childbirth. In the public space of the church of Santa Maria Novella, the frescoes commissioned by Giovanni Tornabuoni show how the representations of men and women follow different conventions which are regulated in part by social realities and in part by shared ideals.

Images of ideal beauty

In the last quarter of the fifteenth century a group of profile images of women were produced, which do not represent specific sitters but types of ideal beauty. It seems that private collections of paintings representing beautiful women began to appear from the mid-1470s. These paintings were probably, in part, seen as a conscious reference to antiquity and in part as a visual equivalent of that strand of poetry, celebrating the poet's relationship to an ideal woman, which has its roots in the *dolce stil nuovo*, and which was fashionable in the second half of the fifteenth century. Alberti had reported the famous story of Zeuxis, who had chosen the most beautiful feature from each of the most beautiful women of the island of Croton, so that he could adequately represent the beauty of Helen of Troy. This story, together with a literary tradition based on Petrarch's sonnets about the portrait of his beloved, Laura, by Simone Martini, offered a convenient *topos* for patrons and a challenge for painters. The circle around Lorenzo the Magnificent provided a fertile ground for the development of these strands through the philosophical writings of the neoplatonist Marsilio Ficino, the poems of Luigi Pulci, of Agnolo Poliziano and of Lorenzo himself. In these writings, the beauty of women is glorified as the physical evidence of their spiritual perfection, since the body is the mirror of the soul. The paintings representing 'invented', ideal beautiful women differ from portraits of actual individuals, however idealised, in that the details of clothing and hairstyles show elements which are purely decorative and fanciful. There is no sense, in these heads, of the peculiarities of an individual, which can be observed, for instance, in the profile portrait of an unidentified woman attributed to Botticelli, in the Galleria Palatina in Florence. The idealisation of the features of all these 'imagined' profiles is carried out to a much greater extent than in the portraits examined above. To this group belong a number of paintings now attributed to the workshop of Botticelli, among which the profile once believed to represent Simonetta Cattaneo, the wife of Marco Vespucci, who died in 1475 at the age of 22 (Figure 27). She was famous in Florence

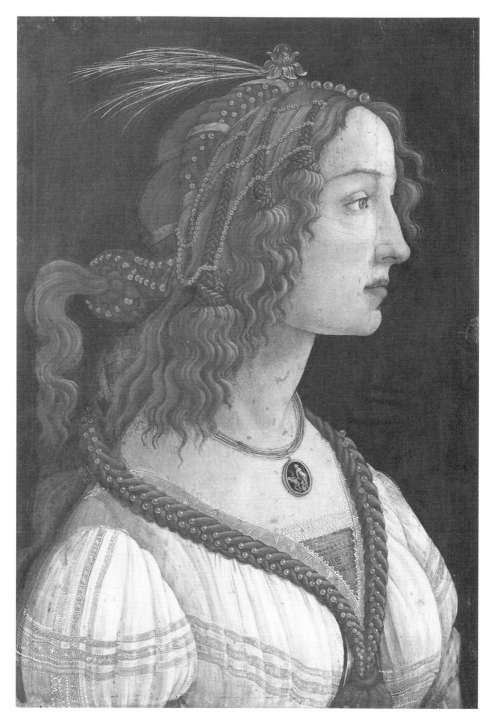

27 Botticelli, *Portrait of a Lady*, c. 1478–90

for being the idealised heroine of both Giuliano de Medici and of his brother Lorenzo the Magnificent. Giuliano's platonic love for her was celebrated in Poliziano's *Stanze*, through the love of the two protagonists, Iulo and the nymph Simonetta. Her death was the occasion for poetical compositions by a number of poets and *letterati*, among which the most famous are four sonnets by Lorenzo the Magnificent. The identification of this profile with Simonetta was based on Vasari's description of a painting by Botticelli: 'in the Guardaroba of the Duke Cosimo are by his [Botticelli's] hand two very beautiful heads of women, one of which, it is said, was the woman loved by Giuliano de Medici'. The other basis for indentification was the jewel around her neck which was believed to be an antique cornelian representing Apollo and Marsyas, listed in the Medici inventory at the death of Lorenzo the Magnificent in 1492. The figures on the pendant seem in fact to be a woman triumphing over a bound satyr.[20] This head and other profiles by Botticelli, one of which is in Berlin and one in the National Gallery in London, all seem to be variations of a type of beauty based on the ideal features of Botticelli's goddesses, nymphs and Madonnas. In the Frankfurt painting, the hair is treated with a richness of ornament and a level of fantasy which go beyond the usual late fifteenth-century representation of hair in portraits of actual individuals: the hair is knotted at the back and tied in a number of tight plaits, with tassels of loose hair curling around the face. Pearls, feathers and a *brocchetta da testa* complete the decoration of her hair, while two long plaits studded with pearls follow the neckline of the light, embroidered garment and meet at the centre in a manner similar to the decoration on the dress of Venus in the *Mars and Venus* by Botticelli (London, National Gallery).[21]

Simonetta Vespucci's name appears in an inscription which purports to identify a female figure painted by Piero di Cosimo *c.* 1485–90 (Figure 28). It has been proved, however, that this inscription was added to the painting at a later date. The head is represented in profile and set against a stormy sky, the lightness of the skin contrasting against the dark clouds. The torso is slightly twisted towards the picture plane, so that both her naked breasts are offered to the viewer's gaze. They are also framed by a striped shawl which is wrapped around her shoulders. Her hair is twisted, plaited and decorated with pearls. Around her neck a snake is intertwined with a gold necklace. The erotic charge of this image, its exploration of sensuality in the juxtaposition of naked flesh and the fabric of the shawl and in the use of jewels and hair, goes well beyond the limits of the descriptions of beauty in those contemporary poems modelled on Petrarch. The presence of the snake alerts the viewer that this representation of beauty could be an *exemplum* of the dangers of lust: this may in fact be that 'very beautiful head of Cleopatra with an asp around her

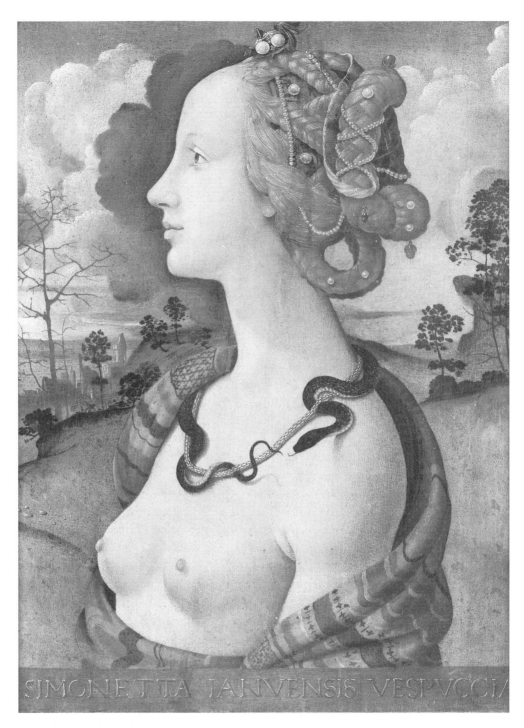

28 Piero di Cosimo, *Portrait of a Lady, c.* 1485–90

76

neck' which Vasari saw in the house of Francesco da Sangallo. Cleopatra was seen as an example of lust (*luxuria*), and images like this depended on their seductive attractions for their effectiveness as moral warnings.[22] Paintings such as Piero di Cosimo's nude bust and Botticelli's ideal heads show how the typology of the profile portrait could be adapted to include images of women which had different functions from actual portraits, and which did not represent specific individuals. They also show that the functions of paintings to be found in domestic interiors were becoming more varied, and that the distinctions between the different genres could be blurred. These are paintings which, under the conventions of portraiture, can be used as visual equivalent of poetry. They would have brought to the mind of the viewers descriptions of lost collections of antiquity, signalling by association the patron's culture and taste. They would have been used as moral warnings veiled under the contemplation of beauty. These paintings show that the significance of feminine beauty and its appeal for the viewer could be separated from the commemoration of an individual and of her virtues.

The end of a tradition

The last decades of the fifteenth century also saw the growing constraints of the tradition of female profile portraits. In male portraiture, the three-quarter pose allowed the painter to create the illusion of an exchange of glances between the sitter and the viewer, and to explore the possibility of conveying a mood, a sense of 'personality'. This, obviously, was not possible with a profile pose.[23]

In one of the most remarkable examples of late fifteenth-century portraiture, Giovanna degli Albizzi's profile appears in a panel painting by Ghirlandaio which used to hang, surrounded by a gold frame, in a room in the Tornabuoni palace (Figure 29). Giovanna is shown in the same pose, with an identical hairstyle and gold brocade gown as in the *Visitation* fresco in Santa Maria Novella, but in this panel the image is cut just below the waist. Her head is silhouetted against the dark background of a niche or a cupboard, in which are placed a jewel, a book, a string of coral beads and a *cartellino* with an inscription and a date. The objects are not just a decorative 'still life', but add meaning to the portrait: coral was meant to bring good luck, and the book, probably devotional, signifies learning and virtue. The date, 1488, probably refers to the year of Giovanna's death, rather than to the year when the portrait was painted. The inscription on the *cartellino*, adapted from an epigram by Martial, alludes to the function of portrait painting and to the skill of the artist: ARS UTINAM MORES ANIMUMQUE EFFINGERE POSSES PULCHRIOR

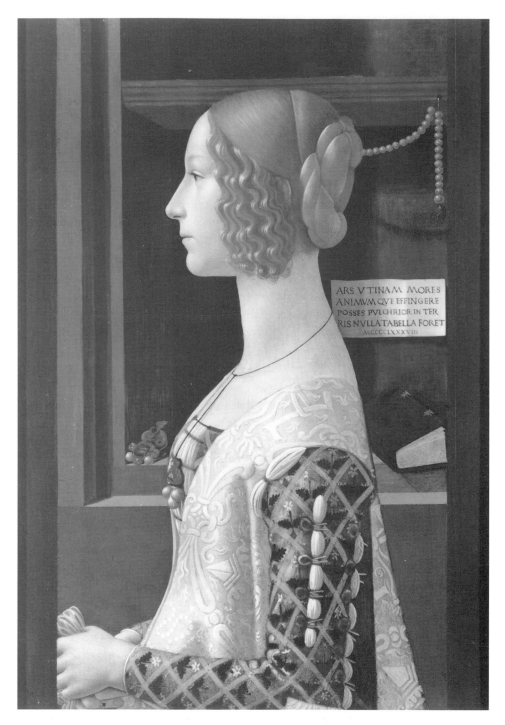

29 Domenico Ghirlandaio, *Portrait of Giovanna degli Albizzi, c.* 1488

IN TERRIS NULLA TABELLA FORET (Art, would that you could represent character [*mores*] and mind [*animum*]. There would be no more beautiful painting on earth). This traditional invocation to the power of painting, with its reference to the painter's desire to convey more than mere physical appearance, is a recurrent *topos* in Renaissance writing on art, which has its roots in ancient Greek epigrammatic literature. In the context of late fifteenth-century painting, this comment on a profile portrait is particularly interesting. Painted at a time when male portraiture had almost completely abandoned the convention of the profile pose, Giovanna degli Albizzi's portrait by Ghirlandaio seems to highlight the contradictions of a convention which had reached its limits.[24] Giovanna's clothing and the objects surrounding her have been reproduced with a particular attention to details: the pages of the book which is not quite closed, the cord tying together the coral beads, the sheen of the pearls, the minute details of the ties, ribbons and embroidered flowers of the sleeve, they all speak of a life which, however, is absent from the iconic image of Giovanna. The modelling of her face is perhaps more naturalistic than in the other profile portraits discussed above, but the *animus* invoked in the inscription eludes the viewer. Alberti had written that the 'movements of the soul' of the painted figure, 'are made known by movements of the body'. Movement and the expression of a state of mind are the cause of the viewer's emotional response to the painted image. However, Alberti's concern was the creation of the *istoria*, the narrative, and portraiture responds to different conventions and artistic problems. The conventions of the profile pose, which lasted so long in the painting of female portraits, were more suitable to convey the *mores*, the constructed behaviour, the virtuous conduct of these idealised women, together with the physical characteristics of a type of beauty, rather than the *animus*, the existence of a mind.

Notes

1 A very useful, brief account of the domestic context in which portraits were seen in Renaissance Florence can be found in M. Wackernagel, *The World of the Florentine Renaissance Artist*, Princeton University Press, Princeton, NJ, 1981 (1st ed. Leipzig, 1938), pp. 169–72. The most complete discussion of Renaissance portraiture is still J. Pope-Hennessy's *The Portrait in the Renaissance*, Phaidon, New York, 1966. The book, originally a series of lectures, includes Northern European as well as Italian examples and organises the vast amount of material examined in a series of thematic chapters. These discuss the relationship between culture and the representation of the individual, problems related to artists' explorations of the genre, specific functions and types of portraits. In the preface, Pope-Hennessy states that 'portraiture is the depiction of the individual in his own character'. The nature of this statement haunts the approach taken in the book – that the relationship between the sitter, the painter and the image produced is somehow transparent. The theoretical problems which

Pope-Hennessy's treatment sidesteps are outlined by C. Gilbert in his review, 'The Renaissance Portrait', *Burlington Magazine*, 110, 1968, pp. 278–85.

2 L. B. Alberti, *On Painting*, trans. J. R. Spencer, Yale University Press, New Haven and London, 1966, p. 63. Recent archival research supports Alberti's emphasis on the importance of posthumous portraits. Discussing the commissioning of portraits in fifteenth-century Florence, J. K. Lydecker writes: 'It is not impossible that portraits were connected with weddings in some way – but no documentary or visual evidence is at hand to prove that Florentines ordered portraits when they married. Where private books surveyed for this study mention portraits, the relevant context is often that of the death of a family member.': 'The Domestic Setting of the Arts in Renaissance Florence', unpublished doctoral dissertation, Johns Hopkins University, 1987, p. 159. See also J. Schuyler, *Florentine Busts: Sculpted Portraiture in the Fifteenth Century*, Garland, New York, 1976.

3 Male profile portraits are examined in J. Lipman, 'The Florentine Portrait in the Quattrocento', *The Art Bulletin*, 18, 1936, pp. 54–102. R. Hatfield's close scrutiny of some Florentine male profile portraits in 'Five Early Renaissance Portraits', *The Art Bulletin*, 47, 1965, pp. 315–34, poses a series of questions which examine the relationship between style, function and the social and political culture in which the portraits were produced: what were the reasons for the uniformity of the portraits? What were they meant to show? What was their social and historical background? The social circumstances in which patrons lived, the different artistic traditions, and the interaction between social and artistic changes constitute the ground on which E. Castelnuovo establishes his analysis of the portrait in Italy ('Il significato del ritratto pittorico nella società', in *Storia d'Italia*, 5, 2, Einaudi, Turin, 1973, pp. 1033–94). Examining the changes taking place from the beginning of the Quattrocento to the end of the Cinquecento, Castelnuovo subtly unravels the tangled relationship between pictorial conventions and artistic problems, the multiplicity of functions of portraiture, the patrons' needs, and the complexities of the shifting realities of Italian society during this period.

4 The only discussion of female portraits as presenting a series of specific questions which are different from those raised by male portraits is P. Simons, 'Women in Frames: The Gaze, the Eye, the Profile in Renaissance Portraiture', *History Workshop Journal*, 25, Spring 1988, pp. 4–30, repr. in N. Broude and M. D. Garrand, *The Expanding Discourse. Feminism and Art History*, Harper Collins, New York, 1992, pp. 39–57. Simons opens up an interesting debate, pointing out that all treatments of Renaissance portraiture ignore gender distinctions, and she sets up to analyse women's profile portraits 'as constructions of gender conventions, not as natural, neutral images'.

5 The concept of *magnificenza* was explored by E. H. Gombrich in 'The Early Medici as Patrons of Art', in *Norm and Form. Studies in the Art of the Renaissance*, Phaidon, London, 1st ed. 1966, 2nd ed. 1971, pp. 35–57.

6 Sumptuary laws were first introduced in the thirteenth century in an attempt to impose restrictions on the aristocracy and control their power. With changes in the economic and political structure of society, these laws change in scope and character. Some laws stressed the dangers of vanity and pride, and attempted to restrain those features – for instance, low-cut necklines – which were considered to be dangerous to the moral well-being of the individuals and of the state. Rules were also imposed in order that the way of dressing would show the difference between respectable women and prostitutes, so that misunderstandings – and therefore disorder – would not arise. Civil authorities were joined by zealous churchmen in the drafting and in the enforcement of such laws, and in some cases excommunication was the penalty. The enforcement of sumptuary laws, however, was easily circumvented: their very number implies that the legislators were engaged in a losing battle. Sumptuary laws, their significance and the interesting relationships between women, society, fashion and legislation are discussed extensively, with very useful bibliographical references, by D. Owen Hughes, 'Sumptuary Law and Social Relations in Renaissance Italy', in J. Bossy (ed.), *Disputes and Settlements. Law and Human Relations in the West*, Cambridge University Press, Cambridge, 1983, pp. 69–99.

7 For Nicolosa Sanuti's oration, see Hughes, 'Sumptuary Law and Social Relations', pp. 86–7.

8 The letter in which Alessandra Macinghi Strozzi describes in great detail to her son Filippo, in exile in Naples, a possible bride for him, and asks him to prepare the jewellery, is in A. Macinghi Strozzi, *Tempo di Affetti e di Mercanti. Lettere ai Figli Esuli*, Garzanti, Milan, 1987, pp. 231–4.

9 On the painting, see S. Ringbom, 'Filippo Lippis New Yorker Doppelporträt: eine Deutung der Fenstersymbolik', *Zeitschrift für Kunstgeschichte*, 48, 2, 1985, pp. 133–7.

10 The portrait of Battista Sforza was probably painted from a death mask. E. Battisti points out that the inscription on the reverse of Federico's portrait refers to him as '*duca*' (*parem summis ducibus*). Federico received this title in August 1474, and Battisti sees the commission of the diptych as marking the legitimation of the dynasty. He also writes that one of the probable functions of the two portraits was to preserve for the couple's son and heir, Guidobaldo, the memory of his parents: E. Battisti, *Piero della Francesca*, 2 vols, Electa, Milan, 1992, I, pp. 278–91, and II, pp. 514–18. Battista Sforza's jewels in the portrait are described in J. Evans, *A History of Jewellery 1100–1870*, Faber and Faber, London, 1st ed. 1953, repr. 1970, pp. 81 ff.

11 For the commission and significance of the Sassetti chapel in Santa Trinita, the identification of the portraits painted in the narrative scenes, and for information about this family, see E. Borsook and J. Offerhaus, *Francesco Sassetti and Ghirlandaio in Santa Trinita in Florence: History and Legend in a Renaissance Chapel*, Davaco, Doornspijk, 1981.

12 The most complete discussion of the Tornabuoni commission for the *cappella maggiore* of S. Maria Novella is by P. Simons, 'Patronage in the Tornaquinci Chapel, Santa Maria Novella, Florence', in F. W. Kent and P. Simons (eds), *Patronage, Art and Society in Renaissance Italy*, Clarendon Press, Oxford, 1987, pp. 221–51. For the contract between Giovanni Tornabuoni and Ghirlandaio, see D. S. Chambers (ed.), *Patrons and Artists in the Italian Renaissance*, Macmillan, London, 1970, pp. 172–5. On this family and its *consorteria*, see G. Pampaloni, 'I Tornaquinci poi Tornabuoni, fino ai primi del Cinquecento', *Archivio Storico Italiano*, 127, 1968, pp. 331–62. The narratives in the lower registers in the *cappella maggiore* of S. Maria Novella, where the portraits of the Tornabuoni men and women appear, would have been invisible to the congregation standing on the other side of the rood screen (*ponte*), which measured eight metres in depth and probably up to four and a half metres in height. The friars' choir, built beyond the *ponte*, would have further impeded the view of the frescoes. It is not clear who was allowed beyond the *ponte*, but it is presumed that the male patrons of private chapels had right of access to that part of the church. Whether the female members of these families had access beyond the *ponte* is not known. For this interesting problem, see the articles by M. B. Hall, 'The *ponte* in S. Maria Novella: The Problem of the Rood Screen in Italy', *Journal of the Warburg and Courtauld Institutes*, 37, 1974, pp. 157–73, and 'The Italian Rood Screen: Some Implications for Liturgy and Function', in S. Bertelli and G. Ramakus (eds.), *Essays Presented to Myron P. Gilmore*, Vol. II, La Nuova Italia, Florence, 1978, pp. 213–18. In this essay, Hall also discusses the separation between men and women in church during religious services and sermons in the fifteenth century.

13 The death in childbirth of Francesca Pitti is the subject of a marble relief by the workshop of Andrea del Verrocchio in the Museo Nazionale del Bargello, Florence, which had been commissioned for her tomb in Santa Maria sopra Minerva in Rome. On the right, Francesca is supported by female attendants on her deathbed, which is surrounded by grieving women. One woman, sitting on the floor, holds the stillborn baby. On the left, the baby is brought to her husband by an old woman. On this relief see G. Passavant, *Verrocchio. Sculptures, Paintings and Drawings*, Phaidon, London, 1969, pp. 181–2. Francesca Pitti had married Giovanni Tornabuoni in 1466. Luca Landucci writes in his *Diario Fiorentino* that, when a group of anti-Medicean Florentines were exiled in September of the same year, Francesca's father Luca Pitti was spared, because he had become a relative of the Tornabuoni. Giovanni's moving letter, announcing the death of his wife and of the baby to his nephew Lorenzo the Magnificent, is quoted by E. Ridolfi, 'Giovanna Tornabuoni e Ginevra de' Benci nel coro di S. Maria Novella in Firenze', *Archivio Storico Italiano*, 5, 6, 1890, pp. 426–56, esp. p. 432.

14 An attempt to identify the women in the Tornabuoni frescoes can be found in the article by E. Ridolfi, 'Giovanna Tornabuoni e Ginevra de Benci'. On the portraits in the Tornabuoni

chapel, see also the essay by C. M. Rosenberg, 'Virtue, Piety and Affection: Some Portraits by Domenico Ghirlandaio', in A. Gentili, P. Mozel and C. Cieri Via (eds) *Il Ritratto e la Memoria*, 3 vols, Bulzoni, Rome, 1989, II, pp. 173–95.

15 The description of the ideal woman by Lorenzo the Magnificent in his *Commento* is in Lorenzo il Magnifico, *Opere*, a cura di A. Simioni, Bari, 1913, vol. I, pp. 25 and 36 ff.

16 Portrait medals of Giovanna degli Albizzi and Lodovica Tornabuoni are illustrated and discussed in G. F. Hill, *A Corpus of Italian Medals of the Renaissance before Cellini*, British Museum, London, 1930, pp. 267 and 275. For this important type of portraiture, see S. K. Scher (ed.), *The Currency of Fame: Portrait Medals of the Renaissance*, exhibition catalogue, Harry N. Abrams Inc. Publishers, New York, 1994. The portrait medals of Giovanna degli Albizzi are discussed by G. Pollard (pp. 135–6), who states that they were probably made for the wedding of Giovanna and Lorenzo Tornabuoni. One of the medals shows on the reverse the three Graces and the inscription CASTITAS PULCHRITUDO AMOR (Chastity Beauty Love), the other the 'martial' Venus and the inscription VIRGINIS OS HABITUM QUE GERENS ET VIRGINIS ARMA (With a maiden's face and mien, and a maiden's weapon). The obverse and the reverse of two different versions are illustrated on pp. 136 and 140–1.

17 G. Pieraccini identified in the figure of the older woman standing with her head covered in the *Birth of S. John the Baptist*, Giovanni Tornabuoni's sister Lucrezia, the mother of Lorenzo the Magnificent, who had died in 1482 at the age of 57. He based his identification on the characteristic Tornabuoni nose, which Lorenzo the Magnificent inherited: *La Stirpe dei Medici di Cafaggiolo*, 3 vols, Nardini Editore, Florence, 1st ed. 1924, repr. 1986, I, pp. 65–72. For an analysis of a three-quarter pose portrait of Lucrezia Tornabuoni by Ghirlandaio in the National Gallery, Washington, dating probably from the mid-1470s, see F. R. Shapley, *Catalogue of the Italian Paintings*, 2 vols, Washington, DC National Gallery of Art, 1979, I, pp. 203–4, II, plate 140.

18 I am grateful to Jane Bridgeman for bringing to my attention the important aspect of clothes appropriate to age.

19 The differences in the deportment and poses between the 'ideal' female figures and the portraits are analysed by S. Fermor in 'Decorum in Figural Movement: The Dance as Measure and Metaphor', in F. Ames-Lewis and A. Bednarek (eds), *Decorum in Renaissance Narrative Art*, Birkbeck College, London, 1992, pp. 78–88, esp. pp. 86 ff.

20 C. Cieri Via discusses the portrait and identifies the jewel as a woman victorious over a bound satyr in 'L' Immagine Dietro al Ritratto', in Gentili *et al.*, *Il Ritratto e la Memoria*, III, pp. 9–29, esp. pp. 13–14. Cieri Via, however, follows the Apollo and Marsyas identification in her essay 'L'immagine del ritratto. Considerazioni sull'origine del genere e sulla evoluzione dal Quattrocento al Cinquecento', in *ibid.*, I, pp. 45–91, esp. p. 71.

21 For the importance of beauty for neoplatonic writing, see E. Cropper, 'On Beautiful Women, Parmigianino, Petrarchismo, and the Vernacular Style', *The Art Bulletin*, 58, 1976, pp. 374–94. C. Dempsey, in *The Portrayal of Love. Botticelli's 'Primavera' and Humanist Culture at the Time of Lorenzo the Magnificent*, Princeton University Press, Princeton, NJ, 1992, examines the cultural background in which ideas about female beauty developed in the Florence of the last decades of the Quattrocento. Dempsey debates whether the Frankfurt painting is a real portrait or a representation of an idealised beauty. He writes that the cornelian hanging around her neck 'seems to identify her at one and the same time as Lorenzo's and the poet's'. The conclusion seems inescapable that we are here contemplating an image of Lorenzo's poetic *donna* [Lucrezia Donati]. He goes on to say that 'the question of portrait and imaginative re-creation, of the interplay between reality and poetic representation, is not easily resolved, and certainly not by a simplistic appeal to "common sense"' (pp. 132 ff.). For a discussion of the Frankfurt panel, with bibliographical indications, see R. Lightbown, *Sandro Botticelli*, 2 vols, Elek, London, 1978, II, pp. 116–17. E. H. Gombrich analyses Botticelli's ideal of beauty in his essay 'Ideal and Type in Italian Renaissance Painting', in *New Light on Old Masters*, Phaidon, London, 1986, pp. 89–124.

22 The Piero di Cosimo painting is the subject of a detailed analysis by S. Fermor in her *Piero di Cosimo. Fiction, Invention and 'Fantasia'*, Reaktion, London, 1993, pp. 93–101. Fermor

stresses how the sensuality of this image and its erotic appeal are linked to the juxtaposition of nudity, hair and jewellery, and how the untamed landscape setting 'adds to the sense of the sitter . . . beyond the bounds of decorous female behaviour'. The averted eyes of a profile head, Fermor adds, may have had a different meaning for fifteenth-century viewers, inviting a gaze which could not be returned, and therefore attracting attention.

23 Patricia Simons explains the continuing use of the profile in female portraits as a strategy to 'cordon off' women, whom she sees as the passive objects of an extreme patriarchy. These portraits, she writes, were 'primarily objects of a male discourse which appropriated a kind of female labour or property'. She goes on to offer a psychoanalytical interpetation of this convention: 'The de-eroticised portrayal of women in profile meant female eyes no longer threaten the seeing man with castration . . . Castration anxieties are also displaced by fetishisa-tion, by the way in which a woman's neck, eye and other features are rendered safe com-modities through fragmentation and distancing, excessive idealisation.' Simons concludes: 'The male gaze continued its triumphal potency while the female gaze remained repressed': Simons 'Women in Frames', pp. 22 and 24.

24 Lorenzo the Magnificent himself wrote two sonnets in his *Canzoniere* on the theme of women's portraits which, in spite of the painter's skill and of the lover's emotions, cannot listen to the lover's sighs and cannot convey the *virtù* of the beloved (see Lorenzo de Medici, *Opere*, ed. T. Zanato, Turin, 1992, sonnet IX, pp. 23–4, and sonnet XLIX, p. 87).

CHAPTER THREE

PORTRAITS 1480–1560:
BEAUTY AND
POWER

❧

In the last decades of the fifteenth century, portraiture continued to be considered as the means through which the living remembered the dead, and art, immortalising the sitter, could defy nature and time. While still used to honour the memory of the dead, portraits were commissioned more and more to signify the status of living women, or to mark important events in their lives, or even to celebrate their beauty. Important changes were developed, in terms of the pose of the sitter, of the position of the figure in relation to the picture plane, and of the medium used. The strict profile was abandoned in favour of the three-quarter pose, which gave prominence to the direction of the gaze, while the introduction of the oil medium allowed artists to explore light effects and the different textures of skin, hair and fabrics.

The changing functions of portraits

During the sixteenth century, the functions of portraits became more varied. They could, for example, be used as important gifts. In 1514 Isabella d'Este, Marchioness of Mantua, gave as a present to the English ambassador a portrait of herself painted by Costa. In 1549, Bronzino painted a pair of portraits of the Duke and Duchess of Florence as a gift for the Bishop of Arras. He was asked by his patrons to paint the dress of the Duchess not as if it were brocade, as this took a long time, but simulating another type of cloth which was equally beautiful, so that he could finish the portraits as soon as possible.

A considerable amount of written evidence shows how, in many cases, portraits helped to keep in mind the memory of distant friends, and were used

to express love and affection. In 1506 Baldassarre Castiglione took the portrait of a woman he loved, painted by Raphael, on a journey to London. It was framed in such a way that it could be covered by a sliding mirror.[1] In one of his poems, Castiglione imagines his wife Ippolita writing that the pain caused by her husband's absence is lessened by his portrait painted 'by the divine hand of Raphael'. Ippolita caresses the painted image and talks to it as if it could answer, and indeed the portrait often seems to be on the point of talking to her: even their child recognises his father in the painting and greets him. Isabella d'Este wrote to Cecilia Gallerani in 1498 asking Cecilia to send her the portrait by Leonardo, because she wanted to compare his work with other portraits by Giovanni Bellini, and '. . . also to have the pleasure of seeing your face again'. Cecilia answered that she was sending the portrait, but warned Isabella that she had aged, and that the portrait was not her true likeness any more. A friend of Isabella d'Este who lived in Ferrara wrote to her in 1495 that, at mealtimes, she placed Isabella's portrait in front of her, so that she could pretend to be with her. Giovanni Maria della Porta, a courtier of the Duchess of Urbino, Eleonora Gonzaga, on seeing her portrait by Titian, described to her his reaction in a letter: '. . . wishing to speak to the picture, I went close to it, but saw that it did not attend to what I said; and suddenly I recalled that great wrong which you have done to me, for so many times you have promised me your portrait but you have never given me one'.[2]

Beauty and portraits

As we have seen in the previous chapter, portraits of women were painted according to specific criteria, expectations and circumstances informed by Renaissance ideals of femininity. In this context, the importance of the influence of Petrarch, not only on Italian Renaissance poetry, but also on the whole discourse concerning the idealisation of women, the expression of love, the description of beauty, cannot be stressed enough: these structures of feelings did not permeate only the literary culture of the time, but influenced almost all areas of cultural life. They can be found in lyric poetry and in epics, in treatises on love and in disquisitions on the beauty of women, in treatises on art and in writings on behaviour and comportment. Following the models provided by Petrarch and Boccaccio, the canon of female beauty became codified by countless descriptions, from Poliziano to Pietro Bembo, from Ariosto to Boiardo. Variations were constructed around a number of features which were constantly repeated: writers praised the attractions of wavy hair gleaming like gold, of white skin similar to snow, to marble, to alabaster or to milk; they admired

cheeks which looked like lilies and roses, and eyes that shone like the sun or the stars. Lips are compared to rubies, teeth to pearls, breasts to snow or to apples.[3]

Lyric poems which praise portraits of women became a popular genre from the two last decades of the fifteenth century. These poems can help the modern viewer to understand some of the functions of portraiture, and may also suggest some of the ways in which Renaissance portraits of women were perceived by contemporary viewers. All these poems have their origin in the two sonnets by Petrarch on Simone Martini's portrait of his beloved, Laura, which have already been mentioned in the previous chapter. The first sonnet on Laura's portrait centres on the conceit that no painter on earth can adequately capture the beauty of the beloved, because the soul is veiled by the body: only in Paradise can real beauty, which belongs to the soul, be portrayed. In the second sonnet the poet laments the fact that the painted image will not answer, even if she seems to listen to his words. He envies Pygmalion, because the image he created did come to life. Lorenzo the Magnificent, following the Petrarchean model, uses the same conceit in a poem about the portrait of his beloved, Lucrezia Donati: the artist has not been able to represent her 'virtue', even if the likeness is perfect. In those poems written from the beginning of the sixteenth century onwards, the painted image is described as looking at the viewer and reacting to his emotions. This kind of perception predicates the change from the profile to the three-quarter pose, with the possibility of an 'exchange of glances' between the sitter and the beholder. The responses of the beholder, which we have found so vividly evoked in their letters, and which are also expressed through poetic conventions, become more plausible with the development of the interest in the rendering of surface and texture, and, especially, in the illusion of the representation of personality.[4]

Leonardo's portraits

In Leonardo da Vinci's *Portrait of Ginevra de' Benci* (Figure 30), painted in Florence probably around 1480, the three-quarter pose of the head allows the viewer to engage with the eyes of the sitter. The panel has been cut, and would have originally included the hands, perhaps in a pose similar to that of the marble bust of a lady by Andrea del Verrocchio in the Museo Nazionale del Bargello in Florence. A silver-point study of hands by Leonardo in the Royal Collection at Windsor may be related to this portrait. The head is shown against a juniper bush – a pun on the sitter's name which we have also found in Pisanello's portrait of Ginevra d'Este. On the right, a landscape with trees,

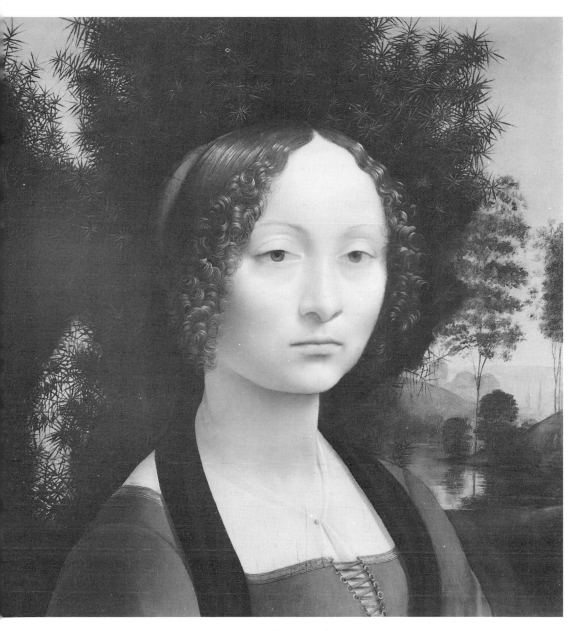

30 Leonardo, *Portrait of Ginevra de' Benci*, *c.* 1480

bushes and water fades into the distance. The description of Leonardo's portrait of Ginevra de' Benci by the Anonimo Gaddiano presents us with the *topos* of the Quattrocento painter as 'imitator of nature': the representation of Ginevra, painted from nature, does not look like a portrait, but like the real person. And in fact this portrait is a study of the appearance of 'reality', that is, of the eye's perception of the physical appearance of the natural world. Leonardo guides the viewer through the sensations caused by his close study of different textures – skin, juniper bush, cloth, veil – of different surfaces reflecting light – hair, skin, water – and by the sense of distance in the landscape background. This portrait shows Leonardo's search for a way in which the painter can 'translate between nature and art' by 'setting out, with nature, the causes of nature's phenomena regulated by nature's laws', as he will note in his writings. The lack of the conventional decorative elements and of the details used in portraiture to establish status, like jewellery or precious fabrics, shows the extent of the artist's selection and his control over the means through which he guides the viewer's perception. In this sense, the painted image of Ginevra is experienced by the viewer as a 'real person'.

This portrait, unlike most of the Florentine profiles painted during the fifteenth century, does not commemorate a dead woman, nor, as it used to be believed, was it commissioned on the occasion of her marriage. Its function, it seems, was very far from the desire to celebrate events related to family history.[5] Ginevra di Amerigo de' Benci married Luigi Niccolini in 1474, when she was 17, and died, childless, in 1521 at the ripe age of 64. She was well known in Florence and Rome for her knowledge of poetry and music, as well as for her beauty and virtues, and Lorenzo the Magnificent wrote two sonnets in her honour. On the reverse of her portrait is a wreath made of laurel and palm branches, encircling a sprig of juniper, adorned with a ribbon inscribed with the motto VIRTUTEM FORMA DECORAT (Beauty adorns virtue). This is not just a reference to the Petrarchean *'ramoscel di palma / et un di lauro'* brought to the poet by the spirit of the dead Laura, but an *impresa* (device) which associates this painting with the Venetian poet and humanist Bernardo Bembo, whose device shows an identical laurel and palm wreath, with the motto VIRTUS ET HONOR. Bembo was in Florence twice in the mid and late 1470s as Venetian ambassador, and his platonic love for the learned Ginevra, to whom he dedicated a number of sonnets, was so well known amongst the members of the Florentine political and cultural elite centred around Lorenzo the Magnificent, that poems were written about their relationship. If this portrait was in fact commissioned by Bembo as an expression of his admiration for Ginevra, it celebrates feelings and sensibilities which are quite new in the history of Quattrocento portraiture. The legendary portrait of Laura by Simone

Martini could have provided a source of inspiration and a literary model for this painting: Petrarch wrote of a portrait which 'seems to listen' when the poet speaks to it, and of his desire for the painted image to come to life. In the love poetry of late fifteenth-century Florence, steeped in the tradition of the *dolce stil nuovo*, the concept that the eyes are the instrument through which love is communicated was almost commonplace. It is therefore appropriate that this portrait, if it was commissioned as an expression of platonic devotion, should reveal to the viewer the eyes of the sitter. However, the image of Ginevra, even if 'real' for the Quattrocento viewer, is still painted according to the conventions of the representation of woman as idealised and set apart from the beholder. In spite of the three-quarter pose, the image remains static and the eyes are not engaged in a dialogue with the viewer.

It is with a later work, conceived and executed by Leonardo in the milieu of the Sforza court in Milan probably in 1490–91, *The Portrait of a Lady with an Ermine*, that artistic problems related to the representation of suggested movement and to a psychological link between painted image and viewer are explored (Figure 31). The sitter has been identified as Cecilia Gallerani, a young woman from a respectable Milanese family who became the mistress of Ludovico il Moro sometime in 1489, and played an important role in the cultural life of the Sforza court. In Leonardo's portrait she emerges from a shadowy background, holding a weasel-like animal, probably a large ermine, which is at the same time the emblem of Ludovico, a symbol of purity, and a pun on her name, from the Greek word for weasel, *galee*. With her shoulders placed diagonally to the picture plane, she seems to turn her head and to look towards the source of light at her left. While she is caressing the ermine's body with her exaggerately elongated, elegant hand, her eyes seem to concentrate on a presence beyond the space of the picture. An impression of thought is conveyed by the eyes: Leonardo's *sfumato*, which masks the corners of her eyes and lips, denies a precise contour and therefore enhances the fleeting sensations of change. How important shadow is in the creation of this illusion is made clear by Leonardo's own words: 'When you wish to make a portrait, do it in dull weather or as evening comes, making the subject stand with his back to one of the walls of the courtyard. Note in the streets when evening comes or when it is gloomy weather, how much grace and sweetness may be seen in the faces of men and women. Therefore, painter, have your courtyard designed with the walls tinted black.'[6]

In a poem by the Florentine Bernardo Bellincioni, the most important among the poets at the Sforza court, the Poet and Nature are engaged in a dialogue which praises Leonardo's portrait of Cecilia Gallerani: Nature is envious of the powers of the painter, but the Poet says that Nature should thank

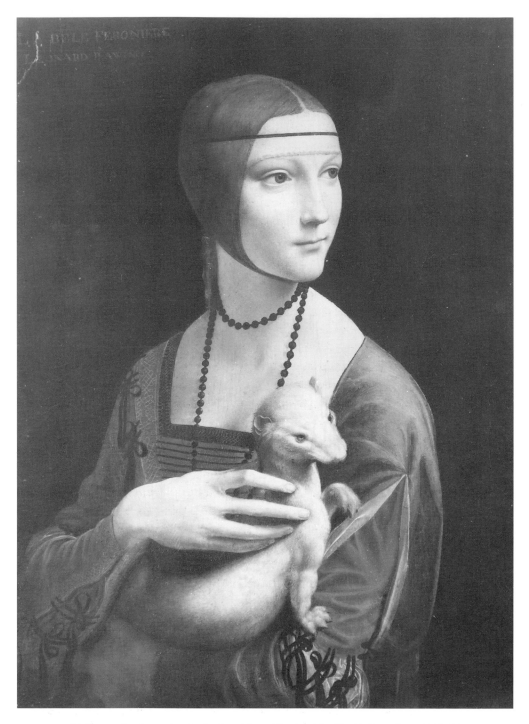

31 Leonardo, *Portrait of a Lady with an Ermine (Cecilia Gallerani)*, c. 1490–91

90

Ludovico il Moro and the mind and hand of Leonardo for showing, even when Cecilia will not be alive any more, what nature and art are; the sun seems a dark shadow in comparison to Cecilia's beautiful eyes, and she appears to listen without speaking. By the late fifteenth century, Petrarch's conceit had already become a stereotype, whenever a beautiful woman was celebrated in verse, and her eyes were always the focus of the poets' praise. Yet it is undeniable that, in the case of Leonardo's portrait, the conventional words of the poet touch on significant innovations in female portraiture.[7] The use of a three-quarter pose, the suggestion of movement implied in the position of the shoulders and head, the importance given to the eyes and to the direction of the gaze, the introduction of the oil medium with the possibilities of emphasising the lustre of the eyes and the texture and surface qualities of skin and hair, are all artistic changes which take place during this period. Comparing the merits of painting and poetry in the *Paragone*, Leonardo, who was familiar with the poetic tradition of the *dolce stil nuovo* and with contemporary poetical genres, affirms the superiority of painting in producing an emotional effect in the viewer: 'And if the poet claims that he can inflame men to love . . . the painter has the power to do the same, and indeed more so, for he places before the lover's eyes the very image of the beloved object, [and the lover] often engages with it, embracing it, and talking with it.' In Leonardo's words, the conventional poetical praise of the beloved and of the power of her eyes is extended to the painted image, which becomes so real that it is now the object of love. Such, then, is the suggestive power of painting. Leonardo's subtlety in conveying the 'movements of the soul', which was rooted in the Florentine tradition of narrative painting as described by Alberti, was developed in Milan, possibly through his knowledge of the portraits by Antonello da Messina produced at the Sforza court. The viewer's sense of the perceived existence of a mind (*animus*) within the painted image lies in the possibility of establishing an imagined relationship, based on a reaction between the sitter and the viewer. The features of the sitter may be more or less idealised, they may still represent an individual through the conventions of a type of beauty, but the impression of a 'personality' has been established.

The *Mona Lisa*

The development of these experiments is the *Portrait of a Lady* in the Louvre which we know as the *Mona Lisa* (Figure 32). We do not know who the sitter was, nor do we know for sure that this is the portrait of an individual, rather than the representation of an ideal. It is not certain whether this is the

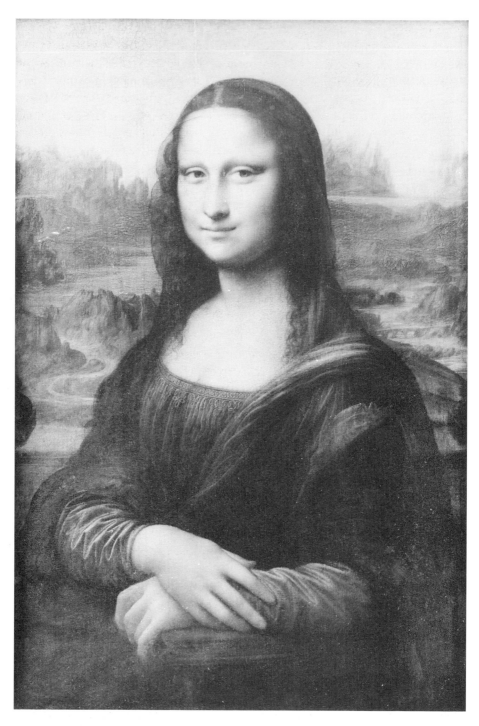

32 Leonardo, *Portrait of a Lady*, early 1500s

92

portrait that Vasari describes in possession of the King of France, Francis I, at Fontainebleau which, he writes, had been commissioned by a Florentine merchant called Francesco del Giocondo, and which represented his wife, Madonna Lisa Gherardini. Vasari adds that Leonardo, after working on this portrait for four years, had left it unfinished. It has also been suggested that the Louvre painting might instead be 'the portrait of a Florentine lady, painted *di naturale* on request of the late Magnificent Giuliano de Medici' which was shown by Leonardo to the secretary of Cardinal Louis of Aragon, Antonio de Beatis, in the Palace of Cloux at Amboise in October 1517. This portrait would have been painted between 1513 and 1516, when Leonardo was in Rome at the Belvedere in the Vatican, under the patronage of Leo X's brother Giuliano de Medici. However, undeniable influences evident on Florentine portraiture in the first decade of the sixteenth century lead to the hypothesis that the Louvre portrait was probably begun when Leonardo was in Florence, in the early 1500s. In this painting the eyes of the sitter seem to engage with the gaze of the viewer, in an apparent demand for an emotional response. The technique of the painter, however, denies the possibility of a precise perception by presenting the viewer with subtle gradations of tone achieved through veiled glazes, which hide the contours of the seats of expression – the corner of the eyes and of the mouth. A connection with the viewer is tantalisingly and elusively established, leading the modern spectator to expect the representation of a fully-fledged individual, but the image is again filtered through the poetic homage to an ideal of femininity which denies the specific peculiarities of the physical characteristics of an individual and of the details of clothing.[8]

Raphael

Raphael almost certainly developed the strong sense of structure evident in his Florentine portraits through his study of Leonardo's so-called *Mona Lisa*. A pen and brown ink drawing shows Raphael's adaptation of the half-length seated pose with the head turning towards the viewer which, before Leonardo, had been used by Lorenzo di Credi (Figure 33). The lesson of Leonardo in Raphael's drawing is evident in the confident placing of the figure in space, with the arms framing the bust, and the wide sleeves touching a parapet parallel to the picture plane. The three great examples of Raphael's portraiture painted in Florence during the first decade of the Cinquecento, *La Gravida* (Florence, Galleria Palatina), *La Muta* (Urbino, Galleria Nazionale delle Marche) and the *Portrait of Maddalena Doni* (Florence, Galleria Palatina), are all variations of the compositional scheme devised by Leonardo.[9] The figures, with their shoulders

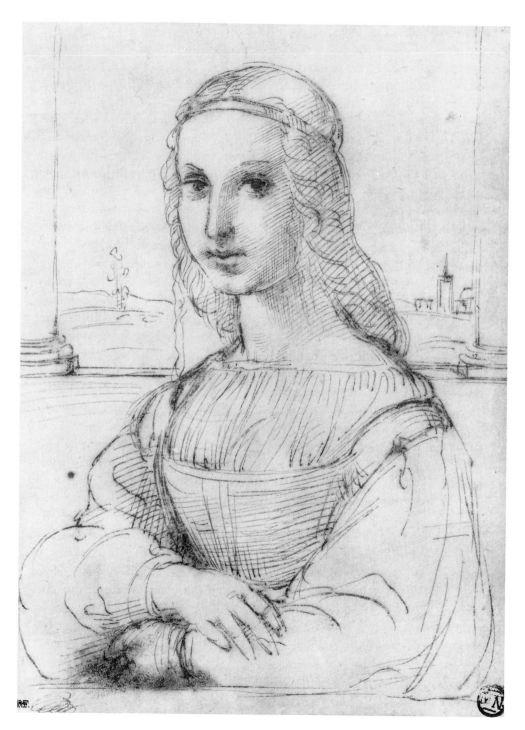

33 Raphael, *Portrait Study*, early 1500s

94

and bust placed diagonally to the picture plane, convey a sense of the physical space around them, even when, as is the case with *La Gravida* and *La Muta*, they are placed against a plain dark background. What is more, the three sitters share the space of the viewer because of the position of their hands, thrust forward towards the picture plane, and they seem to be aware of the presence of the beholder through the direction of their gaze. The differences between Leonardo's *Mona Lisa* and Raphael's three Florentine portraits, however, are as significant as the similarities. Within his strong compositional scheme, Raphael brings to these portraits a close observation of the particular, for example of the details in the jewels and clothes worn by the sitters. This interest in detail, however, is not akin to the study of surfaces and light in Leonardo's *Ginevra de' Benci*, where the painter's attention is focused on an almost scientific exploration of the natural world. Raphael's portraits are different from Leonardo's in that they are also studies of social beings. At the same time, an interest for the peculiarities of the sitters' features is fused with the idealisation of the oval faces, the large, dark, almond-shaped eyes and the plump, sloping shoulders. Raphael succeeds in bringing together a sense of the individual and of her place in society, and the idealised construction of her femininity.

Of these three portraits, the *Maddalena Doni* is the best preserved.[10] Together with its companion, the portrait of Maddalena's husband Agnolo, it was justly famous during the sixteenth century (Figures 34 and 35). Vasari wrote in his *Life of Raphael* that 'while Raphael was living in Florence, Agnolo Doni (who was very cautious with his money in other things, but spent it readily, although still as economically as possible, on works of painting and sculpture, which gave him immense pleasure) commissioned Raphael to paint the portraits of himself and his wife; and these, in Raphael's new style, may be seen in the possession of his son Giovanbattista, in the beautiful and spacious house that Agnolo built on the Corso de' Tintori in Florence, near the Canto degli Alberti'. Maddalena di Giovanni Strozzi married the wealthy cloth merchant Agnolo Doni in January 1504, at the age of 15. Agnolo, who was 30 at the time of the marriage, had occupied important positions in the public life of the city, and was known as a collector of antiquities as well as the patron of Raphael, Michelangelo and Fra Bartolomeo. The images of Agnolo and Maddalena, their shoulders placed diagonally to the picture plane, turn their heads towards the viewer, but while Agnolo's eyes engage directly with the viewer's, Maddalena's gaze just eludes us. Agnolo's face is sculpted by heavy shadows and by highlights which give emphasis to the strength of his features, underlining his nose, lips, chin and eye socket. The planes of Maddalena's placid face, painted in a lighter skin tone, smoothly merge together and are softened by delicate shadows. Husband and wife are shown sitting high up against

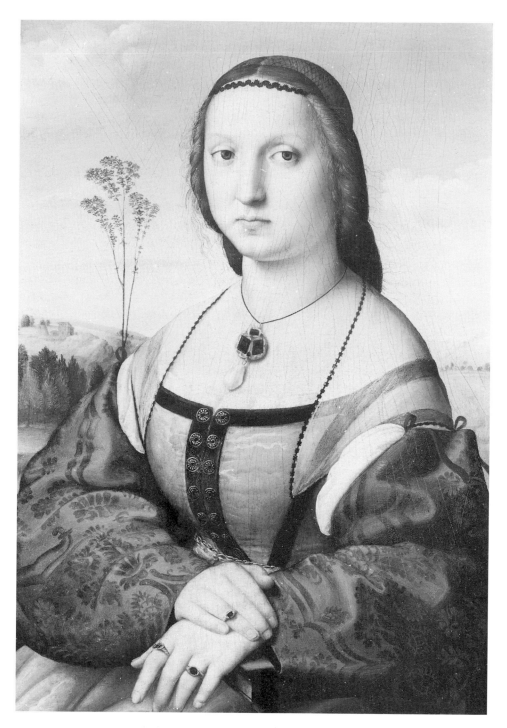

34 Raphael, *Portrait of Maddalena Doni, c.* 1505–7

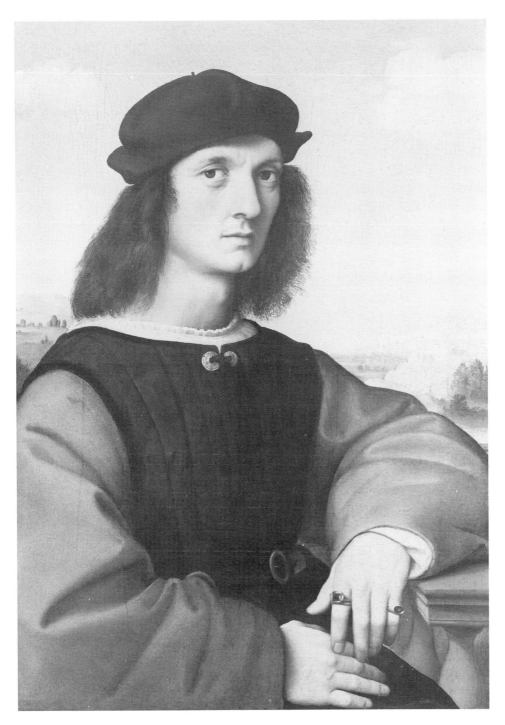

35 Raphael, *Portrait of Angelo Doni*, c. 1505–7

97

a calm, distant landscape, Agnolo's left arm leaning against a parapet, Maddalena's on the arm of her chair.

The two panels have been dated on stylistic grounds between 1505 and 1508, that is, in the years immediately following the marriage of the sitters. On the reverse of both paintings, scenes from the legend of Deucalion and Pyrra allude to an apotropaic function of the portraits by linking the mythical rebirth of mankind with the images of the new couple. These scenes, which were previously thought to have been added at a later stage, are now believed to have been painted by the Maestro di Serumido before the portraits left Raphael's workshop.[11] While hopes for the fecundity of the newly weds are expressed through an allegory, their social status is signalled by the clothes they are wearing. As with the male portraits in the Tornabuoni Chapel in Santa Maria Novella, painted less than twenty years before, Agnolo's image conveys a restrained awareness of his position and wealth, with his simple but elegant and expensive clothing. It is in the detailed rendering of the fashionable *gamurra* and of the jewels worn by Maddalena Doni that Raphael's aims are seen to differ most clearly from Leonardo's. In what was clearly an important commission from such a discriminating patron, Raphael has brought together the results of his study of Leonardo with the concern for the customary display of wealth and status appropriate to portraiture. The red-orange watered silk of the bodice and skirt of the *gamurra*, the dark blue velvet borders of the bodice, the blue damask of the billowing sleeves, the white *camicia* in the light and expensive fabric called *tela di renza*, the veil embroidered with a black border covering Maddalena's shoulders, demonstrate pride in the display of the sumptuous fabrics used in these fashionable garments. The low, wide neckline uncovers the sloping shoulders and emphasises the large jewel which hangs from Maddalena's neck. This pendant is not just a precious object, but it speaks of the virtues proper to a young wife: the upper part of the gold setting is in the shape of a unicorn, the well-known symbol of chastity. The precious stones which decorate the pendant are also charged with meaning: in the body of the mythical animal is set an emerald, a stone which was believed to possess healing qualities and which was also linked to chastity. The sapphire was also a symbol of purity, while the ruby was thought to bring prosperity and strength. The pearl was a customary gift to brides and signified virginity.

Images of beautiful women in Venetian painting

The varying amount of idealisation of the features of the sitters in these portraits is a crucial part of the public image of their femininity, but their identity

is still important: these paintings represent individuals. There is, however, a large group of paintings which are still identified in sixteenth-century sources by the term *ritratto* (portrait). These paintings represent women, principally or exclusively because of their beauty. The boundaries of this type of 'portrait' are, in some instances, difficult for the historian to assess, yet it is important to discover to which genre the painting belongs and which function it fulfilled – whether it was the representation of an ideal or of an individual, whether its purposes were commemorative, celebratory, or purely decorative. We lack the necessary information which would help us to establish with certainty whether, for example, Giorgione's famous *Laura* (Figure 36), painted in Venice, is the portrait of a courtesan called Laura, or of a poet-courtesan, or is a recreation of the portrait of Petrarch's beloved, or the image of an ideal woman or, finally, the portrait of the wife of the man who commissioned it, as has been variously suggested. On the reverse of the painting is an inscription: 'In 1506 on June 1 this was painted by the hand of master Zorzi from Castelfranco, colleague of master Vincenzo Catena on request from master Giacomo'. Are the laurel branches which surround her head a punning reference to the woman's name, as was the case with Ginevra de' Benci's juniper, or an indication of her achievement as a poet, or rather a symbol of conjugal virtues such as chastity, modesty and fidelity? Is the one naked breast simply a sign of alluring sensuality and eroticism, or a sign of fecundity, or a visual demonstration of that balance between chastity and voluptuousness believed to be necessary for a successful marriage? But is it likely that a respectable married woman would be portrayed with her dress and her hair in such a state of disarray, and displayed in a clearly erotic painting? The name 'Laura' was one commonly chosen by prostitutes and courtesans: the laurel branches could therefore be nothing more than a visual pun, a sign of her trade. And finally we may ask whether this painting represents, yet again, not a specific 'real' woman, but rather another visual embodiment of that canon of beauty described by the poets. We know that Pietro Bembo owned a painting representing the poet's 'Laura'. Is Giorgione's *Laura* 'merely' another demonstration of the superior powers of the painter to describe beauty and to seduce the viewer?[12]

Similar questions can be asked about the *Portrait of a lady* by Bartolomeo Veneto (Figure 37). The woman, with a mass of metallic gold ringlets spread over her shoulders, a bare breast, a posy of daisies, anemones and ranunculi in her hand, turns her eyes towards the viewer with a sidelong glance. This painting has been tentatively identified as a portrait, either of Lucrezia Borgia or of Giulia Farnese. It has also been interpreted as a marriage portrait because of the myrtle in the wreath on the head-dress. Again, it could be a representation of an ideal beauty according to the canon, with her gold curls and her

snow-white skin. The flowers in her hand have suggested that this is a representation of the nymph Flora.[13] A number of images of women in various stages of undress, offering flowers to the beholder, belong to this genre, which became particularly important in Venice during the first decades of the sixteenth century, but which spread also to Milan and to Rome, through the work of some of Leonardo's followers. Already in the following century some of these images were known as *Flora*. They could indeed represent the nymph Flora, the goddess of spring, linked to fertility and conception, who presides over love-making. They could also recall to the viewer the Roman prostitute with the same name mentioned by Boccaccio in *De Claris Mulieribus*. What links all these pictures is the erotic tension established between the image and the beholder, and the presence of flowers as signifiers of the pleasures of love. Examples of this type of paintings are Bernardino Luini's *Flora* (Royal Collection, Hampton Court, *c.* 1530), the voluptuous, inviting *Flora* by a follower of Leonardo, perhaps Francesco Melzi (Rome, Galleria Borghese), and Palma Vecchio's *Flora* (London, National Gallery), with her bare breast provocatively underlined by a fluttering blue ribbon. The most famous of these pictures is the so-called *Flora* by Titian (*c.* 1515–20) (Figure 38). Dressed in a *camicia* which

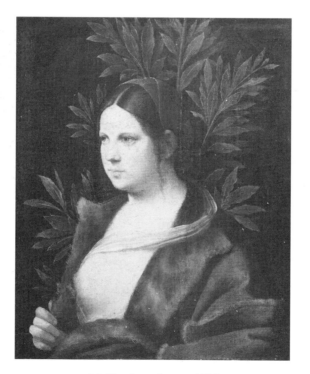

36 Giorgione, *Laura*, 1506

100

falls away from her shoulder revealing part of her breast, she averts her eyes from the viewer's. Her blonde-reddish hair is spread out on her shoulder. Her hand is stretched forward in an ambiguous gesture which seems at the same time to offer flowers to the beholder and to withold them. The texture of the skin and of the soft, wavy hair spread on the shoulder, the expanse of the breast, just hidden from the viewer's eye, the contrast between the light white fabric of the pleated *camicia* and the shiny silk brocade of the rose drape, are a pictorial invitation to the viewer's sense of touch. This complex image of subtle eroticism is not the representation of a nymph caught in the safe distance of a mythological past: her clothes place her firmly in the world of the sixteenth-century viewer. She is not, however, a specific individual, her features appear in a number of paintings by Titian and her physical type recalls, yet again, the poetic canon, with her alabaster skin and golden hair, rose lips and dark eyes.[14]

It was in Venice that the particular type of half-figure paintings representing unidentified beautiful women in contemporary clothes became fashionable during the first decades of the sixteenth century. This development is particularly interesting because, probably for reasons linked to the political and social

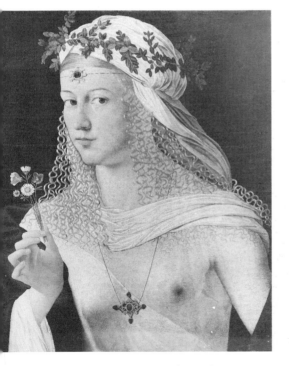

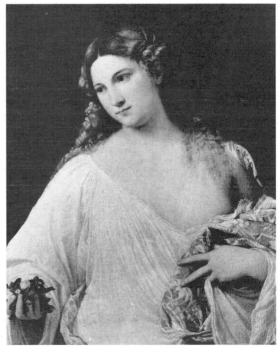

37 Bartolomeo Veneto, *Portrait of a Lady, c.* 1506 38 Titian, *Flora, c.* 1515–20

101

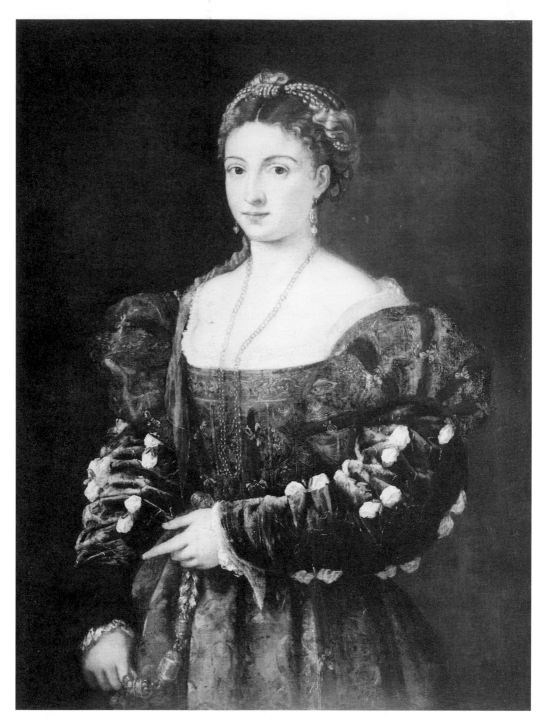

39 Titian, *La Bella*, *c.* 1536

structure peculiar to this city, the tradition of female portraiture, both private and public, which we have seen developing in Florence and in the Northern Italian courts throughout the fifteenth century failed to take root in Venice. In marked contrast to the large number of male portraits which still survive, the portraits of 'real' women in Venetian art are in fact exceptionally rare. Images suggesting dynastic ambition and private demonstrations of personal aggrandisement were frowned upon, and the public role of patrician women as wives and mothers was less crucial to the political organisation of the city than that played either by the aristocratic women of the courts or by the bankers' and merchants' wives and daughters in Florence.[15] While sixteenth-century Venetian inventories list female 'portraits', these represent types rather than individuals. The Venetian pictures of beautiful women play with the senses of the beholder – with touch as well as sight. They invite a sensuous response through the use of clothes and jewels, through the direction of the gaze, which at times invites, at times evades the viewer's eye, and through painting techniques which explore the rendering of the softness and luminosity of skin and hair, the richness of colour and of different textures.[16] To this type belong a number of works by Palma Vecchio for his Venetian patrons, such as the so-called *Violante* in Vienna, *La Bella* in Madrid, and the *Sibyl* at Hampton Court. Successful prototypes were often adapted for different patrons, so that variations on the same theme are very frequent. These paintings are listed in inventories and descriptions of early sixteenth-century private collections in Venice as 'painting of a woman' or 'a canvas with a woman'. That is, they are not representations of individuals, but of types. One version of Palma Vecchio's *Lady with a Lute* was described by Marcantonio Michiel in the collection belonging to Gerolamo Marcello in 1525 as 'a canvas of a woman, waist length, who holds in her right hand a lute, and has her left hand under her head, by Jacopo Palma'. The same figure appears again in an almost identical pose, but without the lute, in another painting by Palma Vecchio, the so-called *Three Sisters* in Dresden. The woman dressed in the rich blue gown in Titian's *La Bella* (Figure 39) is clearly based on the same physical type as the *Girl in the Fur Coat* in the two versions in Vienna and in St Petersburg, and as the *Venus of Urbino* in Florence. X-ray photographs have shown that the first version of the St Petersburg picture was an almost exact copy of the Florence picture.

Titian's *La Bella*, so dignified in her rich gown that this painting has been interpreted at times as the portrait of a lady of high birth, was not painted for a Venetian patron. In a letter dated May 1536, Francesco Maria della Rovere, Duke of Urbino, wrote to his agent in Venice, Gian Giacomo Leonardi: 'You will tell Titian . . . that we want him to finish that portrait of a woman in the blue gown, so that it is beautiful, the whole painting and the cover.' 'Portrait'

(*ritratto*) in this case surely does not mean the likeness of an individual whose identity was known to the patron. This term, in sixteenth-century Italy, was in fact used very loosely to convey the concept of 'representation' or 'portrayal' of practically everything, from actual individuals to saints, animals and even buildings. Here, the woman is not mentioned by name: this is a painting whose function and meaning lie in the representation of female beauty, magnificently attired, and in the pleasures which the beholder derived from it. The dress is as important as the woman, with its blues, browns and golds, and with the seductive rendering of the fabric.[17]

Questions related to the intentions of the painters and to the expectations of the patrons are important. Working in Florence and Milan, in a tradition quite different from Venice, Leonardo documented in his writings his awareness of the conventions of female beauty derived from poetry and of the ways in which painting could affect the viewer: 'The painter's power over men's mind is even greater [than the poet's], for he can induce them ... to fall in love with a picture which does not portray any living woman.' On the other hand there is no evidence that Palma Vecchio or Titian painted their half-figure pictures of women with complex references to contemporary poetry in mind, even if we presume that Titian was fully conversant with its conventions through his friendship with Pietro Aretino. As to the viewers' responses, lack of evidence about this particular genre again does not allow us to make definite statements: the way of writing about paintings was a highly rhetorical exercise and we should not assume that the same conventions were valid for actual discussions about these pictures. It is possible that these responses were multi-faceted, and that they run through the whole gamut of experience. After all, the richness of a work of art lies in its ambiguities and in the multiplicity of responses, at times contradictory, it elicits. Intellectual pleasures may have been provided by associations with well-known classical stories which described paintings of beautiful women in antiquity, or by the viewer's awareness of the contemporary canon of beauty as expounded by poets and writers, or by discussions about the *paragone* between poetry and painting. Last but certainly not least, sensuous pleasure would have been derived from the painters' skill in bringing to life the visual qualities of these mildly erotic images of beautiful women.

The state portrait

In Renaissance Italy beauty, together with nobility of birth, could make a woman famous. Giovanna of Aragon (1502–77), the 'pearl of all Italy' as she was called, was the granddaughter of the King of Naples, Ferdinand I, and the

daughter of Ferdinand, Duke of Montalto. She was celebrated throughout Europe for her beauty and her virtues. The philosopher Agostino Nifo dedicated to her a treatise published in Rome in 1531, *De Pulchro et Amore*, which describes the perfect proportions on which her beauty was based. The poet Girolamo Ruscelli wrote a whole collection of poems for her, published in Venice in the second half of the sixteenth century, the *Tempio alla Divina Signora Donna Giovanna d'Aragona*. In 1518, the same year as Giovanna's betrothal to the Constable of Naples Ascanio Colonna, Cardinal Bibbiena, the papal ambassador to the French court, probably on request from Pope Leo X commissioned Raphael to paint her portrait as a gift to the King of France, Francis I (Figure 40). Raphael sent one of his assistants to Naples to draw Giovanna from life, and left the execution of this large portrait to another assistant. It is not known to what extent Raphael was involved with the commission: whether he was responsible only for the composition, or whether he actually painted part of the picture. Vasari wrote in his *Life of Giulio Romano* that the head was painted by Raphael himself, while the rest was the work of Giulio Romano. The portrait soon became well known: Alfonso d'Este, the Duke of Ferrara, saw the painting in Paris, and asked Raphael for the cartoon, which was sent to Ferrara in February 1519. The aims of this picture are totally different from those concerning either the representation of 'beautiful women' or the small-scale portraits suitable for a domestic setting, which we have seen up till now. The *Giovanna of Aragon* is constructed for a very different relationship between sitter and viewer compared to the examples of Raphael's Florentine commissions from the previous decade. This is not only a celebration of the beauty of the sitter, but also of her very special social status. It is also a present for a king. As such, the painting does not attempt to represent an individual who responds to the beholder, rather it is devised to create a sense of distance and awe. Giovanna is shown in three-quarter length, sitting on a chair decorated with lions, in a vast hall, which can be only dimly perceived. In the background on the left, a window opens on a *loggia* where a woman, seen from the back, is standing. She wears a luxurious dark red velvet gown, with enormous sleeves lined in pink silk and decorated with jewelled buttons. Her *camicia* is embroidered in gold and red thread. She dominates the picture space with the elegant gesture of her arms, so that her wide sleeves spread out. Her small head is set above the expanse of her gown like a jewel. The perfect oval face is expressionless; the eyes do not meet the gaze of the viewer. Everything about her image is refined and mannered, (*manierato* and *artificioso*), two positive and very important attributes of courtly behaviour. Giovanna's right hand with its long, curling, tapering fingers, derives from the hand of one of Michelangelo's *ignudi* (nude male figures) in the Sistine ceiling.

105

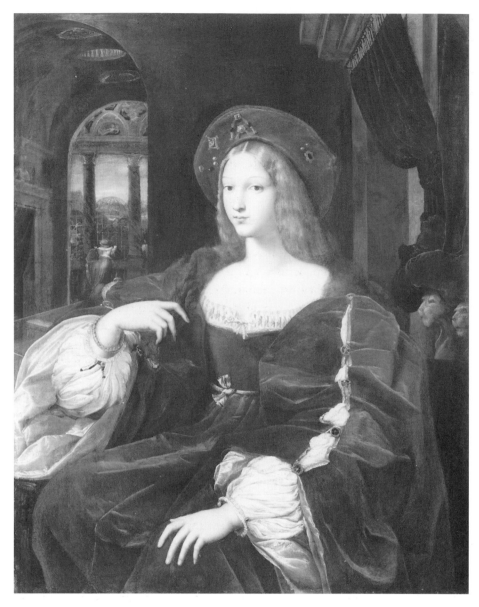

40 Raphael, *Portrait of Giovanna d'Aragona*, 1518

This is the representation of a lady who, through regal deportment and the elegance of gestures, shows the refinement and ease which are the visual expression of the aristocratic ideal set out in Baldassarre Castiglione's *Il Cortigiano*. Her image is the embodiment of those qualities which are indispensable for both men and women at court, *grazia* and *leggiadria*. The portrait of Giovanna

of Aragon met the demands of a society for which court etiquette and preoccupations with rules of behaviour had an ever-increasing importance.

The formula devised by Raphael and Giulio Romano was immediately successful and, through the cartoon and the various copies of the painting, *Giovanna of Aragon* became the prototype for the representation of wives of rulers – 'state portraits' where the sense of an individual presence is subsided in favour of a representation of authority and power. These are not personal portraits; intimacy is absent, personality does not matter, the sitter appears remote from the viewer, and in size, format and style these paintings are constructed around the needs of public display.[18]

The *Giovanna of Aragon* was certainly the model for the *Portrait of a Lady* (Figure 41), attributed to Giulio Romano and probably painted just after the arrival of the artist in Mantua in 1524. The relationship between the figure of the sitter and the space around it is similar, down to the inclusion of a door opening into another room, with a servant admitting three other women, in the background on the right of the sitter. Again, the expressionless, mask-like face is brightly lit and stands out against the dark background. The identity of the sitter is still uncertain. Traditionally, she has been identified as Isabella d'Este because of the rich and extravagant double-layered *camora* (gown) she is wearing, made of ropes of dark velvet edged in gold over a lavender-pink silk gown, in the interlace knot pattern, a device designed for her by Niccolò da Correggio. The sitter is wearing the head-dress Isabella herself had invented, the *zazara*. A rosary hanging from her belt also appears in another portrait of Isabella. In 1524, however, the Marchioness of Mantua was fifty years old, and her features in this picture do not correspond to her other known portraits, such as the profile drawing by Leonardo of 1499 in the Louvre, or the portrait by Titian of 1534–36 in the Kunsthistorisches Museum in Vienna. We know, however, that Isabella was not concerned with obtaining a likeness: after 1516 she decided that posing for portraits was tiring, and that she would not do it again. Her favourite portrait, which Titian painted when she was sixty, was executed from a now lost portrait by Francia, which had been in turn painted from yet another portrait. If the woman in the Giulio Romano portrait is not Isabella d'Este, she must be a lady of the highest rank in the Mantua court, perhaps Margherita Paleologo, who married Isabella's son, Duke Federico Gonzaga, in 1530.[19]

Titian, who would have seen Alfonso d'Este's cartoon of the *Giovanna of Aragon* on his visit to Ferrara in 1519, followed its conventions and adapted its format and compositional scheme for three commissions from aristocratic female patrons: the *Portrait of Eleonora Gonzaga*, Duchess of Urbino (1536–37) (Figure 42); the *Portrait of Giulia Varano*, wife of Guidobaldo II della

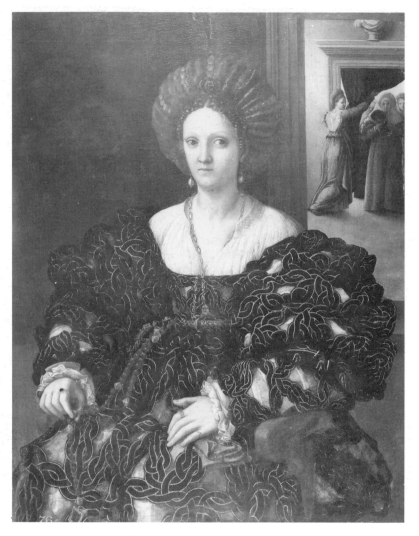

41 Giulio Romano, *Portrait of a Lady, c.* 1524

Rovere (Florence, Galleria Palatina, *c.* 1545–47); and the *Portrait of Isabella of Portugal,* wife of the Emperor Charles V (Madrid, Prado, *c.* 1544–45), which was painted after her death. The portrait of Eleonora Gonzaga, the daughter of Isabella d'Este, was painted as a pendant to the portrait of her husband, Francesco Maria della Rovere. While Francesco Maria's three-quarter length image shows him as a *condottiere,* standing, dressed in his armour, brandishing a general's baton from Venice, with the staffs of command from the Papal State and from Florence placed next to him, Eleonora's portrait illustrates the qualities which *decorum* saw as appropriate to a great lady belonging

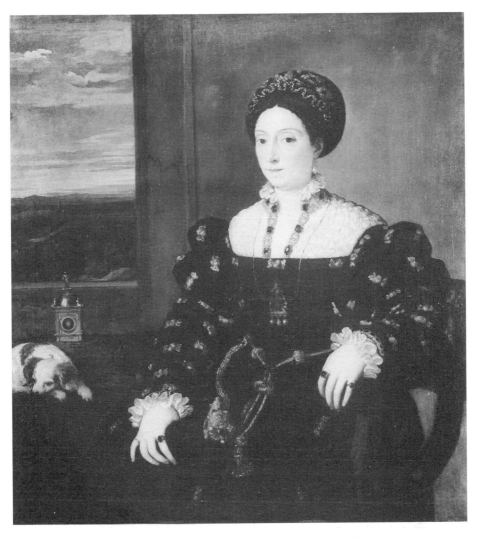

42 Titian, *Portrait of Eleonora Gonzaga*, 1536–37

to a noble family. The black and gold of her gown and head-dress are the heraldic colours of the Montefeltro, the dog and the clock on the table beside her could be fashionable status symbols, or could be read as symbols of fidelity, constancy and transience. The sonnets which Aretino wrote about these two portraits in a letter to Veronica Gambara, the Countess of Correggio, in November 1537 pay homage to the skill of the painter and to the merits and virtues of the couple. Through conventional courtly panegyric, Aretino praises the courage of the Duke 'which protects from danger / Italy, sacred to his manifest virtues', and mentions the 'awesomeness between his brows, / his fiery

109

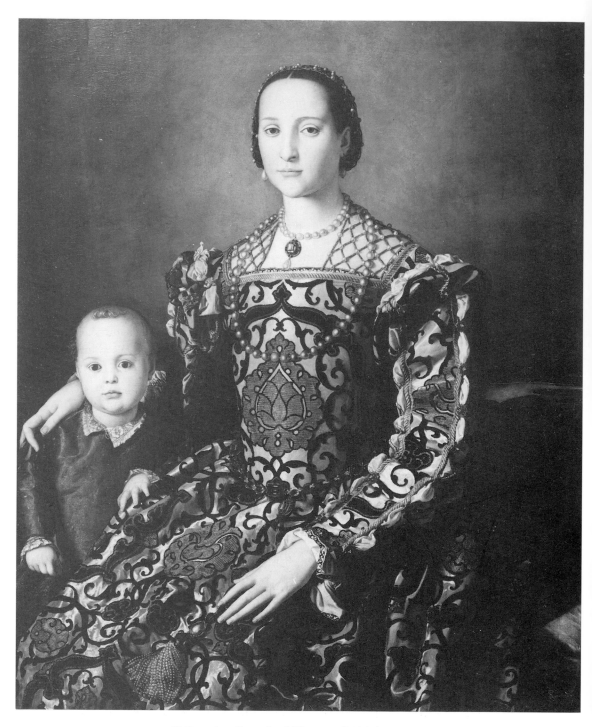

43 Bronzino, *Portrait of Eleonora di Toledo, c.* 1545

spirit' in the eyes of his painted image which 'reveals the victories held within his heart'. The portrait of the Duchess, on the other hand, 'expresses harmony ... and the good offices of her gentle spirit'. She appears in the painting as the embodiment of modesty and honesty, those virtues which characterise femininity, as she sits in silence, while 'chastity and beauty, eternal enemies, / are shown in her likeness, and on her brow / is seen the throne of the Graces'.[20]

The importance of the creation of an image and of myths surrounding the figures of rulers has no clearer example than the campaign of artistic patronage which the Duke and Duchess of Florence, Cosimo I de Medici and his wife, Eleonora of Toledo, actively promoted from the 1540s. In order to secure his hold on the territory, first of Florence and then of Tuscany, and to turn his title into a hereditary one, Cosimo, who belonged to a collateral line of the Medici family, used his power and wealth, and the talent of his court historians and of his court artists. They created for him images of strength, courage and military value, and for his wife of refinement, elegance and grace. Eleonora, who had married the twenty-year old Cosimo in 1539 when she was seventeen years old, was the daughter of the Spanish Viceroy of Naples. She brought to Florence the etiquette and formal manners of the Neapolitan court, and was instrumental in the display of power and stylishness necessary to Cosimo's aims. During the mid 1540s, the Medici court portrait painter, Bronzino, fashioned for her the image of the perfect ruler. His portrait of Eleonora, painted c. 1545, shows how Bronzino had learnt and adapted the lessons of Titian and Giulio Romano (Figure 43). It was obviously so successful that it was copied and adapted to different formats innumerable times. The Duchess is shown in three-quarter length, sitting against what at first seems a blue background, but which in fact is a brilliant sky over a distant landscape, visible on the right. The sky pales around her head, forming a halo of light. She sits with an arm around the shoulders of one of her sons, who has been tentatively identified as Giovanni, born in 1543, or as Francesco, her eldest son and heir to the title, born in 1541.[21] This, therefore, is a dynastic portrait which celebrates not only the Duchess, but also the mother of the future Duke, the heir on which Cosimo's hopes for a new Medici dynasty were founded. It is the first state portrait in which mother and child are shown together. As befits such a formal image, mother and son stare out of the picture, their heads and bodies almost fully frontal. Eleonora's hair is pulled back and held by a gold net decorated with pearls which highlights her face. The necklaces of large pearls reflect the light and complement the skin tones. Contemporary sources describe her beauty and her alabaster skin: the head painted by Bronzino is smooth, with no visible brushmarks, and the use of wood as a support rather than canvas contributes to produce an enamel-like surface. The left hand, elongated, with long, tapering

fingers, is stretched towards the pearl tassel which decorates the heavy gold belt studded with precious stones. This is an icon of power and elegance, and no emotional connection with the beholder is allowed to intrude.

The most striking element of this portrait, however, is the gown, which almost dominates the painting. Bronzino has reproduced with extreme precision and attention to detail a precious cream brocade with black cut velvet and gold bouclé floral motifs. The sleeves are cut, bordered with gold cord and decorated with gold buttons. Each fold, each pucker of the fabric, each gold thread, each different texture, is faithfully reproduced. Eleonora would have worn gowns of this kind only when attending special occasions, like court ceremonies organised for important guests, where a display of wealth and taste was crucial in the power game between rulers. This is a magnificent example of the best Florentine production of exclusive luxury textiles, and Bronzino's portrait would have helped to publicise to other Italian and European rulers the quality of the work carried out by Florentine craftsmen. Over forty silk weavers worked to fulfil the requirements of the ducal court, together with ten craftsmen specialised in the making of gold and silver thread. A workshop in the Palazzo Vecchio was set up exclusively for the weaving of the most precious textiles, such as gold and silver velvet brocade. The weaver was a woman, Francesca di Donato, who was called 'la tessitora della signora duchessa' as a sign of the importance of her work and of the esteem in which she was held. The gown painted with such a precision of detail in Eleonora's portrait did not in fact exist: Bronzino was given a piece of cloth to work from, and a sample in the Bargello shows almost exactly the same design.[22] In the precarious political stage of mid-sixteenth-century Italy, portraits had become essential instruments for the conquest and display of power.

The woman artist and self-portraits: Sofonisba Anguissola

Among all these representations of beauty and power, in which femininity is constructed and signified by rich clothes, jewellery and ornaments, flowers, marble-like skin and elegant, elongated fingers, it is perhaps surprising to find the image of a young woman dressed severely in dark clothes, paintbrush in one hand, mahlstick in the other, standing at an easel (Figure 44). Her hair is simply plaited and wound around her head, emphasising her wide forehead, and her only ornament is a small lace ruffle at the neck and at the wrists. In front of her are the tools of her work: a palette, brushes and a palette knife. On the easel is a small devotional painting representing the Virgin and Child. The artist's head is turned three-quarters towards the viewer, her large eyes

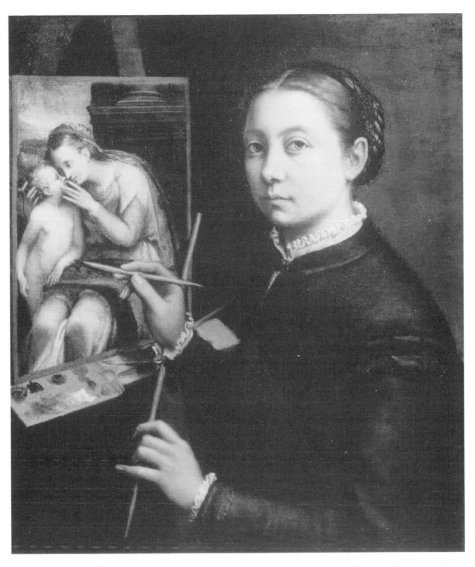

44 Sofonisba Anguissola, *Self-portrait at the Easel, c.* 1556

looking straight out of the canvas. She is Sofonisba Anguissola, born into a noble family in Cremona *c.* 1535, already so well known and so much admired by her mid-sixteenth-century contemporaries while she was still in her early twenties. In 1556, when this self-portrait was probably painted, she was certainly aware of her exceptional position in society as a woman artist. During the 1550s she produced a great number of self-portraits which range from miniatures to a large-scale painting in which she represented her teacher,

Bernardino Campi, painting her portrait – a painting within a painting (Siena, Pinacoteca Nazionale).[23] The self-portraits were essential instruments in the relentless efforts of her father, Amilcare, to publicise his daughter's talent, and were sent as gifts throughout Italy in order to solicit commissions. One was given to the Seneschal of the Duke of Ferrara, Ercole II d'Este, while another was sent to the daughter of the Duke, Lucrezia d'Este. Vasari saw a self-portrait by Sofonisba in the house of the archdeacon of Piacenza, and another in Rome in the Guardaroba of the palace of Cardinal del Monte, which he praised as 'very beautiful'. This painting had originally been given by Sofonisba to Pope Julius III as a gift. One of the most famous sixteenth-century *letterati*, Annibale Caro, also received a self-portrait as a gift, but it was then taken back. Caro wrote an angry letter to Amilcare to complain about this outrageous behaviour: perhaps he was not deemed worthy of keeping the painting 'because her things are for Princes'. This insult, he added, would not stop him from admiring Sofonisba's talent.[24]

What was the image of herself created by this woman artist for her prospective patrons? The identification of Sofonisba as the artist is emphasised in almost all these portraits. In a small self-portrait dated 1554 (Vienna, Kunsthistorisches Museum), the painter, not yet twenty, holds a book in her hand on which is written 'Sophonisba Angussola virgo seipsam fecit'. In a miniature (Boston, Museum of Fine Arts) she holds a roundel decorated with a cryptogram of her father's name, and the inscription 'SOPHONISBA ANGUSSOLA VIR[GO] IPSIUS MANU EX [S]PECULUM DEPICTAM CREMONAE': this young woman (*virgo*) has painted these pictures with her own hand. There are three versions of the self-portrait at the easel, one of which was probably painted by one of her sisters (Mentana, Collezione Federico Zeri).[25] Sofonisba's paintings, as Annibale Caro wrote to her father, are 'two marvels in one': the viewer admires both the picture because it represents a woman, and its maker, who is the woman herself. Sofonisba identifies herself not only as a *maraviglia* (wonder), but also as a *gentildonna*, an educated woman of high birth. In a self-portrait in Naples (Galleria di Capodimonte) she appears playing a spinet, an instrument associated with the accomplishments of a gentlewoman. The austerity of the clothes and the severity of the hairstyle, devoid of any ornament, underline her role as an exceptional woman, who wants to stress her education and her noble birth, but this time not for dynastic reasons. Furthermore, her wide forehead and her large eyes are significant features which recur in all her self-portraits: they are a sign of insight and of intellectual power.[26] A *maraviglia*, different from other women, but still virtuous and modest, the *gentildonna* Sofonisba Anguissola introduces a new aspect in the history of portraiture: that of the creative, intellectual woman, the active subject of the work.

Notes

1 This type of frame is discussed and illustrated in T. J. Newbery, G. Bisacca and L. B. Kanter, *Italian Renaissance Frames*, exhibition catalogue, The Metropolitan Museum of Art, New York, 1990, pp. 54–5.

2 The story about Isabella d'Este's portrait and the letter by Giovanni Maria della Porta are cited by L. Campbell, *Renaissance Portraits. European Portrait Painting in the 14th, 15th and 16th Centuries*, Yale University Press, New Haven and London, 1990, pp. 220–1.

3 M. Rogers discusses the different norms which guided male and female portraiture during the late fifteenth and the sixteenth centuries in 'Sonnets on Female Portraits from Renaissance North Italy', *Word and Image*, 2, 4, October–December 1986, pp. 291–305. She writes: 'Male portraits, like history or biography, present the social status and suggest the actions and virtues of the sitter, claim to deal with objective realities, and allow the spectator to admire only at a distance. Female portraits resemble lyric poetry, and they imply first and foremost portraits of beautiful women.' While this is true in some cases, it is by no means applicable to all portraits. Portraits of rulers, both male and female, were instruments used in the creation of myths which were often crucial for the survival and strengthening of a dynasty, while claiming 'to deal with objective realities'. The portraits of the Duke and Duchess of Florence, Cosimo I de Medici and Eleonora di Toledo, are a typical example of this. The display of social status, as well as beauty and 'virtue', is certainly of the greatest importance in portraits of women, whether aristocratic or not. Rogers rightly points out that there is a special category of female portraits where beauty is the *raison d'être* of the picture: 'their only essential characteristic is their beauty, experienced as if living by the spectator who is encouraged to enjoy an imaginary intimacy with them . . .'. In these paintings the women exist 'without a need being felt for a biographical context'. On the question of identity and idealisation, see also P. Simons, 'Portraiture, Portrayal and Idealization: Ambiguous Individualism in Representations of Renaissance Women', in A. Brown (ed.), *Language and Images in Renaissance Italy*, Clarendon Press, Oxford, 1995, pp. 263–311, esp. pp. 265–73.

4 M. Rogers, in 'Sonnets on Female Portraits', examining those sonnets written from the 1480s to the middle of the sixteenth century, asks whether the poets were merely following well-established literary conventions, or whether they were in fact responding to changes in painting style and technique. The emphasis on the relationship between image and spectator is characteristic of poems written in praise of images of beautiful women. Rogers notes that there is a difference in the poems written about state portraits, like Pietro Aretino's poem written in 1537 about Titian's portrait of Eleonora Gonzaga, where the virtues of the sitter are mentioned, rather than her physical attributes. See also two important articles by E. Cropper, 'On Beautiful Women, Parmigianino, Petrarchismo, and the Vernacular Style', *The Art Bulletin*, 58, 1976, pp. 374–94, and 'The Beauty of Woman: Problems in the Rhetoric of Renaissance Portraiture', in M. W. Ferguson, M. Quilligan and N. Vickers (eds), *Rewriting the Renaissance. The Discourse of Sexual Difference in Early Modern Europe*, University of Chicago Press, Chicago and London, 1986, pp. 175–90.

5 For an account of this portrait, see J. Walker, 'Ginevra de' Benci by Leonardo da Vinci', *National Gallery of Art, Report and Studies in the History of Art 1967*, Washington, 1968, pp. 1–38. The circumstances in which this portrait may have been commissioned are discussed by J. Fletcher in 'Bernardo Bembo and Leonardo's portrait of Ginevra de' Benci', *Burlington Magazine*, 131, 1989, pp. 811–16. Fletcher dates the portrait and discusses the symbolism of the device. Bernardo Bembo never paid for this portrait, nor did he take it with him to Venice, and Fletcher speculates that he may have given it to Ginevra. This portrait had previously been seen as an example of a betrothal or marriage commission. K. Clark (*Leonardo da Vinci. An Account of His Development as an Artist*, 1st ed. Cambridge University Press, Cambridge, 1939; revised ed. Penguin Books, Harmondsworth, 1959) states that 'most Florentine portraits of women were painted to celebrate their marriages' and dates the Ginevra de' Benci 1474 (pp. 28–9). M. Kemp, while noticing the device painted on the reverse, and commenting on Bembo's poems to Ginevra, also links the commission to her

wedding in 1474, and believes it to have been painted while Leonardo was still in Verrocchio's workshop. Kemp remarks on the 'unrelaxed intensity of visual concentration . . . in itself strongly reminiscent of Netherlandish art, above all the manner of Jan van Eyck's meticulous follower, Petrus Christus' (*Leonardo Da Vinci. The Marvellous Works of Nature and Man*, 1st ed. Dent, London, 1981; paperback ed. 1989, pp. 49–50). E. Cropper places this portrait within the Petrarchean tradition of representations of beautiful women, in 'The Beauty of Woman', pp. 183 ff. See also the observations made by M. Garrard in her 'Leonardo da Vinci. Female Portrait, Female Nature', in *The Expanding Discourse. Feminism and Art History*, Harper Collins, New York, 1992, pp. 59–85. Garrard links the unconventional character of Leonardo's portraits of women to his interest in the creative power of nature: 'By sustaining and concretizing the woman-nature metaphor, Leonardo acknowledged and symbolized in positive terms a realm of female power that the majority of men in his era could acknowledge only inversely, through the repressive strategy of declaring women inferior beings' (p. 79).

6 For the dating of the *Cecilia Gallerani*, see also M. Kemp 'Leonardo verso 1500', in *Leonardo & Venice*, exhibition catalogue, Bompiani, Milan, 1992, pp. 45–54, esp. pp. 45 ff. See also J. Shearman, *Only Connect . . . Art and the Spectator in the Italian Renaissance*, Princeton University Press, Princeton, NJ, 1992, pp. 118 ff. P. Simons analyses the portait of Cecilia Gallerani in 'Portraiture, Portrayal and Idealization' (pp. 277–83). She comments that 'the painting itself does little to resolve the question of who was the primary male viewer, husband or Duke, but rather contains enigmatic signals which invoke multiple audiences' (p. 279). Referring to the representation of the idealised Petrarchan woman, she adds that Cecilia's beauty 'becomes a sign for poetry and painting, arts coded as masculine in terms of social practice and as phallocentric in terms of their masterful assertion' (p. 283). For a detailed analysis, together with a discussion of the conditions of the paintings and of the techniques used by Leonardo, see D. Bull, 'Two Portraits by Leonardo: *Ginevra de' Benci* and the *Lady with an Ermine*, *Artibus et Historiae*, 25, 1992, pp. 67–83. For information on Cecilia Gallerani, her relationship with Ludovico il Moro and her position at court, see J. Shell and G. Sironi, 'Cecilia Gallerani: Leonardo's *Lady with an Ermine*', *Artibus et Historiae*, 25, 1992, pp. 47–66.

7 For Bellincione's poem on the portrait of Cecilia Gallerani, and the connections between Leonardo's works and contemporary poetry written in praise of women, see M. Kemp, 'Leonardo da Vinci: Science and the Poetic Impulse', *Journal of the Royal Society of Arts*, 133, February 1985, pp. 196–213. In the context of the role of *intelletto* (intellect) and *fantasia* (imagination) in Leonardo's thinking, Kemp writes that Leonardo's 'microcosm is simultaneously a poetic image and a scientific cause'. Kemp's examination of Leonardo's paintings is based on the important observation that 'Leonardo's relationship to contemporary poetry is not simply a matter of shared conventions . . . but rather a matter of deeply shared habits of mind. These habits of mind embrace such specific points as the position of the courtly woman in the Renaissance and the limits of rational knowledge, as well as the more general if less clearly defined sense of the way imagination feeds on science and vice versa.'

8 The most subtle and informative discussion of this complex painting is Martin Kemp's *Leonardo Da Vinci*, pp. 263 ff. Kemp suggests a dating between 1503 and 1506 for the cartoon. If the Louvre painting is the portrait seen by Antonio de Beatis in October 1517 during his visit at Cloux, Kemp supposes that 'the patron wished to possess the portrait simply as a beautiful picture by Leonardo rather than as a portrait of a specific person'. Kemp quotes Dante's *Convivio* in order to explain the importance of eyes and mouth in conveying emotion: 'The manifestation of the soul in the eyes and mouth "as if under a veil" is precisely what Leonardo is doing in this portrait . . . The lady's knowing reticence of expression also corresponds nicely to Dante's recommendation that a true lady's expression of good humour should be decorously modest and restrained, a recommendation which was repeated again and again in Renaissance writings on behaviour. The tone of Leonardo's portrait is, I believe, deeply imbued with Dantesque qualities and is fully in keeping with the poetic tradition which Dante largely instigated. This was the first painted portrait to be composed in the equivalent of the *dolce stil nuovo*, some two centuries or more after the debut of the "sweet new style" in poetry.' Shearman (*Only Connect*, pp. 121–3) relates the gaze, smile and turning posture of the *Mona Lisa* to the response of the viewer; in this portrait 'the spectator

has been contextualized with the subject, spatially as well as sympathetically'. Shearman goes on to say that, if Leonardo's intention was to represent an individual, this intention has not been fulfilled, because 'the expression, the smile, is not more particularized than its message'. D. Rosand ('Pensieri sul ritratto e la morte', in R. Pallucchini (ed.), *Giorgione e l'Umanesimo Veneziano*, Olschki, Florence, 1981, pp. 293–308) looks at the contrast between the representation of the young woman and the landscape background in which water, he writes, 'can be seen as the symbol and the acting principle of time' (my translation). Rosand places his observations within the context of Leonardo's writing about the destruction caused by the passing of time, and of Renaissance writings on portraiture, art and nature. On the confusion surrounding the information about the possible identity of the sitter and the dating for the Louvre portrait, see also the informative essay by D. A. Brown and K. Oberhuber, '"Monna Vanna" and "Fornarina": Leonardo and Raphael in Rome', in S. Bertelli and G. Ramakus (eds), *Essays Presented to Myron P. Gilmore*, (2 vols), La Nuova Italia, Florence, 1978, II, pp. 25–86.

9 A discussion of Raphael's Florentine portraits within the context of his work is in R. Jones and N. Penny, *Raphael*, Yale University Press, New Haven and London, 1983, pp. 29 ff.

10 For a detailed analysis of the Agnolo and Maddalena Doni portraits, see *Raffaello a Firenze*, *Dipinti e Disegni delle Collezioni Fiorentine*, exhibition catalogue, Electa, Florence, 1984, pp. 105–18. In the same catalogue, see also the entry on *La Gravida* (pp. 99–104) and on another portrait attributed to Raphael, the *Elisabetta Gonzaga* in the Uffizi in Florence. Of the two Doni portraits, the *Maddalena* is believed to have been painted first because an X-ray examination reveals how initially the figure had been placed in an interior, with a landscape visible through a window on the left. This solution was then abandoned by Raphael. F. Zeri and M. Gregori link to these two portraits a portrait cover in Florence (Depositi della Sovrintendenza), decorated with *grottesche*, a burning lamp, a mask and a motto, SUA CUIQUE PERSONA (to each his own mask) (*Raffaello a Firenze*, p. 32). Vasari writes that Agnolo Doni had commissioned a series of panels with *grottesche* for one of the rooms in his palace from a painter specialised in this type of work, Morto da Feltre (Vasari – Milanesi V, p. 204), showing therefore a preference for this fashionable decoration. Whether this panel can be related to the Doni portraits or not, it is interesting to note here the growing use, during the sixteenth century, of sliding painted portrait covers (*coperchio a tirella*), either on wood or canvas, which were inserted in the frame and pulled aside to reveal the painting. Mirrors were often framed and covered in a similar way, and this type of frame was called '*ornamento a forma di sfera*'. These covers seem to have increased in popularity with the disappearance of the hinged portrait diptych. For example, for a portrait by Pontormo, now lost, Bronzino painted a cover with the myth of Pygmalion and Galatea, now in the Palazzo Vecchio in Florence (see *Palazzo Vecchio. Committenza e Collezionismo Medicei*, exhibiton catalogue, Electa, Florence, 1980, pp. 257–8; Campbell, *Renaissance Portraits*, pp. 65–7 and 225, and Newbery *et al.*, *Italian Renaissance Frames*, pp. 54–5 and 64–5).

11 For the attribution of *The Deluge*, painted on the reverse of the *Agnolo Doni* portrait, see *Raffaello a Firenze*, pp. 108, 111, n. 54–8. *The Rebirth of Mankind* was painted on the reverse of the *Maddalena Doni* (*Raffaello a Firenze*, p. 117, and illustrations 40 and 42).

12 The lower part of the painting has been cut; originally, it would have included the sleeve, lying parallel to the picture plane. For a full discussion of this painting and of its interpretations, see the entry by A. Ballarin in *Le Siècle de Titien. L'age d'or de la Peinture à Venise*, exhibition catalogue, Reunion des Musées Nationaux, Paris, 1993, pp. 332–7. E. Verheyen, 'Der Sinngehalt von Giorgiones Laura', *Pantheon*, 26, 1968, pp. 220–7, states that this painting is an allegory of marriage, but J. Anderson, placing it in the context of portraiture in Venice, writes that 'in the circumstances, it is difficult to envisage that Giorgione's *Laura* would have been commissioned . . . to illustrate an abstruse allegory on marriage' ('The Giorgionesque Portrait: from Likeness to Allegory', in F. Pedrocco (ed.), *Giorgione. Atti del Convegno Internazionale di Studio per il V Centenario della Nascita*, 29–31 Maggio 1978, Banca Popolare di Asolo e Montebelluno, Castelfranco Veneto, 1979, pp. 153–8). P. Humfrey questions the 'reality' of the woman represented in the painting, pointing out that 'the laurel motif unavoidably associates her with an ideal figure of the past'. Humfrey perceptively

117

writes that 'Giorgione's own Laura provides an image of the beloved that at once transcends the limiting particularity of real portraiture, while at the same time evoking the living presence with an unprecedently sensuous immediacy' (*Painting in Renaissance Venice*, Yale University Press, New Haven and London, 1995, p. 126). A. C. Junkerman in 'The Lady and the Laurel: Gender and Meaning in Giorgione's "Laura"', *Oxford Art Journal*, 16, 1, 1993, pp. 49–58, interprets Laura's red fur-lined garment as a man's cloak, and writes that 'the evidence of the robe allows us to try out an identity for this woman as a poet' (p. 54). See also E. M. Dal Pozzolo, 'Il Lauro di Laura e delle "maritate Venetiane"', *Mitteilungen des Kunsthistorisches Institut in Florenz*, 37, 1993, pp. 257–92.

13 On Bartolomeo Veneto's *Flora* see Simons, 'Portraiture, Portrayal and Idealization', pp. 299 ff.

14 D. A. Brown discusses the development of a group of paintings of provocative half-figure nudes (Brown and Oberhuber, '"Monna Vanna"', pp. 29–37). For a full analysis of the literary and art-historical tradition of the *Flora* as a nymph and a courtesan, see J. S. Held, 'Flora, Goddess and Courtesan', in M. Meiss (ed.), *De Artibus Opuscola XL. Essays in Honor of Erwin Panofsky*, 2 vols, New York University Press, New York, 1961, I, pp. 201–218. Held examines the meaning of flowers as symbols of love, youth and delight, and states that in the paintings produced in Leonardo's circle, 'the flowers are obvious symbols of the pleasures the figure herself has to bestow'. Held places these pictures in the context of the history of prostitution in Venice during the sixteenth century. E. H. Mellencamp demolishes the belief that Titian's *Flora* is the representation of a bride in her wedding dress, showing that the garment she wears is in fact a *camicia*, and that such a flowing, full-length undergarment was 'the basic costume of the theatrical nymph' ('A Note on the Costume of Titian's *Flora*', *The Art Bulletin*, 51, 1969, pp. 174–7). See also M. Rogers, 'Reading the Female Body in Venetian Renaissance Art', in F. Ames-Lewis (ed.), *New Interpretations of Venetian Renaissance Painting*, Birkbeck College, London, 1994, pp. 77–90. A. C. Junkerman sees Giorgione's *Laura* as the prototype of the very successful 'sensuous half-length images'. She analyses Titian's so-called *Flora* and a large number of these paintings in her '*Bellissima Donna*: An Interdisciplinary Study of Venetian Sensuous Half-Length Images of the Early Sixteenth Century', doctoral dissertation, University of California, Berkeley, 1988.

15 The problem of the absence of female portraits in Venetian painting is related to the role of women in Venetian society and is the subject of an interesting and lengthy discussion by A. C. Junkerman in her '*Bellissima Donna*', pp. 133–73. P. Humfrey mentions two Venetian female portraits, both representing exceptional women: Gentile Bellini's portrait of Caterina Cornaro, Queen of Cyprus, and Carpaccio's portrait of the Tuscan poetess Girolama Corsi Ramos. He notes, however, that 'these celebrities and courtiers are exceptions that prove the rule; and, in general, the subordinate role played by women in Venetian society, and the traditional Venetian emphasis on male lineage, meant that they were not considered suitable subjects for an art-form that in Venice still fulfilled a mainly social function' (*Painting in Renaissance Venice*, p. 107).

16 D. Herlihy, in 'Popolazione e strutture sociali dal XV al XVI secolo', *Tiziano e Venezia* Convegno Internazionale di Studi, Venezia, 1976, Neri Pozza Editore, Vicenza, 1980, pp. 71–4, suggests that the eroticised representation of women in Venetian painting may be related to the decreasing incidence of marriages, and therefore to the growing numbers of single men and women during the sixteenth century and what he calls 'the culture of single men'. See also Simons, 'Portraiture, Portrayal, and Idealization', pp. 292–3.

17 See Cropper, 'The Beauty of Woman', pp. 178 ff., for a summary on the different interpretations of Titian's *La Bella*. R. Zapperi, in his article 'Alessandro Farnese, Giovanni della Casa and Titian's *Danae* in Naples', *Journal of the Warburg and Courtauld Institutes*, I, 54, 1991, pp. 159–71, defines *La Bella* as 'undoubtedly a portrait of a courtesan' (p. 168), and goes on to say that 'the parallelism between the nude woman and the clothed one, the *Venus of Urbino* and *La Bella*, both showing the features of the same courtesan, brought about a *de facto* reintroduction of the close connection between love and sensuality which the Petrarchan tradition had sought to dissolve'.

18 For a full treatment of state portraits, see M. Jenkins, *The State Portrait, its Origins and Evolution*, Monographs III, College of Art Association of America, New York, 1947. The

terms *manieroso* and *artificioso*, which in the sixteenth century were positive and compliment-ary, and denoted stylishness and elegance, are examined by J. Shearman in the context of stylistic developments of sixteenth-century art, in *Mannerism*, Penguin Books, Harmondsworth, 1967, pp. 18 ff. On the portrait of Giovanna of Aragon, see *Raphael dans les Collections Françaises*, exhibition catalogue, Reunion des Musées Nationaux, Paris, 1984, pp. 98 ff., and the entry by Sylvia Ferino in *Giulio Romano*, Electa, Milan, 1989, p. 275.

19 Giulio Romano's *Portrait of a Lady* is analysed by J. T. Martineau in *Splendours of the Gonzaga*, exhibition catalogue, Amilcare Pizzi, Milan, 1981, pp. 160–2.

20 For the portrait of Eleonora Gonzaga, see the entry in M. Gregori (ed.), *Tiziano nelle Gallerie Fiorentine*, exhibition catalogue, Centro Di, Florence, 1978, pp. 121 ff., and also the entry in *Titian. Prince of Painters*, exhibition catalogue, Marsilio Editori, Venice, 1990, pp. 220–2. Aretino's poem on Eleonora's portrait is quoted in translation on p. 220. P. Simons discusses the construction of masculinity and femininity in the *Eleonora Gonzaga* and its companion, the *Francesco Maria della Rovere*, and analyses Aretino's poem on the two portraits in an interest-ing article, 'Alert and Erect: Masculinity in some Italian Renaissance Portraits of Fathers and Sons', in R. C. Trexler (ed.), *Gender Rhetorics. Postures of Dominance and Submission in His-tory*, Medieval & Renaissance Texts and Studies, Binghamton, NY, 1994, pp. 163–75. While stressing the feminine qualities and attributes in the portrait of the Duchess, Simons also sees ambiguities: 'the passive, domesticated lapdog might suggest not only the expected fidelity but also the carnality of her sexual nature . . . Eleonora's very fine and rich girdle just happens to fall on her lap in a manner which outlines a shape reminiscent of a vulva' (pp. 174–5).

21 The portrait of Eleonora di Toledo is analysed by K. Langedijk in *The Portraits of the Medici*, 3 vols, SPES, Florence, 1981–87, I, pp. 98 ff. Langedijk identifies Eleonora's son in the portrait as Francesco, from a comparison with the various portraits of the young Medici princes. She also mentions that the 1553 inventory of the Guardaroba lists 'a portrait of the Duchess and of Don Francesco, Braccia 2'. She links the 'immobility of the duchess' and the 'serenity of the sky' to concepts of *serenitas* and *tranquillitas*, qualities which were attributed to rulers. On Eleonora di Toledo, her life and her personality, see G. Pieraccini, *La Stirpe dei Medici*, 3 vols, Nardini Editore, Florence, 1st ed. 1924, repr. 1986, II, pp. 55–70.

22 The gown represented in the Bronzino portrait is discussed in an essay by R. Orsi Landini, 'L'amore del lusso e la necessità della modestia. Eleonora fra sete e oro', in *Moda alla corte dei Medici. Gli abiti restaurati di Cosimo, Eleonora e don Garzia*, exhibition catalogue, Centro Di, Florence, 1993, pp. 35–45. See also, in the same catalogue, G. Lazzi, 'La moda alla corte di Cosimo I de' Medici', pp. 27–34. The importance of textiles and of fashion in the power structure of the ducal court in Cinquecento Florence is assessed by R. Bonito Fanelli in 'I drappi d'oro; economia e moda a Firenze nel Cinquecento', in AA. VV., *Le Arti del Principato Mediceo*, SPES, Florence, 1980, pp. 407–26.

23 For a discussion of this painting, which has been dated on stylistic ground *c.* 1559, see Garrard, 'Here's Looking at Me', Renaissance Quarterly, Fall 1994, 47, 3, pp. 556–622.

24 Letters and documents concerning the life and career of Sofonisba Anguissola are in *Sofonisba Anguissola e le sue sorelle*, exhibition catalogue, Leonardo Arte, Milan, 1994, pp. 361–402, while contemporary printed sources on this artist are on pp. 403–11.

25 The self-portrait at the easel is very similar, in pose and composition, to that by the Flemish artist Catharina van Hemessen, dated 1548 (Basle, Oeffentliche Kunstsammlung), who also painted in the same year the portrait of a young girl playing the virginal (Cologne, Wallraf-Richartz Museum). It is unlikely that Sofonisba would have seen these paintings, but she would have probably known about the work of this artist from Antwerp. We might speculate whether this exceptional image of a woman painter at the easel had been reproduced through the medium of print. On Catharina van Hemessen, see A. Sutherland Harris and L. Nochlin *Women Artists 1550–1950*, Alfred Knopf, New York, 1976, p. 105. Valerio Guazzoni writes that the girl playing the virginal is not the painter, but her sister. He suggests the two paintings could have originally formed a diptych celebrating the skills of these two sisters in painting and in music (*Sofonisba Anguissola e le sue sorelle*, p. 330). It is interesting to note that Catharina went to work in Spain for Mary of Hungary in 1556, just a few years before Sofonisba.

26 Angela Ghirardi points out that the spinet denotes an educated and virtuous woman, while the lute appears in paintings representing courtesans or women of dubious morals ('Lavinia Fontana allo specchio. Pittrici e Autoritratto...', *Lavinia Fontana 1552–1614*, exhibition catalogue, Museo Civico Archeologico, Bologna, 1994, p. 42). Ghirardi emphasises the importance of Baldassarre Castiglione's *Il Cortegiano* as a model for educated gentlewomen. See also Garrard, 'Here's Looking at Me', pp. 589 ff. The motif of the wide forehead and large eyes in the self-portraits of Dürer, Leonardo, Parmigianino and Sofonisba Anguissola was discussed by Mary Rogers, in 'The Artist as Beauty' (unpublished paper).

CHAPTER FOUR

FEMALE NUDES IN RENAISSANCE ART

❊

How 'obvious' are the subject matter and functions of fifteenth- and sixteenth-century images in which representations of female nudes appear? What kind of emotional responses did these paintings provoke? What was considered erotic during the fifteenth and sixteenth century? Did contemporary viewers, for instance, see these nudes first and foremost as erotic or pornographic pictures? Did they perceive a difference between 'erotic' and 'pornographic' images? What were the intentions of the painters who produced these images? Answering these questions is not as easy at it seems. We cannot expect twentieth-century responses to the nude and to erotic images to be similar to those of fifteenth- and sixteenth-century viewers. In fact, it is impossible to reach a definition of what is 'erotic' or 'pornographic' outside a particular cultural context. Sex is not just a matter of human biology, and the conditions for sexual arousal are cultural as well as biological. Even within the period examined by this book, attitudes to sex, to sin, to the nude and to the representation of the nude changed considerably, and the writings by churchmen, theorists and artists during the Counter-Reformation alert us to reactions concerning images of nudity which respond to different sensibilities. For the modern viewer, the nudes painted by Giorgione and Titian may seem more sensuous and erotic than the fifteenth-century nudes painted inside the lids of *cassoni*. We may respond to the way the artist imitates with oil paint the softness and texture of the skin and of the hair, to the way he has arranged the body on the canvas, to the devices he has used in order to invite the gaze of the viewer. We may find the pose of a fifteenth-century nude painted inside a *cassone* lid awkward, and the conventions used in the representation of the human body distancing and

121

less enticing, but our perceptions were not necessarily shared by contemporary viewers. The Dominican Girolamo Savonarola obviously found these images dangerous, and he condemned in his sermons those 'very dishonest figures, naked girls and men' which were kept in many houses and which decorated *lettucci* (day-beds) and *lettiere* (beds), since he believed that such lascivious pictures could corrupt those who saw them. Many of the paintings burnt in the bonfires of the vanities (*bruciamenti delle vanità*) during the Carnival of 1496 in Florence would have belonged to this type.[1]

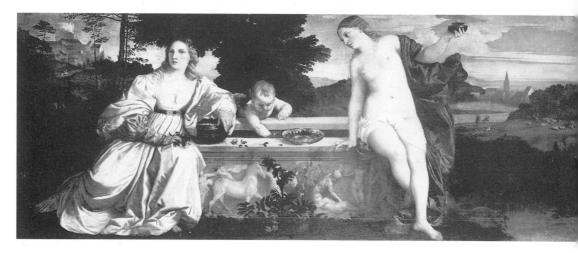

45 Titian, *Sacred and Profane Love, c.* 1514

The nude: meanings and interpretations

Visual evidence is, by its very nature, often very ambiguous, and when there is no clear written evidence, the historian can only speculate, guided by an understanding of the cultural climate in which the paintings were commissioned and executed. All historians agree in identifying as Venus the nude figure, accompanied by Cupid, that sits on a well decorated with antique reliefs in Titian's so-called *Sacred and Profane Love* of *c.* 1514 (Figure 45). But who is the woman dressed in a white gown? According to one authoritative interpretation, the two women represent two aspects of the goddess of love, respectively the Celestial Venus (platonic love) and the Terrestrial Venus (sensual love). Nakedness stands here for the purity of spirituality. Celestial Love carries a flaming vase because it is more passionate, while Sensual Love wears a rich and ornate gown. Other historians believe that the subject matter of this

122

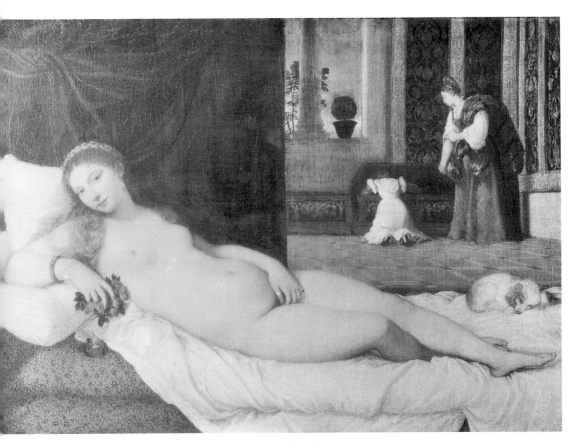

46 Titian, *Venus of Urbino*, 1538

picture derives from a well-known work, the *Hypnerotomachia Poliphili* by Francesco Colonna, published in Venice in 1499. According to this reading of the painting, Venus (the naked woman) is shown listening to the tale of the heroine, Polia. Yet another reading suggests that the painting could be, more simply, a marriage picture, with the naked Venus accompanying an idealised portrait of a bride wearing a garland of myrtle, the plant sacred to the goddess of love and associated with marriage. Convincing evidence, such as the coat of arms which appears on the relief, links this picture to the marriage of Niccolò Aurelio and Laura Bagarotto, which took place in Venice in 1514.[2]

In Titian's *Venus of Urbino* (Figure 46) the subject matter and the format recall those fifteenth-century nudes painted inside the lids of *cassoni*. Who is the nude woman, who lies on the bed in a sixteenth-century setting, looking seductively towards the viewer? What was the function of this picture? When we turn to documentary evidence for an answer, we find that the evidence is

not easy to assess. Guidobaldo della Rovere bought this picture from Titian in 1538, the year in which he became Duke of Urbino.[3] He calls it *la donna nuda* in a letter to his agent in Venice. The sale was being delayed because Guidobaldo could not afford to pay the painter, and he was worried that Titian would sell the picture to somebody else. Vasari saw this painting in Pesaro in 1548, and described it as *una Venere giovanetta*, even if the nude does not have any of the usual attributes which identify Venus. This painting, like the *Sacred and Profane Love*, has been interpreted as a marriage picture. The woman, as Vasari writes, could be Venus, personifying aspects of love within marriage. The little dog curled up on the bed would then be a symbol of fidelity, while the two *cassoni* in the background and the myrtle plant on the windowsill would provide other references to marriage. This picture, however, was painted four years after Guidobaldo's marriage to the eleven-year-old Giulia Varano. Was Vasari mistaken in his identification? The contemporary setting and the absence of attributes distance the image from mythology, and according to another interpretation this picture represents in fact 'just' the seductive image of a naked woman. Visual and documentary evidence do not seem to be sufficient to reach a satisfactory solution to the problems raised by this picture.[4]

In the case of Giorgione's *Sleeping Venus*, the prototype for all the Venetian reclining nudes of the Cinquecento, the meaning has been obscured for the modern viewer by the vicissitudes of the painting. Marcantonio Michiel saw it in 1525 in the house of Girolamo Marcello at San Tomado in Venice, and described it as 'the canvas representing Venus, nude, sleeping in a landscape with Cupid'. Michiel added that the nude 'is by Giorgio di Castelfranco; but the landscape and the Cupid were finished by Titian'. Traces of a Cupid sitting at Venus's feet and holding an arrow, still visible through X-ray photography, were painted over during the nineteenth century. A seventeenth-century description by Carlo Ridolfi mentions that Cupid also held a small bird in his hand. Not only did the presence of Cupid help to identify the nude as the goddess of love, but the bird – if Ridolfi was right – would have provided a witty erotic pun on the words '*uccello*' (bird) and '*passerotto*' (sparrow), which are colloquial terms for 'penis'. It is possible that the *Sleeping Venus*, with the suggestive position of the hand of the goddess which does not hide the genitals but brings attention to them, belongs to the tradition of epithalamic paintings, and that it was commissioned for the marriage of Girolamo Marcello and Morosina Pisani in 1507.[5]

Contemporary responses to the nude

In an attempt to reconstruct the intentions which guided the patrons and the painters, and to understand the functions of these paintings and the way in

which these images were seen, we have to look for the scarce surviving written evidence. Letters may provide us with useful insights, but these voices have to be understood and interpreted. Some letters were written merely to convey information, and in these we may find observations which illustrate, to a certain extent, the direct reactions of the viewer in front of a painting. Other letters were constructed around self-conscious expositions of contemporary ideas about art; they were often written following the conventions of literary models of descriptions of works of art (*ekphrasis*), rich with references to classical sources and *topoi*. These letters are also very useful, because they can give us an impression of another, less spontaneous, way of seeing, through the learned comments and elaborations of meaning of the culturally sophisticated sixteenth-century public in front of a picture.

No woman has conveniently left her observations, in a letter, on the representation of the nude, and the few comments made by men on women's reactions have to be viewed with caution, as they are probably evidence of conventions linked to literary fashions rather than truthful accounts of actual events. In an erotic-satirical work written in France in the 1580s, *Les Dames Galantes*, Pierre de Bourdeille, Seigneur de Brantôme, describes how the rich Florentine Ludovico di Ghiaceti took a group of ladies to see a collection of paintings of erotic subjects. One of them, after examining the paintings, could not control her excitement any longer, and rushed off to satisfy her desire with her escort. 'Such paintings and pictures do more harm to delicate minds than people realise', Brantôme sighs, ironically. On women's reactions to the *male* nude, Brantôme mentions the disparaging comments of a lady on the size of the genitals of the Farnese Hercules at Fontainebleau.[6] Vasari writes that in Florence an altarpiece by Fra Bartolomeo, representing St Sebastian, had to be removed from the church in which it was displayed: it had such a 'sweet air', that it caused all the women who saw it to sin because of its 'beauty and the lascivious imitation of life' (*leggiadria e lasciva imitazione del vivo*). In Rome, a '*bella gentildonna*' objected to the genitals of the figure of Mercury, painted by Raphael and his assistants in the entrance *loggia* of the villa of Agostino Chigi, and she asked Raphael to hide the 'shameful part' (*vergogna*).[7]

Isabella d'Este and the nude

Images representing nude women, whether painted to mark the occasion of a marriage or not, were, of course, almost always commissioned by male patrons. One of the rare exceptions is the patronage of Isabella d'Este, the Marchioness of Mantua. In her *studiolo*, nudes appeared in the mythological paintings

commissioned from Mantegna (*Parnassus* and *Expulsion of the Vices*), Lorenzo Costa (*The Reign of Comus* and *Allegory of the Court of Isabella d'Este*), Perugino (*Battle of Love and Chastity*), and Correggio (*Allegory of Vice* and *Allegory of Virtue*). These were executed from the 1490s to the 1520s, the last two for her new *studiolo* in the Corte Vecchia.[8] This group of paintings, which illustrate moralising subjects, were commissioned to provide an edifying comment on the strength of virtues and on the nature of love and of the arts. As Isabella wrote in a letter to her agent in Venice, Michele Vianello, she wanted from Giovanni Bellini 'an antique subject with a beautiful meaning'. In another letter, this time to Agostino Strozzi, Abbot of Fiesole, she complained that Perugino, who had been given strict and complex instructions for his *Battle of Love and Chastity*, was painting 'a certain nude Venus and she was meant to be clothed and doing something different. And this is just to show off the excellence of his art.'[9] It can be safely assumed that Isabella's intention was not to create a decorative scheme centred around an erotic display of the nude body, even if Mantegna's *Parnassus* reveals a subtle erotic wit. Correggio's two *Allegories*, however, commissioned at a later stage, are very different in style from the other pictures, and his soft and fleshy figures brought a note of open sensuality and eroticism to Isabella's new *studiolo*.[10]

Isabella herself was addressed as the embodiment of the naked Venus in a poem written by the court physician and humanist Battista Fiera, probably about Mantegna's *Parnassus*. Fiera had later to apologise for his inappropriate comparison, as he had overlooked that, in the painting, the adulterous Venus is accompanied by her lover Mars, while her enraged cuckholded husband, Vulcan, looks on.[11]

Erotic prints

Prints, being relatively cheap to produce and easy to distribute, opened up to a much larger public than the elite (who could commission paintings) the possibility of owning images of erotic and pornographic subjects.[12] This area is unfortunately difficult to document because of the ephemeral quality of the objects themselves. There were, of course, prints of different qualities and prices, sold in shops and by travelling sellers. Each edition would have probably run into several hundreds. We do not know exactly who the buyers were, but we can presume that they belonged to different social categories. Vasari, writing about what was and is perhaps the most famous series of erotic prints, Giulio Romano's *Modi* (Postures), sixteen positions of sexual intercourse engraved by

Marcantonio Raimondi in 1524, tantalisingly states that the prints were found in 'those places one would have least suspected'. And Pietro Aretino, who had added his *Sonetti Lussuriosi* to the prints for a second edition in 1525, sent to Cesare Fregoso 'the book of sonnets and the lustful figures that you so desired'. It was probably to the *Modi* that Federico Gonzaga, the Marquess of Mantua, referred in a letter to Aretino, when he thanked him for some sonnets and illustrations he had received. The series and its popularity worried Pope Clement VII to such an extent, that he sent Marcantonio Raimondi to prison and ordered the plates and prints to be destroyed. Vasari, who disapproved of the whole enterprise and called the sonnets '*disonestissimi*', tells us that Giulio Romano escaped the Pope's wrath only because he had already left Rome for Mantua. Marcantonio Raimondi's life, Vasari writes, was spared through the intervention of the Cardinal de Medici and of the sculptor Baccio Bandinelli. Obviously, some copies escaped: Brantôme mentions that a '*bella e onesta donna*' he knew kept, with her husband's consent, an illustrated copy of the Aretino book. He also writes that from his Parisian shop the Venetian printer called Bernardino Torresani, a relative of Aldo Manunzio, sold 'in less than a year more than fifty sets of the two volume Aretino to many men, married and unmarried, and also to some women'.

Fragments of the *Modi* still exist in the British Museum, and the series is known to the modern viewer through a group of fourteen woodcuts, probably printed in Venice in 1527. The protagonists of these sexual encounters are idealised *all'antica* types rather than individuals, even if Aretino gave the images a topical and provocative flavour by mentioning, in his sonnets, well-known courtesans and famous men. In these images, the women are anything but passive objects of the sexual desire of men: they reciprocate every gesture and every caress, they actively seek and give pleasure.[13]

The nude in interiors: frescoes and easel paintings

We have already seen how in the fifteenth century reclining male and female nude or almost nude figures were painted on the inside of *cassone* lids with apotropaic functions: these were images which were believed to possess an almost magical power to influence conception and ensure beauty for the offspring. Towards the end of the fifteenth century nudes come out from inside the *cassoni* to find their place on the walls of the bedroom (*camera*). These decorative panels were obviously very successful. Vasari mentions that Botticelli 'in many houses around the city . . . painted in his own hand . . . many naked

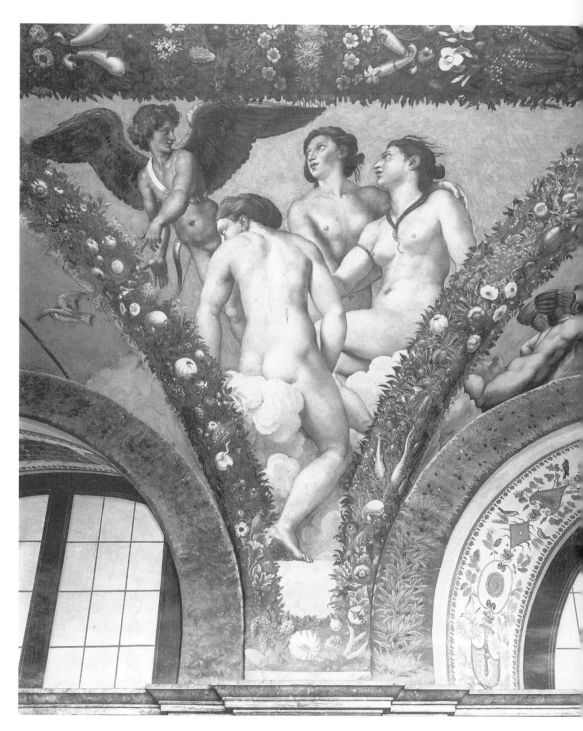

47 Raphael, *Cupid and Three Graces, c.* 1518

128

women', and a number of different representations of the naked Venus were produced in Botticelli's workshop during this period. These were based on the model of the *Venus pudica*, such as the *Venus* now in the Galleria Sabauda, Turin.

From the beginning of the sixteenth century images of female nudes, usually in the context of mythological narratives, were to be found in a number of different locations, from the private apartments and bedrooms of aristocratic and wealthy patrons to the bathrooms of cardinals. These erotic nudes were sometimes used in an attempt to recreate the mood and subject matter of the lost paintings of the ancient Roman world. The fresco decoration of the Roman *villa suburbana* on the Tiber belonging to the Sienese banker Agostino Chigi, carried out by Raphael and his workshop from 1512, is a good example of the taste for this type of painting. It brings together antique sources for its subject matter and the delight in the representation of the naked body in a building dedicated to pleasure and relaxation. The two *logge* of this villa surrounded by gardens were adorned by Raphael's *Galatea* and by the *Stories of Love and Psyche*, the latter derived from *The Golden Ass* by Apuleius. These frescoes created a perfect setting for entertainments such as the festivities of August 1519 attended by Pope Leo X and by twelve cardinals, on the occasion of the marriage of Agostino Chigi with his Venetian mistress, Francesca Ordeaschi, and of the legitimisation of their two sons. The mood of eroticism of the *Stories of Love and Psyche* was perfectly captured by Giovanni da Udine, who painted witty visual puns based on references to fertility and the sexual symbolism of fruit and vegetables within the garlands framing the stories. Above the stretched hand of a flying Mercury is what Vasari calls a *capriccio*: a phallic marrow, with two aubergines as testicles, penetrating a ripe, open fig.[14] The nudes in the *Stories of Love and Psyche* frescoes (Figure 47) painted by Raphael's assistants Giulio Romano and Francesco Penni, were criticised by Vasari for lacking grace and sweetness (*grazia* and *dolcezza*), and they have been further obscured by nineteenth-century restorations and repaintings.[15] Their sensuality is still conveyed by the numerous red chalk drawings made for some of the figures. These studies are remarkable for the rendering of the softness of the flesh and for the way in which they fuse idealisation with a naturalism which has prompted the suggestion that some of these are, unusually for the time in central Italian art, studies from actual nude female models.[16]

The erotic images which, it seems, existed in public places, like bathhouses (*stufe*), inns and brothels have of course long since disappeared. Of these 'dishonest images' we can gain an impression from a comic set-piece in Aretino's *Ragionamenti della Nanna e della Antonia*, where his character Nanna describes the erotic paintings in the convent where she was a nun.

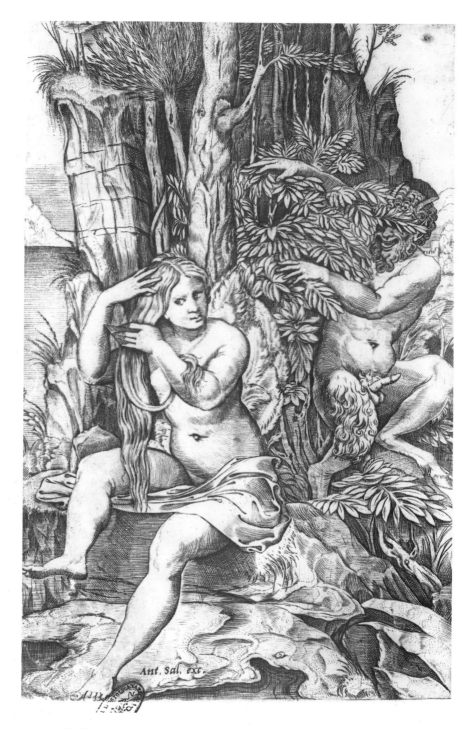

48 Marcantonio Raimondi or Marco Dente da Ravenna, *Pan and Syrinx*

Bathrooms decorated with erotic images were also appreciated by a different public. Raphael planned the decoration for the bathroom (*stufetta*) of his close friend, Cardinal Bernardo Dovizi da Bibbiena, in his apartment in the Vatican Palace, for which the Cardinal himself wrote the iconographic programme. The frescoes were painted by Raphael's assistants, including Giulio Romano, during the spring and summer of 1516. The *stufetta* is a small vaulted room, redolent of ancient Rome, with its *grottesche*, its marble reliefs and its niches. Here Cardinal Bibbiena was planning to place a statuette of Venus, coveted by Pietro Bembo who, in a letter to the Cardinal, writes that Raphael could not fit it in the *stufetta*. Bembo asks for the statuette, saying that he will place it in his *camerino*, and that he will 'desire [her] every day with more delight, than you ever could, because you are constantly occupied'. The now damaged mythological scenes, known to us also through a series of engravings by Marco Dente and Marcantonio Raimondi, centre around the figure of Venus. She is seen stepping on her shell while turning her back to the viewer; lying between Adonis's knees while he caresses her breast; wounded by Cupid's arrow; and carried by a sea-monster. A fresco showing Venus with one leg raised, extracting a thorn from her foot, is known only from an engraving. Another, in which Pan, with an erect penis, ogles a nymph who sits combing her hair with her legs apart, has been defaced by scratches (Figure 48). These erotic images would have delighted Cardinal Bibbiena, a man who was not only a learned humanist familiar with neoplatonic philosophy, but was also the author of *La Calandria*, a play performed at the papal court of Leo X in 1514, with a comic plot based on mistaken identities and full of sexual jokes.

From the early sixteenth century, framed easel paintings increasingly became important elements of the decoration of private dwellings. These paintings were at times kept covered by curtains, as was the case with portraits and religious images. In a widely-read treatise written at the beginning of the seventeenth century, the *Considerazioni sulla Pittura*, the Sienese Giulio Mancini suggests that mildly erotic pictures representing nude women, or subjects like Mars and Venus, should be placed in secluded gardens or in private ground floor rooms. He goes on to suggest that 'lascivious things are to be placed in private rooms, and the father of the family is to keep them covered, and only uncover them when he goes there with his wife, or an intimate who is not too fastidious. And similar lascivious pictures are appropriate for the room where one has to do with one's spouse, because once seen they serve to arouse one and to make beautiful, healthy and charming children ... because each parent, through seeing the picture, imprints in their seed a similar constitution which has been seen in the object or figure ...'.[17] In the early sixteenth century,

however, bedrooms were not yet totally private rooms, and the paintings described in the Venetian collections were not necessarily pictures displayed only for the eyes of the owner and his wife. The nymph by Palma Vecchio placed above a door, seen by Marcantonio Michiel in 1512 in the house of the Venetian Francesco Zio, was very probably a reclining nude. 'The large figure of a woman, nude, lying down, painted behind a bed' by Savoldo was described by Michiel in the Venetian house of another collector, the merchant Andrea Odoni, in 1532.[18]

Paintings and sexual passion

The power of images to arouse sexual passion could be justified by respectable cultural precedents based on antique literature, a familiar *topos* for the educated elite who commissioned nudes for their *camere*. These images are described as possessing almost magical qualities. Pliny in his *Historia Naturalis*, writes of the statue of Aphrodite by Praxiteles, which was in the temple dedicated to the goddess on the island of Cnidos. He describes how the statue had to be protected from the sexual assaults of men who could not refrain themselves from masturbating on it. Pliny also mentions artists painting their lovers under the guise of goddesses. Numerous other stories from Greek and Roman literature, in which men fall in love with works of art and are sexually aroused by them, were well known in the fifteenth and sixteenth centuries, with Vasari mentioning the 'unbound lust' (*sfrenata libidine*) of the artists of antiquity in the introduction to his *Vite*. In another antique text, the play *The Eunuch* by the Latin writer Terence, we read of a young man, Chaerea, who is excited by a painting he sees in the house of the courtesan Thais. The picture represents Jupiter impregnating Danae under the guise of a shower of gold: looking at it, Chaerea feels encouraged to follow the example of the god, and lets his imagination dwell on what he is about to do with the young girl he desires. This play was a favourite one at the Ferrara court.[19] One of the characters in a sixteenth-century play, Alessandro Piccolomini's *L'Amor Costante*, the ignorant poet Messer Ligdonio, mixes up his mythological references when he compares his love for Margherita to the passion of Jupiter who, transformed into shining gold, falls into the lap of the 'sugar sweet' Leda.

The story of Jupiter's seduction of Danae, who had been locked in a tower away from the prying eyes of men by her father Acrisios, is the subject of a picture painted by Correggio for the Duke of Mantua, Federico Gonzaga, *c.* 1531 (Figure 49).[20] It was part of a series representing the *Loves of Jupiter*, probably commissioned to decorate one of the rooms in the Palazzo del Te, the

pleasure villa just outside Mantua built for the Duke by Giulio Romano. Here Federico could meet his mistress, Isabella Boschetti, far from the disapproving eyes of his mother, Isabella d'Este.[21] The principal *sala* of Federico's private apartment was decorated, like the entrance *loggia* of Agostino Chigi's villa in Rome, with episodes from the story of Love and Psyche. In this series of frescoes painted by Giulio Romano and his assistants, the naked body triumphs, and the erotic stories range from the suggestiveness of the *Pasiphae and the Bull* to the explicit representation of sexual intercourse in *Jupiter and Olympia*. The *Sala di Ovidio*, in another suite of rooms in the Palazzo del Te, was probably the setting for the series of paintings by Correggio. Arranged under a painted frieze, they showed images of mortals seduced by the king of the gods – subjects which also appeared in the frieze in one of the *sale* of Agostino Chigi's villa. The four canvases painted by Correggio for Federico Gonzaga show Jupiter as an eagle flying away with Ganymede; Jupiter, transformed into a cloud, ravishing Io; Jupiter in the guise of a swan seducing Leda; and, finally, impregnating Danae as a golden rain. While the damaged surface of the *Danae* does not allow us to appreciate fully the quality of the texture of the surface, the composition and the poses of the figures leave no doubt as to the mood of the picture. Danae, leaning back naked on a bed, opens her legs and stretches a cloth over them to catch the falling drops of gold, and gazes smiling at her lap. An adolescent Cupid sits on the bed, his legs parted, his genitals exposed, twisting his body around, and, as an accomplice to the seduction, helping Danae to hold the cloth, while two small *amorini* stand in front of the bed, sharpening their arrows. The sensuality of this painting and of its companions is the result of a perfect match between the particular talents of the painter and the preferences of the patron. In the *Battle between Love and Chastity* (Paris, Louvre), commissioned in 1505 by Federico's mother, Isabella d'Este, from Perugino for her *studiolo*, the loves of the gods had been only elements placed in the background. In Federico's pictures the mood is one of open sensuality and eroticism.[22]

Federico's taste in art is conveyed quite vividly in a letter from Pietro Aretino dated October 1527, in which Aretino writes that the sculptor Iacopo Sansovino will send to the Duke a statue of Venus, 'so real and so alive, that it fills with lust the thoughts of all who look at her'. In the same letter, Aretino adds that Sebastiano del Piombo, following Federico's wishes, is to paint a picture for him: Sebastiano is free to choose 'any subject he likes, apart from hypocrisies, stigmata, or nails'.[23] In 1530, Titian painted for Federico a picture with '*donne nude*', which has not been identified. A large painting by Giulio Romano, the *Two Lovers* (Figure 50) is linked to Federico's taste in erotica. It represents a man and a woman lying on an *all'antica* bed. The woman's

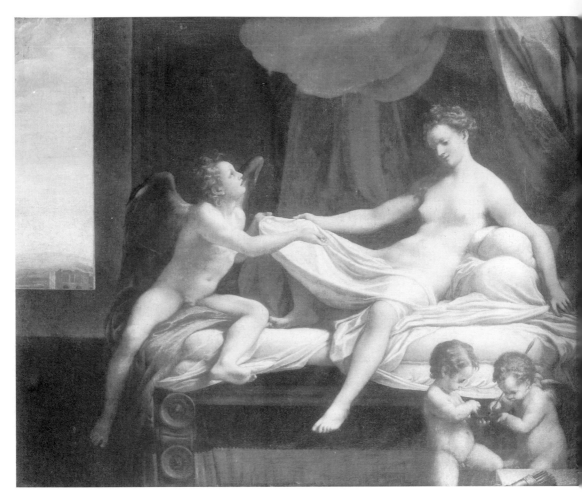

49 Correggio, *Danae*, *c.* 1531

slippers and her *camicia* are on two footstools near the bed, under which is hidden a cat. The couple are spied upon by an old hag – a classic procuress (*ruffiana*) type – who is seen framed in a doorway, just entering (or leaving) the room, accompanied by a dog who is sniffing the keys she holds. These keys so prominently displayed by the old procuress could be a pun on the Italian word *chiavare* (to put a key in the lock), a colloquial term for sexual intercourse, and the painting certainly invites the viewer to spy upon a sexual congress. In his *Life of Giulio Romano*, Vasari writes that he had seen this painting in the collection of Vespasiano Gonzaga, the Duke of Sabbioneta, who had obtained it from Federico as a gift. The *Two Lovers* is Giulio Romano's demonstration of an erotic subject in Roman style – a style which would have

been familiar to Federico, who had spent his adolescence as a hostage at the court of Pope Leo X.[24] It is, however, more openly erotic than Roman works such as Sodoma's *Marriage of Alexander and Roxana*, painted in 1518 in the bedroom of Agostino Chigi's *villa suburbana*. In the Giulio Romano painting, the woman lies between the open legs of her lover, one arm around his neck, and she looks into his eyes while she lifts a piece of drapery from his genitals. It is possible that with this painting, exceptional for its size and for the treatment of the subject matter, Giulio Romano was attempting to recreate one of the famous lost erotic pictures of antiquity.[25]

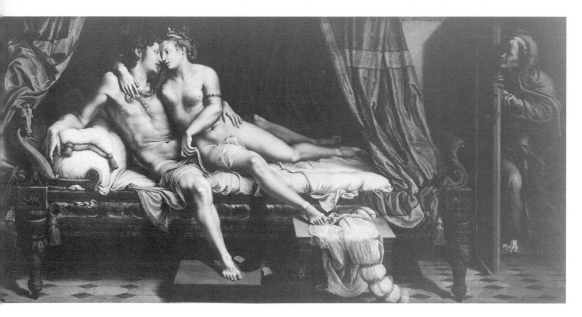

50 Giulio Romano, *Two Lovers, c.* 1523–24

Titian, the nude and sixteenth-century comments

Another *Danae*, this time painted by Titian, is described in a letter from the Papal Legate in Venice, Giovanni Della Casa, to Cardinal Alessandro Farnese, written from Venice in September 1544 (Figure 51). Here we have a very spontaneous and direct response to an erotic image. Della Casa visited Titian's workshop in September 1544, and there he saw a nude that Titian was painting on commission from the Cardinal. In his letter, Della Casa comments that the nude 'will bring the Devil down on the back of Cardinal San Silvestro', a stern Dominican theologian and a censor of the Church. It is so arousing, he writes, that Titian's *Venus of Urbino*, which Alessandro Farnese had seen

135

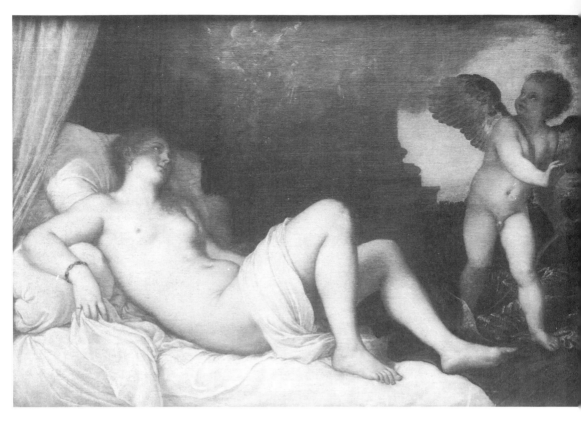

51 Titian, *Danae, c.* 1544–45

in Pesaro in the rooms of Guidobaldo della Rovere 'is like a Theatine nun
compared to this'. Della Casa adds that Titian, in order to curry favour with
Cardinal Farnese, will paint on the nude the portrait head of a woman, known
to the Cardinal, with the help of a sketch by Giulio Clovio which was being
sent from Rome. The sketch will also be utilised for a portrait of the same
woman.[26] This woman has been identified with a Roman courtesan called
Angela, with whom Alessandro was so infatuated that he sent her a precious
rosary as a present, so that she could adorn herself with it. The painting rep-
resenting the nude was taken to Rome by Titian the following year, and there
it was repainted. X-ray photographs show that the original composition was
a nude in a contemporary setting, a subject therefore closer to the '*donna nuda*',
the *Venus of Urbino*. Titian subsequently changed the subject matter, turning
the nude into a mythological character. It is probable that he did so because
the reference to antiquity would have made the subject more acceptable for
a Cardinal.[27] A few years later, in a book published in Rome in 1552, the

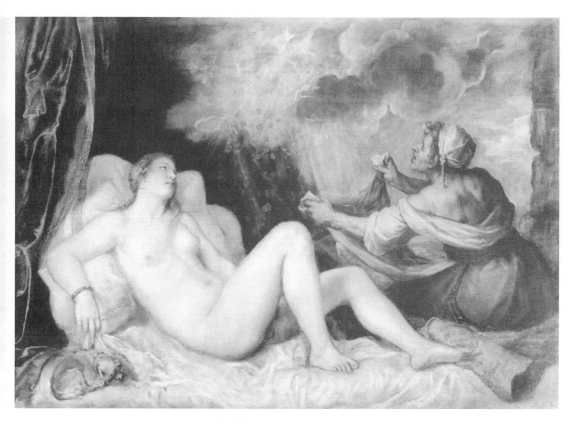

52 Titian, *Danae, c.* 1549–50

Dominican Ambrogio Catarino Politi would criticise those churchmen who collected mythological paintings, because, he wrote, images of nude goddesses like Venus and Diana lead to lustful thoughts.[28] In Titian's painting, Danae reclines on a bed, her body turned three-quarters towards the viewer, with one leg flexed, and a piece of cloth draped around her thigh. A pearl ear-ring, a bracelet and a ring decorate her body which, softly lit, is totally relaxed and abandoned to pleasure. This is an image of complete sexual fulfillment: the legs are slightly parted, the head thrown back, as she looks towards the golden coins falling on her. A winged Cupid, carrying his bow, stands on the bed and turn his head towards the mysterious presence of Jupiter. Vasari writes that Michelangelo, who had painted an intensely erotic *Leda* for the Duke of Ferrara Alfonso d'Este (1529), known to us only through copies, saw the *Danae* in the Belvedere and commented that he 'very much liked its colouring and its style (*il colorito suo e la maniera*), but it was a pity that in Venice they did not learn good drawing from the first, and that her painters

137

did not have a better method to study'.[29] Alessandro Farnese obviously liked his *Danae*, since he kept the painting in his *camera propria*, and it was still there in 1581.

In another version of the same subject, this time painted for the *camerino* of Prince Philip of Spain and already in Madrid by the summer of 1554, Titian increased the seductive power of the figure of Danae by removing Cupid and introducing an old woman who stands behind the bed and tries to catch the golden coins (Figure 52). This time there is no drapery around Danae's thigh, and the shadowy form of her hand can be seen between her legs. She looks upwards, and her mouth is slightly open. The dark skin of the old woman is a foil for Danae's soft, luminous body, painted with broken brushstrokes, without contour lines, shimmering upon the crumpled sheets of her bed. Titian mentions his *Danae* in a letter he sent to Philip in October 1554, after the

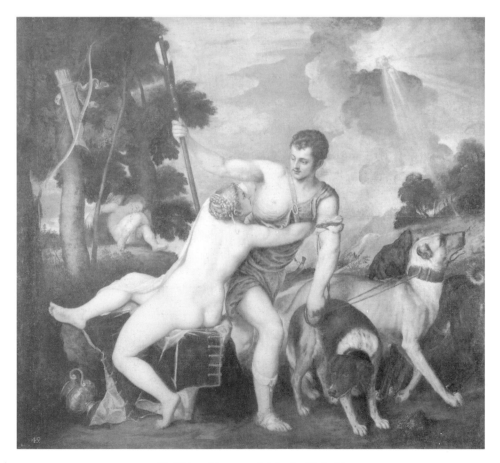

53 Titian, *Venus and Adonis*, 1551–54

138

young prince's marriage to Mary Tudor. He writes that, since the *Danae*, by then already in Madrid, shows the body 'entirely from the front', he wants to introduce a variation, and the new *poesia* which he is sending, the *Venus and Adonis* (Figure 53), shows 'the opposite side'. Titian comments that the *camerino* in which they will be placed will therefore be more lovely to behold. He promises Philip to send him yet another *poesia*, the *Perseus and Andromeda*, which will show another view of the body, and there will be yet another in a painting with the story of *Medea and Jason*.[30] This letter makes it clear that Titian was certainly aware of the erotic charge of the paintings for Philip's *camerino*, where the viewer was to be surrounded by naked female bodies seen from all sides. However, he was not just providing pictures for a *voyeur's* paradise: behind his comments lies also an awareness of the primacy of painting within the debate on the *paragone*, the comparison of the relative merits of painting

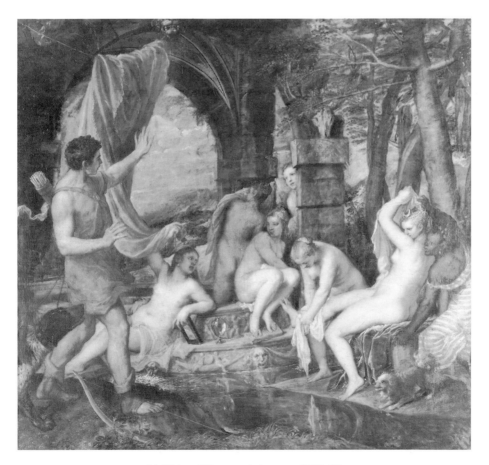

54 Titian, *Diana and Actaeon*, 1556–59

139

and sculpture in achieving an accurate representation of nature.[31] Ludovico Dolce in his *Dialogo della Pittura*, published in Venice in 1557, explains that the best way the painter has to demonstrate his ability to improve on nature is to show perfection in the body of a naked woman. The skill of the artist and the pleasure of the viewer depend on well-proportioned, graceful, slightly animated and pleasingly coloured figures. Each figure painted by Titian 'is alive, it moves, and its flesh trembles'. Titian's pictures for Philip will reveal the body from different viewpoints, as sculpture can do, but painting is closer to nature than sculpture, and therefore a superior art, because it also acts on the viewer through the beauty and the seduction of colour. The eroticism of these nude bodies, then, is the vehicle through which the painter reveals to the viewer the very essence of painting.[32] In another *poesia* for Philip II, the *Diana and Actaeon*, painted between 1556 and 1559 (Figure 54), a painting which explores the tragic consequences of a mortal man gazing at a naked goddess, Titian changed the original position of the body of Diana, represented in the act of turning away from the gaze of Actaeon. He repainted it in such a way that the viewer sees her torso not only in profile, but also from the back, in another demonstration of the potential of the art of painting.[33] The *Diana and Actaeon*, with its multitude of female nudes arranged in a spacially complex composition, is Titian's most complete demonstration of his skill as a painter of the female figure. By calling his paintings for Philip '*poesie*', Titian refers to the comparison between painting and poetry that Ludovico Dolce also stresses in his *Dialogo della Pittura*. Mythological paintings are like poetry because they deal with 'fiction', with ancient tales, and not with the 'reality' of *istoria*: to mythology belong the licence and freedom of invention proper to the poets. These paintings, therefore, present the body to the viewer in such a way as to demonstrate both the ability and the imagination of the artist: when placed together in Philip's *camerino*, the paintings will recreate a poetic image of the world, which also embraces the erotic.

A sixteenth-century description

Although we do not know enough about the way in which paintings were actually discussed in the sixteenth century, the conventions of learned disquisitions on art are revealed, in all their complexities, in another letter, written this time by Ludovico Dolce to Alessandro Contarini and published in 1559, in which Dolce describes Titian's *Venus and Adonis*. This is one of the most

complete contemporary responses to the art of Titian that we have, a real 'set piece', with its ekphrastic description of the actions and feelings of the two figures, with its references to the great art of antiquity, its comments on the effects achieved by Titian's painting technique and on Titian's complete mastery of both *disegno* and *colorito*. The viewer, Dolce writes, cannot avoid being aroused by this painting as eroticism is part of the subject matter, not just in the representation of Venus herself and of her beauty, but in the 'lascivious and loving gestures' with which Adonis comforts Venus. Eroticism is in the very way in which Titian paints and the viewer is compelled to respond to the artist's technique, which brings the figure to life:

> Venus is shown from the back, not for lack of art, but to demonstrate double art. Because in turning her face towards Adonis, trying to hold him back with both arms, and half sitting on a purple cloth, she shows everywhere certain sweet and lively feelings, such as one cannot see except in her. Here is such wonderful skill of this divine spirit that in the lower parts one can see the compression of the flesh caused by sitting. What else can I say? Only that every stroke of the brush is such as Nature herself can apply. Venus looks as she would have been if she really existed. Her countenance shows the clear signs of the fear for the unhappy death of Actaeon . . . And if the Venus coming out of the sea, painted by Apelles, so much praised by the ancient poets and writers, was half as beautiful, then she did deserve those praises. I swear to you, my lord, that there is no man with such good eyesight and judgement who, seeing her, does not believe she is alive. There is no man made so cold by his age, or so hard of constitution, who will not feel warmed, softened, and will not feel his blood running in his veins. No one should be surprised: if a statue made of marble could, with the stimulus of its beauty, penetrate a young man to the very marrow so much so that he left his stain on it, what could this one do, since she is made of flesh, and she is beauty itself, and she seems to breathe?[34]

Dolce makes it clear that the erotic power of painting lies in the development of those techniques that allow the viewer to experience the figure in his imagination also through the sense of touch, which is evoked by the sense of sight. Already in 1515, Giovanni Bellini had invited the viewer to look at an image of a seated nude woman looking at herself in a mirror (*Woman with a Mirror*, Vienna, Kunsthistorisches Museum). In fact, she is looking at a reflection of a reflection, since another mirror is hanging on the wall just behind her head. Mirrors and reflected images play an important part in sixteenth-century Venetian painting, as the artists exploited the qualities of the oil medium in an exploration of texture, of reflected forms and of light. Sight and touch complement each other, and nowhere more satisfactorily and fully than in Titian's paintings. The act of looking is forcefully presented in Titian's so-called *Pardo*

Venus (Paris, Louvre), painted perhaps during the 1540s for Prince Philip, through the inviting gesture of the satyr who draws back the drapery covering the smooth flesh of the sleeping nymph. In the *Diana and Actaeon* for Philip II the tragic consequences of Actaeon's invading gaze are conveyed through the disorder and tension of a dramatic composition, worked out and adjusted directly on the canvas, in which Titian crowds female bodies shown in a variety of poses. Here his brushstrokes suggest, rather than imitate, the form of the body and the textures of skin and hair.

The nude: modern interpretations

The complexity of artistic intentions in these representation of the female nude cannot be denied. From Raphael's and Giulio Romano's images inspired by Roman antiquity, to Giorgione's *Sleeping Venus* in Dresden, to Titian's late *poesie*, we can trace constant experimentations with subject matter, sources, composition and technique. We have also seen how some of these paintings were discussed by contemporary viewers in terms of their erotic appeal, how they were related to sixteenth-century artistic theories, and how comparisons were made with the famous lost works of antiquity. No comments, however, exist in contemporary sources about the meaning of these pictures, and a number of art historians have attempted to find, in the literary and philosophical culture of the sixteenth century, complex reasons and justifications for the function and the iconography of these nudes. This process has almost always succeeded in divesting them of their eroticism. Antique and contemporary texts have been suggested as the source for precise programmes. The frankly erotic small frescoes in the *stufetta* of Cardinal Bibbiena, for example, have been interpreted as being based on a coherent, complex and erudite neoplatonic programme which links them all, supposedly illustrating the hierarchies of celestial, terrestrial and bestial levels, and presenting Venus under her two aspects as Venus Coelestis and Venus Vulgaris.[35] The most elaborate meanings have been attached to a number of late paintings by Titian, which are variations on the theme of a reclining female nude seen in a contemporary setting, in the company of a man playing a musical instrument. These are: *Venus, Cupid and the Organ Player* (Figure 55) and *Venus and the Organ Player* (Madrid, Prado); *Venus, Cupid and the Organ Player* (Berlin, Staatliche Museum); *Venus, Cupid and the Lute Player* (Cambridge, Fitzwilliam Museum) and another *Venus, Cupid and the Lute Player* (New York, Metropolitan Museum). In all of them, the naked, bejewelled body of Venus is tilted towards the picture plane

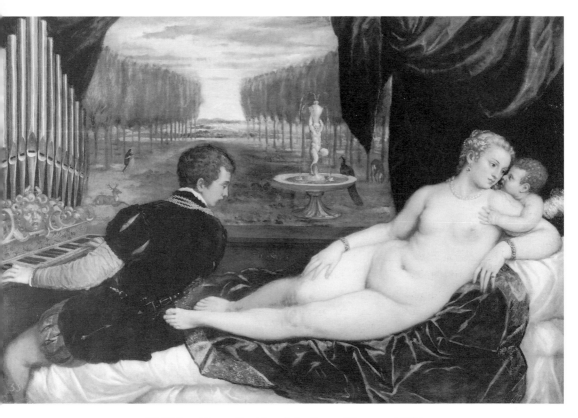

55 Titian, *Venus, Cupid and the Organ Player*, c. 1550

and displayed on a bed covered with dark red velvet. The musician, dressed in contemporary clothes, turns to look at her – and in the first two pictures his gaze is unmistakably directed to her genitals. This group of pictures has been seen by some art historians as a series of allegories of the hierarchy of the senses, that is, as visual representations of the neoplatonic concept that hearing and sight allow the mind to know Beauty. The musician hears the music he is playing and looks at the naked body of Venus, which represents Beauty. The subject of these paintings, according to this reading, is a glorification of the spiritual senses over the lower ones, like touch, smell and taste, through which Beauty cannot be really perceived.[36] This moralising interpretation is based on antique and contemporary texts which would have been known in Cinquecento Venice, but there is no evidence that this kind of painting was used as an illustration of such complex ideas, nor that the contemporary public viewed it as such. It is therefore legitimate to doubt whether Titian would have considered these ideas relevant to these commissions.[37]

143

There are paintings, however, which openly rely on the symbolism of objects and attributes to convey their meaning. In these cases the symbols are usually placed within the composition in such a way as to attract attention; they are easily singled out and at times they may be odd and strange objects which stimulate the curiosity of the viewer. The meaning, however hard for us to decipher, is never based on complex philosophical theories. One of these paintings is the *Venus and Cupid* by Lorenzo Lotto, painted very probably in Bergamo between 1513 and 1526 (Figure 56). Here the profusion of symbols and of erudite motifs indicates that they would have been suggested to the painter by the patron. Against a red drape placed as a backdrop, the goddess of love lies, half reclining on a blue cloth which covers a grassy meadow. She is naked except for a transparent ribbon tied under her breasts, and looks, smiling, towards the viewer. She wears an ear-ring, a jewelled gold crown and

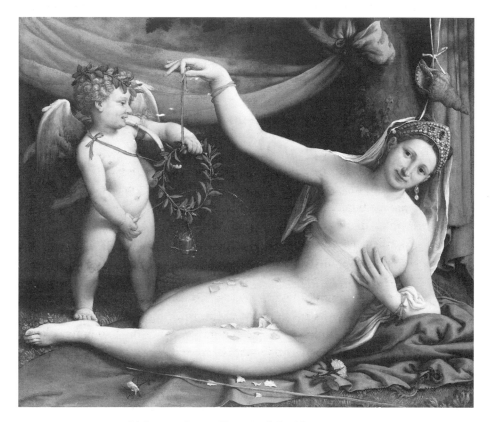

56 Lorenzo Lotto, *Venus and Cupid, c.* 1513–26

a veil which covers her hair. In her right hand she holds a small garland of myrtle, to which is attached an incense burner. Next to her stands Cupid, with his bow and arrows, crowned with a myrtle wreath, who laughs and urinates on Venus through the garland which she is holding. Behind her is a tree trunk, half-covered with ivy, from which hangs a conch shell. In front of her, almost parallel to the picture plane, is a stick; in the foreground, a snake slithers from under the blue cloth, on which is a pink rose; rose petals are scattered over Venus's thighs and between her legs. This painting, with its array of symbolic objects, has been linked to the tradition of marriage pictures. The presence of the urinating Cupid – a sign of good fortune and of fertility – seems to fit with this interpretation, which is also supported by the myrtle, placed very much in evidence, and by the suggestive shape of the conch. The gesture of Cupid can also be interpreted as a metaphor for sexual intercourse. The ivy is a common symbol of fidelity, while the roses with their thorns, the snake – perhaps a symbol of lasciviousness – and the rod with which Cupid was chastised, may warn the couple against the negative aspects of marriage.[38]

Another puzzling painting which relies on symbols to convey its meaning is Bronzino's *Allegory with Venus and Cupid* (Figure 57). Painted in Florence during the mid 1540s, it has been tentatively identified as a picture which was sent to France as a gift to King Francis I from Duke Cosimo de Medici. Vasari was probably referring to this picture when he described 'a painting of singular beauty . . . in which was a naked Venus, and a Cupid kissing her, and on one side Pleasure (*Piacere*) and Play (*Giuoco*) with other Loves, and on the other side Fraud (*Frode*), Jealousy (*Gelosia*) and the other passions of love'.[39] There is no difficulty in identifying the goddess of love who holds a golden apple and an arrow, while provocatively kissing her son, with her tongue in his mouth. The adolescent Cupid gazes into her eyes, while embracing her and holding her nipple between his finger, his buttocks suggestively thrust forward. The smooth, serpentine bodies of this incestuous couple are placed against a tightly knit group of allegorical figures and symbols. These are presented to the viewer as an enticingly complex courtly game. Against a background of laurel branches, Father Time, with an hour-glass on his shoulder, holds a blue curtain and looks towards a figure with a mask-like face. Below Cupid's wing, a screaming figure brings its bony hands to its unkempt hair. On the opposite side is a monster with the head of a beautiful girl, whose silk dress cannot hide an animal body covered with scales, furry paws and a snake-like tail. She twists around, holding in her hands, which are inverted, a honeycomb and the sting of her tail. Next to her, a naked boy, smiling, carries roses in his hands; he has an anklet of bells, and steps on a thorn which pierces his right foot.

According to one interpretation, this painting is an allegory of the folly

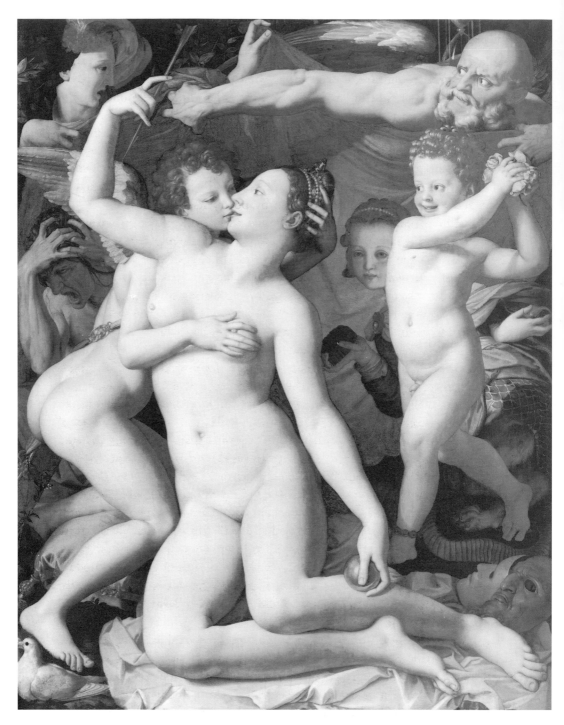

57 Bronzino, *Allegory with Venus and Cupid*, mid-1540s

of love and lust, which time reveals ridden with cruelty and deceit. Another reading sees this painting as a representation of the power of beauty, personified by Venus holding the golden apple, who conquers Cupid with her kiss and takes the arrow from him, while Time reveals Fraud.[40] But is Time drawing back the curtain, or is he in fact on the point of concealing the group from the viewer's gaze? And is the mask-like face a representation of Fraud, or rather of Oblivion – without memory because without brain? Is Fraud personified by the monstrous creature with the beautiful face? Could this picture illustrate instead the enduring power of poetry, symbolised by the laurel branches, which will last after Time and Oblivion obliterate Love and its companions, Pleasure, Fraud and Jealousy, emotions celebrated by poetry itself?[41]

Yet another interpretation has attempted to see this image as a warning against the terrible consequences of syphilis. This disease had ravaged Europe since the end of the fifteenth century, and was the subject of numerous treatises. The *morbus gallicus* could be represented in this painting by the toothless, discoloured figure screaming with pain and tearing at its hair which, it seems, shows some of the symptoms of the disease. These symptoms are first hidden by Oblivion, but they are then uncovered by Time. Bronzino's painting would seem to reveal not only the pain and deceit of love, beauty and lust, but also illness, madness and, finally, death under the gleaming surface of this mid-sixteenth-century representation of elegant and graceful naked bodies.[42]

It seems unlikely that Bronzino had been given an exact programme to follow, with precise instructions about the representations and meaning of the figures. X-ray photographs of this picture reveal that the painter changed his mind about some elements of the composition and about the position of the figures. Originally, Venus's right hand touched Cupid's hair. Her arm was then moved, and the arrow was added. Therefore, the motif of 'the disarming of Cupid' must have been a second thought, not present in the original programme. The difficulties in establishing the identity of the allegorical figures and even in interpreting their gestures derive from the fact that in the 1540s the iconography of these allegories had not yet been codified, and the modern iconographer cannot rely on useful sources such as Vincenzo Cartari's *Le Imagini con la Spositione de li Dei Antichi* of 1556, and Cesare Ripa's *Iconologia* of 1593 for interpretations.[43]

Bronzino's *Allegory* obviously met with the approval of its public and suited the taste of its viewers: copies in France and a version now in Budapest (Szepmuveszeti Muzeum) are evidence of its success. Whatever the meaning of the *Allegory*, a great part of the enjoyment of looking at this painting would have been the erudite and elegant display of conceits, explanations and elaborations which were so fashionable in the milieu of sixteenth-century courts.

The seduction of Venus operates not only through the pleasures offered by the representation of a smooth body, and the '*singolare bellezza*' of the colours and of the enamel-like surface of the painting, but also through the intellectual delights of the decoding game.[44]

Notes

1 The most famous discussion of the nude is K. Clark, *The Nude. A Study of Ideal Art*, first published John Murray, London, 1956, repr. by Pelican Books, Harmondsworth, 1960. Cf. n. 7, Introduction.

2 The title *Sacred and Profane Love* was given to this painting in 1793. The various interpretations of the picture are summarised by H. Wethey in *The Paintings of Titian. III: The Mythological and Historical Paintings*, Phaidon, London, 1975, pp. 175–9, and by C. Hope, 'Problems of Interpretation in Titian's Erotic Paintings' in *Tiziano e Venezia*, Convegno Internazionale di Studi, Venezia, 1976, Neri Pozza Editore, Vicenza, 1980, pp. 111–24. For a comprehensive discussion of this painting, of the results of the recent cleaning, of its interpretations and for an analysis of its cultural context, see *Tiziano Amor Sacro e Amor Profano*, exhibition catalogue, Electa, Milan, 1995. For the neoplatonic interpretation of *Sacred and Profane Love*, see E. Panofsky, *Problems in Titian, Mostly Iconographic*, Phaidon, London, 1969, pp. 110–19, and E. Wind, *Pagan Mysteries of the Renaissance*, Oxford University Press, Oxford, 1980, pp. 141–51. W. Friedlander analyses the painting as an episode from the *Hypnerotomachia Poliphili* in 'La tintura delle rose', *The Art Bulletin*, 20, 1938, pp. 320–4. C. Hope does not accept either reading, and interprets the *Sacred and Profane Love* as a marriage picture. A more appropriate title for this painting, Hope writes, would be *The Bride of Niccolò Aurelio at the Fountain of Venus* (*Titian*, Jupiter Books, London, 1980, pp. 34 ff.). Rona Goffen provides information about the Aurelio-Bagarotto marriage and explores the meaning of the sexuality of the bride in 'Titian's *Sacred and Profane Love*: Individuality and Sexuality in a Renaissance Marriage Picture', in J. Manca (ed.), *Titian 500*, Studies in the History of Art, XLV (Center for Advanced Study in the Visual Art, Symposium Papers XXV, 1993, pp. 121–46. Goffen points out that the cleaning of the painting has revealed some important changes which were carried out by Titian. The white dress of the 'bride' was originally red; her *camicia* was painted out; a large figure behind the putto has also been painted out; there seems to be another version of the 'bride' at her right (p. 138). On this aspect, see the essay by L. Lazzarini, 'Indagini scientifiche sui materiali e la tecnica pittorica dell' *Amor Sacro e Profano* di Tiziano, in *Tiziano Amor Sacro e Amor Profano*, pp. 345–52. The changes seem to exclude a precise 'programme' elaborated for this picture in advance. On this problem, see the important observations by John Steer in his review of *Titian 500*, 'Interpreting Titian', *The Art Book*, 2, 4 November 1995, 5.

3 On Guidobaldo della Rovere, the owner of the *Venus of Urbino*, his marriage to Giulia Varano and his relationship with his father, Francesco Maria della Rovere, see the informative article by K. Eisenbichler, 'Bronzino's Portrait of Guidobaldo II della Rovere', *Renaissance and Reformation. Renaissance et Réforme*, n.s. 12, Winter 1988, pp. 22–8.

4 Wethey's discussion of this picture includes various interpretations, among which is T. Reff's, who saw it as a symbol of 'marital love and fidelity' (*The Paintings of Titian*, III, pp. 203–4). Charles Hope also examines Reff's hypothesis ('Problems of Interpretation', pp. 118 ff.) and explains his reservations. He also points out that Vasari's identification of the figure as Venus should be questioned: 'elsewhere in the *Vita* of Titian Vasari quite certainly misidentified two of his female figures in a similar context; and he may have used the phrase unthinkingly here to indicate that the girl was naked, especially as paintings of mere anonymous women were not common in Florence. The same is not true of Venice' (p. 119). See also the interesting observations by M. Pardo on the context to the *Venus of Urbino* as an erotic image, in her

essay 'Artifice as Seduction in Titian', in J. Grantham Turner (ed.), *Sexuality and Gender in Early Modern Europe. Institutions, Texts, Images*, Cambridge University Press, Cambridge, 1993, pp. 55–89. David Rosand ('So-and-So Reclining on Her Couch', in *Titian 500*, pp. 101–19) links the *Venus of Urbino* to the genre of marriage pictures. Rosand takes issue with 'reductivist' readings of the nude and, considering Titian's working methods, he uses Panofsky's 'synoptical table of interpretation' to reach the conclusion that the 'naked woman' can accommodate various levels of meanings and interpretations, 'from *una Venere Mondana*, goddess of base passion, to the celestial deity of divine love. And the Neoplatonic hierarchy of Venuses articulated just such a range of possibilities' (p. 113).

5 On this painting, see the analysis by J. Anderson, 'Giorgione, Titian and the Sleeping Venus', in *Tiziano e Venezia*, pp. 337–42. Anderson examines the iconography of the reclining, sleeping female nude and establishes its roots in the tradition of the epithalamia. She notes that the meaning of the painting would have been easily understood by its audience. For an analysis of the X-rays, and for an account of past restorations, see M. Giebe, '*Venere dormiente*, Dresda, Gemäldegalerie Alte Meister', in *Tiziano Amor Sacro e Amor Profano*, pp. 369–85. Giebe points out that there is now no visible trace of the bird in Cupid's hand, which was described by Ridolfi in 1648 and by Hans Posse in his 1931 study. Recent investigations seem to exclude the existence of the bird (see Rosand, 'So-And-So Reclining on Her Couch', p. 116, n. 21). The position of the hand in both Giorgione's *Sleeping Venus* and Titian's *Venus of Urbino* – a variation on the gesture of the *Venus pudica* – is noted by R. Goffen ('Renaissance Dreams', *Renaissance Quarterly*, 40, 1987, pp. 682–706) who agrees on the epithalamic function and looks at the evidence provided by fifteenth-century medical writings on sex within marriage and on conception, and suggests that 'this kind of caress, which under normal circumstances would have been soundly condemned, was approved by theologians in one situation only, namely when a husband had withdrawn from his wife before she had made her own emission, which was believed necessary for conception' (p. 699). The importance given to female sexual pleasure in sixteenth-century treatises on sexuality is discussed by E. Renzetti, 'La Sessualità nei Libri Segreti del XVI e XVII Secolo', in G. Bock and G. Nobili (eds), *Il Corpo delle Donne*, Transeuropa, Bologna, 1988, pp. 47–68.

6 See Brantôme, *Les Dames Galantes*, Gallimard, Paris, 1981 (English translation: *The Lives of Gallant Ladies*, trans. A. Brown, Elek Books, London, 1961, pp. 30–1). For the literary genre which sees women as the eager participants and initiators of erotic adventures, see P. Findlen, 'Humanism, Politics and Pornography in Renaissance Italy', in L. Hunt (ed.), *The Invention of Pornography. Obscenity and the Origins of Modernity, 1500–1800*, Zone Books, New York, 1993, pp. 49–108.

7 Vasari's comment on the Fra Bartolomeo St Sebastian is in Vasari – Milanesi IV, p. 188. On this painting, see J. Cox-Rearick, 'Fra Bartolomeo's St Mark Evangelist and St Sebastian with an Angel', in *Mitteilungen des Kunsthistorisches Institut in Florenz*, 18, 1974, pp. 329–54. The comment about Raphael's Mercury is in P. Giovio, *Lettere Volgari*, ed. L. Domenichini, Venice, 1560, pp. 14v–15r.

8 Isabella d'Este's commissions are discussed by J. Fletcher, 'Isabella d'Este, Patron and Collector', in *Splendours of the Gonzaga*, exhibition catalogue, Amilcare Pizzi, Milan, 1981, pp. 51–63.

9 Both letters are cited in D. S. Chambers, *Patrons and Artists in the Italian Renaissance*, Macmillan, London, 1970: to Michele Vianello, 28 June 1501, p. 127; to Agostino Strozzi, 19 February 1505, p. 140.

10 R. Lightbown, *Mantegna*, Phaidon, Oxford, 1986, discusses the responses to Isabella d'Este's mythological paintings (pp. 200–3). On Isabella's attitude to the nude, see R. M. San Juan, 'The Court Lady's Dilemma: Isabella d'Este and Art Collecting in the Renaissance', *Oxford Art Journal*, 14, 1991, pp. 67–78. Leandro Ventura ('Isabella d'Este: committenza e collezionismo', in *Isabella d'Este. I Luoghi del Collezionismo*, exhibition catalogue, Civiltà Mantovana, Il Bulino, Modena, 1995, pp. 47–69) discusses the themes of *castitas* (chastity) and *virtus* (virtue) in the mythological paintings commissioned by Isabella, and stresses the importance of the theme of the struggle to overcome the impulses of a base nature, which links the paintings and the decorative elements of the *grotta* and the *studiolo*.

11 For the Battista Fiera incident, see R. Jones, ' "What Venus did with Mars": Battista Fiera and Mantegna's Parnassus', *Journal of the Warburg and Courtauld Institutes*, 44, 1981, pp. 193–8. Jones points out that, in a poem addressed to Francesco Gonzaga, Fiera distinguishes between erotic paintings (*molles fucos et blandimenta . . . delicias Veneris*') and serious subjects (*'seria . . . et subnascentia Rerum semina*') (p. 193).

12 For erotic prints in the sixteenth century, see H. Zerner, 'L' Estampe érotique au temps de Titien', in *Tiziano e Venezia*, pp. 85–90, and G. Lise, *L'Incisione erotica del Rinascimento*, Milan, 1975. Both Zerner and Lise discuss the series *The Love of the Gods* engraved by Jacopo Caraglio from drawings by Perino del Vaga and Rosso Fiorentino. P. Findlen discusses the relationship between 'high' and 'low' art and the role of printing in the development of what she calls 'a pornographic culture', in her essay 'Humanism, Politics and Pornography', in Hunt, *The Invention of Pornography*, pp. 54 ff.

13 The *Modi*, its history and the fragments which still exist, are analysed by L. Lawner, *I Modi. The Sixteen Pleasures. An Erotic Album of the Italian Renaissance*, Peter Owen, London, 1988. Since Aretino's sonnets mention the names of a number of famous courtesans, Lawner sees the prints as 'a gallery in album form of sixteen different courtesans (with their noble lovers), each with a name and a special art' (p. 26), and mentions the existence of contemporary lists of prostitutes and positions to support her argument. For Vasari's discussion of the *Modi*, see the *Vita di Marcantonio Bolognese*, Vasari – Milanesi V, p. 418.

14 Vasari's description of the *capriccio* is in Vasari – Milanesi VI, p. 558. On the role of erotica in the decoration of the *Loggia*, see P. Morel, 'Priape à la Renaissance. Les guirlandes de Giovanni da Udine à la Farnésine, *Revue de l'Art*, 69, 1985, pp. 14–28.

15 The *Loggia di Psiche* frescoes are undergoing a cleaning and restoration campaign which will provide important evidence as to the extent of Raphael's own interventions, his assistants' work, and any changes carried out during subsequent restorations.

16 The drawings for the *Loggia* are analysed by K. Oberhuber, 'Raphael's Drawings for the Loggia of Psyche in the Farnesina', in *Raffaello a Roma. Il Convegno del 1983*, Edizioni dell'Elefante, Rome, 1986, pp. 189–207. See also A. Weston-Lewis in *Raphael. The Pursuit of Perfection*, exhibition catalogue, Edinburgh, 1993, pp. 96–103. See also p. 104 for an engraving by Giulio Bonasone of a lost drawing by Raphael for the *Loggia*.

17 The passage from Mancini is cited by D. Freedberg in *The Power of Images. Studies in the History and Theory of Response*, University of Chicago Press, Chicago and London, 1989, p. 3.

18 On Venetian collections, see O. Logan, *Culture and Society in Venice 1470–1790: The Renaissance and its Heritage*, Batsford, London, 1972, especially the chapter on 'Patronage and Collecting Art', pp. 148–219.

19 On the importance of Terence's *The Eunuch* and on different responses to this play, see C. Santore, 'Danae: The Renaissance Courtesan's Alter Ego', *Zeitschrift für Kunstgeschichte*, 54, 1991, pp. 412–27, esp. pp. 422–3. Santore points out that, in spite of having been cited by St Augustine as an example of the dangerous influence of indecent images, this play was chosen by Isabella d'Este for repeated performances.

20 The story of Danae, its sources, the transformations of the myth throughout the Middle Ages and its iconography, are the subject of an interesting article by M. Millner Kahr, 'Danae: Virtuous, Voluptuous, Venal Woman', *The Art Bulletin*, 60, 1978, pp. 43–55, with bibliography. See also Santore, 'Danae: The Renaissance Courtesan's Alter Ego'.

21 For the decoration of the Palazzo del Te, see E. Verheyen, *The Palazzo del Te in Mantua. Images of Love and Politics*, Johns Hopkins University Press, Baltimore and London, 1972.

22 The *Loves of Jupiter* series by Correggio is analysed at length by E. Verheyen in 'Correggio's *Amori di Giove*', *Journal of the Warburg and Courtauld Institutes*, 29, 1966, pp. 160–92. Verheyen discusses the evidence for the setting of the four pictures, and looks at the *Danae* in the context of the other paintings of the series and of the relationship between Federico and Isabella Boschetti: 'the *Amori* prove the unlimited power of Eros (who had conquered Federigo himself) and whom even Jupiter could not withstand' (p. 191).

150

23 Aretino's letter to Federico Gonzaga about the *Venus* by Sansovino is in F. Pertile and E. Camesasca (eds), *Lettere sull'Arte di Pietro Aretino*, 3 vols, Edizioni del Milione, Milan, 1957–60, I, p. 17.

24 S. Ferino Pagden discusses Giulio Romano's references to paintings in Rome, and perceives in the subject matter of the *Two Lovers* the possible influence of Pietro Aretino (see 'I Due Amanti di Leningrado', in *Giulio Romano. Atti del Convegno Internazionale di Studi su 'Giulio Romano e l'espansione europea del Rinascimento'*, Mantua, 1989, pp. 227–36). Puns on the terms *chiave* and *chiavare* are frequently used in sixteenth-century texts such as Cardinal Dovizi da Bibbiena's *La Calandria*, Aretino's *Ragionamenti* and Anton Francesco Doni's treatise, *La Chiave*.

25 C. Davis (review of the exhibition *Giulio Romano*, Mantua, 1989, in *Kunstchronik*, 2, February 1991, pp. 65–83) speculates whether the *Two Lovers* was painted for a specific location. While it is not possible to come to any conclusion about this matter, the painting must have certainly been destined for a bedroom. Davis sees this painting as an attempt to recreate an antique erotic picture, *Atalanta and Meleager*, by Parrhasios. This picture was kept by the Emperor Tiberius in his bedroom, and was described by the historian Suetonius in his *Lives of the Emperors*. Davis suggests that Giulio Romano would have been trying to emulate Parrhasios after reading about his 'personal and artistic character' and his conversations with Socrates on painting. He adds that the two lovers Meleager and Atalanta were represented with erotic emphasis in Greek and Roman art, and that in the picture owned by Tiberius Parrhasios had painted an act of fellatio ('*tabulum, in qua Meleagro Atalanta ore morigeratur*') (p. 82). Davis also adds that it is unlikely that the painting, as Vasari states, would have been given by Federico as a gift to his cousin Vespasiano Gonzaga, as he was only a boy of ten at the time of Federico's death. I am grateful to Margaret Daly Davis for drawing my attention to this article.

26 Della Casa's letter was first analysed by C. Hope, 'A Neglected Document about Titian's "Danae" in Naples', *Arte Veneta*, 31, 1977, pp. 188–9.

27 Titian's *Danae* for Alessandro Farnese is discussed by R. Zapperi in 'Alessandro Farnese, Giovanni della Casa and Titian's *Danae* in Naples', *Journal of the Warburg and Courtauld Institutes*, 54, 1991, pp. 159–71. Zapperi analyses the letter from Della Casa and explores the possible reasons for the changes carried out by Titian. Examining the evidence for the relationship between Cardinal Farnese and the 'sister-in-law of the Signora Camilla', the courtesan Angela, Zapperi points out that the painting, with the motif of the gold coins, 'could . . . be regarded as a euphemistic representation of the coupling of its owner with the courtesan'. In his essay 'Il Cardinale Alessandro Farnese: Riflessi della Vita Privata nelle Committenze Artistiche', in L. Fornari Schianchi (ed.), *I Farnese. Arte e Collezionismo. Studi*, Electa, Milan, 1995, pp. 48–57, Zapperi links the *Danae* to a portrait in Naples, Galleria Nazionale di Capodimonte, which, he writes, is an idealised likeness of the courtesan Angela. He discusses the relationship between the head of the *Danae*, the portrait and its X-ray picture. David Rosand looks at the evidence provided by the Della Casa letter and by the X-ray photograph of the painting in order to assess the relationship between Titian's working methods and the evolution of meanings of pictures of this kind ('So-And-So Reclining on Her Couch', p. 111).

28 Politi's comment in his book *Disputatio . . . de cultu et adoratione imaginum*, is discussed by Carlo Ginzburg, 'Tiziano, Ovidio e i Codici della Figurazione Erotica nel Cinquecento', in *Tiziano e Venezia*, in the context of Counter-Reformation attitudes about the danger of erotic images. (English trans. 'Titian, Ovid and Sixteenth-Century Codes for Erotic Illustrations', in *Myths, Emblems, Clues*, trans. J. Tedeschi and A. C. Tedeschi, Hutchinson Radius, London, 1990, pp. 77–95).

29 Michelangelo's criticism of Titian's *Danae* is in Vasari – Milanesi VII, p. 447.

30 C. Hope, examining the difference in technique between the *Danae* for Alessandro Farnese and that for Philip, with its looser handling, points out that what matters here is Titian's 'flexibility of approach' in subject matter and technique (*Titian*, pp. 117 ff.). Hope concludes that 'the *poesie* were not just sophisticated erotica, but a highly self-conscious, calculated

demonstration of what the art of painting could achieve' (pp. 125 ff.). Hope expands this important point in 'Problems of Interpretation in Titian's Erotic Paintings', where he discusses Titian's letter to Philip (p. 114).

31 On the significance of Titian's definition of his paintings as *poesie*, see G. Padoan, '"Ut Pictura Poesis": Le "Pitture" di Ariosto, le "Poesie" di Tiziano', in *Tiziano e Venezia*, pp. 91–102. Padoan's essay also explores the erotic qualities of Titian's nudes, and stresses the crucial importance of this aspect of the works. 'Titian is an erotic painter not because he paints nudes, but because in Titian's female nudes the erotic undertone is consciously explored. It is important to make this distinction, because erotic representation is a very complex question; it is not easy to evaluate since the actual degree of its intensity changes according to culture and to historical period. What can produce in us a certain type of sensation does not always find an exact correspondence in the culture in which (that artifact) was produced. By itself, the representation of the nude does not necessarily carry an erotic charge . . . There is no doubt that Titian looks at the female nude – deliberately asked for by the patron – with this particular intensity' (p. 99) (my translation). The importance and seriousness of the erotic in Titian's paintings is discussed by M. Pardo in a clear and informative essay, 'Artifice as Seduction in Titian', in Grantham Turner, *Sexuality and Gender in Early Modern Europe*, pp. 55–89. Pardo sees 'artifice itself as a vehicle for the erotic' and attempts 'to locate the erotic dimension of Renaissance figurative art in the very strategy of its making.'

32 For Ludovico Dolce's *Dialogo della Pittura*, see P. Barocchi (ed.), *Trattati d'Arte del Cinquecento fra Manierismo e Controriforma*, 3 vols, Laterza, Bari, 1960–62, I, pp. 143–206.

33 Ellis Waterhouse discusses the 'tragic' qualities in the *Diana and Actaeon*, (*Titian's Diana & Actaeon*, Oxford University Press, London and New York, 1952). Waterhouse sees this painting as showing 'a feeling of moral responsibility' introduced by the Counter-Reformation theorists.

34 Dolce's letter to Contarini is in G. G. Bottari, *Raccolta di Lettere sulla Pittura, Scultura e Architettura*, Rome, 1759, III, pp. 257–60. The letter is discussed by C. Ginzburg in 'Tiziano, Ovidio e i codici della figurazione erotica'. Ginzburg notes that the aesthetic qualities of the painting are merged, in Dolce's words, with the explicit enjoyment of the eroticism of the figure. He points out that this letter used not to find much space in Titian's scholarship, and that, in fact, it used to be published in an abbreviated (censored) form. R. Goffen ('Renaissance Dreams') discusses also Titian's letter to Philip II about the *Danae* and the *Venus and Adonis*, and she places Dolce's letter to Contarini in the context of the *paragone*. She stresses the erotic quality of the painting as well as its emotional content, again insisting that 'what Titian made manifest in his nudes is undeniably erotic, but not merely erotic'. M. Rogers ('Decorum in Lodovico Dolce and Titian's *poesie*', in F. Ames-Lewis and A. Bednarek (eds), *Decorum in Renaisssance Narrative Art*, Birkbeck College, University of London, 1992, pp. 111–20) relates some of the ideas expressed in Dolce's letter to his *Dialogo* of 1557. She studies the concept of *decorum* in relation to the nude, and charts the changes in Dolce's attitudes to the nude and to morality as expressed in the different editions of his translations of Ovid's *Metamorphoses*, from 1539 to 1561. Rogers also examines the representation of the nude in Titian's *poesie* in relation to Dolce's writing, and points out how, in his later mythological pictures, Titian contravenes Dolce's norms of *decorum* for beauty and for the nude: 'He selects situations where nudity causes lust, shame, violation and revenge, and explores the physical manifestations of these.' Looking at *Diana and Actaeon*, Rogers writes that 'nudity provokes in Actaeon not pleasure but rather shock, which is shared by the viewer who seems to occupy Actaeon's position and to encounter the goddess's glare. The daring liberties Titian has taken with her twisting anatomy . . . convey the intensity of her recoil and rage.'

35 For the interpretation of the decoration of the *stufetta* of Cardinal Bibbiena, see the essay by H. Malme, 'La "stufetta" del Cardinal Bibbiena e l'iconografia dei suoi affreschi principali', in *Quando gli Dei si spogliano. Il bagno di Clemente VII a Castel Sant'Angelo e le altre stufe romane del primo Cinquecento*, Romana Società, Rome, 1984, pp. 34–50.

36 The complex neoplatonic interpretation of the 'Venus and the musician' group of paintings by Titian was put forward by O. Brendel in 'The Interpretation of the Holkham Venus', *The Art Bulletin*, 27, 2, 1946, pp. 65–75. This view was criticised by A. Hamill and, quite fully,

by U. Middeldorf in their letters published in *The Art Bulletin*, 29, 1947, pp. 65–7. Middeldorf considers problems of art-historical methodology as well as the context, both cultural and social, in which these paintings were produced. This context, he writes, was much wider than that of neoplatonic philosophy – and historians should consider also different kinds of evidence. He suggests that the paintings 'may just be plain statements that all three senses depicted, sight, hearing, and touch, are important in the pursuit of the pleasures of love'. Considering the function of the painting, he adds: 'the fact that they were produced in an extraordinary number of replicas does not encourage an attempt to look in them for purity of thought. They must have been shared by a variety of people whose taste can scarcely have coincided in an admiration for idealistic theories of love.' E. Panofsky follows Brendel's allegorical reading in *Problems in Titian*, pp. 121 ff.

37 C. Hope points out how 'the clear sexual imagery of these compositions' makes Brendel's interpretation incongruous. Hope also questions the identification of the nude with the goddess Venus. In the 'organist' pictures, Cupid is not there as an attribute or agent of the goddess: he is there to convince the woman – a courtesan? – to give in to the musician. Hope writes that the musical symbolism is very important here: 'If this association of music and very overt sexual symbolism appears rather incongruous, it is perhaps worth recalling that many madrigals of this period were equally explicit. It is also significant that the basic theme of these madrigals was of a man's desire to win the favours of a woman, but never of Venus herself; it is always a mortal rather than a goddess who is involved' ('Problems of Interpretation in Titian's Erotic Paintings', p. 123). David Rosand, in 'Ermeneutica Amorosa: Observations on the interpretations of Titian's Venuses', *Tiziano e Venezia*, pp. 375–81, discusses the context in which these paintings can be placed. He criticises the attitude according to which 'meaning must be exact and singular; moreover, it can be discovered and defined only when the interpreter has found a relevant text, presumably *the* relevant text' (p. 381).

38 Lotto's *Venus and Cupid* is placed within the specific generic tradition of marriage paintings by K. Christiansen in an article which examines the meaning of the symbols, the precedents for the use of the '*putto mingens*' and the possible links between the iconography of this painting and texts such as the Epithalamium by Statius for Lucius Arruntius Stella and his bride ('Lorenzo Lotto and the Tradition of Epithalamic Paintings', *Apollo*, 124, 1986, pp. 166–73). See also the entry by S. Beguin in *Le Siècle de Titian*, pp. 546–7.

39 Vasari – Milanesi VII, pp. 598–9.

40 For these interpretations of Bronzino's *Allegory*, see E. Panofsky, *Studies in Iconology*, 1st ed. Oxford University Press, Oxford, 1939, repr. Harper & Row, New York and London, 1972, pp. 86 ff. Panofsky stresses the erotism of this picture, calling it 'exquisitely lascivious'. He concludes that this is an image of 'Luxury rather than an ordinary group of Venus embracing Cupid, and this is corroborated by the fact that Cupid kneels on a pillow, a common symbol of idleness and lechery'. See also the two discussions of Panofsky's position by A. H. Gilbert and H. W. Janson, in *The Art Bulletin*, 22, 1940, pp. 172–5. Janson writes: 'If . . . the picture really represents a moralistic indictment of Luxury in the spirit of the Counter-Reformation, it would appear strange that there is no hint of such a significance in Vasari's account of it.' (p. 175). M. Levey, in 'Sacred and Profane Significance in Two Paintings by Bronzino', in *Studies in Renaissance and Baroque Art Presented to Anthony Blunt on his 60th Birthday*, Phaidon, London and New York, 1967, pp. 30–3, sees the subject as representing Venus disarming Cupid. He writes that Pleasure and Play 'are the emotions that Cupid is going to feel when pleasure's sting, his own folly, even perhaps his mother's deceit, are all experienced by him; Time will show.' For a summary of these interpretations and for a discussion of the cultural climate in which the picture was created, see G. Smith, 'Jealousy, Pleasure and Pain in Agnolo Bronzino's "Allegory of Venus and Cupid"', *Pantheon*, 39, 1981, pp. 250–8.

41 For a questioning reassessment of the possible meaning of this picture, see C. Hope, 'Bronzino's *Allegory* in the National Gallery', *Journal of the Warburg and Courtauld Institutes*, 45, 1982, pp. 239–43.

42 J. F. Conway, 'Syphilis and Bronzino's London Allegory', *Journal of the Warburg and Courtauld Institutes*, 49, 1986, pp. 250–5.

43 C. Gould, *The Sixteenth-Century Italian Schools*, National Gallery Catalogues, London, 1975, pp. 41–4, discusses the *pentimenti*.

44 The vicissitudes of pictures of erotic content purchased by the National Gallery in London during the nineteenth century and censored by restorers under the guidance of Sir Charles Eastlake are discussed in an interesting article by J. Anderson, 'A "most improper picture". Transformations of Bronzino's Erotic Allegory', *Apollo*, February 1994, pp. 19–28. Anderson points out that the offending tongue and nipple of Venus were painted out before the picture was put on show.

THE CULT OF FEMALE SAINTS: IMAGES OF DEVOTION AND *EXEMPLA*

❁

The function of sacred images

In Renaissance society, religion was inextricably bound with all aspects of life, private and public. In Renaissance cities, pictures of religious subjects were to be found everywhere, not only in churches, but also in government and administrative buildings, the meeting halls of guilds and confraternities, hospitals and hospices, and in tabernacles placed at street corners. In the houses of people belonging to all levels of society, paintings and prints of varying quality and price were available for private devotion.[1]

These pictures were either cult images (*imagini*) or narratives (*istorie*). The *imagini* represented one or more figures, and their function was devotional: they were the focus of prayers and were usually commissioned in honour of the Virgin or of specific saints.[2] To this type belong, for example, those altarpieces representing the Virgin Mary, usually shown sitting on a throne holding the Child and flanked by attendant saints, which we call *sacre conversazioni*. On the *predella*, small narrative pictures illustrated a crucial moment in the lives of the the saints which accompanied the Virgin, or episodes from the story of Christ's redemption of mankind.[3] The devotional images kept in private houses were usually to be found in the *camera*, the more personal and private room in the house of a wealthy family. In the fifteenth century these devotional paintings were often accompanied by a candle-holder, and they were sometimes provided with shutters or kept covered by a curtain. The inventory made in 1418 of the contents of the Medici family house in the Via Larga in Florence, lists a number of paintings of religious subjects; in a *camera* there was 'a panel of Our Lady in a tabernacle with two painted shutters with a silk veil in front'.

155

Private devotional pictures were often commissioned on the occasion of weddings: an image of the Virgin is included among the list of furnishings bought by Bernardo di Stoldo Rinieri for his marriage to Bartolomea di Diotisalvi Diotisalvi in the late 1450s in Florence. Luigi di Ugolino Martelli bought a tondo of the Madonna from Botticelli in the late 1480s, after his marriage to Marietta di Bartolomeo Bartolini. Vasari writes that Raphael painted a picture 'which showed Our Lady and between her legs a child to whom St John, delighted, is offering a bird, with much happiness and pleasure in one and the other' for his friend Lorenzo Nasi, who had just got married.[4] These images for private devotion often represented, as these examples show, a *Nostra Donna*, as the Virgin is called in fifteenth- and sixteenth-century inventories, either as the Virgin Annunciate, or holding the Child, or kneeling in front of him in adoration. Fresco cycles told the stories of the lives of Christ, of the Virgin and of the saints on the aisle walls and in the apse of churches, in private funerary chapels and in sacristies. Their function was, on the whole, devotional and didactic. By the fifteenth century these stories were familiar to all through sermons and through what was perhaps the most widely-read religious text, the *Golden Legend*, written by Jacopo da Varagine c. 1280. This was a collection of the lives of the saints, and of episodes from the lives of Christ and the Virgin, organised in a sequence which followed the liturgical calendar.[5]

At the core of all the different functions which religious images and stories fulfilled was the belief in the power of paintings (and sculptures) to convey the presence and qualities of what was represented. We have seen how, in the case of portrait painting, the image could take the place of the absent person, or of the dead. Alberti, in *On Painting*, writes that 'painting contains a divine force which . . . makes the dead seem almost alive' and, discussing religious images, he adds that 'painting is most useful to that piety which joins us to the gods and keeps our souls full of religion'. Leonardo, writing about the superiority of painting over poetry, states that 'people are moved by [paintings] to beseech the portraits of the Gods making fervent vows'. This power to inspire, to move the viewer emotionally, was felt to be particularly strong in the case of religious paintings: they represented individuals – the Virgin Mary, or the saints – who not only had lived lives of exemplary qualities, but who were also channels of communication between human beings and God. These images could protect, but also even 'see' and listen to whoever was praying in front of them. The holiness of what was represented was bound up with the object itself, which became endowed with almost magical properties. Miracle-working images, such as the Virgin in the church of the SS. Annunziata in Florence, or the

Nostra Donna of Impruneta, were believed to possess special powers. The image itself was the focus of the devotion and of the emotion of the faithful, it embodied and made visible the unlimited power (*virtù*) of the celestial being, and, most importantly, brought a very special honour to the city which possessed it.[6]

The strength of the emotional needs that the viewers brought to their interaction with the sacred images cannot be discounted either in an examination of their functions. These needs were given a religious channel by a process of meditation, accomplished through visualisation and identification, encouraged by prayer manuals of the time, such as the *Zardino de Oration*, written especially for women in 1454 and printed in Venice in 1494. The emphasis placed on emotions in prayers was not confined to women. The Florentine Giovanni di Paolo Morelli writes in his *Ricordi*, begun in 1393, of the despair he experienced after the death of his son Alberto. Not being able to articulate his pain through words, he sought help from the image of the Virgin Mary, represented standing at the right of the cross in a panel with a *Crucifixion* he had at home:

> My heart and my spirit being calm, my eyes turned to the right side of the true Crucified where, looking, I saw his pure and holy blessed mother at the foot of the cross. I contemplated in my mind the pain of that pure Virgin, mother of the pure and precious son. I thought about the many dangers that she had borne from the day of his birth, and [how] finally she saw him before her eyes dead and whipped by dissolute sinners, abandoned by his apostles. She found herself alone with John at so cruel a judgement and before torments as cruel as [the soldiers] had been able to use on the most precious skin of her beloved son. No one had comforted her; she was alone, abandoned with her son. Thinking about this brought me such torment and such pain, that I really believed my soul would leave my body . . . Gazing upon her so full of torment, I began to cry and became so anguished that for a long time my eyes could not stop.

He begun to say the *Salve Regina* and to pray to the Virgin:

> I stood up and took hold of the *tavola* with devotion and kissed it in the same places where, during his illness, my son had sweetly kissed it, after he had repeatedly asked that he regain his health. Then after I put it back in the usual place, and again knelt down, I said the *Credo* and the Gospel of St John, and while I was reciting it, my eyes were fixed on his figure, which was represented at the left of the cross, with so much anguish and so much sadness as it is possible to show in a human body, so much so that I could not finish his holy Gospel because I could not hold back my tears . . . Holding the tavola in my arms, I repeatedly kissed the Crucifix and the figure of his mother and of the evangelist.[7]

157

The Virgin Mary

The Virgin Mary could give strength to men and women as a consoling mother: she was herself a mother who had suffered. The role of Mary as Mother of God had been decreed by the Council of Ephesus in 431. The influence of the preaching of the mendicant orders, with their devotion to Mary, combined with the conventions of the poetry of the *dolce stil nuovo* with the image of the *donna angelicata* to whom the poet defers, placed the cult of the Virgin firmly at the core of the devotional fervour of the faithful. Mary was the means through which God's plan of the salvation of mankind had been possible, and the innumerable representations of the Virgin Annunciate testified to the crucial moment of the Incarnation. As the mother of Christ, she was the mediator between him and mankind, and the embodiment of the power of mothers: Christ could not refuse her requests. On a symbolic level, she represented the Church. The Apocryphal Gospels and an important Franciscan text, the *Meditationes Vitae Christi*, written *c.* 1300, amplified the role that Mary had in the official Gospels. These texts are the source for the stories of the life of Mary illustrated by fourteenth- and fifteenth-century painters. She could also be an *exemplum* for young girls and for wives. Paolo da Certaldo, in his *Libro di Buoni Costumi*, had written:

> The young, virginal girl must live following the example of the Holy Lady the Virgin Mary, who was the first and highest virgin, and queen, and mirror of all the other virgins, and of all the other women. She did not spend time outside her house, chatting here, there and everywhere, nor listening to men nor looking at them, not doing other vain things, on the contrary, she was shut away in a hidden and honest place . . . And so all faithful Christian women should learn from her and follow her, so that they would be acceptable to God and to their husbands and to everybody else they know.[8]

The behaviour of the Virgin Mary was used as example for women by St Bernardino of Siena in one of his sermons. Discussing the painting by Simone Martini in the cathedral of Siena, now in the Uffizi, which shows the Virgin Annunciate being scared by the Angel, St Bernardino encourages girls to 'take her as an example . . . of what you should do. Never talk to a man unless your father or mother is present'. Girolamo Savonarola, preaching in Florence in 1496, reproached painters who represented the Virgin Mary beautifully dressed because 'she went dressed as a poor woman, simply, and so covered that her face could hardly be seen, and likewise Saint Elizabeth went dressed simply'. Those ideals of femininity which we have already seen illustrated in the *cassone* and *spalliere* panels are proposed again to women through these omnipresent religious images. What is stressed is a behaviour which is, above all, chaste and

modest, but also industrious. The praise of virginity was based on a long tradition in Christian writing, but the well-being and stability of society demanded that men and women should marry, and that individual interest should be subsumed within those of the group. Women were taught to be wives and mothers through images of the Mother of Christ, of her own mother, St Anne, and of her cousin, St Elizabeth. Women's virtuosity, according to these examples of contemporary exortations, was eminently practical: women had to be trained to be good wives, and to fulfil their tasks in busy households.

The emphasis of so many devotional images, which were to be found in private houses, was on the Virgin Mary and on the humanity of Christ expressed through the emotional bonds amongst the members of his family. It is possible that this interest was not just the result of painters illustrating well-known religious stories, but that it was an aspect of the contemporary preoccupation with family and lineage.[9] The panel painted by Masaccio and Masolino, probably around 1425, known in English as *The Virgin, Child and St Anne* (Florence, Uffizi) is called in Italian *Sant'Anna Metterza*, that is, 'St Anne who is placed third', to emphasise her importance after the Virgin Mary and Christ (Figure 58). St Anne and Mary appear as majestic and hieratic figures of power. Sitting on a throne, St Anne towers over the seated Mary, who holds Christ on her lap. A damask cloth is held behind them by three angels, while two more angels, at the sides of the throne, swing their censers in homage. Vasari saw this altarpiece in the church of St Ambrogio in Florence, in a chapel next to the door leading to the nuns' parlour. It has been suggested that one of the functions of this image was to stress the obedience of the Benedictine nuns to their Mother Superior, as well as to channel the devotion of the faithful to the cults of the Corpus Domini and of the Immaculate Conception.[10]

Stories such as the Visitation (a feast which was officially introduced in the liturgical calendar by Pope Nicholas V in 1475), the birth of Mary and that of St John the Baptist, the childhood of Mary, and images of Christ as a child stress the humanity of Christ and the emotional response of the viewer to the sacred stories, which had been encouraged by the preaching of the Dominicans and the Franciscans since the thirteenth century. In the fifteenth and early sixteenth century these stories were set within contemporary interiors, bringing them close to the imagination and the experiences of the viewers.

It cannot be ignored that, as well as being a 'mirror' of meek virginity and of those womanly virtues, humility and obedience, the images of the Virgin also provided examples of power and strength. Visually, the images of *Nostra Donna* dominated the public spaces of all Renaissance cities. In churches and in the most important buildings this female image was present, sitting on a throne, flanked by attendant saints and angels, her majesty signified by a cloth

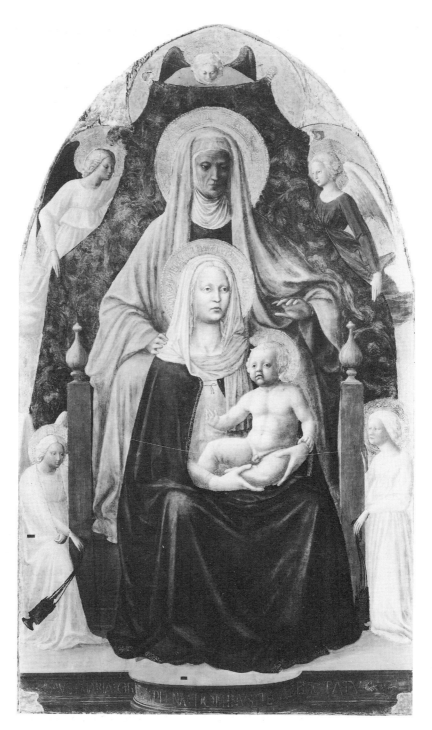

58 Masaccio and Masolino, *The Virgin, Child and St Anne, c.* 1425

160

of honour. It is to the Virgin only that these images are dedicated: she is the object of devotion, and the Child who accompanies her is present as her attribute.[11] She is not only the frightened handmaid of the Lord, accepting her destiny with obedience, or recoiling in terror in front of the angel in the Annunciation, but as the '*Madonna della Misericordia*' she spreads her cloak to provide protection to men and women, and as '*Santa Maria del Soccorso*' she towers over the devil, beating back his attempts to take possession of a child. She is carried to heaven in glory after her death as the '*Assunta*', and she sits at the right of her son who crowns her as '*Regina Coeli*'.

The role of patron saints

The contact between saints and their faithful was emotional and direct: saints had gained, through martyrdom, or through a lifelong dedication to sacrifice and good works, special merits which could be used in the relationship between God and mankind. Requests could be made, which the saints would transmit to God, interceding for the faithful; their merits would assure God's attention.[12] Patron saints (local saints, or the protectors of confraternities or guild, or the saints after whom men and women were named) were particularly important in religious rituals during the feast-days, in acts of personal devotion, and in the patronage of paintings, because of what was seen to be their personal 'investment' in their protégés. Their cult images were present in altarpieces commissioned for a church or for a chapel dedicated to them, and they regularly recur in works painted in the cities under their protection. The patron saint of the town of S. Giminiano, St Fina, is represented with flowers in one hand, and a model of the town in the other in a painting by Lorenzo di Niccolo' di Pietro Gerini of 1402 (S. Giminiano, Museo Civico). A fresco cycle painted by Ghirlandaio *c.* 1475 is dedicated to this thirteenth-century saint, who died at the age of fifteen. It was painted in the Collegiata church in S. Giminiano, in the chapel where she is buried. An inscription on her tomb invites those devoted to the saint to believe in miracles, because the painted stories bear witness to them: '*Miracula quaeris? / Perlege quae paries vivaque signa docent*' (Are you asking for miracles? Look at those that these walls and the lively images illustrate). In the first of the stories, the young saint lies on the wooden plank which was her bed for the long years of her illness (Figure 59). While two women look after her, Pope Gregory the Great appears surrounded by cherubim announcing the day of her death. On the plank are the violets which were found under her rotting body after her death. The second story, set in the apse of a church, open at the sides to show a view of the characteristic towers

of S. Giminiano, represents the funeral of the saint (Figure 60). St Fina lies on a bier at the centre of the composition, surrounded by choirboys. A bishop accompanied by two acolytes reads the service, while some young men and three older men in sombre contemporary attire look on. In the meantime, three miracles are taking place: an angel rings the bells of a belltower, a small blind boy kisses the feet of the saint and regains his sight, and a woman with a crippled arm, who had nursed Fina, touches her hands and is healed. The two frescoes, with their wealth of naturalistic details, the precise setting of S. Giminiano, and the portrait heads in the funeral scene, bring the thirteenth-century story within the experience of contemporary viewers. What happens on the walls of this chapel is indeed a miracle, as the cult of this adolescent saint is also kept alive by the vivid presence of the painted stories.[13]

Religious images as *exempla*

The power of painting to impress in the viewer an example of behaviour was one of the didactic functions of images, as we have already seen in the case of painted furniture commissioned for weddings. Religious images were felt to be a most important instrument for the edification of the soul. An important section of Giovanni Dominici's *Regola del Governo di Cura Familiare* is dedicated to the education of children. Images, Dominici writes, are the first stage in the journey of the child towards a moral life: they are a mirror in which children can recognise themselves:

> In the first consideration, which is to bring them up for God . . . you should observe five little rules . . . The first is to have paintings in the house, of holy little boys or young virgins, in which your child when still in swaddling clothes may delight, as being like himself, and may be seized upon by the like thing, with actions and signs attractive to infance. And as I say for paintings, so I say of sculptures. The Virgin Mary is good to have, with the child on her arm, and the little bird or the pomegranate in his fist. A good figure would be Jesus suckling, Jesus sleeping on his mother's lap, Jesus standing politely before her, Jesus making a hem and the mother sewing that hem. In the same way he may mirror himself in the holy Baptist, dressed in camel skin, a small boy entering the desert, playing with birds, sucking on sweet leaves, sleeping on the ground. It would do no harm if he saw Jesus and the Baptist, the little Jesus and the Evangelist grouped together, and the murdered innocents, so that fear of arms and armed men would come over him.

These images are attractive because of their subject matter. They are effective because children can identify with them, and identification is seen as the first

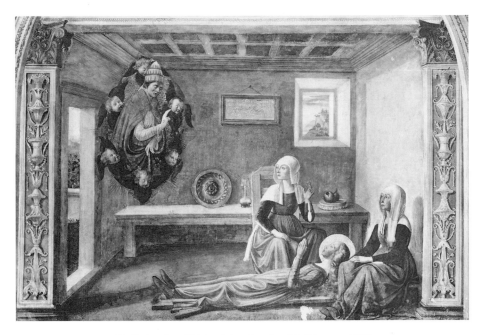

59 Domenico Ghirlandaio, *Death of St Fina*, c. 1475

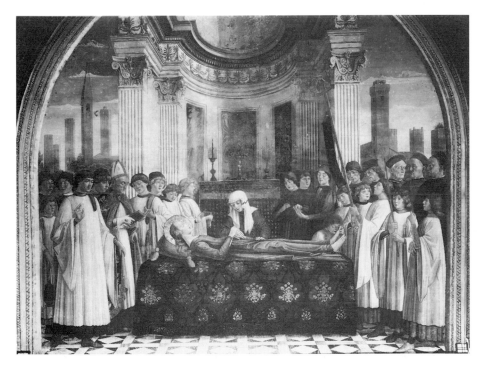

60 Domenico Ghirlandaio, *Funeral of St Fina*, c. 1475

step towards imitation. Dominici stresses that, because of this, girls should be shown images which are deemed to be specifically suitable for them:

> And so too little girls should be brought up in the sight of the eleven thousand virgins, discussing, fighting, and praying. I would like them to see Agnes with the fat lamb, Cecilia crowned with roses, Elizabeth with many roses, Catherine on the wheel, with other figures that would give them love of virginity with their mother's milk, desire for Christ, hatred for sins, disgust at vanity, shrinking from bad companions, and a beginning, through considering the saints, of contemplating the supreme saint of saints.[14]

How much and in what ways the consciousness and lives of small girls and young women were actually shaped by these examples is difficult to ascertain. An ideal may have been proposed through written texts, through sermons and through images, but it is not possible to know whether it was followed to the letter. The lives of the female saints that Giovanni Dominici singled out as examples for young girls – the early Christian martyrs and the thirteenth- and fourteenth-century women who had dedicated their lives to the care of others, to good works and to prayer – present contradictory traits. They are often women who chose to live their lives following their own vocation, and finding their own role in contemporary society, often outside of marriage and of family life. Women, as 'sisters of Eve', were seen as weaker, more frail, vain and light, an easier prey to the devil than men were and, as Dominici writes, 'further away from the natural aim, which lies in the debate of intellectual truth'. It seems, however, that these mirrors of chastity and virtue offered to them not only models of renunciation, passivity and obedience, but also models of active life. Religion has been seen by some modern historians as a major factor in the oppression of women, unquestionably fostering submissive behaviour through the use of sacred images as *exempla*, but it is useful to ask whether in fact it also provided women with the means to find dignity and to gain respect within their own sphere of action. Symbols and *exempla* are not simple repositories of a single one-dimensional meaning, and their power lies also in the multiplicity of interpretations that can be extracted from them. Dominici includes Elizabeth of Hungary in his list of appropiate examples for young girls, and neutrally describes her as 'carrying roses'. The most famous episode in her life, however, is one which demonstrates strength of purpose and defiance: she disobeyed the men of her family in her desire to serve the poor and the sick. The food she had stolen from her kitchen and was carrying to the poor was miraculously transformed into roses when her husband, the powerful Landgrave of Thuringia, ordered her to show what she was hiding. After she was widowed at the age of twenty, she fulfilled her desire to follow the example of St Francis and became a Franciscan tertiary.

Episodes from the life of the fourth-century virgin and martyr Catherine of Alexandria were painted by Masolino on the left-hand wall of a chapel in the church of S. Clemente in Rome, probably between 1428 and 1431. In this case, the images were not primarily intended to inspire young girls, in the words of Giovanni Dominici, towards 'love of virginity, desire for Christ, hatred of sin'. The decoration of the chapel was commissioned by the Milanese Cardinal Branda Castiglione, Titular of S. Clemente, a humanist who had taught at the University of Pavia, had carried out important diplomatic missions for a number of popes, and had also been active in the repression of the Hussite heresy. It is not known who prepared the programme for the fresco decoration of the chapel, which includes, as well as the stories of St Catherine of Alexandria, the life of St Ambrose, archbishop and patron saint of Milan, the *Crucifixion*, the *Annunciation*, and an image of St Christopher.[15] Five episodes from the life of St Catherine are painted on two levels: St Catherine, arguing, rejects the statuette of a pagan god; Catherine converts to Christianity the Empress Faustina, who is then put to death; Catherine then argues with a group of philosophers, who are also converted to Christianity and then martyred; in the last scene, Catherine survives the torture of the wheels thanks to the intervention of an angel, but is then beheaded. In the stories, the figure of the saint is given prominence not only by the dark colour of her garments, but also by her gestures: she is shown calmly arguing, using her arms and hands to emphasise her speeches. In the first scene, she raises her arm in rejection of idolatry, while in the *Dispute with the Pagan Philosophers*, she counts on her fingers the points of her arguments (Figure 61). She stands, severe, calm and firm, at the centre of the perspectival construction of this *istoria* between two rows of seated philosophers, holding their attentive gaze. Masolino conveys the meaning of the stories with a great economy of gesture: this is a woman of strength and courage, who is not intimidated, and who defends the truth of her religion with her intellectual gifts. The aspect of Catherine which is stressed here is her role as a learned saint and as a patron of education. The *Golden Legend* lists her merits, starting from her wisdom and her eloquence, and then her constancy, her chastity and her dignity. Catherine, writes Jacopo da Varagine, was an accomplished philosopher, and possessed not only knowledge, but also an admirable eloquence.[16]

St Catherine of Alexandria was the focus of devotion for both men and women. In a painting by Lorenzo Lotto dated 1523, representing the mystic marriage of St Catherine, a seductive St Catherine bows her head as Christ, held by the Virgin Mary, places the ring on her finger (Figure 62). Behind Mary's chair is the full-face portrait of the patron, Niccolò Bonghi, a wealthy and important

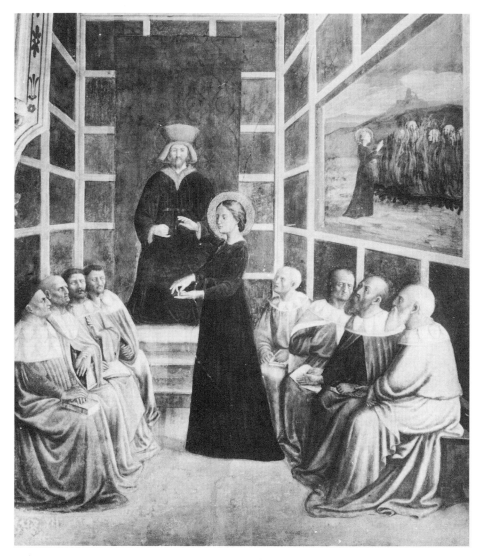

61 Masolino, *St Catherine and the Philosophers, c.* 1428–31

citizen of Bergamo. He stares out at the viewer, and we seem to be witnessing a private vision, an experience which is made more immediate because of the earthly beauty of the saint and because the event takes place in a domestic setting. The painting, given by Lotto to Bonghi in lieu of rent, was seen by Marcantonio Michiel in Bonghi's own house, and it was described as 'the painting of Our Lady with St Catherine and the angel and with the portrait of M. Niccolò'.

Richly dressed in a contemporary gown, St Catherine of Alexandria appears

again as the mystic bride of Christ, together with St Lawrence and St Ursula, in an altarpiece painted by Girolamo Romanino, probably to mark the foundation, in 1535, of what would become one of the most important amongst the religious orders for women in the sixteenth century, the *Orsoline Dimesse* (Figure 63). The founder of the Ursulines was Angela Merici, a Franciscan Tertiary who was considered to be a saint during her own life. She died in 1540, and was buried in the church of St Afra, in Brescia (now dedicated to St Angela Merici herself), where she had founded her order. In the painting, dressed in a humble brown garment, with a white cloth on her head, she kneels in prayer next to St Ursula, the patron saint of the order, who had been martyred together with her eleven thousand virgin attendants. Merici, who was illiterate, worked to provide a religious education for young girls, and her followers lived as governesses with the families of their pupils. The Ursulines were drawn from all levels of society, without distinction. They made a solemn promise to keep their virginity, but did not take vows, nor did they have to wear a prescribed habit. Merici had wanted to offer women an alternative to the convent, and her order did not follow any specific rule till much later in the century.[17]

A 'living saint' and her chapel

For a significant number of women a life of virtue, prayer and good works brought fulfilment and even fame. In 1513 Raphael was commissioned by Antonio Pucci, a Florentine canon, to paint an altarpiece for a spacious and elegant, newly-built chapel in the left transept of the church of S. Giovanni in Monte in Bologna (Figure 64). The prestige of the artist, who at the time was involved in a number of important papal projects in Rome, alerts us to the extraordinary circumstances surrounding the commission and the iconography of this picture. The chapel belonged to Elena Duglioli dall'Olio, a woman who, since 1506, was the focus of an extraordinary devotion, both in Bologna and outside that city, because she was considered by many, including Antonio Pucci and his uncle, the powerful cardinal Lorenzo Pucci, to be a living saint.[18] Even Popes Julius II, Leo X and Clement VII knew of her; Lucrezia Borgia, the wife of Alfonso d'Este, had heard of Elena's visions, and she had been invited to France by the princesses of Nemours and of Alençon. Her fame derived from her frequent ecstatic visions and from her pious, contemplative life, but especially from the widespread knowledge that, immediately after her wedding in 1487, she had persuaded her much older husband not to consummate their marriage. Her virginity was the essential element in her saintly *persona*.

The altarpiece, a *sacra conversazione*, was dedicated to St Cecilia, who is represented standing between St Paul, St John the Evangelist, St Augustine and Mary Magdalen.[19] According to the *Golden Legend*, Cecilia was a young Roman of noble birth, who had dedicated her virginity to Christ. On her wedding night she had convinced her husband, Valerian, to respect her vow of chastity, and she had then succeeded in converting him and his brother to Christianity. The two brothers were subsequently put to death, and so was Cecilia.[20] During the first decade of the sixteenth century, in Bologna, a remarkable series of ten frescoes, illustrating episodes from the lives of St Cecilia and her husband Valerian, had been commissioned by the lord of the city, Giovanni Bentivoglio, for a small church near S. Giacomo Maggiore, from a group of painters, among whom were Francesco Francia, Lorenzo Costa and Amico Aspertini.[21]

The saint's dedication to her virginity was a focus for Elena Duglioli dall'Olio's imitation and devotion. Elena, who was buried in her own chapel

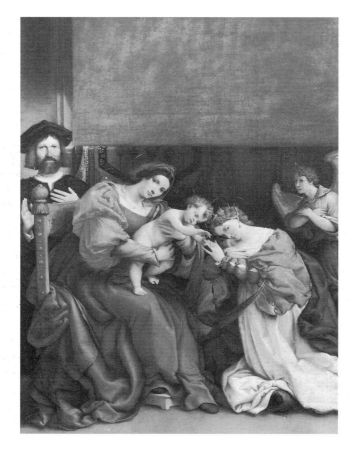

62 Lorenzo Lotto, *Mystic Marriage of St Catherine*, 1523

at her death in 1520, identified herself with the saint. She had received as a present a relic of St Cecilia, which was kept in a silver reliquary, also commissioned by Antonio Pucci. In the Raphael painting Cecilia is shown with her eyes turned towards heaven, as if listening to the choir of the angels who appear, as in a vision, through the clouds. Her face is rapt, as Vasari notes, with 'that abstraction that one can see in the face of those who are in ecstasy'. The saints who flank her in the altarpiece were chosen not only because of the location (the church is dedicated to St John, and St Augustine is the patron saint of the order to which the church belonged), but also for their attitude to chastity. St Paul and St Augustine laid the foundations for the Church's traditional praise of chastity and virginity, St John the Evangelist was known as a patron saint of virginity, and Mary Magdalene, one of the most elegant and graceful of all Raphael's figures, was an *exemplum* of faith and contemplative life, and of repentance from the sins of the flesh. Elena's visions, during which

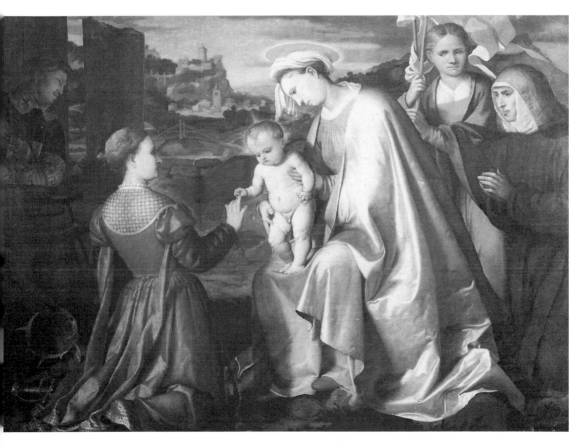

63 Girolamo Romanino, *Mystic Marriage of St Catherine, c.* 1535

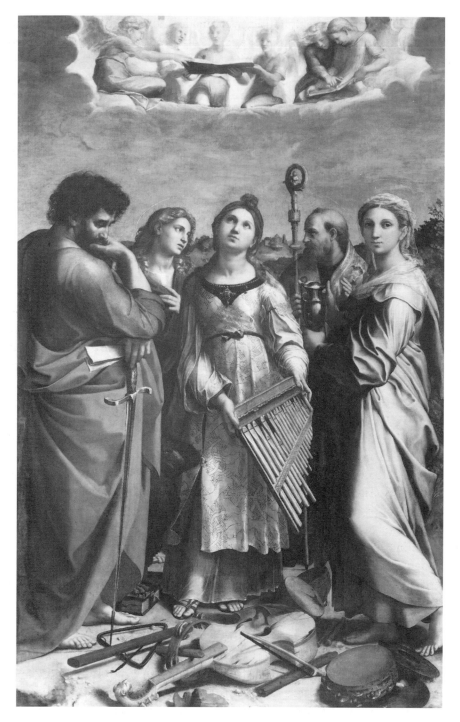

64 Raphael, *St Cecilia Altarpiece*, *c.* 1513–16

she reported hearing heavenly music, were made known through her contemporary biographies, and all the five saints in the altarpiece also experienced visions. Cecilia, according to the *Golden Legend*, had preferred celestial music to the sound of the nuptial instruments. For Elena, as well as for Cecilia, the real music belonged to another, higher, sphere: in the altarpiece, musical instruments lie, broken and discarded, on the ground. After her death, Elena herself became an object of cult in her own chapel. *Ex-voto* were hung not only around the St Cecilia altarpiece, but also around a portrait of the Blessed Elena which had been placed in the chapel. Even today her tomb is adorned with flowers, candles burn in front of it, and a special prayer dedicated to her is affixed on the grate which closes her chapel.

The Third Orders and St Catherine of Siena

The presence of women in the religious life of the Renaissance city was undeniably an important aspect of society, and the great innovation of the second half of the fifteenth century is the growth of the importance of the tertiary orders.[22] These allowed married women, often widows, to follow their religious vocation while still living at home, or in communities with a small number of other women, or in open monasteries, without taking the solemn vows of the Second Orders. These women were able to have control of their own property through the administration of sums of money destined for their order, or by providing dowries for poor women. The importance of the orders of nuns and of tertiaries in society is reflected in the iconography of cult images, such as the altarpiece painted *c.* 1470 and attributed to Pier Francesco Botticini, in the church of S. Spirito in Florence. This *sacra conversazione* represents St Monica, the mother of St Augustine of Hippo and of St Perpetua, dressed in the garb of a widow or of a nun, sitting on a throne, surrounded by Augustinian nuns. St Catherine of Siena, together with the two Franciscan tertiaries, Elizabeth of Hungary and the Blessed Angela of Foligno, was also deeply committed to the care of the sick, one of the most important activities of the Franciscan and Dominican tertiaries. St Catherine, who died in 1380 and was canonised in 1461, represented an example for those women who carried out their religious mission within the world and, more frequently during the sixteenth century, for those whose religiosity took a different path, that of ecstatic visions. In a *sacra conversazione* probably painted *c.* 1473 and attributed to Cosimo Rosselli, Catherine of Siena is characteristically represented as a Dominican nun, with a white tunic and veil and black cloak (Figure 65). The iconography follows the example of the Botticini St Monica altarpiece in S. Spirito. St Catherine

171

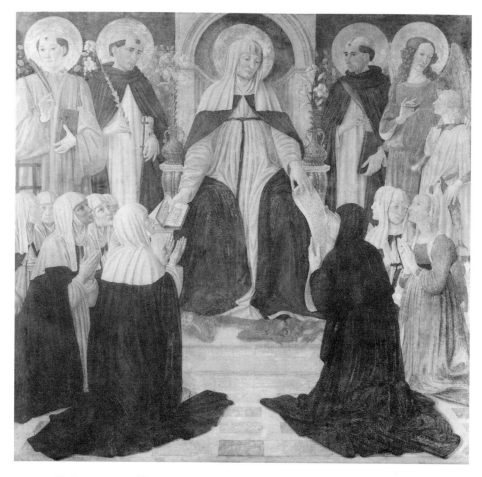

65 Cosimo Rosselli, *Sacra Conversazione with St Catherine of Siena, c.* 1473

is shown sitting on a throne, flanked by St Lawrence and St Dominic on her right, St Peter Martyr and the Archangel Raphael with Tobias on her left. Her importance is indicated by her size: her head is on the same level as those of the standing saints. Her power is represented by a devil which lies squashed under her feet. Vases with lilies, one of St Catherine's traditional attributes, are placed on the arms of her throne. With her right hand, she gives the bound volume of the Rule to the kneeling nuns of the Second Order and with the left she offers a paper of regulations to a kneeling group of members of the Third Order, two of whom are in secular dress. One is a widow dressed in black, the other an elegant young woman in a green and red gown with her hair covered by a veil and her hands, which are joined in prayer, decorated with rings. The altarpiece was perhaps commissioned for the church of S. Domenico al Maglio

(also known as S. Domenico di Cafaggio) in Florence, which was attached to the convent of St Catherine.[23]

The iconography of St Catherine was established very soon after her death: she is always shown wearing the habit of the Dominican nuns, almost always carrying a lily and a book, and sometimes also a thin crucifix to emphasise the stigmata she received from Christ. Images were instrumental in the spreading of her cult: not only altarpieces, frescoed images, and private devotional paintings, but also prints, especially woodcuts, and small paintings on paper. These cheaper, 'low art' objects were produced in vast numbers, especially in Venice and in Siena, from the end of the fourteenth century. They were hung in churches, but were also bought by the faithful to be kept at home. It seems that the first image of St Catherine to be kept in a private house, in Venice, belonged to a young woman called Maria Sturion, who had dedicated her life to the saint, becoming a Dominican tertiary and leaving money to the order before her death in 1399. Images of St Catherine were the focus of the devotional fervour of both men and women. Again in Venice, a learned man of science called 'Mastro Andrea' kept an image of Catherine in his house. The banker Niccolò dei Guidiccioni had obtained a miracle from the saint, and always kept her image with him.[24]

Catherine's official life, the *Legenda Major*, written by Raimondo da Capua in the last decades of the fourteenth century, was one of the most important sources for the iconography of her images. It was reprinted many times, both in Italy and in the rest of Europe, and was often illustrated with woodcuts. This text places much emphasis on her intellectual strength, and on the special gifts bestowed on her by Christ to help her accomplish his mission. It stresses how Christ's intention is to work through women because they are 'naturally weak and uncultured . . . I shall lead you in front of Popes, the leaders of the Church and of the Christian people, so that, through the meek, as it is my custom, I shall humiliate the pride of the strong'.[25]

In the sixteenth century, images which stress Catherine's contemplative life and her visions, often symbolised by the representation of her mystic marriage with the Christ Child, became more popular. In a large altarpiece painted *c.* 1509 by Fra Bartolomeo for the Dominicans of San Romano in Lucca (Lucca, Pinacoteca), St Catherine kneels with St Mary Magdalene, in contemplation of a vision of God the Father, who appears in heaven surrounded by angels.[26]

Mary Magdalene

One of the most interesting figures of saints, both for the history of her cult and for the changes in the iconography of her images during the fifteenth and

sixteenth centuries, is Mary Magdalene. A 'composite' saint, her *persona* in the Western church was made up of three different women: Mary of Magdala, who was freed from the demons who possessed her, found Christ's empty sepulchre and met Christ after his resurrection; an unnamed woman who anointed Christ's feet and then dried them with her hair, and whose sins were forgiven; and Mary of Bethany, the sister of Martha and Lazarus. A fourth Mary was at times conflated into this image, Mary of Egypt, a repentant prostitute who lived as a hermit in the desert, covered only by her hair. The Franciscans and the Dominicans were responsible for the popularity of the cult of Mary Magdalene: she was the patroness of the Dominican order, and two of the fresco cycles dedicated to her in the fourteenth century are in Franciscan churches. She is often represented at the feet of the cross, dressed in red, her blond hair flowing down her shoulders, grieving over the death of Christ, or standing in *sacre conversazioni*, holding as her attribute the jar of ointment with which she had anointed Christ's feet.

During the fifteenth century, the special devotion for Mary Magdalene of the Dominican St Antonino, the Archbishop of Florence, promoted the iconography of the saint as a hermit who expiates her sins through penance. In his writings, Antonino indicated to women that they should follow the example of Mary Magdalene. In a number of paintings commissioned during this period, the saint appears as a hermit, gaunt, with long, unkempt hair covering her body. Perhaps the most famous of all these images is a sculpture: Donatello's *Mary Magdalene* (Florence, Museo dell'Opera del Duomo), haunting in her relationship to the viewer, with her open mouth in a skull-like face, her sunken eyes and skeletal hands. To this iconographical type belong the penitent Magdalene in prayer transported by angels, by Antonio Pollaiuolo (Staggia, Pieve di St Maria Assunta), and the panel by Filippino Lippi (Florence, Galleria dell'Accademia), where the saint's body is covered by ragged drapery, her hair reaches down to her knees, and her thin hand holds the ointment jar. This last image, with its intensity and pathos, reminds the viewer of the time when Savonarola's influence in Florence was strongest.[27]

Mary Magdalene was the obvious patron saint of repentant prostitutes: in the church of Sant'Elisabetta delle Convertite in Florence, the convent of the 'converted nuns', was an altarpiece painted by Botticelli in the early 1490s, representing the Trinity, which appears as a vision, flanked by Mary Magdalene and by St John the Baptist against the barren rocks of a desert landscape (Figure 66). This image of the saint follows the type of the penitent hermit, hands lifted in prayer, gaunt face, and hair entirely covering her body.[28] In the following century, Mary Magdalene continued to be the patron saint of repentant prostitutes: Vasari writes that it was for one of them (*per una meretrice*)

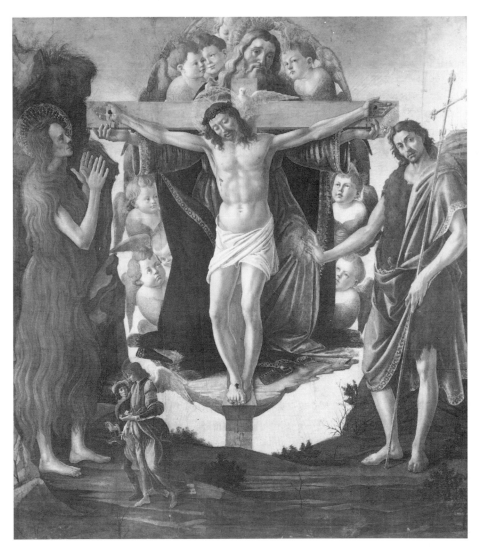

66 Sandro Botticelli, *The Holy Trinity with St John the Baptist, Mary Magdalene, Tobias and the Angel (Pala delle Convertite), c.* 1490s

that Giulio Romano painted 'four stories of the Magdalene and the four Evangelists in the vault of the chapel of the Trinity', which were then engraved by Marcantonio Raimondi.[29]

During the sixteenth century, the image of Mary Magdalene as an ascetic was abandoned by Northern Italian painters, who emphasised the strength and depth of her repentance by contrasting it with her seductive beauty. These representations of the Magdalene, which were extremely successful, are disturbingly

sensual for the pictorial techniques used in the rendering of flesh, hair and of the texture of fabrics, for the painters' interest in the study of light, and for the poses and the choice of physical types. This is evident in Correggio's *Noli Me Tangere* of 1513 (Madrid, Prado) which was in the house of the Ercolani family in Bologna; in his *Lamentation* of the mid 1520s (Parma, Galleria Nazionale) for the Del Bono chapel in the church of S. Giovanni Evangelista in Parma, and in the small *Mary Magdalene reading in a Landscape*, now lost, but formerly in the Gemäldegalerie in Dresden. A *Mary Magdalene in the Desert* is described in a letter of September 1528, written by the Countess Veronica Gambara to Isabella d'Este. The Countess, who had commissioned the painting from Correggio, comments on the contrast between the beauty of the saint and her expression:

> He represents the Magdalene in penitence in the desert in a fearsome cavern, kneeling on the right with her hands clasped and raised to the heavens to implore pardon for her sins; her admirable attitude, the noble and lively grief on her most beautiful face are so marvellous as to stupefy the spectator. In this work [Correggio] has expressed all the sublime quality of the art of which he is a master.[30]

Savoldo's various versions of his Magdalene wrapped in a silk cloak, painted between 1520 and 1536 (in the National Gallery, London, in the Uffizi, Florence, and in the Staatliche Museen Preussischer Kulturbesitz, Gemäldegalerie in Berlin) are displays of the painter's virtuosity in the representation of the texture of the silk and of the different qualities of the light. They are demonstrations of artifice and of the possibilities of the medium of oil paint. They are also, and this is very important, images which involve the spectator's emotions and invite a reaction. By turning Mary Magdalene's head, mysteriously covered in her cloak, towards the viewer, the painter includes us in what perhaps is the crucial moment of revelation after the resurrection of Christ. Savoldo seems to have represented the event described in the Gospel, when Christ calls Mary Magdalene, and she finally recognises him: 'Jesus said to her "Mary". She, turning, said to him "Rabbi"'.[31]

Titian, his patrons and Mary Magdalene

Titian painted a number of half-figure versions of the image of Mary Magdalene, many of which are now lost. These images, executed for very important patrons belonging to the *milieu* of the Italian and foreign courts, link the saint to those fashionable representations of beautiful women we have seen in a

previous chapter. In all the paintings of this type which survive, the figure is shown half-length; the saint's abundant blond hair ripples on her shoulders, catching the light, contrasting with the texture of the skin; the head is thrown back; the body is silhouetted against the dark grotto and the dramatic sky of the landscape background. In March 1531, Federico Gonzaga wrote to Titian, asking him to paint a Mary Magdalene for the Marchese del Vasto, specifying that it should be 'as tearful as possible', and pointing out that this was to be a very special gift. It seems, however, that the painting, now lost, was in fact not for the Marchese, but for his 'adoptive mother', Vittoria Colonna, who had expressed her wish to have such a painting. While Titian, in Venice, was speedily working on the picture, Federico Gonzaga wrote to Vittoria Colonna to let her know that he had commissioned a Mary Magdalene, 'very beautiful, and as tearful as possible'. The finished work was promptly sent to Mantua, and Federico wrote to Titian to let him know how much both he and his mother, Isabella d'Este, had liked it, and how grateful he was for this *bellissima opera*.[32] The *Mary Magdalene* now in the Galleria Palatina in Florence (Figure 67) was mentioned by Vasari, who writes that 'a half-figure painting of a St Mary Magdalene, with her hair spread out, which is a rare thing' was kept in the *guardaroba* of Francesco Maria della Rovere, Duke of Urbino, together with three secular works by Titian, 'two very beautiful female heads' and the 'young reclining Venus'.[33] Eyes fixed heavenwards, mouth slightly open, with her luxuriant hair covering her shoulders but revealing her breasts, her right hand touching her heart, Mary Magdalene grasps her hair with her left hand, just below her waist, in a pose derived from an antique Venus.[34]

This type of image was modified in the 1560s, probably because of changing attitudes towards the *decorum* of religious images. Titian kept the same pose, but added a chemise to cover the saint's breasts, a striped shawl, a skull and a book. These last two objects symbolise the transitory quality of life and beauty, and indicate the importance of the contemporary practice of meditation exercises on repentance and death. The eyes of the Magdalene, turned towards heaven, are full of tears, an example of the fashion for the intensely emotional expressive quality of the devotional images produced during this period. The success of the formula is obvious: one version of this type was painted for Philip II in 1561, and another was sent as a gift to Cardinal Alessandro Farnese in 1567 (Figure 68). Titian described a Magdalene sent to the Duke of Alba in 1573 as being 'converted to penance'. In a letter to Philip II written in April 1561, Titian asks for two thousand scudi which the king owed him: the Magdalene he has painted for him, with tears in her eyes, will help to transmit his request. Vasari describes one of the many versions, which he probably saw in 1566 in Venice:

He then did a three-quarter figure of a dishevelled St Mary Magdalene, that is with her hair falling over her shoulders, around her throat and on her breast, to send to the Catholic King. Turning her head up with her eyes raised to heaven, she shows her remorse by the redness of her eyes, and by her tears her pain for her sins, so that this painting greatly moves those who look at it, and, what is more, even if it is very beautiful, it does not induce lust, but compassion. This painting,

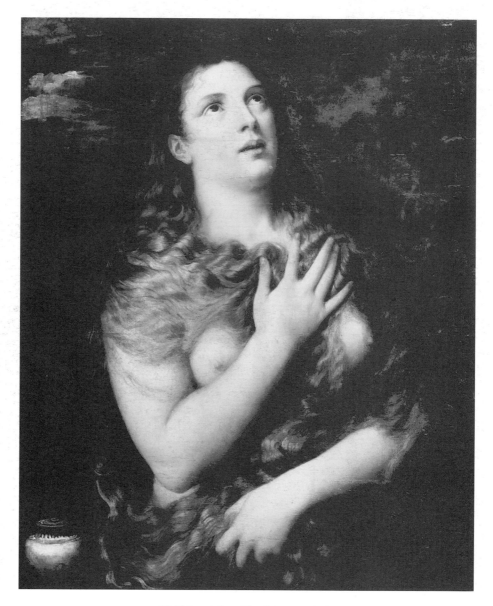

67 Titian, *Mary Magdalene, c.* 1535

178

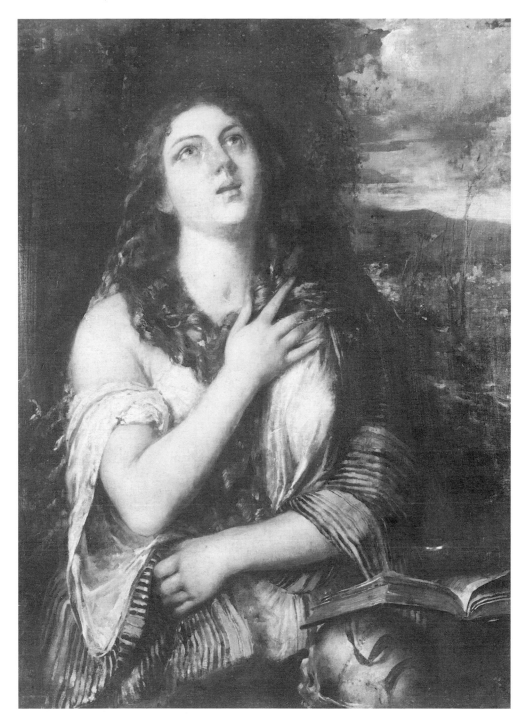

68 Titian, *Mary Magdalene, c.* 1567

when it was finished, so pleased Silvio [Badoer], a Venetian gentleman, that he gave one hundred *scudi* to Titian in order to have it, as somebody who is greatly delighted by paintings. Titian was compelled to paint another, which was equally beautiful, to send to the Catholic King.[35]

What has been interpreted as a prim denial of the sensuality of the image could be, in fact, an astute disclaimer. Vasari is at pains to warn his readers that the appropriate reaction to this painting should be compassion, not lust, and that Titian's *Magdalene* is within the bounds of *decorum* because it is not erotic. Would he have had the need to stress this point, if no one had ever remarked on the sensuality of these images? Vasari was writing at a time when preoccupations with the *decorum* of religious images were the subject of writings by churchmen, such as *De Cultu et Adoratione Imaginum* of 1552 by the Dominican Ambrogio Catarino Politi, and were also the core of the deliberations on the use of public devotional images of the XXV session of the Council of Trent of December 1563. The relationship between the erotic and the sacred was certainly present in the mind of fifteenth- and sixteenth-century viewers: we have already read Vasari's comment about the reaction of the Florentine women to Fra Bartolomeo's *St Sebastian*. Vasari was obviously sensitive to the question of *decorum*, as it appears clearly in a passage of his *Life of Fra Angelico*: defending the beauty of figures of male and female saints, he writes that they should be more beautiful because they are celestial beings, and those who see them as lascivious 'reveal their infected and corrupt soul'. He then warns his readers that he does not approve of almost naked figures painted in churches as they show that the painter has not had respect for the place.[36] Vasari also tells the story of a man who asked a painter called Il Nunziata, who was well known for his jokes, for an image of the Virgin. The man 'disliked those painters who could only do lascivious things, and . . . he therefore wanted him to paint a picture of Our Lady, which should be honest, middle aged, and which did not move one to lust, [and] Nunziata painted him one with a beard'.[37] Leonardo had made comments about the seductive power of religious images, since beauty could exert its power in ways which were less legitimate: 'It once happened to me that I made a picture representing a divine subject, which was bought by a man who fell in love with her. He wished to remove the emblems of divinity in order to be able to kiss the picture without scruples. But finally his conscience overcame his sighs of desire and he . . . was obliged to remove the painting from his house.'[38]

Were Titian's *Mary Magdalenes* perceived as chaste expressions of the profundity of repentance, or was their earthly beauty too alluring for a religious image? Fifteenth- and sixteenth-century texts mention parallels between chaste nudity and truth, and between the repentant Mary Magdalene and Venus. Her

beauty is seen in these writings as a demonstration of her sincere desire to repent. Savonarola himself had preached in 1496 that 'creatures are beautiful in proportion to their participation in the nearness and beauty of God. And the body is more beautiful that houses a beautiful soul'. These texts would have tinted the perceptions of the viewers, but the same painting could have been seen in different ways according to the context in which it was placed.[39]

As far as Titian's intentions are concerned, we can only guess. The Florentine Baccio Valori, in his *Ricordi*, reports a conversation with the painter which may throw a different light on this matter. Valori writes that, having met Titian in his workshop in Venice *c.* 1559, the painter showed him 'a Magdalene in the desert, very attractive; and I remember that I said to him that she was too attractive, so fresh and dewy (*fresca e rugiadosa*) while doing penance. As he understood that I meant that she should be thin from fasting, he answered me grinning, warning me that she had been portrayed on the first day before she began to fast, so that he could represent her in the painting as a penitent, but as attractive as he could, and that she certainly was'.[40]

Notes

1 The religious dimension of Renaissance culture is clearly discussed by T. Verdon in 'Christianity, the Renaissance, and the Study of History', in T. Verdon and J. Henderson (eds), *Christianity and the Renaissance. Images and Religious Imagination in the Quattrocento*, Syracuse University Press, Syracuse, NY, 1990, pp. 137 ff., with bibliographical indications.

2 H. van Os makes an important contribution to the study of the function of religious art in *The Art of Devotion in the Late Middle Ages in Europe 1300–1500*, Merrell Holberton, London, 1994. In the same volume, see also the essay by E. Honée, 'Image and Imagination in the Medieval Culture of Prayer: a Historical Perspective', pp. 157–73, which explains the genesis of individual prayers and of the need for private devotional paintings. Honée points out that private devotional images do not belong to a separate genre from images painted for churches. He reminds the reader that the use of private devotional images is predicated on an individual and subjective experience of faith, and on the importance of prayer by the laity, which was encouraged by the mendicant orders with their emphasis on a more emotional spirituality. The illustrations of the Books of Hours and small paintings and diptyches were originally used to give the lay man and woman a focus for their prayers. Honée adds: 'In a learning process that lasted for centuries, ordinary believers were trained in spiritual values that had evolved in the claustral world of the monastics. Two activities deserve special mention: personal prayer and meditation. It was by no means self-evident that large numbers of lay people should have taken up these exercises.'

3 For the differences between images and narratives, and for a discussion of the function and iconography of altarpieces, see C. Hope, 'Altarpieces and the Requirements of Patrons', in Verdon and Henderson, *Christianity in the Renaissance*, pp. 537–71. Hope writes that the function – and therefore the meaning – of altarpieces is on the whole very straightforward, and denies that the choice of subject matter had anything to do with the liturgy of the Mass. He goes on to say: 'There is no hint in any document of the period, as far as I know, that people wished to express or sought any deep theological message in altarpieces' (p. 554). Discussing Titian's *Pesaro Madonna* in the church of the Frari in Venice, he explains that 'the picture is first and foremost an invitation to us to honor a particular groups of saints, second,

an expression of the donor's devotion to these saints, and, third, an invitation to us to remember him in our prayers to them' (p. 551).

4 For the two fifteenth-century marriage commissions, see J. K. Lydecker, 'The Domestic Setting of the Arts in Renaissance Florence', unpublished doctoral dissertation, Johns Hopkins University, 1987, pp. 96 and 123. For Raphael's Nasi commission, the *Madonna of the Goldfinch* in the Uffizi in Florence, see Vasari – Milanesi IV, p. 321.

5 On the narrative conventions of fifteenth-century fresco cycles, see, also by C. Hope, 'Religious Narrative in Renaissance Art', *Journal of the Royal Society of Arts*, 134, 1985, pp. 804–15.

6 R. C. Trexler analyses the power of religious images and their role in Renaissance society's rituals in his *Public Life in Renaissance Florence*, Cornell University Press, Ithaca, NY and London, 1980, pp. 61–73, and 113–15. His discussion of the relationship between the faithful and the image is particularly enlightening, with its emphasis on the psychological mechanisms which govern it.

7 On Morelli's *Ricordi*, see R. C. Trexler, 'In Search of Father: the Experience of Abandonment in the *Recollections* of Giovanni Pagolo Morelli', *History of Childhood Quarterly*, 3, 1975, pp. 225–52, repr. in *Dependence in Context in Renaissance Florence*, Medieval & Renaissance Texts & Studies, Binghamton, NY, 1994, pp. 171–201. The original of Giovanni di Paolo Morelli's *Ricordi* is in V. Branca (ed.), *Mercanti Scrittori. Ricordi nella Firenze tra Medioevo e Rinascimento*, Milan, 1986, pp. 307–11. M. Baxandall describes clearly and imaginatively the process of visualisation, and the relationship between prayers and images, in *Painting and Experience in Fifteenth Century Italy. A Primer in the Social History of Pictorial Style*, Oxford University Press, Oxford, first published 1972, 2nd ed. 1988, pp. 40–8.

8 Cited in *Mercanti Scrittori*, p. 59. The literature on the significance and iconography of the Virgin Mary is too vast to be listed here. M. Warner, *Alone of All Her Sex. The Myth and Cult of the Virgin Mary*, Quartet Books, London, 1978, with extensive bibliography, is still the most complete account in English.

9 The importance of matriarchial figures and of the family in the iconography of the life of Christ is discussed by J. Bossy in *Christianity in the West 1400–1700*, Oxford University Press, Oxford, 1985, pp. 9 ff., and by S. F. Matthews Grieco in her informative and interesting essay, 'Modelli di Santità Femminile nell'Italia del Rinascimento e della Controriforma', in L. Scaraffia and G. Zarri (eds), *Donne e Fede. Santità e Vita Religiosa in Italia*, Laterza, Bari, 1994, pp. 303–25, esp. pp. 306–7. In connection with representations of the Holy Family, Matthews Grieco points out that, up to the second half of the sixteenth century, St Joseph is a 'marginal figure' in comparison with the importance given to the women, Mary, St Anne, St Elizabeth, and to the two children, Christ and St John the Baptist.

10 *The Virgin, Child and St Anne* is discussed by P. Joannides in his *Masaccio and Masolino. A Complete Catalogue*, Phaidon Press, London, 1993, pp. 104 ff. and 369–72. T. Verdon examines the possible function and meanings of this work in 'La Sant'Anna Metterza: riflessioni, domande, ipotesi', in L. Berti and A. M. Petrioli Tofani (eds), *I pittori della Brancacci agli Uffizi*, Gli Uffizi, Studi e Ricerche, 5, Florence, 1988, pp. 33–58. St Anne was the focus of particular devotion in Florence because on the feast day dedicated to her, on 26 July 1343, the tyrant Walter of Brienne, the so-called Duke of Athens, had been driven out of the city.

11 This point is made convincingly by Hope in 'Altarpieces and the Requirements of Patrons', pp. 544 ff., and by M. Kemp in the Introduction to P. Humfrey and M. Kemp (eds), *The Altarpiece in the Renaissance*, Cambridge University Press, Cambridge and New York, 1990, p. 12.

12 On the cult of saints, see D. Weinstein and R. M. Bell, *Saints and Society. The Two Worlds of Western Christendom, 1000–1700*, The University of Chicago Press, Chicago and London, 1982.

13 The stories from the life of St Fina are analysed by Weinstein and Bell, *Saints and Society*, pp. 33 ff.

14 Cited in C. E. Gilbert, *Italian Art 1400–1500*, Sources and Documents in the History of Art Series, Prentice-Hall, Inc., Englewood Cliffs, NJ, 1980, pp. 145–6. For a discussion of this

passage, see D. Freedberg, *The Power of Images. Studies in the History and Theory of Response*, University of Chicago Press, Chicago and London, 1989, pp. 4 ff.

15 The chapel in S. Clemente, its patron and the iconography of the stories are discussed by P. L. Roberts, *Masolino da Panicale*, Clarendon Press, Oxford, 1993, pp. 100 ff. Roberts points out that 'The virgin-martyr St Catherine of Alexandria was also associated with the defence of religious orthodoxy. In the early fifteenth century, she was considered a spiritual predecessor of the as yet uncanonised Catherina of Sienna who, like Cardinal Branda, had been intimately involved in bringing about the end of the Great Schism and the consequent return of the papacy to Rome.' (p. 102). P. Joannides, in *Masaccio and Masolino*, pp. 399–413, comments on the connection between the interests of the patron and the subject matter of the St Catherine frescoes, but without making precise topical links which would limit the significance of the stories: 'The Catherine cycle is specifically concerned with steadfastness, conversion and martyrdom. It is significant that the popular and poetic episode of St Catherine's mystical marriage with the Infant Christ is omitted. Stress is laid on the devotional and physical contexts that Branda must have known well. The ceremony in the temple, where Catherine seems to mock the Emperor's worship of the idol, registers her intellectual and moral superiority from the first, particularly relevant to a cardinal concerned with fighting heresy. The scene below represents a debate before a court, with Catherine as an ambassadress for the Faith, a role Branda had often to perform.'

16 The significance of St Catherine of Alexandria in fifteenth- and sixteenth-century writing, and the changing iconography of the saint from Masolino to Tintoretto, is discussed by Marta Ajmar in her 'Typology of Illustrious Women', in *Culture, Society and Women in Renaissance Italy*, forthcoming.

17 On Angela Merici and her order, see M. King, *Women of the Renaissance*, University of Chicago Press, Chicago and London, 1991, pp. 109 ff., and P. Caraman, *St Angela: the Life of Angela Merici Foundress of the Ursulines (1474–1540)*, Longmans, London, 1963.

18 On Elena Duglioli dall'Olio see the entry by M. Romanello in *Dizionario Biografico degli Italiani*, 41, Istituto della Enciclopedia Italiana, Rome, 1992, pp. 799–802. On her life and cult, and on the relationship between the woman and the painting, see the informative essay by G. Zarri, 'L'altra Cecilia: Elena Duglioli dall'Olio', in *La Santa Cecilia di Raffaello: Indagine per un Dipinto*, Alfa, Bologna, 1983, pp. 83–118. A print showing Elena as a 'saint' and derived from her portait is illustrated in Zarri's essay.

19 Raphael's *St Cecilia* altarpiece is discussed in R. Jones and N. Penny, *Raphael*, Yale University Press, New Haven and London, 1983, p. 146. For a fuller analysis of the iconography, see S. Mussakowski, 'Raphael's St Cecilia: An Iconographical Study', *Zeitschrift für Kunstgeschichte*, 3, 1968, pp. 1–26. R. Stefaniak, in 'Raphael's *Santa Cecilia*: a fine and private vision of virginity', *Art History*, 14, 3, September 1991, pp. 345–71, puts forward what she considers to be the solution to a series of complex problems which, she thinks, underpin the iconography, composition and meaning of this altarpiece.

20 For the life of St Cecilia, see Jacopo da Varagine, *The Golden Legend*, ed. G. Ryan and H. Ripperger, Arno Press, New York, 1941, pp. 689–95.

21 On the frescoes in the Oratorio di S. Cecilia in Bologna, see M. Calvesi, *Gli Affreschi di S. Cecilia in Bologna*, Bologna, 1960, and D. Scaglietti, 'La Cappella di Santa Cecilia', in *Il Tempio di San Giacomo in Bologna: Studi sulla Storia e le Opere d'Arte. Regesto Documentario*, Officine Grafiche Poligrafici Il Resto del Carlino, Bologna, 1967, pp. 133–46.

22 The spiritual life of women during the Renaissance is explored by M. King in chapter 2 of her *Women of the Renaissance*. The context for the religious life of women in this period is given by E. Schulte van Kessel, 'Virgins and Mothers between Heaven and Earth', in N. Zemon Davis and A. Farge (eds), *A History of Women in the West. III Renaissance and Enlightenment Paradoxes*, Harvard University Press, Cambridge, Mass., and London, 1993, pp. 132–66. The debate about the role of religion in the lives of Renaissance women, and about the impact of religious ideals is summarised by L. Scaraffia and G. Zarri in the Introduction to *Donne e Fede*, esp. pp. viii ff. On the one hand, M. R. Miles, in her *Carnal Knowing. Female Nakedness and Religious Meaning in the Christian West*, Burns & Oates, Tunbridge Wells,

1992, writes that 'figures of the ideal woman – like the Virgin – played as important a role in shaping real women's subjectivity and socialization as negative female images that formulated what women must avoid' (p. 139). M. King, on the other hand, places much importance on the positive experience of sainthood, and she writes that the path of holiness offered a respectable way out from submission within the family. She points out that, in fifteenth-century Italy, the number of women saints had reached 29 per cent, while from 1305 to 1500 women made up 55 per cent of lay saints (*Women of the Renaissance*, chapter 2, 'Women and the Church', pp. 81–156).

23 For the original location of the St Catherine of Siena altarpiece in Edinburgh, see W. and E. Paatz, *Die Kirchen von Florenz*, V. Klostermann, Frankfurt, 1955, II, p. 6.

24 The iconography of St Catherine of Siena is analysed by L. Bianchi and D. Giunta, *Iconografia di Santa Caterina da Siena, I: L'Immagine*, Rome, 1988. The information on the prints and paintings on paper is on pp. 68 ff. S. F. Matthews Grieco explains the changes in the iconography of St Catherine before and after the Counter-Reformation in *Donne e Fede*, pp. 317 ff. She writes that even the images which give emphasis to the contemplative life of the saint cannot be seen as a passive model for women, since they privilege a choice for a 'relative autonomy both from the Church and from their family. As brides of Christ, the women belonging to the Second and Third Order could try to circumvent the authority both of the priest and of their family, embracing the spiritual authority of their "Bridegroom" . . .' (pp. 319–20). M. King, in *Women of the Renaissance*, p. 120, discusses the mystic marriage of St Catherine and the experience of the ecstatic union with Christ described by a number of fifteenth- and sixteenth-century women.

25 For the importance of the *Legenda Major* by Raimondo da Capua, see the essay by A. Volpato, 'Tra Sante Profetesse e Santi Dottori: Caterina da Siena', in E. Schulte van Kessel (ed.), *Women and Men in Spiritual Culture (XIV–XVII centuries), A Meeting of South and North*, Netherlands Government Publications Office, The Hague/Rome, 1986, pp. 149–61.

26 The Fra Bartolomeo altarpiece in Lucca is discussed by R. M. Steinberg in an interesting article which charts the importance of Savonarola's writings for the iconography of this painting, 'Fra Bartolomeo, Savonarola and a Divine Image', *Mitteilungen des Kunsthistorisches Institut in Florenz*, 18, 1974, pp. 319–28.

27 For a full treatment of the figure of Mary Magdalene, see S. Haskins, *Mary Magdalen*, Harper Collins, London, 1993, and M. Mosco (ed.), *La Maddalena tra Sacro e Profano*, exhibition catalogue, Milan/Florence, 1986. The iconography of Mary Magdalene as a haggard hermit is analysed by S. Wilk, 'The Cult of Mary Magdalen in Fifteenth Century Florence and its Iconography', *Studi Medievali*, 3, 2, 1985, pp. 685–98. See also S. Matthews Grieco, 'Modelli di Santità, Rinascimento e Controriforma', in *Donne e Fede*, pp. 312 ff.

28 The *Pala delle Convertite* by Botticelli, and the probable circumstances of its commission, is discussed in R. Lightbown, *Sandro Botticelli*, 2 vols, Elek, London, 1978, I, pp. 109–12. Lightbown provides information about this order of nuns, and comments on what may seem the incongruous presence, in the foreground, of a diminutive Archangel Raphael accompanied by Tobias. The Archangel Raphael was the patron of doctors and apothecaries, and the fabric of the church and convent of the Convertite had been placed under the care of the Arte dei Medici e degli Speziali since 1458. Four predella panels, now in the John G. Johnson Collection, Philadelphia, illustrate episodes from the life of Mary Magdalene, from her conversion to her death. For the institution of the Convertite see M. S. Mazzi, *Prostitute e Lenoni nella Firenze del Quattrocento*, Il Saggiatore, Milan, 1991, pp. 393–403.

29 For the Giulio Romano stories of Mary Magdalene, see Vasari – Milanesi V, p. 417.

30 The letter from Veronica Gambara to Isabella d'Este is cited in full by C. Gould in *The Paintings of Correggio*, Faber, London, 1976, p. 186.

31 The half-figure format is traced back to a number of paintings by Antonello da Messina and by Leonardo, and linked to the use made of the turning half-figure by Giorgione in the article by M. Pardo, 'The Subject of Savoldo's *Magdalene*', *The Art Bulletin*, 71, 1, 1989, pp. 67–91. A. C. Junkerman looks at the half-figure sixteenth-century Magdalenes in the context of

the Venetian sensuous half-figure type in her '*Bellissima Donna*: An Interdisciplinary Study of Venetian Sensuous Half-Length Images of the Early Sixteenth Century', doctoral dissertation, University of California, Berkeley, 1988, pp. 406 ff.

32 The letters by Federico Gonzaga, his agent in Venice and by Titian are cited in J. A. Crowe and G. B. Cavalcaselle, *Titian: His Life and Times*, J. Murray, London, 1877, vol. I, pp. 450–2, and in C. Gandini (ed.), *Tiziano. Le Lettere*, Magnifica Comunità di Cadore Editrice, Pieve di Cadore, 1976, pp. 24–6, 195 and 265. On Vittoria Colonna, see the entry by G. Patrizi in *Dizionario Biografico degli Italiani*, 27, Rome, 1982, pp. 448–57. Vittoria Colonna was the widow of Ferdinando Francesco d'Avalos, Marquess of Pescara. After the death of her husband, she had tried to enter a convent, but her family and the Pope would not allow her to follow her vocation. While she was living in Naples in 1530, she became close to a circle of followers of Valdes.

33 Vasari – Milanesi VII, pp. 443–4.

34 For Titian's *Mary Magdalene* in the Pitti, see C. Hope, *Titian*, pp. 75–6, and B. Aikema, 'Titian's Mary Magdalen in the Palazzo Pitti: An Ambiguous Painting and its Critics', *Journal of the Warburg and Courtauld Institutes*, 57, 1994, pp. 48–59. For the St Petersburg version, see the entry by I. Artemieva in *Titian, Prince of Painters*, exhibition catalogue, p. 334, and for the version in Naples, Galleria Nazionale di Capodimonte, see the entry by F. Valcanover, p. 336. Haskins discusses this 'courtly' version of the penitent saint in *Mary Magdalen*, pp. 236–48.

35 Vasari – Milanesi VII, p. 454.

36 For Vasari's comment on the beauty of figures of saints, see *ibid.*, II, pp. 518–19.

37 *Ibid.*, VI, pp. 535–6.

38 Leonardo's story on the seductive religious image is in his *Treatise on Painting*, ed. A. P. McMahon, Princeton University Press, Princeton, NJ, 1956, p. 22.

39 The beauty of female saints, from St Catherine (as described by Pietro Aretino in his *Vita di Caterina Vergine* of 1540) to Mary Magdalene, and its significance, is discussed in a very interesting essay by M. Pardo, 'Reading the Female Body in Venetian Renaissance Art', in F. Ames-Lewis (ed.), *New Interpretations of Venetian Renaissance Painting*, pp. 77–90.

40 Baccio Valori's passage from his *Ricordi* is cited by Haskins, *Mary Magdalen*, p. 245.

CONCLUSION

'Did women have a Renaissance?' In 1977 the American historian Joan Kelly-Gadol disregarded the accepted way in which historical periods have traditionally been labelled, and asked this provocative question. According to her argument, there was no 'rebirth' for women during the fifteenth and sixteenth centuries: on the contrary, women lost those financial and legal advantages they had previously enjoyed. With this essay, Kelly-Gadol invited her readers to question ideological assumptions about the economic, political and cultural roles of women, the problems connected with female sexuality during this period and the bias embedded in the cultural products of the Renaissance, such as literature.[1]

Kelly-Gadol was not the first historian to concentrate on the lives of women during the Renaissance, but her blunt and controversial question became the focus for a polemical reassessment of this period.[2] During the intervening twenty years, this perspective has evolved and the debate has become more subtle. Historians have begun to ask new questions about the experiences of women, the interactions between men and women, and to define new areas of historical enquiry. We are also becoming more aware that, just as there was in this period throughout Italy a great variety of local traditions in art and architecture, and therefore a diversity in artistic languages and styles, there were also great differences between cities in the laws and regulations concerning the lives of women. Research in the history of women has opened up the possibility of asking related questions in the field of art history, and some of these form the starting-point for discussion of the material presented here. Twenty years ago a book like the present one could not have been written.

A recent magisterial overview of the history of women from 1500 to 1800, which embodies this new approach, begins with a reflection on the image of Eve tempted by the serpent. In *The Prospect Before Her* Olwen Hufton writes that the myth of Eve 'might almost be said to be the foundation text for western European ideas on the essence of womanhood'. This negative view is then balanced by the positive example of the Virgin Mary, the second Eve. Together, these two female icons allow Hufton to sketch the mental universe of the period she is examining and to begin to illustrate the 'construction of woman' within Western European culture. As a historian, however, her subject is the actual experience of women, and 'how it might reflect and modify the imagery'.[3] The images she mentions in the context of her discussion acquire the

186

character and the power of symbols, divested of the peculiarities of function and of the specific circumstances related to their commission – areas which are the province of art history.

Images of women – mythological, historical and religious heroines, allegorical personifications, actual individuals, idealised beautiful women – were everywhere in Renaissance Italy. They could be found at street corners, in city squares, in government buildings, guild halls, princely palaces, private houses, religious institutions, churches and chapels. With such a vast array of material available to the art historian, one of the first problems which has to be faced is that of the principles used in the selection and organisation of the works to be examined.

This book has looked at paintings representing women as part of the complex culture of the Italian Renaissance, neither as illustrations of the physical reality of this period, nor as direct examples of 'life as it was', but rather as aspects of those systems of thought and structures of sensibility which constituted the culture of the time. Thoughout the book the paintings are seen as the result of the close collaboration and necessary interaction between artists and patrons, and, in many cases of *letterati* and poets. The material presented here, chapter by chapter, is linked together by a number of criteria, the most important of which are those of artistic genres and of the function of the works. There are, however, recurring themes which run through the chapters into which the book is divided. One of these themes is the importance of the ideal – as a set of values which guided the individual and the group through life, and as the principle at the heart of artistic practice. Amongst these ideals are those of civic morality and of appropriate behaviour and appearance. Other ideals, those of female beauty, spread from literature to visual representation and also to 'real life'. Finally, the artist was conscious that he had to exercise selection and to 'improve on nature'. He had to do this through the harmony of parts and through systems of proportion in order to reach the perfection achieved by the artists of antiquity.

This leads us to the second theme, that of the supremacy of the culture and history of antiquity. The art of that distant past was a constant inspiration for the artists and the patrons of this period. The role of an artistic genre such as portraiture owed its importance to the knowledge of Roman portraits, while mythological paintings were also seen as an attempt to recapture the culture of what they thought of as their antique ancestors, its richness and its authority. The lessons provided by Greek and Roman literature, but especially by history, were seen as the moral guide for the elite of Renaissance Italy. History was '*magistra vitae*', and as such could be used as exemplary material to inspire towards good actions or courageous behaviour.

187

While history was the guide of the educated members of society, a painted story or an effigy could act directly on the emotions of any viewer. The special capacity of images to move the viewer is another of the themes of this book. Alberti wrote: 'It occurs rarely in any other art that what delights the experienced also moves the inexperienced'.[4] Throughout this period we find written evidence stating that images are effective as *exempla* in all kinds of circumstances, and the stories chosen for the decoration of marriage furniture, the representations of saints and of scenes from their lives fall into this category. Emotional response was not limited to the function of moral *exempla* and to the power of religious images. It is also expressed, through different languages and a different emphasis, in front of the portraits of a loved woman or of a ruler, and in front of the seductive power of a sensuous nude. In the written testimonies of this period we find evidence of the strong emotive bonds between the viewer, the painting as an object and what is represented. Images 'reach out' towards the viewer: an effigy of the Virgin offers consolation in moments of despair, while a nude in the bedroom answers the hopes for a strong and beautiful progeny.

At the core of this book lies the crucial question: what do we discover about the paintings of this period when we select only images of women? The central theme is that there are problems related to genre, function, subject matter and technique which are peculiar to the representation of women. In Renaissance Italy, beauty was a desired, almost necessary characteristic of the well-born young man or woman. The need to give visual form to the type of female beauty described by poets brought about the development of new genres, like the half-figure representations of idealised women, and the refining of artistic techniques developed to convey the qualities of female beauty. In many cases, it is useful to look at the differences between what was considered appropriate behaviour for women *and* for men, their roles in society. The development of feminine virtues and the *exempla* offered to them through both secular and religious images can only be understood in this context. Again, the different conventions required in male and female portraiture to convey the ideals appropriate to men and women can highlight the nature of the artistic problems and of the solutions 'discovered' in order to solve them.

It is fitting to end this book with the voice of a Renaissance woman, the poet Gaspara Stampa (1523–54). In two of the numerous poems she wrote celebrating her love for Count Collaltino di Collalto, she invites artists to produce two portraits. In one, they will have to represent the physical beauty of her lover, and also his character and personality. The other portrait will show her image, but without her heart, which she has lost to the man she loves. Her face will express two emotions: happiness because she is close to her lover, and fear

that he will leave her for another woman. The vicissitudes of a real relationship are conveyed through the Petrarchan conventions of sixteenth-century love poetry. While Petrarch used in his sonnets the conceit of the portraits of Laura to demonstrate that painting could not express her real beauty, Gaspara Stampa calls on the power of art to convey the interior life and the clashes of feelings:

> You artists, who are able to reflect
> In marble, bronze, and colours, or in wax,
> A lifelike form precisely like the true one,
> Even surpassing that which nature made,
> Come all together in a gracious group
> To shape the fairest creature the First Care
> Ever produced, since in creation's time
> With His own hands, he formed Adam and Eve.
> Portray my count, and keep it well in mind
> To show the inward man as well as outer,
> That your portrayal may be lacking nothing.
> Take special care to show his double heart –
> As you well see he has just such a one:
> His own and mine, given to him by Love.
>
> Then paint my portrait from the other side,
> Just as you see me, as I truly am,
> Alive without a soul, breast without heart,
> By an unheard-of miracle of Love.
> And like a ship that moves without its rigging,
> Lacking a rudder, lacking main- or foremast,
> Gazing forever on that blest North Star
> That guides the ship wherever it may go.
> And then observe that on the left-hand side
> My countenance is always sad and woeful,
> But on the right is joyful and triumphant.
> My happy side has only this one meaning:
> That I am standing close beside my lord;
> The sad, fear that another woman holds him.[5]

Notes

1 J. Kelly-Gadol, 'Did Women Have a Renaissance?', in R. Bridenthal and C. Koonz (eds), *Becoming Visible. Women in European History*, Houghton Mifflin, Boston, 1977, pp. 137–64.

2 Among the different stances taken by historians, see: L. Martines, 'A Way of Looking at Women in Renaissance Florence', *The Journal of Medieval and Renaissance Studies*, 4, 1, 1974, pp. 15–28; S. Chojnacki, 'Patrician Women in Early Renaissance Venice', *Studies in*

189

the Renaissance, 21, 1974, pp. 176–203; by the same author, 'The Power of Love: Wives and Husbands in Late Medieval Venice', in M. Erler and M. Kowaleski (eds), *Women and Power in the Middle Ages*, The University of Georgia Press, Athens, Georgia, 1988, pp. 126–48; M. W. Ferguson, M. Quilligan and N. J. Vickers (eds), *Rewriting the Renaissance. The Discourse of Sexual Differences in Early Modern Europe*, The University of Chicago Press, Chicago, 1986; E. G. Rosenthal, 'The Position of Women in Renaissance Florence: Neither Autonomy nor Subjection', in P. Denley and C. Elam (eds), *Florence and Italy: Renaissance Studies in Honour of Nicolai Rubinstein*, Westfield College, University of London, London, 1988, pp. 369–81; J. Bryce, 'Women's Experience in Renaissance Florence: Some Recent Research', *Association of Teachers of Italian Journal*, 55, Spring 1989, pp. 3–16; D. Herlihy, 'Did Women Have a Renaissance? A Reconsideration', in *Women, Family and Society in Medieval Europe: Historical Essays 1978–1991*, Berghahn, Oxford, 1995, pp. 31–56. Stanley Chojnacki makes a number of very important observations concerning approaches to Renaissance gender studies in 'Comment: Blurring Genders', *Renaissance Quarterly*, 40, 1987, pp. 743–51. He writes that 'simple patriarchy, whatever its prescriptive potency, is less satisfactory as the sole point of orientation in the observation of familial, matrimonial, and sexual behavior in practice'. He goes on to advocate a 'more elaborated approach to gender' (p. 748). Olwen Hufton discusses the differing ideological positions in the Introduction to her *The Prospect Before Her. A History of Women in Western Europe. Vol. I, 1500–1800*, Harper Collins, London, 1995, pp. 1–24.

3 *Ibid.*, pp. 26 and 58.

4 L. B. Alberti, *On Painting*, trans. J. R. Spencer, Yale University Press, New Haven and London, 1st ed. 1956, repr. 1966, p. 67.

5

> *Voi, che 'n marmi, in colori, in bronzo, in cera*
> *imitate e vincete la natura,*
> *formando questa e quell'altra figura,*
> *che poi somigli a la sua forma vera,*
> *venite tutti in graziosa schiera*
> *a formar la piu' bella creatura,*
> *che facesse giamai la prima cura,*
> *poi che con le sue man fe' la primiera.*
> *Ritraggete il mio conte, e siavi a mente*
> *qual è dentro ritrarlo, e qual è fore;*
> *si che a tanta opra non manchi niente.*
> *Fategli solamente doppio il core,*
> *come vedrete ch'egli ha veramente*
> *il suo e 'l mio, che gli ha donato Amore.*
>
> *Ritraggete poi me da l'altra parte,*
> *come vedrete ch'io sono in effetto:*
> *viva senz' alma e senza cor nel petto*
> *per miracol d' Amor raro e nov'arte;*
> *quasi nave che vada senza sarte,*
> *senza timon, senza vele e trinchetto,*
> *mirando sempre al lume benedetto*
> *de la sua tramontana, ovunque parte.*
> *Ed avertite che sia 'l mio sembiante*
> *da la parte sinistra afflitto e mesto,*
> *e da la destra allegro e trionfante:*
> *il mio stato felice vuol dir questo,*
> *or che mi trovo il mio signor davante;*
> *quello, il timor che sarà d'altra presto.*

Gaspara Stampa. Selected Poems, ed. and trans. L. A. Stortoni and M. Prentice Lillie, Italica Press, New York, 1994, pp. 48–51. On this important poet, see also F. Bassanese, *Gaspara Stampa*, Twayne, Boston, 1982.

190

SELECT BIBLIOGRAPHY

Here are suggestions for general background reading and sources for further research. Other suggestions are contained in the footnotes.

History and women

Bock, G., 'Women's History and Gender History: Aspects of an International Debate', in *Gender & History*, 1, 1, Spring 1989, pp. 7–30.

Duby G. and Perrot M. (eds), *A History of Women*, Harvard University Press, Cambridge, Mass., 1992: vol. III, N. Zemon Davis and A. Farge (eds), *Renaissance and Enlightenment Paradoxes*.

King, M., *Women of the Renaissance*, The University of Chicago Press, Chicago, 1991.

Klapisch-Zuber, C., *Women, Family and Ritual in Renaissance Italy*, The University of Chicago Press, Chicago, 1985.

Panizza, L., 'A Guide to Recent Bibliography on Italian Renaissance Writings About and By Women', *Bulletin of Italian Studies*, 22, 1989, pp. 3–24.

Wiesner, M. E., *Women and Gender in Early Modern Europe*, Cambridge University Press, Cambridge, 1993.

Feminism and history of art

Broude N. and Garrard, M., 'An Exchange on the Feminist Critique of Art History', *The Art Bulletin*, 71, March 1989, p. 125.

Garrard, M. D., '"Of Men, Women and Art": Some Historical Reflections', *Art Journal*, Summer 1976, pp. 324–9.

Garrard, M. D., 'Feminism: Has it Changed Art History?', in L. B. Gellman, J. Leob and E. H. Fine (eds), *Women's Studies and the Arts*, Women's Caucus for Art, 1978.

Gouma-Peterson T. and Mathews, P., 'The Feminist Critique of Art History', *The Art Bulletin*, 69, 3, September 1987, pp. 326–57.

Klinger, L. S., 'Where's the Artist? Feminist Practice and Poststructural Theories of Authorship', *Art Journal*, 50, 2, Summer 1991, pp. 39–47.

Orenstein, G., 'Art History', *Signs: Journal of Women in Culture and Society*, 1, 2, Winter 1975, pp. 505–25.

Pollock, G., 'Vision, Voice and Power: Feminist Art History and Marxism', *Block*, 6, 1982, pp. 6–9.

Weedon, C., *Feminist Practice and Poststructuralist Theory*, Blackwell, Oxford, 1987.

Wolff, J., *Feminine Sentences: Essays on Women and Culture*, Polity Press, Cambridge, 1990.

Women's patronage

King, C., 'Women as Patrons: Nuns, Widows and Rulers', in D. Norman (ed.), *Siena, Florence and Padua. Art, Society and Religion*, 2 vols, Yale University Press, New Haven and London,

1994, II, pp. 243–66. Examines women's patronage during the fourteenth century. The patronage of Margareta Pellegrini and the Pellegrini Chapel by Michele Sanmicheli is the subject of a forthcoming article by the same author, to be published in *Renaissance Studies*.

Wood, J. M., 'Breaking the Silence: the Poor Clares and the Visual Arts in Fifteenth-Century Italy', *Renaissance Quarterly*, 48, 2, Summer 1995, pp. 262–86. Deals with the range of commissions and with the financial aspects of the patronage of religious orders.

Isabella d'Este as patron

Chambers, D. S., *Patrons and Artists in the Italian Renaissance*, Macmillan, London, 1970, pp. 124–50.

Cole, A., *Art of the Italian Renaissance Courts. Virtue and Magnificence*, Weidenfeld and Nicolson, London, 1995, pp. 160–9.

Ferino-Padgen, S. '*"La Prima Donna del Mondo" Isabella d'Este Fürstin und Mäzenatin der Renaissance*, exhibition catalogue, Vienna, 1994.

Hope, C., 'Artists, Patrons and Advisers in the Italian Renaissance', in G. F. Lytle and S. Orgel (eds), *Patronage in the Renaissance*, Princeton University Press, Princeton, 1981, pp. 293–343.

Kolsky, S., 'Images of Isabella d'Este', *Italian Studies*, 39, 1984, pp. 47–62.

Martindale, A., 'The Patronage of Isabella d'Este at Mantua', *Apollo*, 59, 1964, pp. 183–91.

San Juan, R. M., 'The Court Lady's Dilemma: Isabella d'Este and Art Collecting in the Renaissance', *Oxford Art Journal*, 14, 1991, pp. 67–78. Examines the standard of assessment of Isabella d'Este as a patron and collector, and sees gender as a significant factor in social positioning.

Isabella d'Este. I Luoghi del Collezionismo, exhibition catalogue, Civiltà Mantovana, Il Bulino, Modena, 1995.

Sofonisba Anguissola

Caroli, F., *Sofonisba Anguissola e le sue sorelle*, Mondadori, Milan, 1987.

Garrard, M. D., 'Here's Looking at Me: Sofonisba Anguissola and the Problem of the Woman Artist', *Renaissance Quarterly*, 47, 3, Fall 1994, pp. 556–622.

Gregori, M., 'Fama e oblio di Sofonisba Anguissola', in *Sofonisba Anguissola e le sue sorelle*, exhibition catalogue, Leonardo Arte, Milan, 1994, pp. 11–46. An examination of the fortunes of Sofonisba's career.

Guazzoni, V., 'Donna, pittrice e gentildonna. La nascita di un mito femminile del Cinquecento', in *ibid*., pp. 57–70. The development of the myth of the woman artist in the sixteenth century.

Kusche, M., 'Sofonisba Anguissola al servizio dei re di Spagna', pp. 89–116; and 'Sofonisba e il ritratto di rappresentanza ufficiale nella corte spagnola', in *ibid*., pp. 117–52. Analyses Sofonisba's Spanish career and her contribution to the development of the state portrait at the Spanish court.

Studies on the iconography of female characters in Renaissance art

It is only possible to give here limited biographical indications on some of these studies, and to draw to the attention of the reader some of the approaches followed in recent research.

Baskins, C. L., '"La Festa di Susanna": Virtue on Trial in Renaissance Sacred Drama and Painted Wedding Chests', *Art History*, 14, 3, September 1991, pp. 329–44. Sees the story of Susannah as outlining the contradiction between the public display of virtue of this heroine and the reality of an increasingly privatised domestic space for Renaissance women.

Baskins, C. L., 'Typology, Sexuality, and the Renaissance Esther', in J. Grantham Turner (ed.), *Sexuality and Gender in Early Modern Europe. Institutions, Texts, Images*, Cambridge University Press, Cambridge, 1993, pp. 31–54. An examination of the 'typological texts and pictures' of Esther through the instrument of semiotic theory. Baskins concludes that 'domestic pictures of Esther generate meaning out of the conflicting discourses of female sexuality and Christian typology' (p. 51).

Cole Ahl, D., 'Benozzo Gozzoli's Santa Rosa da Viterbo Cycle: the Decorum of Saintly Narrative', in F. Ames-Lewis and A. Bednarek (eds), *Decorum in Renaissance Narrative Art*, Birkbeck College, London, 1992, pp. 61–9. A study of the way in which a lost fresco cycle representing stories from the life of S. Rosa, painted in the convent of the Poor Clares in Viterbo, followed the iconography of Franciscan female saints, and the rituals associated with nuns taking their vows.

Even, Y., 'The Loggia dei Lanzi. A Showcase of Female Subjugation', in N. Broude and M. D. Garrard (eds), *The Expanding Discourse. Feminism and Art History*, Harper Collins, New York, 1992, pp. 127–37. A speculative assessment of the motivations for the choice of sculptures to be displayed in the Loggia dei Lanzi. Even concludes that Cellini's *Perseus* and Giambologna's *Rape of a Sabine* 'convey a powerful message: the political and biological subjugation of the female by the male'.

Lazzaro, C., 'The Visual Language of Gender in Sixteenth-Century Garden Sculpture', in M. Migiel and J. Schiesari (eds), *Refiguring Woman. Perspectives on Gender and the Italian Renaissance*, Cornell University Press, Ithaca and London, 1991, pp. 71–113. An examination of images representing different aspects of Nature, such as the goddesses Diana of Ephesus, Ceres and Venus.

Millner Kahr, M., 'Danae: Virtuous, Voluptuous, Venal Woman', *The Art Bulletin*, 60, 1978, pp. 43–55.

San Juan, R. M., 'Mythology, Women and Renaissance Private Life: the Myth of Euridice in Italian Furniture Painting', *Art History*, 15, 2, June 1992, pp. 127–45.

Santore, C., 'Danae: the Renaissance Courtesan's Alter Ego', *Zeitschrift für Kunstgeschichte*, 54, 1991, pp. 412–27.

Prints

Bury, M., 'The Taste for Prints in Italy to *c.* 1600', *Print Quarterly*, 2, 1, 1985, pp. 12–26.

Landau D. and Parshall, P., *The Renaissance Print 1470–1550*, Yale University Press, New Haven and London, 1994. A detailed study of prints, mostly destined for the top end of the market.

Matthews Grieco, S., *'Querelles des Femmes' or 'Guerre des Sexes'? Visual Representations of Women in Renaissance Europe*, exhibition catalogue, European Culture Research Centre, European University Institute, Florence, 1989.

Matthews Grieco, S., *Histoire et Iconographie de la Femme au XVIe Siècle, Representations, Mythes, Discourses*, Paris, 1990.

Matthews Grieco, S., 'Persuasive Pictures: Didactic Prints and the Construction of Female Identity', in L. Panizza (ed.), *Culture, Society and Women in Renaissance Italy*, forthcoming. A discussion of Italian prints representing women. The author also examines those prints which were not the product of important artists, and which were not bought by members of the elite.

Russell H. D., with Barnes, B., *Eva / Ave. Women in Renaissance and Baroque Prints*, exhibition catalogue, National Gallery of Art, Washington, The Feminist Press, New York, 1990.

Marriage and society

Diefendorf, B. B., 'Family Culture, Renaissance Culture', *Renaissance Quarterly*, 40, 1987, pp. 661–81.

Gregory, H., 'Daughters, Dowries and the Family in Fifteenth-century Florence', *Rinascimento*, 2, 27, 1987, pp. 215–37. Uses letters as evidence for a discussion of the attitudes of the Florentine elite towards marriage, and the role of daughters in the building of family alliances.

Jordan, C., *Renaissance Feminism. Literary Texts and Political Modes*, Cornell University Press, Ithaca and London, 1990, pp. 41 ff.

Kent, F. W., 'La Famiglia Patrizia Fiorentina nel Quattrocento. Nuovi Orientamenti nella Storiografia Recente', in D. Lamberini (ed.), *Palazzo Strozzi. Meta' Millennio 1489–1989*, Atti del Convegno di Studi (Firenze, 3–6 Luglio 1989), Istituto della Enciclopedia Italiana, Rome, 1991, pp. 70–91.

King, M. L., 'Caldiera and the Barbaros on Marriage and the Family: Humanist Reflections of Venetian Reality', *Journal of Medieval and Renaissance Studies*, 6, 1, 1976, pp. 19–50, discusses Francesco Barbaro, *De Re Uxoria*.

Lugli, V., *I Trattatisti della Famiglia nel Quattrocento*, Formaggini, Bologna and Modena, 1909. A descriptive account of writings on marriage by Giovanni Dominici, S. Antonino, S. Bernardino da Siena, Pier Paolo Vergerio and Maffeo Vegio.

Lydecker, J. K., 'The Domestic Setting of the Arts in Renaissance Florence' (unpublished doctoral dissertation, Johns Hopkins University, 1987), pp. 146–59, discusses marriage and its rituals.

Molho, A., 'Visions of the Florentine Family in the Renaissance', *Journal of Modern History*, 50, 2, June 1978, pp. 304–11.

Molho, A., *Marriage Alliance in Late Medieval Florence*, Harvard University Press, Cambridge, Mass., 1994.

Strocchia, S., 'La Famiglia Patrizia Fiorentina nel Secolo XV: la Problematic a della Donna', in D. Lamberini (ed.) *Palazzo Strozzi*, pp. 126–37.

Houses and furnishings

Barriault, A. B., 'The Abundant, Beautiful, Chaste and Wise: Domestic Painting of the Italian Renaissance in the Virginia Museum of Fine Art', *Arts in Virginia*, 30, 1, 1991, pp. 2–21.

Goldthwaite, R. A., 'The Florentine Palace as Domestic Architecture', *American Historical Review*, 77, 4, October 1972, pp. 907–1012.

Goldthwaite, R. A., 'The Empire of Things: Consumer Demand in Renaissance Italy', in F. W. Kent and P. Simons with J. C. Eade (eds), *Patronage, Art and Society in Renaissance Italy*, Clarendon Press, Oxford, 1987, pp. 153–75.

Goldthwaite, R. A., 'L'Interno del Palazzo e il Consumo dei Beni', in Lamberini, *Palazzo Strozzi*, pp. 159–66.

Goldthwaite, R. A., *Wealth and the Demand for Art in Italy, 1300–1600*, Johns Hopkins University Press, Baltimore, 1993.

Lydecker, J. K., 'Il patriziato Fiorentino e la Committenza Artistica per la Casa', in *I Ceti Dirigenti nella Toscana del Quattrocento*, Comitato di Studi sulla Storia dei Ceti Dirigenti in Toscana, Atti del V e VI Convegno, Florence, 10–11 December 1982; 2–3 December 1983, Papafava, Florence, 1987, pp. 209–21.

Pons, N. 'Arredi Domestici e Oggetti di Devozione Privata', in *Maestri e Botteghe. Pittura a Firenze alla Fine del Quattrocento*, exhibition catalogue, Palazzo Strozzi, 16 October 1992–20 January 1993, Silvana Editoriale, Florence, 1992, pp. 219–31.

Schiaparelli, A., *La Casa Fiorentina e i Suoi Arredi nei Secoli XIV e XV*, Sansoni, Florence, 1908, repr. in 2 vols, ed. M. Sframeli and L. Pagnotta, Le Lettere, Florence, 1983.

Thornton, P., *The Italian Renaissance Interior, 1400–1600*, Weidenfeld and Nicholson, London, 1991.

Cassoni and spalliere

Filippini, C., 'Tematiche e Soggetti Rappresentati su Forzieri, Spalliere e Deschi da Parto', in *Maestri e Botteghe*, pp. 232–7.

Watson, P. F., 'Virtù and Voluptas in Cassone Painting', unpublished doctoral dissertation, Yale University, 1970.

Witthof, B., 'Marriage Rituals and Marriage Chests in Quattrocento Florence', *Artibus et Historiae*, 5, 1982, pp. 43–59.

Young men, women and behaviour

Chemello, A., 'Donna di palazzo, moglie, cortigiana: ruoli e funzioni sociali della donna in alcuni trattati del Cinquecento', in A Prosperi (ed.), *La Corte e il 'Cortegiano'. II. Un Modello Europeo*, Bulzoni, Rome, 1980, pp. 113–32.

Martines, L., 'A Way of Looking at Women in Renaissance Florence', *Journal of Medieval and Renaissance Studies*, 4, 1, Spring 1974, pp. 15–28.

Rosenthal, E. G., 'The Position of Women in Renaissance Florence: Neither Autonomy nor Subjection', in P. Denley and C. Elam (eds), *Florence and Italy: Renaissance Studies in Honour of Nicolai Rubinstein*, Committee for Medieval Studies, Westfield College, London, 1988, pp. 369–81.

Trafton, D. A., 'Politics and the Praise of Women: Political Discourse in the Courtier's Third Book', in R. Hanning and D. Rosand (eds), *Castiglione: the Ideal and the Real in Renaissance Culture*, Yale University Press, New Haven, 1983, pp. 29–44.

Trexler, R. C., 'Ritual in Florence: Adolescence and Salvation in the Renaissance', in C. Trinkhaus and H. Oberman (eds), *The Pursuit of Holiness in Late Medieval and Renaissance Religion*, Brill, Leiden, 1974, pp. 200–61.

Trexler, R. C., *Public Life in Renaissance Florence*, Cornell University Press, Ithaca, 1980, pp. 387–96.

Portraits

Burke, P., 'The Presentation of the Self in Renaissance Portrait', in *The Historical Anthropology of Early Modern Italy. Essays on Perception and Communication*, Cambridge University Press, Cambridge, 1987, pp. 150–67. An important discussion of portraits 'not from the usual point of view – that of the painters and their individual achievements – but from the point of view of the sitters, not as individuals so much as social types'. Burke explores the ways in which portraiture, during this period, was used in the construction of public identities, and invites the reader to see the painter as 'a rhetorician'. A study of the changing 'rules of rhetoric' of a particular society can help us to decode the signs embodied in the portraits.

Campbell, L., *Renaissance Portraits. European Portrait Painting in the Fourteenth, Fifteenth and Sixteenth Centuries*, Yale University Press, New Haven and London, 1990. Presents a wealth of extremely useful visual material supported by written sources in an attempt to explore the

195

functions of different types of portraits, and to document the intentions of painters and patrons. Campbell does not follow a chronological structure in order to free himself from 'Florentine notions of artistic "progress"', but in doing so his discussion of the complexities of the changes in function, and of the stylistic differences which are closely related to these changes, lacks the necessary emphasis. For a review of Campbell's approach, see S. Fermor, 'In a Glass Darkly: Three Views of Renaissance Portraiture', *Art History*, 5, 14, 1991, pp. 431–4. Fermor also discusses J. Pope-Hennesy, *The Portrait in the Renaissance*.

Gentili, A., Morel, P. and Cieri Via C., (eds), *Il Ritratto e la Memoria*, 3 vols, Bulzoni Editore, Rome, 1989.

Woods-Marsden, J., '"Ritratto al naturale": Questions of Realism and Idealism in Early Renaissance Portraiture', *Art Journal*, 46, 1987, pp. 209–16.

In the chapter 'Portraits and Poets' in his book *Only Connect . . . Art and the Spectator in the Italian Renaissance*, Princeton University Press, Princeton, NJ, 1992, John Shearman concentrates on the problem presented by those portraits which engage the viewer in an emotional dialogue, and by those contemporary texts which alert the viewer to the presence of an *animus* in the painted image.

Clothes and sumptuary laws

Bridgeman, J., 'Why Sumptuary Laws Did Not Work', in *Culture, Society and Women in Renaissance Italy*, forthcoming. An excellent discussion of the aims of sumptuary legislation, seen in the context of contemporary writings about behaviour associated with dress codes.

Davanzo Poli, D., 'Le Cortigiane e la Moda', in *Le Cortigiane di Venezia dal Trecento al Settecento*, exhibition catalogue, Venice, 2 February–16 April 1990, Berenice, Milan, 1990.

Lazard, M., 'Le Corps Vetu: Signification du Costume à la Renaissance', in *Le Corps à la Renaissance*, Actes du XXX Colloque de Tours 1987, Aux Amateurs des Livres, Paris, 1990, pp. 75–94.

Muzzarelli, M. G., ' "Contra Mundanas Vanitates et Pompas": Aspetti nella Lotta contro i Lussi nell'Italia del XV Secolo', *Rivista di Storia della Chiesa in Italia*, 40, 1986, pp. 371–90. A discussion of Bernardino da Siena, Giovanni da Capestrano, Giacomo della Manca and Bernardino da Feltre and their battle against luxurious and provocative clothing.

Nevinson, J. L., 'L'Origine de la Gravure de Modes', in *Actes du 1er Congres International d'Histoire du Costume* (Venice, 1952), Centro Internazionale delle Arti e del Costume, Milan, 1955, pp. 202–12.

Newett, M., 'The Sumptuary Laws of Venice in the 14th and 15th Centuries', in T. F. Tout and J. Tait (eds), *Historical Essays by Members of the Owens College Manchester*, Longmans, London, 1902, pp. 245–78.

Newton, S. M., 'The Body and High Fashion During the Renaissance', in *Le Corps à la Renaissance*, pp. 23–9.

For an example of Florentine mid-sixteenth-century sumptuary legislation which stresses the ranking of social groups and illustrates the many exemptions, see C. Carnesecchi, *Cosimo I e la Sua Legge Suntuaria del 1562*, Florence, 1902. This law specifies that the term 'the exempted' should include both husband and wife, 'because if God makes them one, we do not think that the law should divide them; and this avoids adding to the disputes and arguments between them, which unfortunately are the consequences of marriage' (p. 37).

Women and beauty

Cropper, E., 'On Beautiful Women, Parmigianino, "Petrarchismo", and the Vernacular Style', *The Art Bulletin*, 58, 1976, pp. 374–94.

Fermor, S., 'Movement and Gender in 16th-Century Italian Painting', in K. Adler and M. Pointon (eds), *The Body Imaged. The Human Form and Visual Culture since the Renaissance*, Cambridge University Press, Cambridge, 1993, pp. 129–45.

Matthews Grieco, S., 'The Body, Appearance and Sexuality', in N. Zemon Davis and A. Farge (eds), *A History of Women in the West. III. Renaissance and Enlightenment Paradoxes*, Harvard University Press, Cambridge, Mass., 1993, pp. 46–84. Makes references to the canon of beauty in the context of everyday life.

Perouse, G.-A., 'La Renaissance et la Beauté Masculine', in *Le Corps à la Renaissance*, pp. 61–76.

Pozzi, G., 'Il ritratto della donna nella poesia d'inizio Cinquecento e la pittura di Giorgione', in R. Pallucchini (ed.), *Giorgione e l'Umanesimo Veneziano*, Olschki, Florence, 1981, pp. 309–41. With bibliographical references for the canon of female beauty in the history of Italian literature, from Petrarch to the sixteenth century.

Yavneh, N., 'The Ambiguity of Beauty in Tasso and Petrarch,' in J. G. Turner (ed.), *Sexuality and Gender in Early Modern Europe. Institutions, Texts, Images*, Cambridge University Press, Cambridge, 1993, pp. 133–57.

Venetian painting collections

Fletcher, J., 'Marcantonio Michiel: His Friends and his Collection', *Burlington Magazine*, 124, 1981, pp. 453–66.

Fletcher, J., 'Marcantonio Michiel: "che ha veduto assai"', *Burlington Magazine*, 123, 1981, pp. 602–8.

Fletcher, J., 'Marcantonio Michiel's Collection', *Journal of the Warburg and Courtauld Institutes*, 36, 1973, pp. 382–5.

For Marcantonio Michiel's inventory, see D. Chambers and B. Pullan (eds), *Venice, a Documentary History, 1450–1630*, Blackwell, Oxford, 1992, pp. 424 ff.

Titian

Giorgi, R., *Tiziano, Venere, Amore e il Musicista in cinque dipinti*, Gangemi Editore, Rome, 1990. A review of all the various interpretations of the paintings with Venus and a musician.

Robertson, C., *'Il Gran Cardinale' Alessandro Farnese, Patron of the Arts*, Yale University Press, New Haven and London, 1992, pp. 72 ff.

Robertson, G., 'Honour, Love and Truth: An Alternative Reading of Titian's *Sacred and Profane Love*', *Renaissance Studies*, 2, 1988, pp. 268–79.

Studdert-Kennedy, W. G., 'Titian: the Fitzwilliam Venus', *Burlington Magazine*, C, 1958, pp. 349–51, discusses the importance of music and the erotic significance of madrigals.

Studdert-Kennedy, W. G., 'Titian: Metaphors of Love and Renewal', *Word and Image*, 3, 1, 1987, pp. 27–40.

Entries on the *Danae* and on the female portrait in Naples, in L. Fornari Schianchi and N. Spinoso (eds), *I Farnese. Arte e Collezionismo*, exhibition catalogue, Electa, Milan, 1995, pp. 208–10 and 216–17.

Ludovico Dolce

Roskill, M., *Dolce's 'Aretino' and Venetian Art Theory of the Cinquecento*, New York University Press, New York, 1968.

197

Erotic images and the Church

Freedberg, D., 'Johannes Molanus on Provocative Painting, "De Historia sanctarum imaginum et picturarum, Book II, Chapter 42', *Journal of the Warburg and Courtauld Institutes*, 34, 1971, pp. 229–45.

Devotional paintings

Bradshaw-Nishi, M. J., 'Masolino's Saint Catherine Chapel, San Clemente, Rome: Style, Iconography, Patron and Date', doctoral dissertation, Indiana University, 1984.

Dunkerton, J., Foister, S., Gordon, D. and Penny, N., *Giotto to Dürer. Early Renaissance Paintings in the National Gallery*, Yale University Press, New Haven and London, 1991, Chapter one, 'Christian Worship and Imagery', pp. 22–76, on the function of public and private devotional images, on subject matter and iconography, and on the patronage of religious orders and confraternities.

Hope, C., 'Religious Narrative in Renaissance Art', *Journal of the Royal Society of Arts*, 134, 1985, pp. 804–15.

Humfrey P. and Kemp M. (eds), *The Altarpiece in the Renaissance*, Cambridge University Press, Cambridge and New York, 1990.

Ringbom, S., 'Devotional Images and Imaginative Devotions. Notes on the Place of Art in Late Medieval Private Piety', *Gazette des Beaux Arts*, 6, 75, 1969, pp. 159–70.

Ringbom, S., *Icon to Narrative. The Rise of the Dramatic Close-up in Fifteenth-century Devotional Painting*, 1st ed., Acta Academiae Aboensis, ser. Humaniora, 31, 2, Åbo, 1965; 2nd ed., Davaco, Doornspijk, 1984.

On the context for private devotional paintings and on the way in which they were displayed, see J. K. Lydecker, 'The Domestic Setting of the Arts in Renaissance Florence', unpublished doctored dissertation, Johns Hopkins University, 1987, pp. 175 ff.

Women and religious life

Atkinson, C. W., Buchanan, C. H. and Miles M. R. (eds), *Immaculate and Powerful. The Female in Sacred Images and Social Reality*, Crucible, Wellingborough, 1987.

Brucker, G. A., 'Monasteries, Friaries and Nunneries in Quattrocento Florence', in T. Verdon and J. Henderson (eds), *Christianity in the Renaissance*, pp. 41–62.

Cohen, S., 'Convertite e Malmaritate: donne "irregolari" e ordini religiosi nella Firenze rinascimentale', *Memoria*, 5, 1982, pp. 42–63.

Herlihy, D., 'Did Women Have a Renaissance? A Reconsideration', in *Women, Family and Society in Medieval Europe. Historical Essays 1978–1991*, Providence, RI, Oxford, Berghahn, 1995, pp. 33–56, esp. 34–44. Looks at female saints and stresses the importance of women's religious experience.

Scaraffia L. and Zarri G. (eds), *Donne e Fede. Santita' e Vita Religiosa in Italia*, Laterza, Bari, 1994. Especially important are the following two essays: G. Barone, 'Società e Religiosità Femminile (750–1450)', pp. 61–113; and G. Zarri, 'Dalla Profezia alla Disciplina (1450–1650)', pp. 177–225.

Catherine de Sienna. Catalogue de l'Exposition au Musée du Palais de Papes, exhibition catalogue, Avignon, 1992.

INDEX

Numbers in *italics* refer to illustrations.
Works are indexed under artists' names.